RENAISSANCE

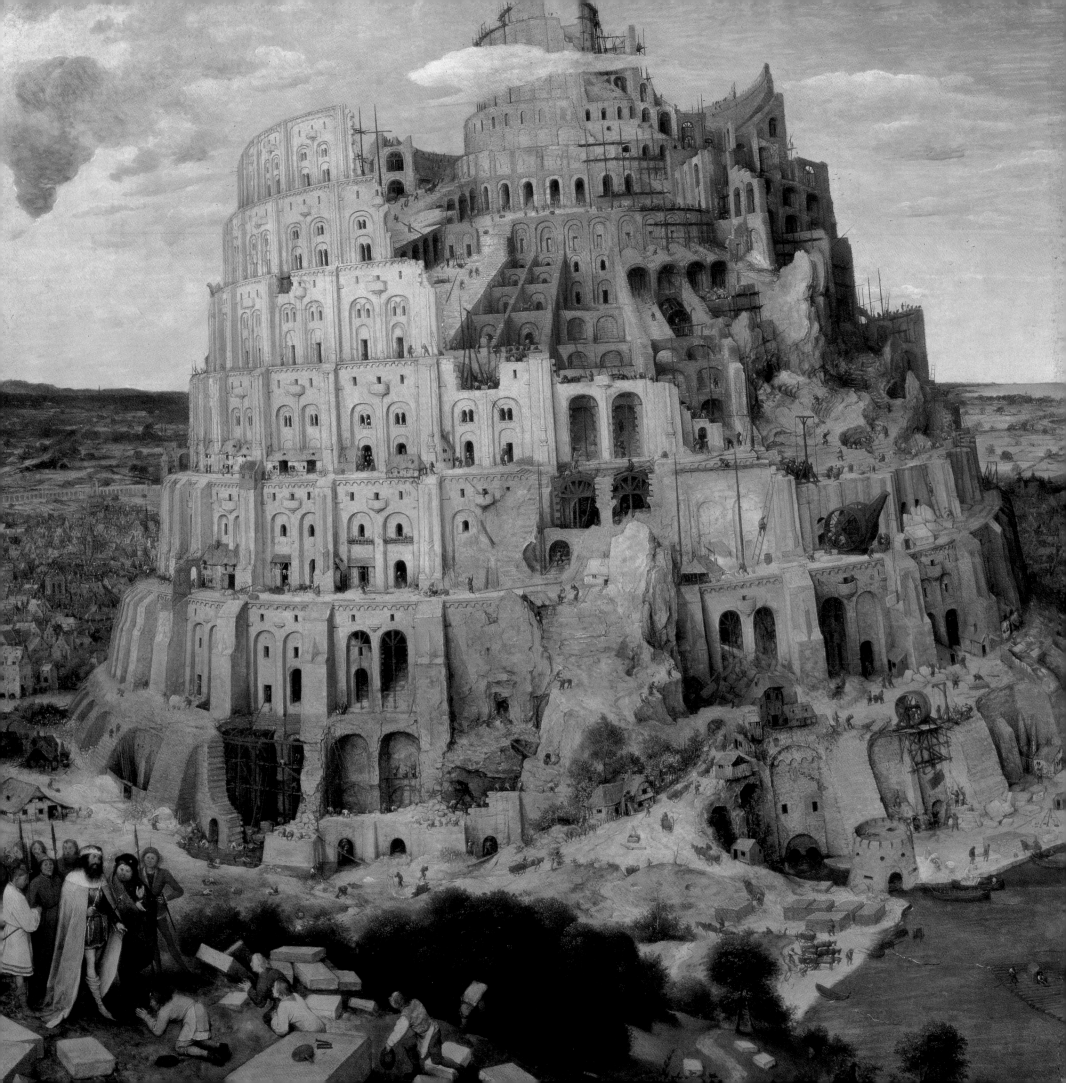

Christopher Masters

RENAISSANCE

MERRELL
LONDON · NEW YORK

CONTENTS

'If the fragments of holy antiquity, the ruins and debris and even the shavings, fill us with stupefied admiration and give us such delight in viewing them, what would they do if they were whole?'[1] There was nothing particularly unusual about the enthusiasm for antiquity expressed in 1499 by Poliphilo, the hero of Francesco Colonna's prose poem *Hypnerotomachia Poliphili*. Nostalgia for the ancient world was stimulating artists, poets and princes across Italy, and was the dominant principle of the phenomenon that we now call the 'Renaissance'.

Yet everything else about Poliphilo's experience was decidedly out of the ordinary. During his convoluted quest for the maiden Polia, Poliphilo loses himself in a forest; encounters a frightful dragon; translates ancient hieroglyphs; and develops an obsession with women's footwear, from 'half-boots of gilded leather' to sandals with silk thongs, gold rings and pearled latchets – 'decorations fit to dazzle and blind even wild bulls!'[2] He also attends a banquet where at each course the tablecloths – and the maidservants' robes – change colour, and marvels at the fresh napkin that accompanies every morsel. *This* is civilization.

Above all, Poliphilo records, in extraordinary detail, fantastic Classical structures, often 'gnawed by decay and old age',[3] yet still adorned with precious paintings and reliefs. Many of these imaginary compositions were to influence sixteenth-century artists, including Titian, Correggio and Giulio Romano, as did the woodcuts that accompanied the book's first edition. In one of the most memorable episodes, Poliphilo visits the tomb of Adonis, the lover of Venus. He describes a relief on one side of the sarcophagus depicting Venus, who has pricked her leg on a rose while rushing to save Adonis from his rival, Mars – an event skilfully adapted by Giulio Romano for the Palazzo del Te in Mantua (opposite).

The story typifies the morbid eroticism that permeates the whole of Colonna's book, which ends with a passionate embrace – 'And I quickly responded to her swelling tongue, tasting a sugary moisture that brought me to death's door' – and Polia's sudden disappearance. She dissolves 'like the smoke … from a stick of incense … . This was the point, O gentle readers, at which, alas, I awoke.'[4] So, at the end, the whole rambling tale, with its catalogue of decayed antiquity and unconsummated love, turns out to have been no more than an erotic fantasy – like Giulio Romano's vibrant fresco.

How different are both story and painting from the image of the ancient world created by Giulio's teacher, Raphael, in the *School of Athens* (page 8), in the Vatican in Rome! In this majestic work, the philosophers and mathematicians of ancient Greece are reunited in an appropriately rational, balanced composition. At the centre, Plato points upwards at the reality

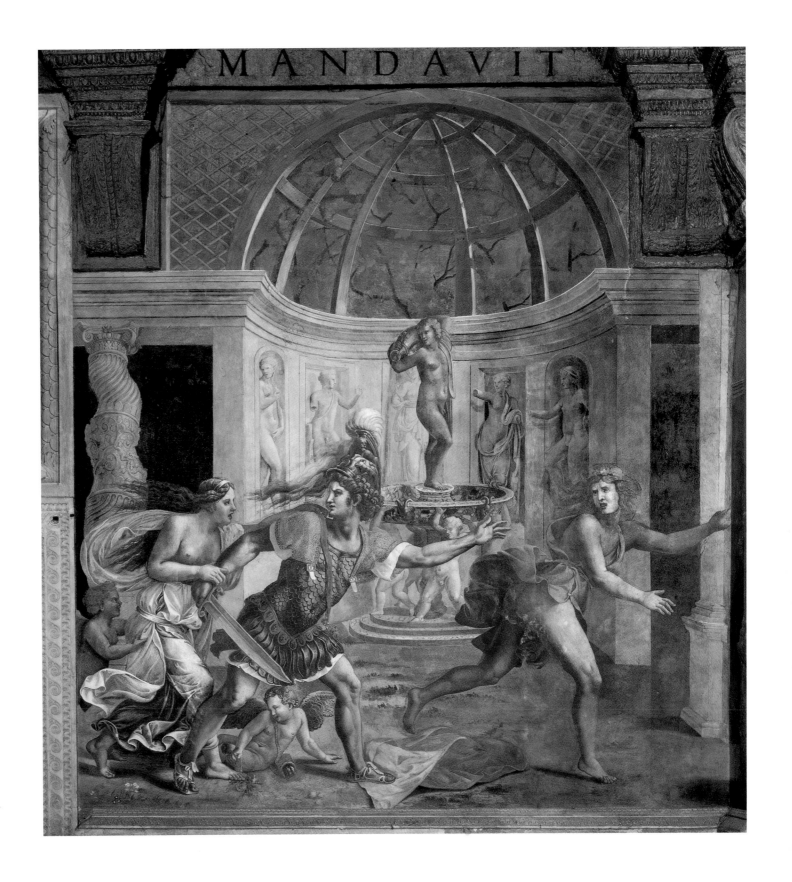

Giulio Romano (?1499–1546)
Venus, Mars and Adonis

1528
Fresco
Mantua, Palazzo del Te, Sala di Amore e Psiche

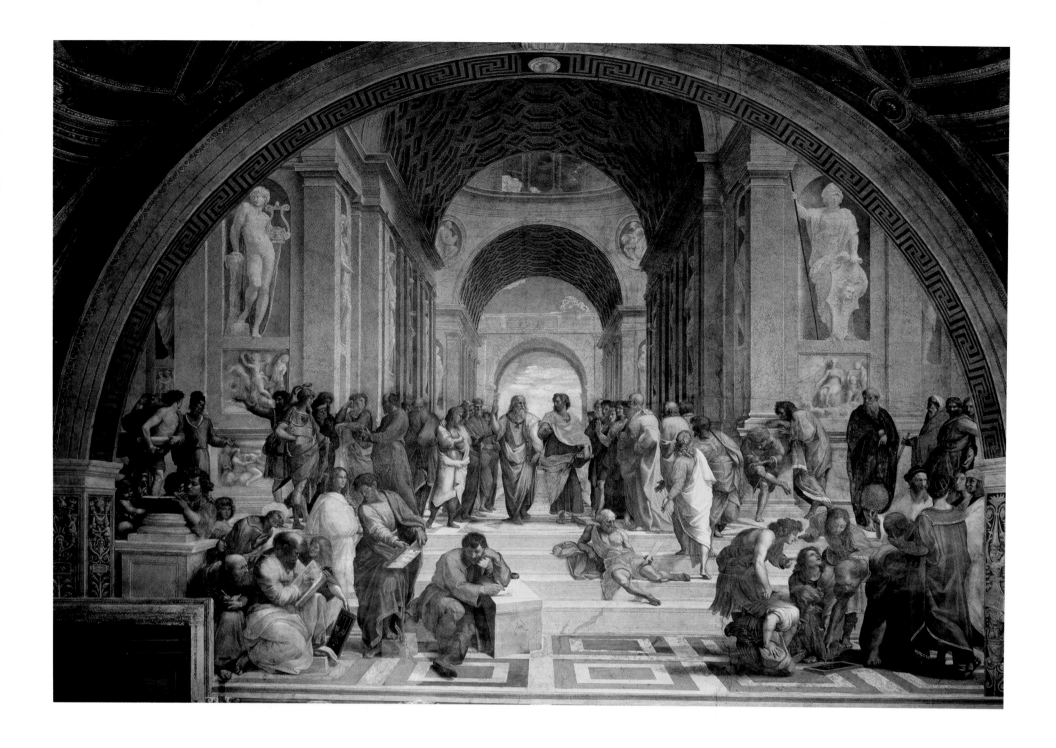

Raphael (1483–1520)

School of Athens

1510–11
Fresco
Rome, The Vatican, Stanza della Segnatura

of ideal forms in which he believed, while Aristotle's downward gesture reflects his emphasis on observation of the natural world. The other thinkers include Diogenes (sprawling across the steps), Euclid (bending over his slate) and Ptolemy (holding a celestial sphere), while the figure brooding in the foreground is probably a portrait of Michelangelo. Above them rises a monumental structure, inspired by Donato Bramante's design for the rebuilding of St Peter's Basilica: with its symmetry and formal perfection, it could hardly be more unlike the eccentric ruins described in *Hypnerotomachia*, even though both are clearly inspired by antiquity.

Raphael's fresco was not made in isolation: on the opposite wall another painting, the *Disputation over the Most Holy Sacrament* (1510–11), has a Christian theme, emphasizing that the leaders of the Church, who commissioned these works, regarded pagan learning as complementary to their teaching. Collectively, these images demonstrate the tendency towards systematic, logical thought that is one of the qualities of the Italian Renaissance – although not, as we have seen, a ubiquitous one.

Despite the variety of ways in which Italian artists and writers responded to antiquity, most were influenced by the activities of humanist scholars. 'Humanism' in its broadest sense was a type of learning in which Classical texts were used as the basis of what we would now describe as the 'humanities', such academic subjects as grammar, history, poetry and philosophy. There had been humanists in the Middle Ages, but during the fifteenth century certain cities – above all Florence – developed this culture to an unprecedented degree. There is no doubt that this greatly contributed to the serious study of Roman art and architecture, which had a profound effect on artistic developments during this period.

Sometimes the Renaissance humanist could seem a little precious. The fifteenth-century Florentine Niccolò Niccoli (*c.* 1364–1437) was described by his biographer, Vespasiano da Bisticci, as 'the neatest of men': when he dined, 'he ate from the finest of antique dishes … his drinking cup was of crystal … to see him at the table like this, looking like a figure from the ancient world, was a noble sight indeed'.[5] This was meant as a compliment, yet others mocked Niccoli for 'probing' ancient buildings or for getting excited about diphthongs like a schoolboy with his grammar.

But this was pedantry with a purpose. Sometimes the scholars who worried over such subtle linguistic points also came across texts by authors who had almost been forgotten, giving a new breadth of subject-matter to poets and painters. Recently found verse by the Romans Lucretius and Catullus, for example, inspired Piero di Cosimo (page 230) and Titian (page 67), while Tacitus' *Germania*, written during the first century AD and discovered in a German monastery in the 1420s, profoundly influenced the development of landscape painting. Its impact was not immediate – it was fifty years before it was published – but in the early sixteenth century its vivid descriptions of the ancient German forests and their inhabitants fired the imaginations of the writer Conrad Celtis and the great Bavarian artist Albrecht Altdorfer (page 207).

So the uses of antiquity were varied indeed. Yet perhaps the most important technical invention of the Renaissance had little to do with the Classical world. Linear perspective – the technique of representing parallel lines as if they were converging towards a vanishing point – was in fact known to Roman painters. Nonetheless, because in the early fifteenth century no

ancient pictures had yet been discovered, its development by Filippo Brunelleschi and his fellow Florentines was a feat of true originality. This did not, however, occur in a vacuum. Problems of perspective and the definition of three-dimensional bodies demanded mathematical skills similar to those that were part of the everyday commercial life of a city. The use of geometry (together with such concepts as π, denoting the ratio of the circumference of a circle to its diameter) to calculate quantities accurately was shared by artisans, wealthy merchants and humanists. It is, therefore, unsurprising that representatives of different professions and social classes laid claim to this common mathematical culture during the Renaissance. In the 1430s, for example, the scholar Leon Battista Alberti wrote the first analysis of perspective for painters; twenty years later, the painter Piero della Francesca produced a mathematical treatise for merchants; and, in the following century, the painter Hans Holbein included a textbook for merchants among the attributes of two French scholar-diplomats (page 184).

Jan van Eyck (*c.* 1395–1441)
The Virgin and Child with Chancellor Rolin

c. 1435
Oil on panel
66 × 62 cm (26 × 24⅛ in.)
Paris, Musée du Louvre

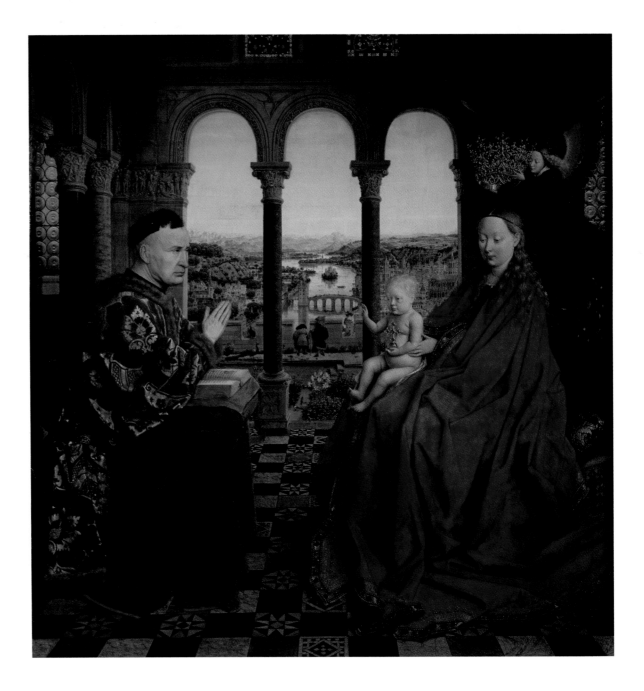

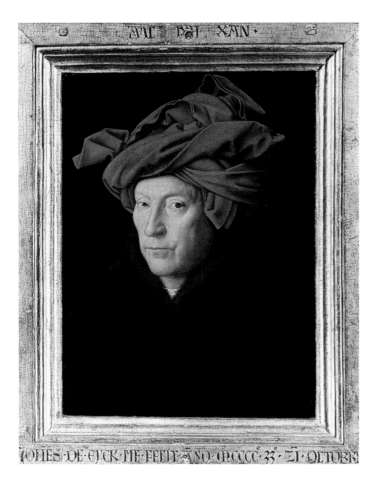

Jan van Eyck (c. 1395–1441)
Portrait of a Man (Self-Portrait?)
Inscribed *AS I CAN* at the top of the frame
1433
Oil on panel, with original frame
26 × 19 cm (10¼ × 7½ in.)
London, The National Gallery

A practical grasp of mathematics; humanist learning; a certain liberation of the imagination inspired by antiquity: these are all factors that helped to create the unique art of this period, and they tend to concentrate our attention on a relatively small area of Europe – the Italian peninsula from Rome to the Alps. However, other regions or countries also require attention: Germany (at least from the time of Albrecht Dürer), France and, above all, the southern Netherlands (modern Belgium). There achievements in the use of oil paint were accompanied in the early fifteenth century by remarkable innovations in portraiture, landscape and the depiction of interiors – developments that can all be seen in Jan van Eyck's extraordinary *The Virgin and Child with Chancellor Rolin* (opposite).

This emphasis on a few countries at certain times may seem to suggest that there was little of interest occurring in the rest of Europe or that such areas as Germany sprang into life only around 1500. In fact, European art of the late Middle Ages is almost an embarrassment of riches. In this respect, the term *Renaissance* ('rebirth'), invented in the nineteenth century, is misleading, since it implies a moribund civilization waiting to be renewed by inspiration from antiquity. This was not the case: if it had been, then Gothic art and architecture would not have persisted in northern Europe as long as they did. Nor, even when something new did appear, as certainly occurred in fifteenth-century Flanders, was it necessarily concerned with a revival of ancient culture.

When Jan van Eyck added the inscription *AS I CAN* to the frame of one of his paintings (left), or floridly wrote his name and the date in the centre of the portrait of Giovanni Arnolfini and his wife (page 147), he was not merely boasting of his ability and prestige. He was signalling a new self-awareness – a sense that he, like others of his contemporaries, was doing something different. In Italy this consciousness was inevitably expressed through comparisons with antiquity: Alberti, for example, praised certain of his contemporaries for 'a genius … in no way inferior'[6] to that of the ancients. However, by around 1490 Giovanni Santi, the father of Raphael, had replaced 'in no way inferior' with something a little stronger. Armed with a list of artists that ranged from Van Eyck to Leonardo da Vinci, Santi claimed in a verse chronicle that 'So many have been famous in our age/ They make any other time seem poor.'[7] Like many of his contemporaries, he regarded his century as not merely a period of 'rebirth' but as something even more emphatic – 'our age', an era apart, a time of unprecedented achievement.

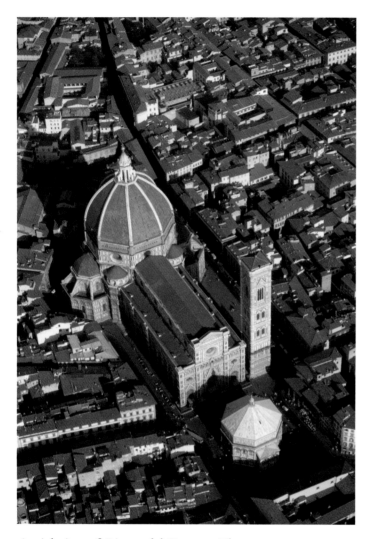

Aerial view of Piazza del Duomo, Florence

The imitation of antiquity is not an Italian invention. Across medieval Europe, at various times, artists created works that were clearly modelled on ancient sculpture. Yet Nicola Pisano's reliefs, particularly those decorating the pulpit in the baptistery in Pisa, completed in 1260 (opposite), are of exceptional importance, above all because they create a real sense of the physical bulk of the bodies beneath the drapery. A similar effect was created in painting in the early fourteenth century by Giotto di Bondone: in *The Annunciation to St Anne* (opposite), the Virgin's mother is visited by an angel in a structure that is part Classical temple, part doll's house, and yet the illusion of space effectively complements the sculptural qualities of the figures.

Although Giotto's greatest achievement, the Scrovegni Chapel, is in Padua, the artist was in fact a Florentine, and it was in his native city that his impact was to be strongest. By the middle of the fourteenth century, however, his influence seemed to be waning. Bernardo Daddi's *Madonna and Child with Angels*, completed in 1347 only shortly before the catastrophe of the Black Death, is a beautiful but rarefied image (opposite), later set within a Gothic tabernacle by the artist known as Orcagna. Stylistically, these works offer only a few hints of the artistic revolution that was to begin in Florence half a century later.

Style, however, is just part of the story. Daddi's image is the altarpiece of a chapel in the Orsanmichele, a hall patronized by Florence's wealthy guilds. These organizations, which represented such trades as the bankers, cloth importers and armourers, were to play a vital role in commissioning key works of the Early Renaissance: the institutional framework for the great projects of the fifteenth century was already in place.

Indeed, the aerial view of the Piazza del Duomo in Florence (left) is dominated by medieval buildings that corporate patrons helped to embellish during the Renaissance. The most spectacular feature – the immense cupola of the *duomo*, or cathedral – was built from 1420 to 1436 by the great architect Filippo Brunelleschi, under the supervision of the Guild of Wool Merchants, which administered the cathedral's office of works. The rest of the building, however, is a Gothic structure, begun in the late thirteenth century by Arnolfo di Cambio. Close by is the campanile, or bell tower, apparently designed by Giotto and decorated with expressive, gaunt figures (now removed) by the sculptor Donatello (page 14).

The most revered edifice in Florence, however, was the baptistery, in front of the cathedral's entrance: although actually constructed in a Romanesque style between around 1059 and 1150, it was believed to have been once the temple of Mars, a survivor of Florence's largely imaginary ancient past.

Nicola Pisano (*c.* 1220/25–before 1284)
The Adoration of the Magi, pulpit relief

c. 1255–60
Marble
85 × 113 cm (33 ½ × 44 ½ in.)
Pisa, baptistery

Giotto di Bondone (1267/75–1337)
The Annunciation to St Anne

c. 1305
Fresco
Padua, Scrovegni (Arena) Chapel

Bernardo Daddi (*fl. c.* 1320–1348) and
Andrea di Cione, known as Orcagna
(1315/20–1368)
Madonna and Child with Angels,
in a tabernacle

Panel by Daddi, 1346–47 (tabernacle by Orcagna,
1355–59)
Tempera on panel (with marble, inlaid stone
and glass)
Dimensions unknown
Florence, Orsanmichele

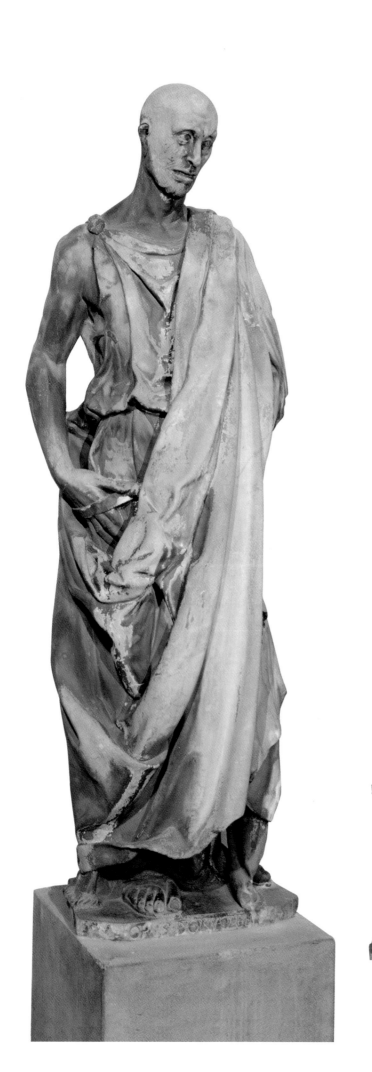
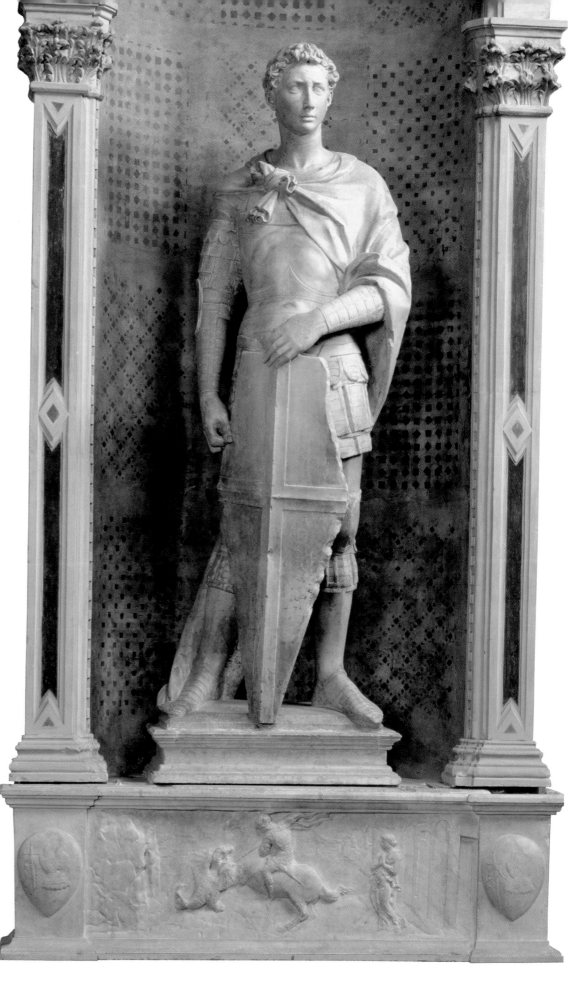

Donatello (1386/87–1466)
Habakkuk

c. 1426
Marble
Height 195 cm (76¾ in.)
Florence, Museo dell'Opera del Duomo

Donatello (1386/87–1466)
St George with relief of *St George
Slaying the Dragon*

c. 1410–17
Marble
Height of figure 209 cm (82¼ in.);
relief 39 × 120 cm (15⅜ × 47¼ in.)
Florence, Museo Nazionale del Bargello

Lorenzo Ghiberti (1378–1455)
The Sacrifice of Isaac

1401–03
Gilt bronze
45 × 38 cm (17¾ × 15 in.)
Florence, Museo Nazionale del Bargello

As well as exerting an immense influence on the development of Renaissance architecture in Florence, the baptistery was also the setting for two of the most extraordinary projects of the period: the bronze doors executed by Lorenzo Ghiberti between 1403 and 1452. The first commission, for the north doors, was awarded to Ghiberti as the result of a competition held by the Guild of Cloth Importers, for which he produced the remarkable *Sacrifice of Isaac* (below). This relief already displays certain Renaissance features, in particular the idealized nude body of Isaac, influenced by ancient Roman sculpture. It was, however, for the second set, the 'Gates of Paradise' (the east doors), that Ghiberti designed the most sophisticated scenes, in which the characters move in credible three-dimensional settings, sometimes adorned with Classical arcades (page 241).

Ghiberti's graceful, sinuous figures distinguish him from Donatello, whose *St George* (opposite) is an athletic warrior, awaiting battle with an appropriately alert pose and expression. Commissioned by the Guild of Armourers, he originally stood in a niche on the exterior of the Orsanmichele, above *St George Slaying the Dragon*, a relief that contains one of the earliest examples of linear perspective.

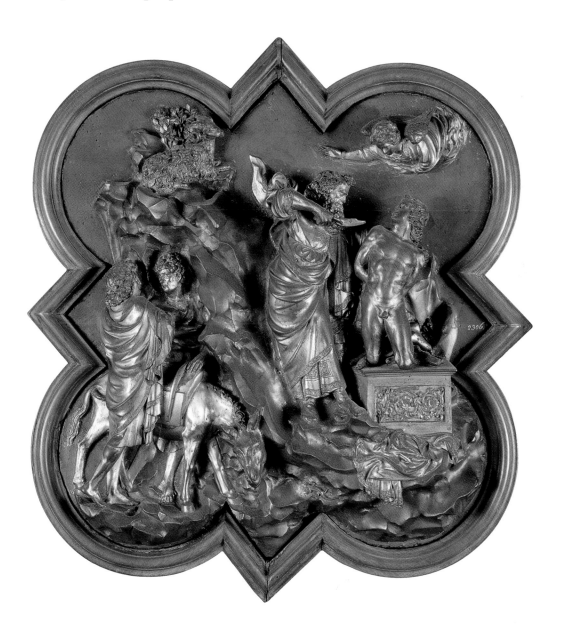

This technique was apparently devised by Brunelleschi, although his painted demonstrations have unfortunately not survived. By the late 1420s, however, examples of perspective were being produced on a larger scale by Masaccio: *The Trinity* (below), for example, is a frescoed funerary monument in which the figures are set in front of a spacious Classical structure, evidently influenced by the architectural designs of Brunelleschi. Masaccio's greatest works, the murals painted with Masolino at the Brancacci Chapel in the church of Santa Maria del Carmine in Florence, combine an illusion of space with naturalistic human figures, vigorously modelled in light and shade (or chiaroscuro). While the chapel's entrance arch represents *The Fall of Man* and *The Expulsion from the Garden of Eden* (page 87), the interior depicts scenes from the life of St Peter

Masaccio (1401–1428)
The Trinity
c. 1426–27
Fresco
Florence, Santa Maria Novella

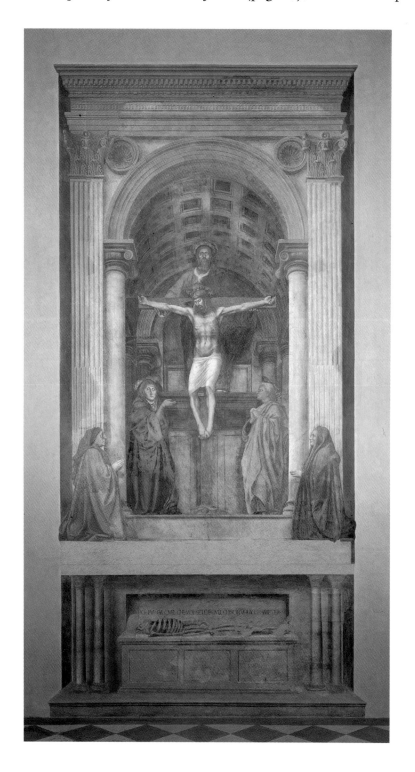

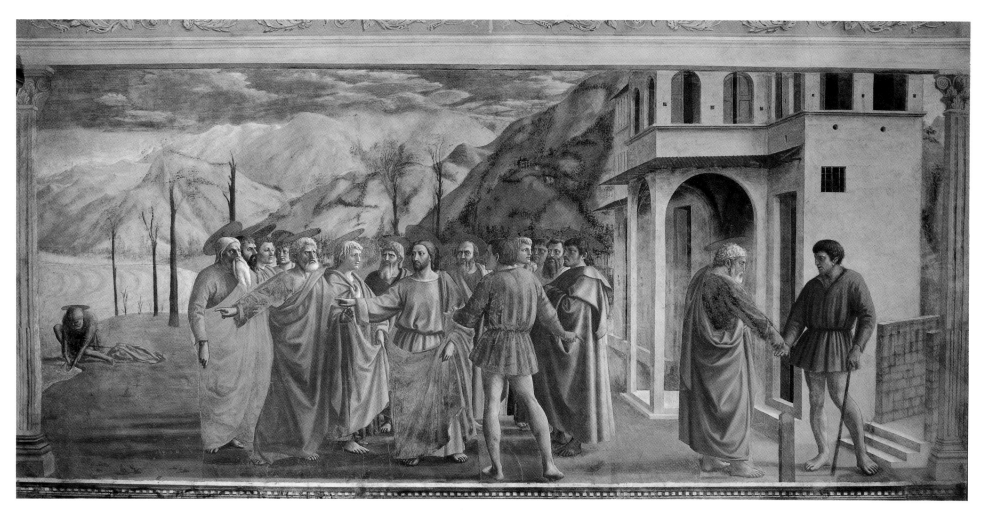

Masaccio (1401–1428)
The Tribute Money

c. 1424–28
Fresco
Florence, Santa Maria del Carmine,
Brancacci Chapel

(page 161). In *The Tribute Money* (above) – in which Christ tells St Peter and the other apostles to pay the tax demanded by the official in the foreground – the fresco manages to depict several episodes, arranged in a balanced, monumental composition that anticipates the High Renaissance (see pages 30–39).

The new realism developed in Masaccio's works had some competition, however. Gentile da Fabriano's *Adoration of the Magi* (page 18) is adorned by the picturesque courtiers and animated beasts that accompany the three wise men in their veneration of Christ. It exemplifies the artificial, elegant style sometimes known as International Gothic, which was an important feature of western European art in the late fourteenth and early fifteenth centuries. The graceful figures and emphasis on pattern that appear in this painting can still be seen in the work of such artists as Fra Angelico (page 19) and Paolo Uccello (page 138), who were otherwise influenced by more recent developments, especially perspective.

Yet Fra Angelico was in some respects an innovator himself. Together with Filippo Lippi (page 19) and Domenico Veneziano (page 82), he devised the *sacra conversazione*, a type of altarpiece in which the Virgin and Child appear with saints in a single image, rather than, as before, in distinct panels. Moreover, the characters sometimes (though not always) seem to be conscious of one another, giving the paintings a new intimacy and warmth. Above all, they inhabit a defined space that has at least some continuity with the reality outside.

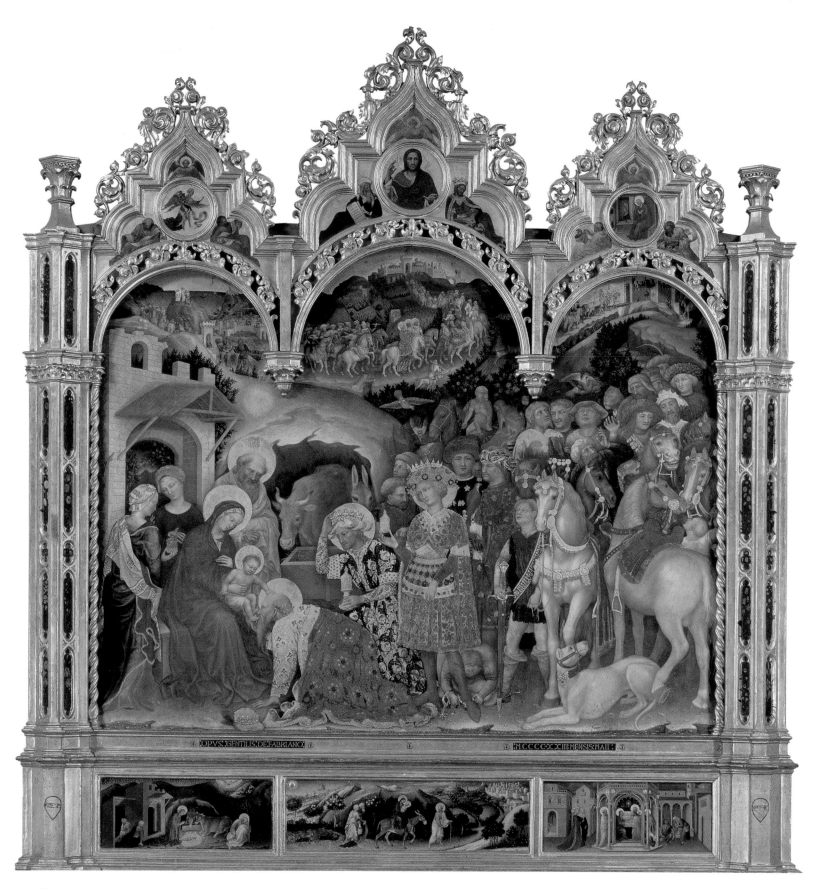

Gentile da Fabriano (*c.* 1385–1427)
Adoration of the Magi (The Strozzi altarpiece)

1423
Tempera on panel
300 × 283 cm (118⅛ × 111⅜ in.)
Florence, Galleria degli Uffizi

Filippo Lippi (*c.* 1406–1469)
Virgin and Child with Sts Frediano
and Augustine
(The Barbadori altarpiece)

1437
Tempera on panel
208 × 244 cm (81 ⅞ × 96 in.)
Paris, Musée du Louvre

Fra Angelico (1395/1400–1455)
The San Marco altarpiece

1440
Tempera on panel
220 × 227 cm (86 ⅝ × 89 ⅜ in.)
Florence, Museo di San Marco

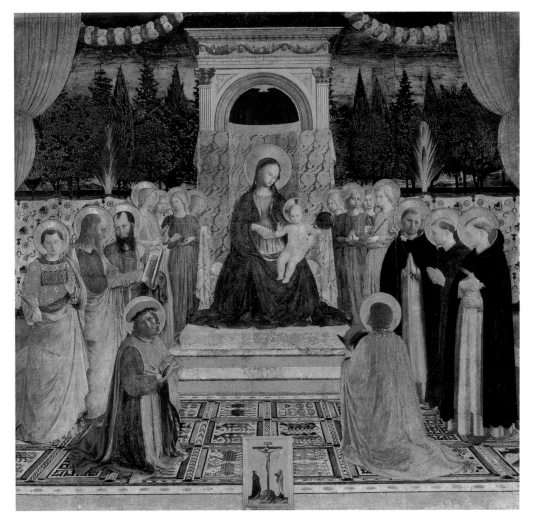

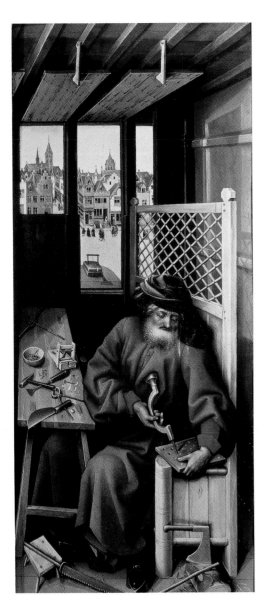

Robert Campin (*c.* 1375/79–1444)
and an assistant
St Joseph, from the Merode triptych
('Annunciation triptych')

c. 1425
Oil on panel
64.5 × 27.3 cm (25⅜ × 10¼ in.)
New York, The Metropolitan Museum of Art,
The Cloisters Collection

By the middle of the fifteenth century Florentine artists had achieved remarkable breakthroughs. Yet, in another part of Europe, other developments were occurring that were of equal import-ance. The reform of painting achieved by Netherlandish artists can be seen in a panel from the Merode triptych (left), attributed to Robert Campin and an assistant, in which St Joseph has been transformed into a fifteenth-century carpenter, drilling away in a workshop overlooking a Flemish street.

As well as representing everyday settings, Netherlandish artists had discovered another means of giving their work an illusion of reality. For much of the fifteenth century artists in Italy used tempera, in which the pigment was mixed with egg yolk, for painted panels. This was in addition to the fresco technique for murals, whereby the colours were usually applied on to the freshly plastered wall while it was still wet, in order to make them more durable. In The Netherlands, panel painters had by the 1430s begun to exploit linseed or walnut oil more fully than ever before, in order to create extraordinary optical effects unknown in tempera – rich, luminous colours and subtle variations of tone and texture. Oil was also very slow-drying, allowing changes to be made easily: infrared photography has shown, for example, that Giovanni Arnolfini's raised hand in Van Eyck's portrait (page 147) was originally painted at a slightly different angle.

Oil paint was used with spectacular results in the Van Eyck brothers' Ghent altarpiece (opposite), especially in the central panel, *The Adoration of the Lamb*. Here patriarchs, prophets, apostles and martyrs venerate Christ in the symbolic form of the Lamb of God, amid the lush landscape of paradise. The naturalism of the sky, with its gradual changes in colour, is matched, in the upper level, by the delicate modelling of Adam and Eve, whose nude bodies frame the less realistic figures in the centre – above all the solemn, hieratic figure of God, probably painted by Jan van Eyck's brother Hubert.

Portraiture was another area reformed by the Netherlandish painters: in Rogier van der Weyden's *Portrait of a Lady* (page 22), the woman's head is turned at an angle to the picture plane, in contrast to the more formal profile format that was popular in Italy. Although the composition gives the painting an air of realism, this is combined with extraordinary refinement in the treat-ment of the sitter's fingers and headdress.

A rich combination of naturalism and abstraction is also a feature of Van der Weyden's greatest painting, *Descent from the Cross* (page 23). Here the depiction of grief is so strong, the poses so expressive, that we can momentarily forget the artificiality of the image – the

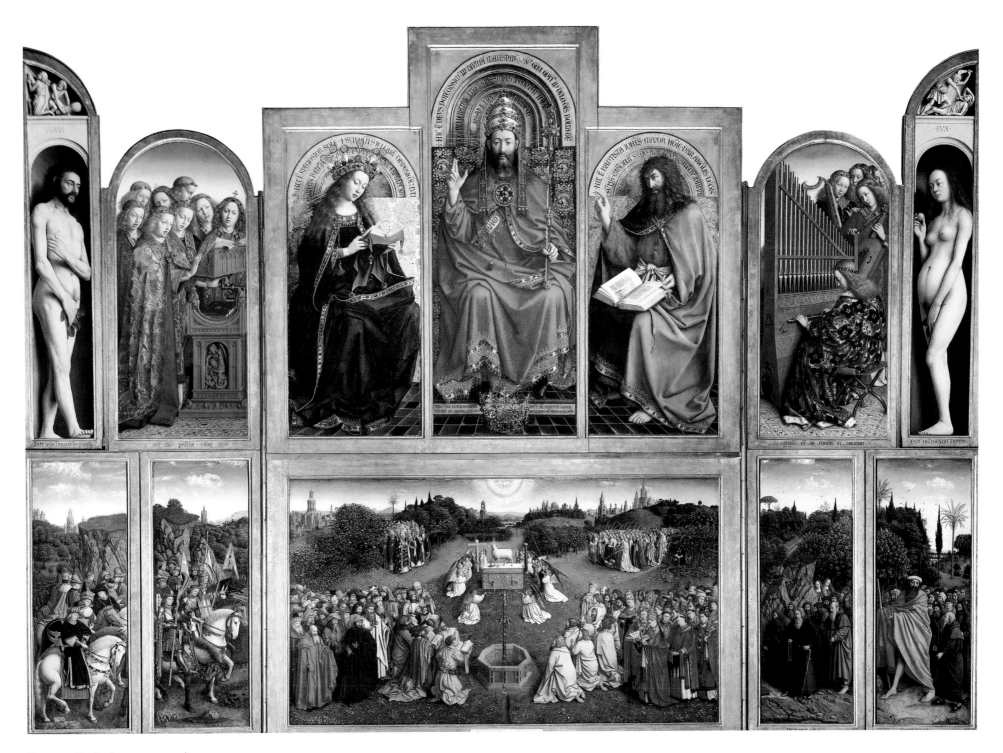

Jan van Eyck (*c.* 1395–1441)
and Hubert van Eyck (*c.* 1385/90–1426)
The Ghent altarpiece, with interior
panels open

Completed 1432
Oil on panel
375 × 520 cm (147 ⅝ × 204 ¾ in.)
Ghent, St Bavo's Cathedral

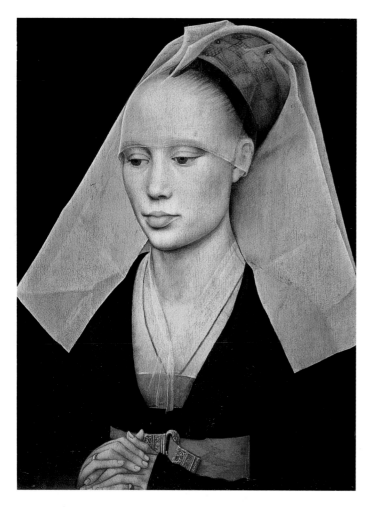

whole scene confined within a shallow, gilded box, framed by tracery, like a relief in a Gothic cathedral.

This timeless quality – the feeling that real experiences have been frozen – seems to have influenced other artists of this generation, such as Dieric Bouts (below), whose figures mourn over Christ's emaciated body with eloquent, yet restrained gestures. Unlike Van der Weyden, Bouts presents the group in a landscape of striking naturalism, seen from a characteristically high viewpoint. Most spectacularly, the sense of depth is emphasized by subtle shifts of tone, in which Bouts brilliantly exploits the optical effects of oil paint.

Rogier van der Weyden (*c.* 1399–1464)
Portrait of a Lady

c. 1460
Oil on panel
37 × 27 cm (14⅝ × 10⅝ in.)
Washington, D.C., National Gallery of Art

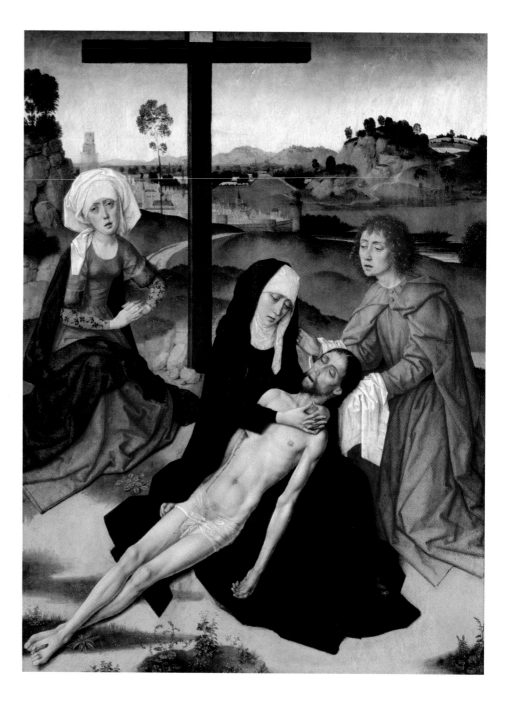

Dieric Bouts (*c.* 1415–1475)
The Lamentation

c. 1455–60
Oil on panel
69 × 49 cm (27⅛ × 19¼ in.)
Paris, Musée du Louvre

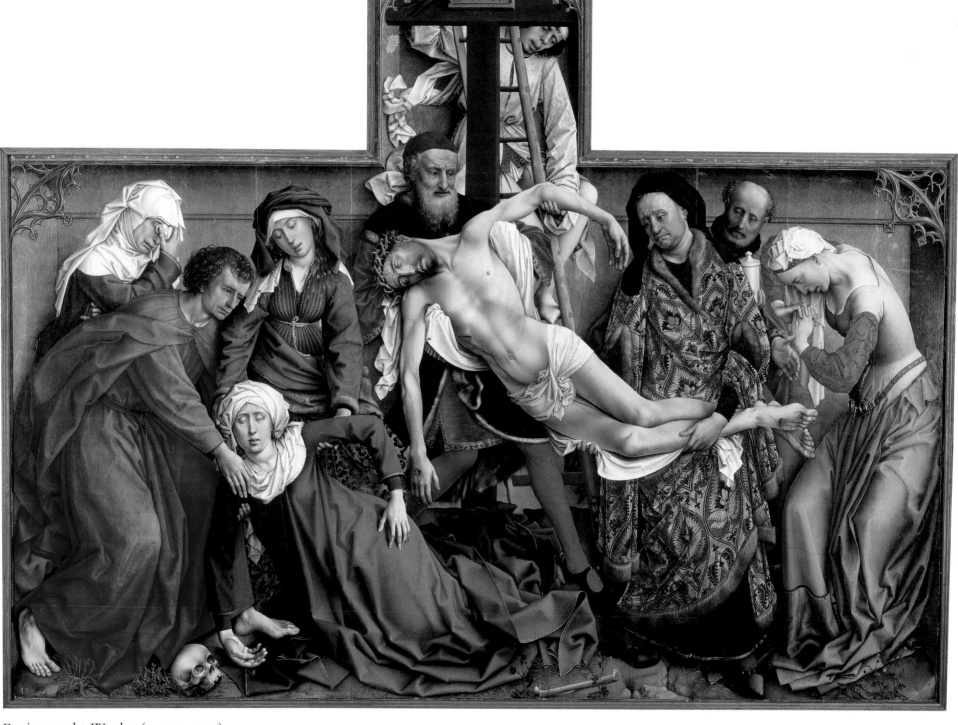

Rogier van der Weyden (*c.* 1399–1464)
Descent from the Cross

c. 1435
Oil on panel
220 × 262 cm (86 ⅝ × 103 ⅛ in.)
Madrid, Museo Nacional del Prado

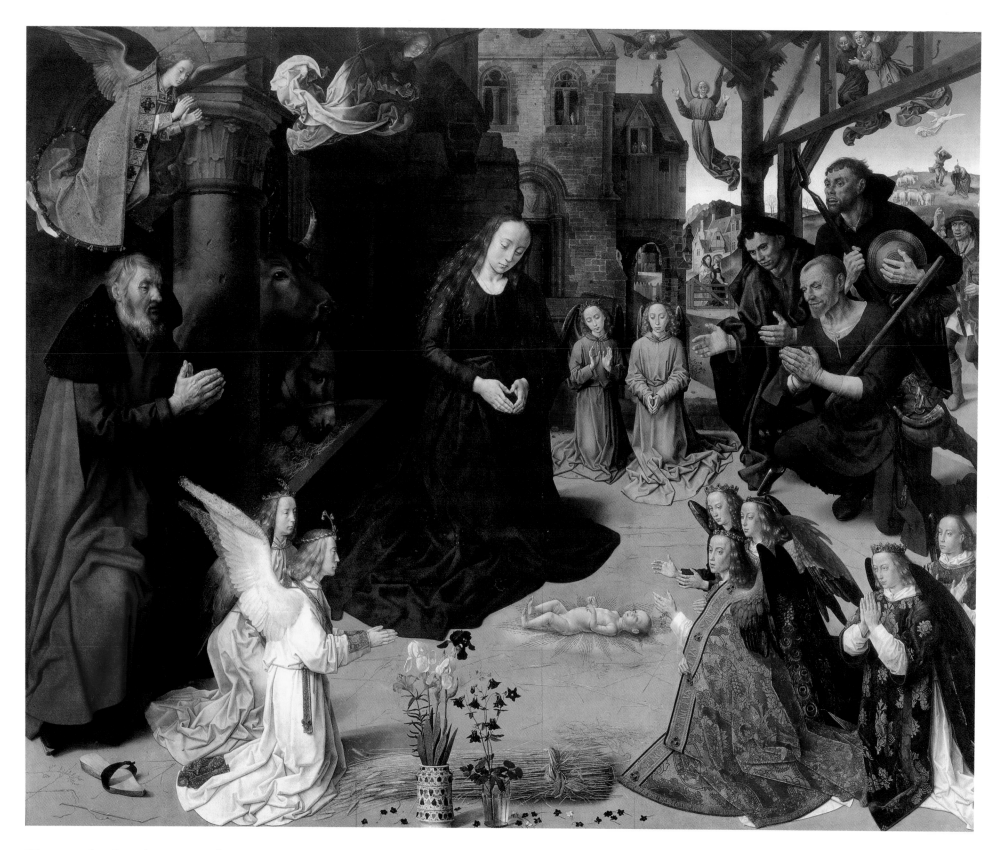

Hugo van der Goes (*c.* 1440–1482)
*Christ Child Adored by Angels
and Shepherds*,
central panel of the Portinari triptych

c. 1477–78
Oil on panel
253 × 304 cm (99⅝ × 119⅝ in.)
Florence, Galleria degli Uffizi

The Florentines of the Quattrocento (the fifteenth century) were not immune to the achievements of The Netherlands. In 1483 the banker Tommaso Portinari brought to Florence a magnificent altarpiece by the Ghent painter Hugo van der Goes (opposite). Its naturalistic setting, and strange combination of the supernatural and the mundane, made a huge impression. The most direct response can be seen in the depiction of the shepherds in Domenico Ghirlandaio's altarpiece for the Sassetti Chapel in Santa Trinita (below), although in other respects the Italian's prosaic style hardly bears the comparison.

More generally, Florentines were influenced by Netherlandish developments in portraiture, landscape and the technique of oil painting. Andrea del Verrocchio's *Baptism of Christ* (page 26) is dominated by the type of fit, energetic figure that appears in many of his sculptures, but perhaps its most extraordinary aspects are the luminous, poetic landscape and the use of oil to

Domenico Ghirlandaio (1448/49–1494)
Adoration of the Shepherds

1485
Tempera on panel
167 × 167 cm (65 ¾ × 65 ¾ in.)
Florence, Santa Trinita, Sassetti Chapel

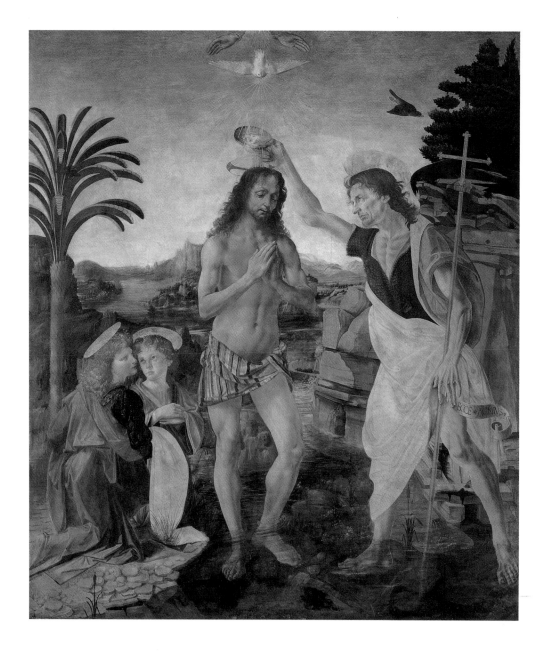

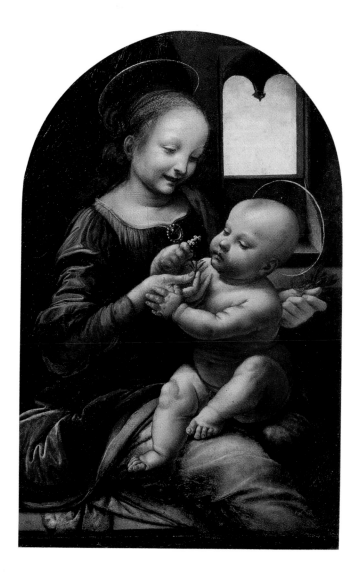

Andrea del Verrocchio (1435–1488),
with Leonardo da Vinci (1452–1519)
Baptism of Christ

1473–c. 1478
Tempera and oil on panel
180 × 152 cm (70⅞ × 59⅞ in.)
Florence, Galleria degli Uffizi

Leonardo da Vinci (1452–1519)
Madonna with a Flower (Benois Madonna)

c. 1478
Oil on canvas, transferred from panel
49.5 × 33 cm (19½ × 13 in.)
St Petersburg, The State Hermitage Museum

represent the transparent water. Together with the graceful angel on the far left, these features were probably the responsibility of Verrocchio's pupil, the young Leonardo da Vinci, who went on to produce a few individual works in Florence (above) before leaving for Milan around 1482.

In contrast to Verrocchio, Sandro Botticelli, a pupil of Filippo Lippi, developed a more poetic style, in both his secular and religious paintings. The *Madonna of the Magnificat* (opposite) has sinuous, linear figures, echoing the curve of the frame, with elegant gestures and a very specific ideal of beauty. Some of these qualities can also be seen in the work of Botticelli's brilliant pupil Filippino Lippi, the son of Filippo. In *The Vision of St Bernard* (opposite), the Virgin Mary is even more elongated than in Botticelli's painting, as she appears to an equally lissom St Bernard, writing in his al fresco study.

Unlike republican Florence, other Italian city-states were governed by princes, many of whom presided over sophisticated humanist courts. Some artists worked for a number of rulers: Piero della Francesca, for example, roamed around central Italy, producing particularly notable work for the Duke of Urbino, Federico da Montefeltro (pages 170 and 171). Two of the most

important artistic centres, Ferrara and Mantua, were the homes of Cosimo Tura and Andrea Mantegna, respectively: both painters, in their different ways, combined Christian imagery with a crisp, lapidary style, although Mantegna's Classicism was far more orthodox than Tura's (page 28).

Mantegna's early compositions undoubtedly influenced those of his brother-in-law, the Venetian Giovanni Bellini. Yet Bellini's paintings always have warmer colours and softer outlines, qualities that became even stronger after he took up the oil medium in the 1470s. They are obvious in the *sacra conversazione* known as the San Giobbe altarpiece (page 29), where the reflections from the mosaic apse create an optical effect that is characteristic of Venetian painting. This exemplifies the immense richness of the Italian Renaissance, where local styles developed even as new techniques and imagery were transmitted from one city to another.

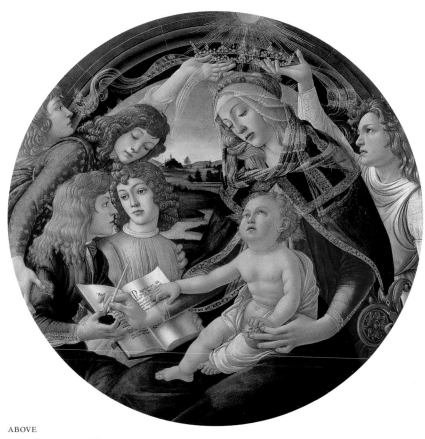

ABOVE

Sandro Botticelli (1444/45–1510)
Madonna of the Magnificat

1481–85
Tempera on panel
Diameter 118 cm (46½ in.)
Florence, Galleria degli Uffizi

RIGHT

Filippino Lippi (c. 1457–1504)
The Vision of St Bernard

c. 1485–90
Tempera and oil on panel
208 × 196 cm (81⅞ × 77⅛ in.)
Florence, Badia Fiorentina

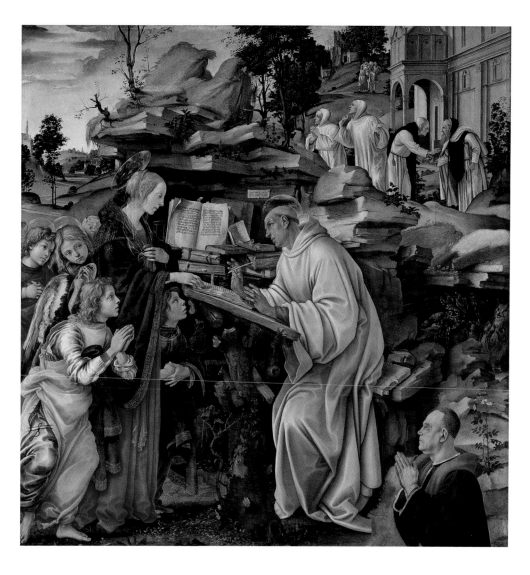

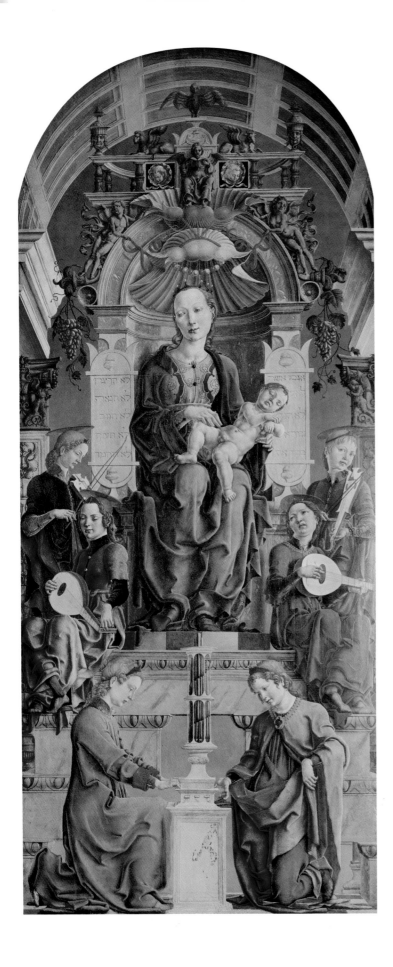

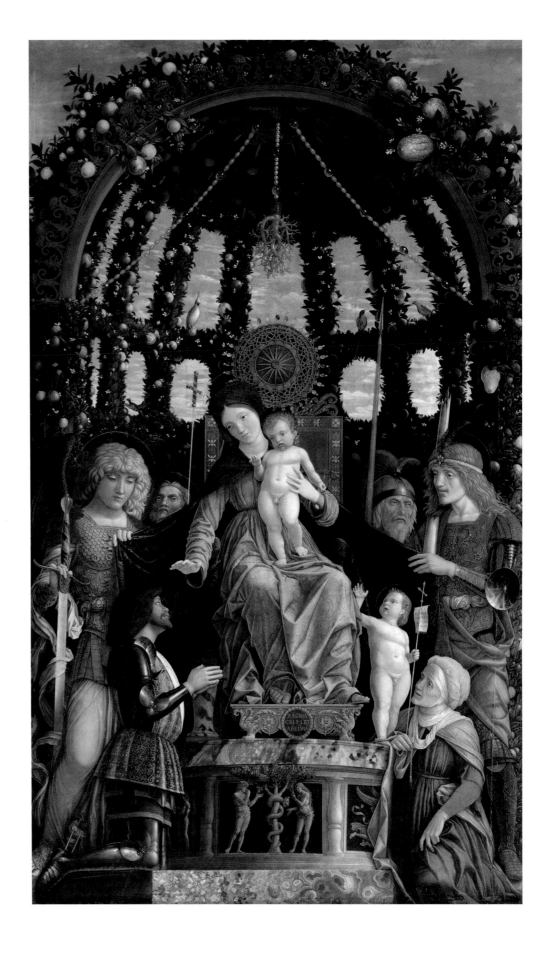

OPPOSITE, LEFT

Cosimo Tura (?1430–1495)
The Virgin and Child Enthroned

Mid-1470s
Oil and tempera on panel
239 × 101.6 cm (94⅛ × 40 in.)
London, The National Gallery

OPPOSITE, RIGHT

Andrea Mantegna (1430/31–1506)
Madonna of Victory

1496
Oil on canvas
285 × 168 cm (112¼ × 66⅛ in.)
Paris, Musée du Louvre

RIGHT

Giovanni Bellini (?1431/36–1516)
The San Giobbe altarpiece

c. 1480
Oil on panel
471 × 258 cm (185⅜ × 101⅝ in.)
Venice, Gallerie dell'Accademia

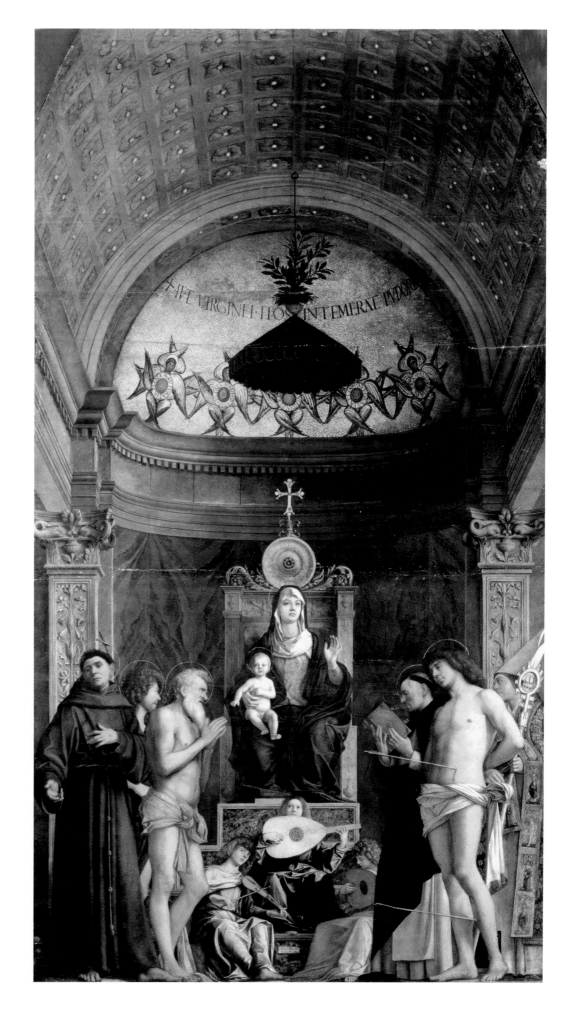

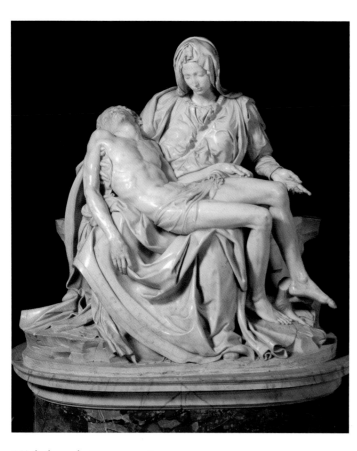

Michelangelo Buonarroti
(1475–1564)
Pietà

1498–99
Marble
174 × 195 cm (68½ × 76¾ in.)
Rome, St Peter's Basilica

The sixteenth-century painter and art historian Giorgio Vasari (1511–1574) eloquently described the *Mona Lisa* of Leonardo da Vinci (opposite) in his *Lives of the Artists:* 'If one wanted to see how faithfully art can imitate nature, one could readily perceive it from this head The eyes had their natural lustre and moistness The nose was finely painted, with rosy and delicate nostrils as in life. The mouth ... appeared to be living flesh rather than paint. On looking closely at the pit of her throat one could swear that the pulses were beating.'[8] And as for the famous smile, 'so pleasing that it seemed divine', Leonardo employed musicians and jesters to keep the lady Lisa amused while she was sitting for him.

Naturalism, merriment – these are refreshingly unmystifying explanations for the portrait's appeal. Yet there is something more to this picture, a very distinctive type of beauty that reappears in the artist's other paintings (see page 224). It does not conform to any abstract canon of proportions: as Vasari points out, Leonardo even records imperfections in the eyebrows, 'growing thickly in one place and lightly in another and following the pores of the skin'.[9] Rather, this poetic quality derives from Leonardo's handling of paint and the relationship that is established between the sitter and her setting.

Famously, Leonardo invented *sfumato*, a smoky atmosphere that softens the outlines, helping to integrate the figure with the fantastical landscape behind her. This contributes to the sense of 'harmony', a quality associated with the art of the early sixteenth century – the so-called 'High Renaissance' – although it is very hard to define except by reference to particular works.

The term 'High Renaissance' implies some sort of culmination, as if all earlier endeavours had led to this climax. Vasari certainly seemed to believe this: for him, art reached its peak in the work of Michelangelo, whom 'the benign ruler of heaven' sent down, endowed not only with skill 'in each and every craft' and 'perfection in design', but also with 'true moral philosophy and the gift of poetic expression'.[10] Although the model of art history that Vasari established may now seem out of date, his analysis of Michelangelo is still compelling. Certainly Michelangelo is a very different figure from Leonardo. Pre-eminently a sculptor, he made his name in Rome in the 1490s with such works as the idealized *Pietà* in St Peter's (left), before returning to his native Florence. There he created a colossal statue of *David* (page 32), whose *contrapposto* pose, with head turned and one leg flexed forward, was carved with exceptional skill from a narrow marble block.

Leonardo da Vinci (1452–1519)
Portrait of Lisa Gherardini, wife of
Francesco del Giocondo (Mona Lisa
or *La Gioconda)*

1503–06
Oil on panel
77 × 53 cm (30⅜ × 20⅞ in.)
Paris, Musée du Louvre

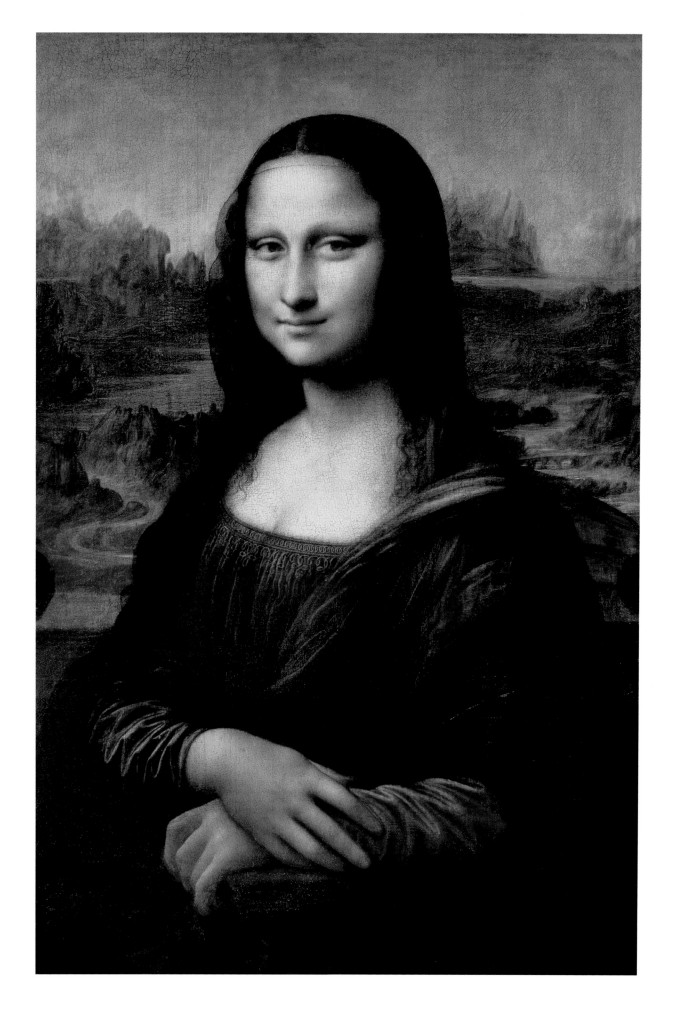

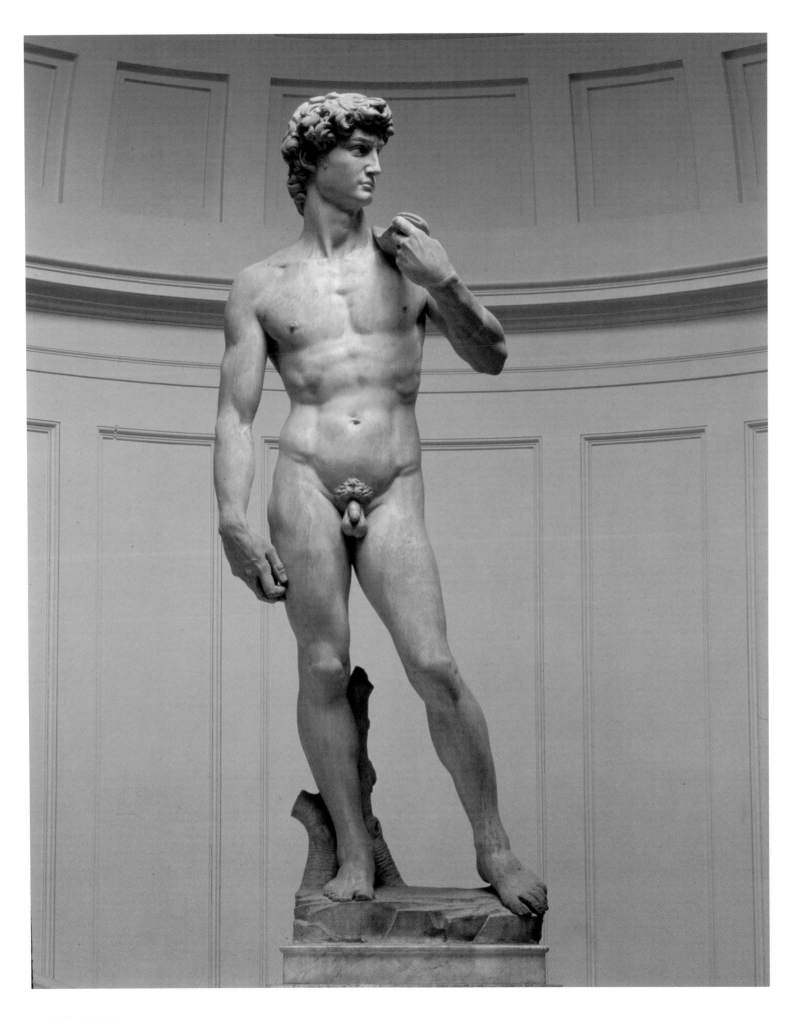

It was during his second stay in Rome that Michelangelo made his grandest creation, the painting of the Sistine Chapel ceiling in the Vatican for Pope Julius II (page 34). The central section consists of scenes from the Book of Genesis, including the memorable *Creation of Adam* (page 35), in which a lethargic Adam reaches out towards the life-giving finger of God. Most impressive of all, however, is the vault's harmonious structure, divided into compartments by simulated Classical architecture, on which sit dynamic figures, ranging from nude youths to Old Testament prophets and Classical sibyls.

The male nudes in the ceiling were followed by the similarly twisted 'Slaves' or 'Captives', marble sculptures intended for the tomb of Julius II, although not included when the monument was eventually completed in 1545. They have been interpreted as representing the Arts mourning

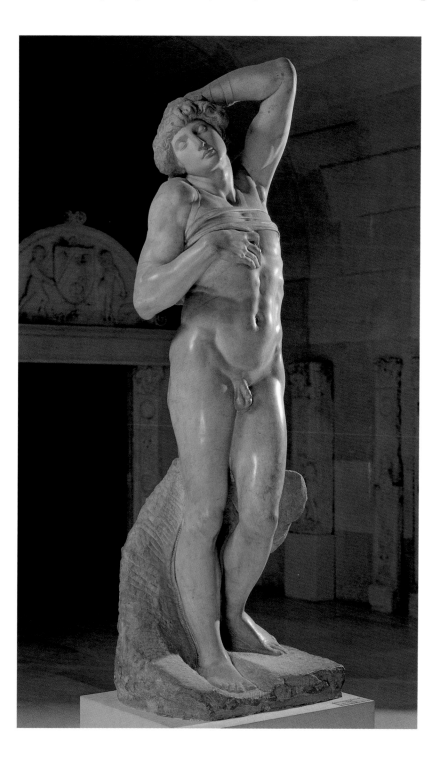

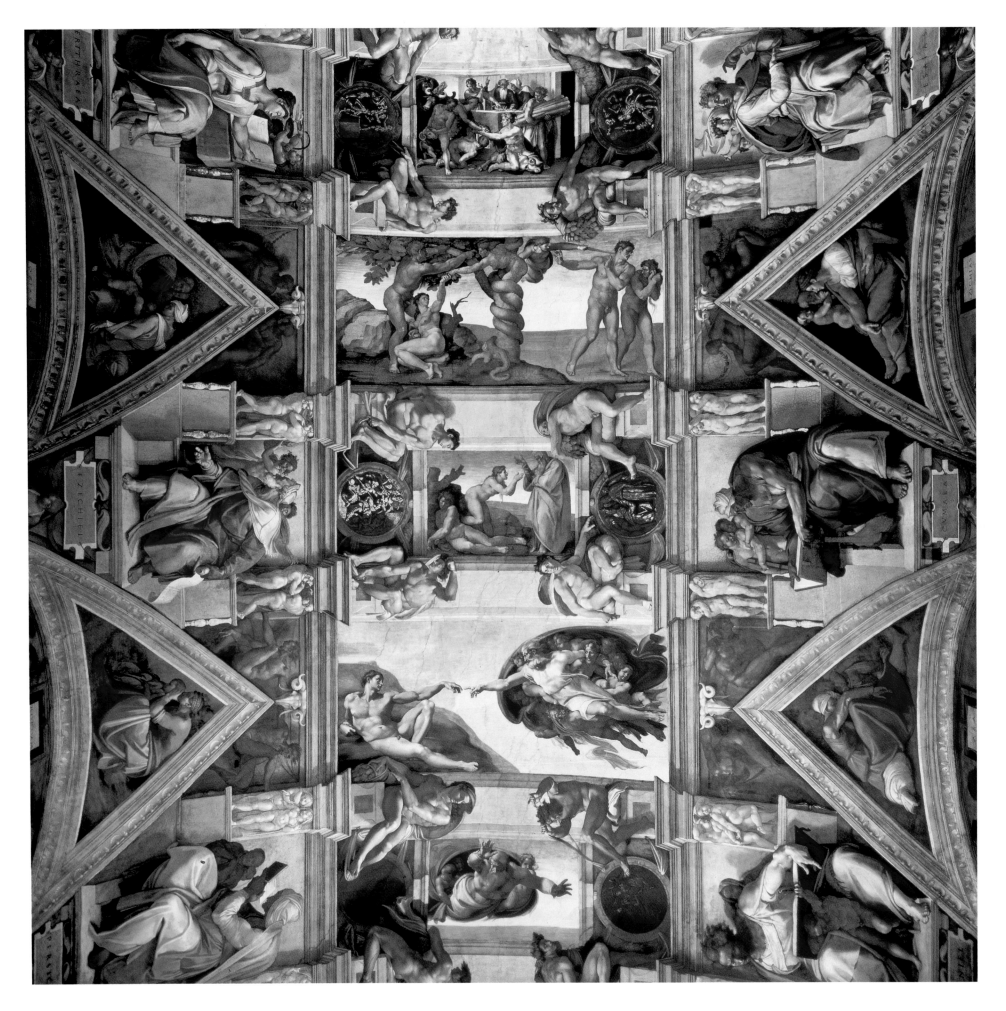

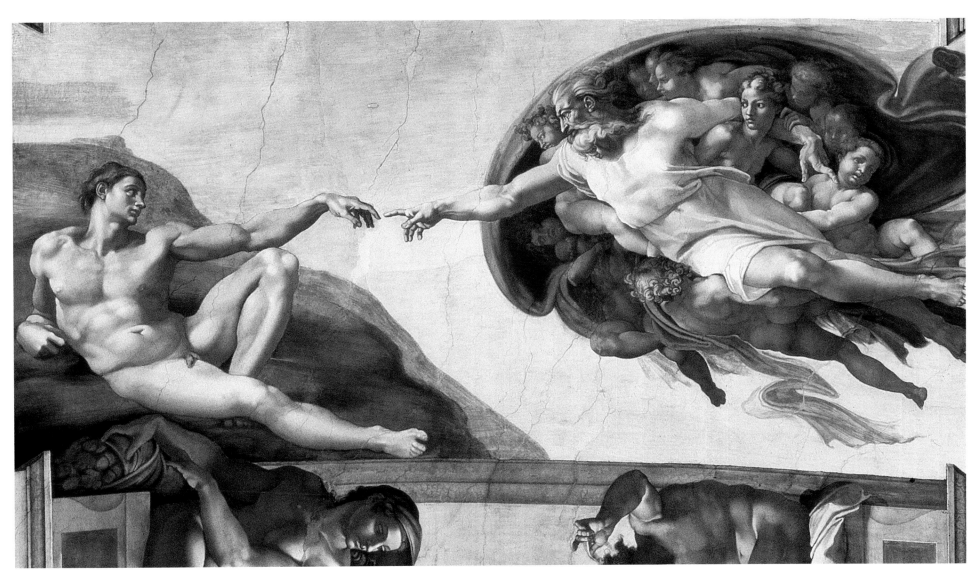

OPPOSITE
Michelangelo Buonarroti (1475–1564)
Sistine Chapel ceiling

1508–12
Fresco
Rome, The Vatican

ABOVE
Michelangelo Buonarroti (1475–1564)
The Creation of Adam, from the Sistine
Chapel ceiling

1511–12
Fresco
Rome, The Vatican

the death of their papal patron, or the soul struggling to escape the burden of the body, yet, whatever their meaning, such figures as the languid *Dying Slave* (page 33) exemplify 'the gift of poetic expression' to which Vasari referred.

As well as decorating the Stanze in the Vatican (page 8), Raphael – the youngest of the three great High Renaissance artists – also produced remarkable devotional pictures. Sometimes these are clearly influenced by Michelangelo's monumental style, although in *The Sistine Madonna* (below) Raphael has characteristically lightened the tone by adding the engaging cherubs at the bottom. His secular works are even more charming. In *The Triumph of Galatea* (opposite), the animated, twisted figures burst with joy and energy. Yet nothing is allowed to become out of

Raphael (1483–1520)
The Sistine Madonna

c. 1512–13
Oil on canvas
269.5 × 201 cm (106⅛ × 79⅛ in.)
Dresden, Gemäldegalerie Alte Meister

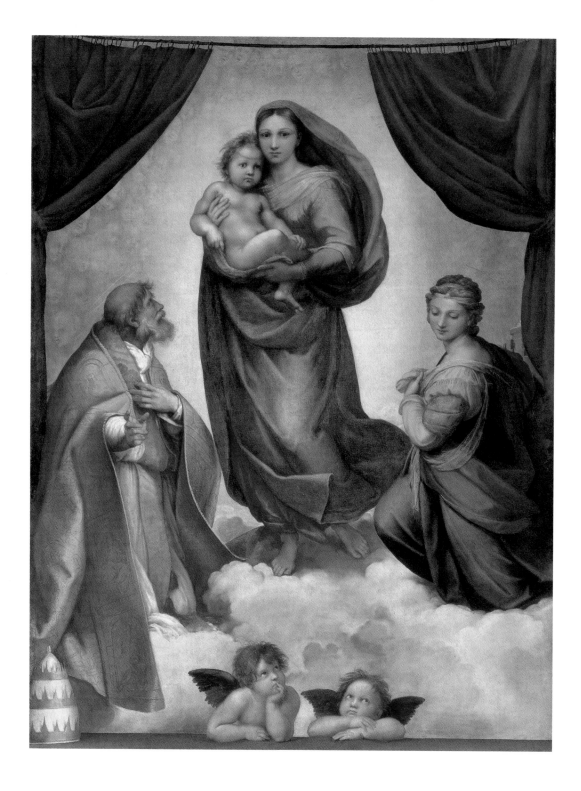

Raphael (1483–1520)
The Triumph of Galatea

c. 1511
Fresco
Rome, Villa Farnesina

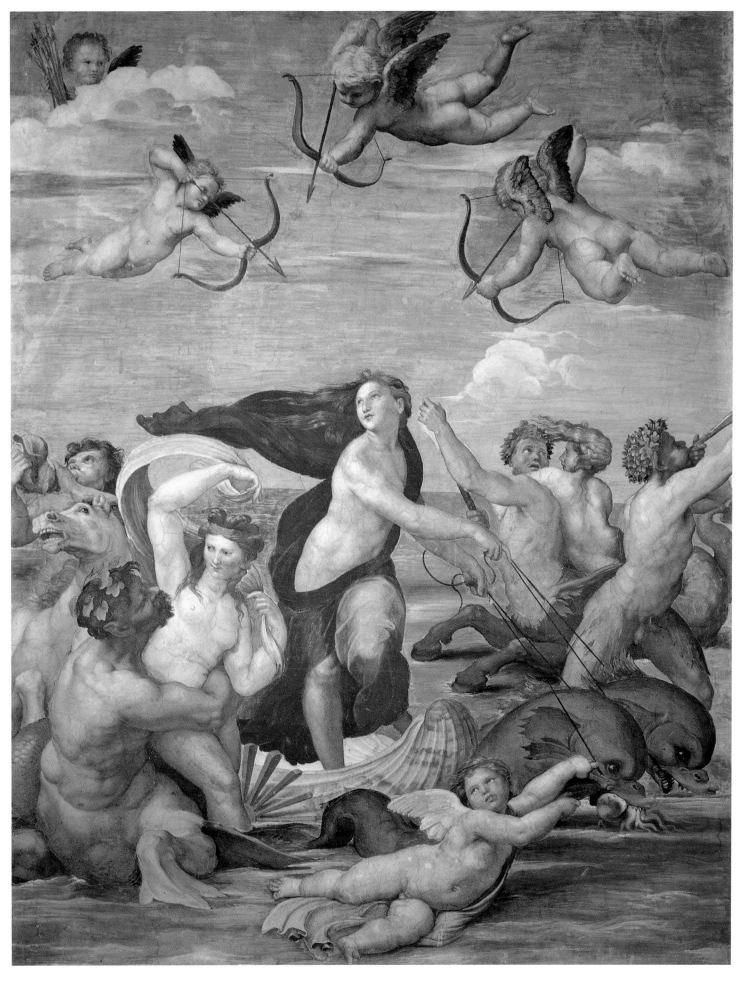

control, and the characters' poses reflect one another brilliantly, creating a composition that is balanced without being tediously symmetrical.

During this period Venice remained to some extent aloof from the excitement in Rome. Raphael's riotous *Galatea* is quite different from *Sleeping Venus* (below), a passive nude by the Venetian Giorgione, as well as from early paintings by Titian (page 261), which are influenced by Giorgione's idyllic landscapes and warm tones. Within a few years, however, Titian had combined the fireworks of Venetian colour with a more dynamic quality – a development demonstrated most spectacularly in the great altarpiece of *The Assumption of the Virgin* (opposite).

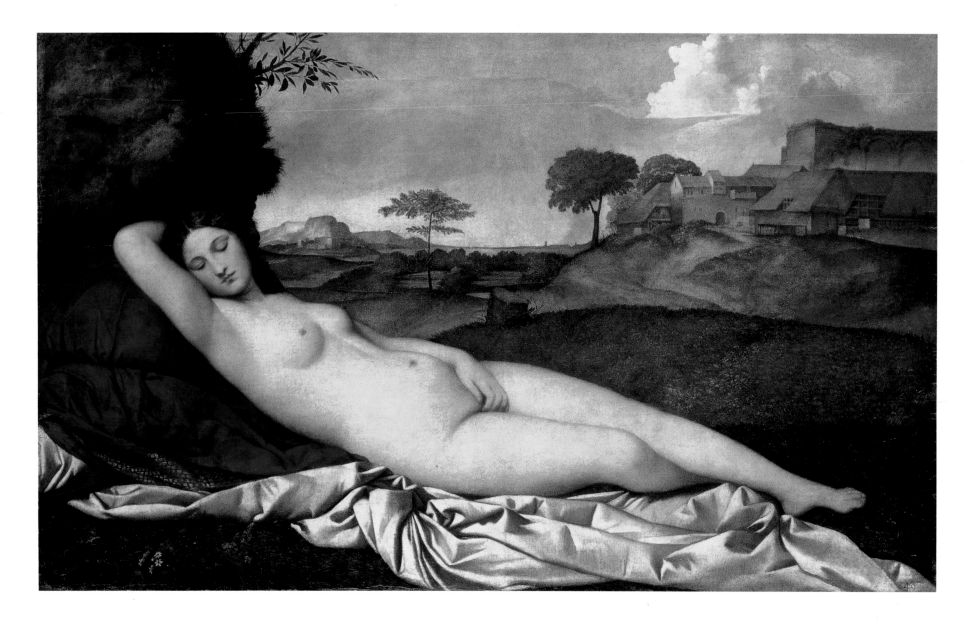

Giorgione (?1477/78–before late 1510),
completed by Titian (Tiziano Vecellio)
(*c.* ?1485/90–1576)
Sleeping Venus
c. 1508–10
Oil on canvas
108.5 × 175 cm (42¾ × 68⅞ in.)
Dresden, Gemäldegalerie Alte Meister

Titian (Tiziano Vecellio)
(*c.* ?1485/90–1576)
The Assumption of the Virgin

1516–18
Oil on panel
690 × 360 cm (271 ⅝ × 141 ¾ in.)
Venice, Santa Maria Gloriosa dei Frari

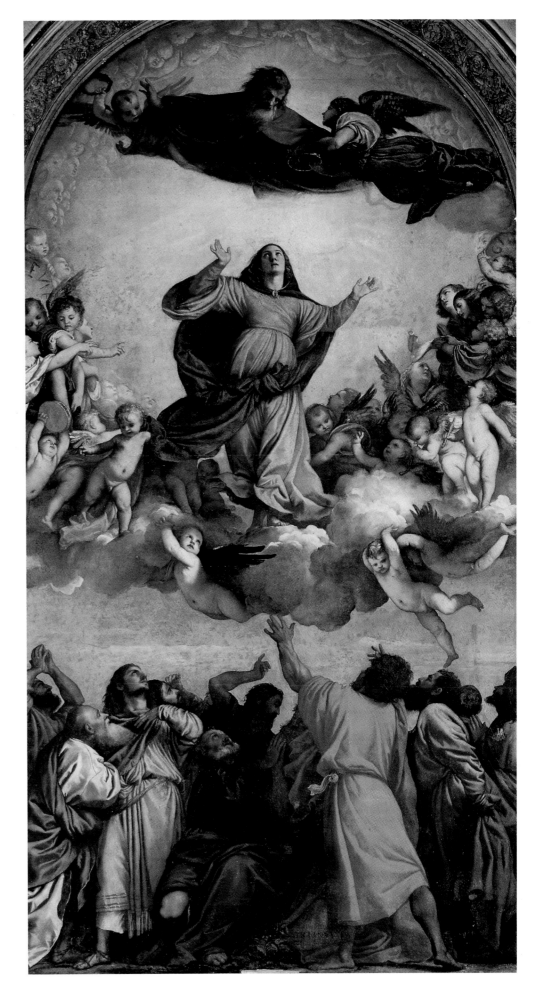

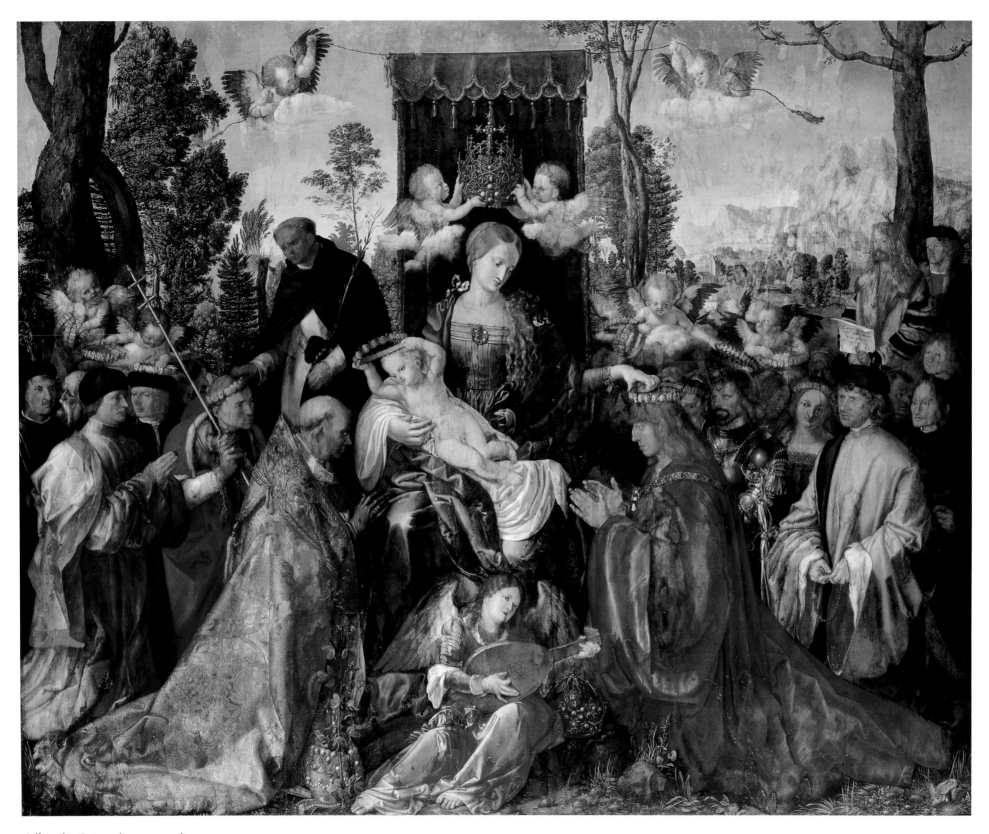

Albrecht Dürer (1471–1528)

The Feast of the Rose Garlands

1506
Oil on panel
162 × 194.5 cm (63¾ × 76⅝ in.)
Prague, Národní Galerie

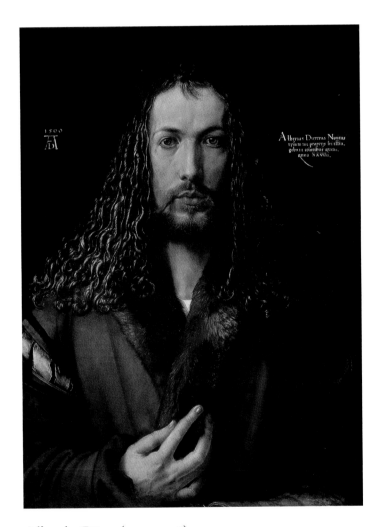

Albrecht Dürer (1471–1528)
Self-Portrait

1500
Oil on panel
67 × 49 cm (26⅜ × 19¼ in.)
Munich, Alte Pinakothek

'How shall I long for the sun in the cold; here I am a gentleman, at home I am a parasite.'[11] With these words, the German artist Albrecht Dürer unfavourably compared his status in Nuremberg with his reception during a visit to Venice in 1506. Dürer had already made clear his longing for appropriate recognition in the most emphatic way possible – by portraying himself in the pose of the Saviour (left), a striking demonstration of the belief that the artist's creative ability derived from God. In Venice, however, his talents were recognized in a more conventional way, with the commission of an altarpiece (opposite), in which the Virgin and Child, helped by St Dominic, give rose garlands to a group headed by the pope and the Holy Roman Emperor. Although commissioned, in celebration of the rosary, by Venice's German merchants, the painting was praised by the city's elite: even the doge and the patriarch came to see it. The recognition was justified, since the altarpiece deftly combined Dürer's native style with Venetian characteristics, from the musical angel at the bottom to the rich colours that light up the whole panel.

Back in Germany, Dürer continued to absorb Italian influences. It is hard, for example, to imagine the bulky anatomy and complex pose of *Melencolia I* (below) without the example of

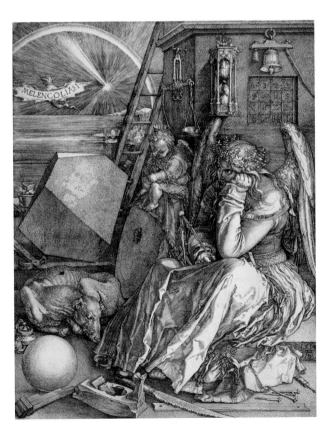

Albrecht Dürer (1471–1528)
Melencolia I

1514
Engraving
24.2 × 19.1 cm (9½ × 7½ in.)
London, The British Museum

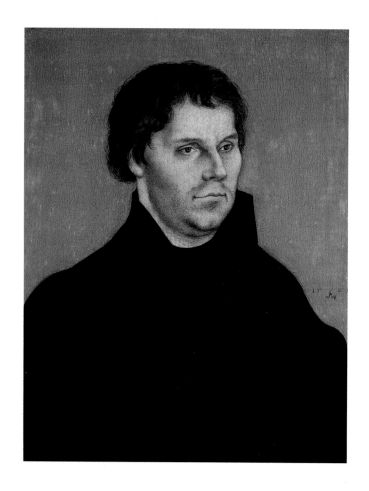

Michelangelo. Yet the brooding figure, identified by the inscription on the wings of a bat, has a disturbing significance unique to Dürer. Despairing of the understanding achieved by more philosophical intellects, she ignores the instruments of measurement, construction and geometry scattered around her. It is perhaps unsurprising that she has been interpreted as representing the melancholy humour of the artist – a kind of 'spiritual self-portrait'.[12] In this analysis, *Melencolia* is an image of a soul in crisis, an inner turmoil soon to be joined by external upheavals that started just three years later.

Compared with Dürer, Lucas Cranach seems a more conventional figure. His mythological pictures are playfully erotic (page 68), while his *Portrait of Martin Luther* (left) follows a realist tradition that began in the fifteenth century. Yet Cranach was in fact a confidant of Luther and an enthusiastic supporter of his Protestant Reformation from its inception in 1517. Since Luther did not himself prohibit religious images, the Cranach family made paintings representing baptism and the Eucharist – the sacraments described in the New Testament – as well as biblical scenes that emphasize the Protestant doctrine of redemption: in Lucas Cranach the Younger's *Christ and the Woman Taken in Adultery* (below), the sinner is forgiven through faith and God's grace. Among artists, Luther's influence was not confined to Cranach. There is strong evidence that Dürer was also sympathetic to Lutheran ideas, even though he must have been shocked at the destruction of religious images by the most extreme Protestants.

In contrast to the austere, didactic quality of many Lutheran paintings, Catholic art often overwhelmed the senses, reproducing the effect of a religious vision. Correggio's *Assumption of the Virgin* in Parma Cathedral (opposite) is an extraordinary example, brilliantly anticipating

ABOVE
Lucas Cranach the Elder
(1472–1553)
Portrait of Martin Luther

1525
Oil and tempera on panel
40 × 26.6 cm (15¾ × 10½ in.)
Bristol, City Museum and Art Gallery

RIGHT
Lucas Cranach the Younger
(1515–1586)
Christ and the Woman Taken in Adultery

After 1532
Oil on copperplate
84 × 123 cm (33⅛ × 48⅛ in.)
St Petersburg, The State Hermitage Museum

OPPOSITE
Correggio (Antonio Allegri)
(?1489–1534)
Assumption of the Virgin

1522–30
Fresco
Parma Cathedral

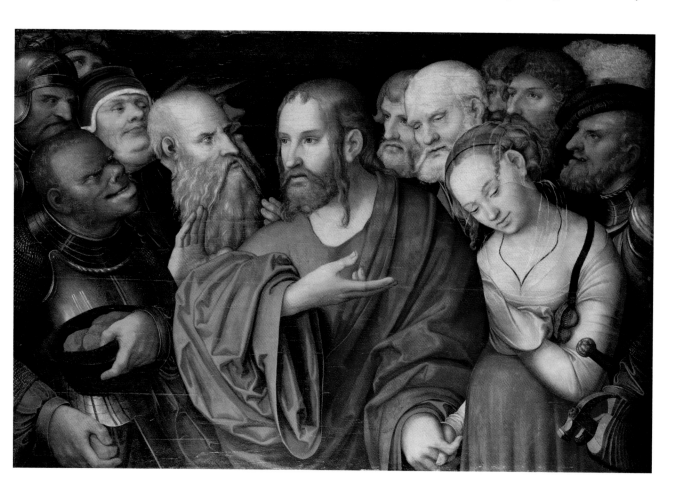

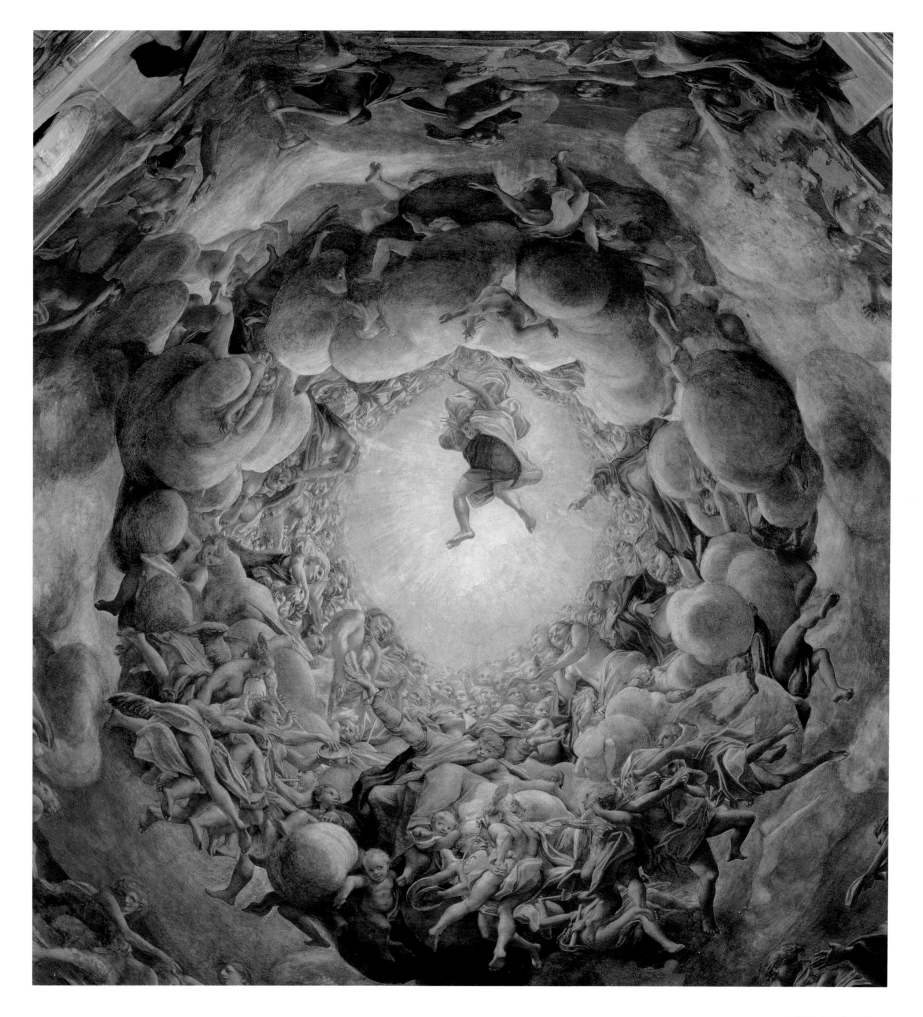

the effect of a seventeenth-century Baroque ceiling. Parmigianino's *Madonna and Child with Sts John the Baptist and Jerome* (right) is not as illusionistic, but still encourages the viewer to believe that he or she is sharing St Jerome's experience, with another figure, John the Baptist, acting as intercessor.

The strained poses and elongated proportions of Parmigianino's painting are typical of Mannerism, a complex style that was a reaction against the more balanced, rational art of the High Renaissance. The development of Mannerism is often linked to the crisis following the Sack of Rome in 1527, when Rome was pillaged by Imperial troops who entered the city as a leaderless mob. It is true that the sacking drove Mannerist artists, such as Parmigianino, from Rome across Italy. Yet Mannerist qualities were not in themselves the direct products of historical events, and they had in fact been developing in Tuscan art over the course of the 1520s, as can be seen in paintings by Rosso Fiorentino and Jacopo da Pontormo (opposite), in which distorted figures are painted with sharp, discordant colours.

The sombre atmosphere following the Sack of Rome may account, however, for the grimness of Michelangelo's *Last Judgement* (page 46), on the altar wall of the Sistine Chapel. In contrast to the ceiling, painted a quarter of a century earlier, this is a crowded composition, in which the figure of Christ is surrounded by a host of contorted figures. These are arranged in a circular motion that begins with the resurrection of the dead, runs round the upper wall and finishes with the torments of the damned, as predicted in the Book of Revelation.

Michelangelo's fresco broadly follows the structure of medieval Last Judgements: it is more orthodox, for example, than Pieter Bruegel's slightly later vision of *The Triumph of Death* (page 47), with its army of skeletons, led by Death on a red horse, mounting a final onslaught on the living. Yet Michelangelo was in fact criticized for certain inaccuracies – his angels, for example, do not have wings – and, above all, for the nudity of many of his figures. This censorious atmosphere was in part created by the Council of Trent (1545–63), the congress in which the leading clergy discussed their response to the challenges of the Reformation. Among

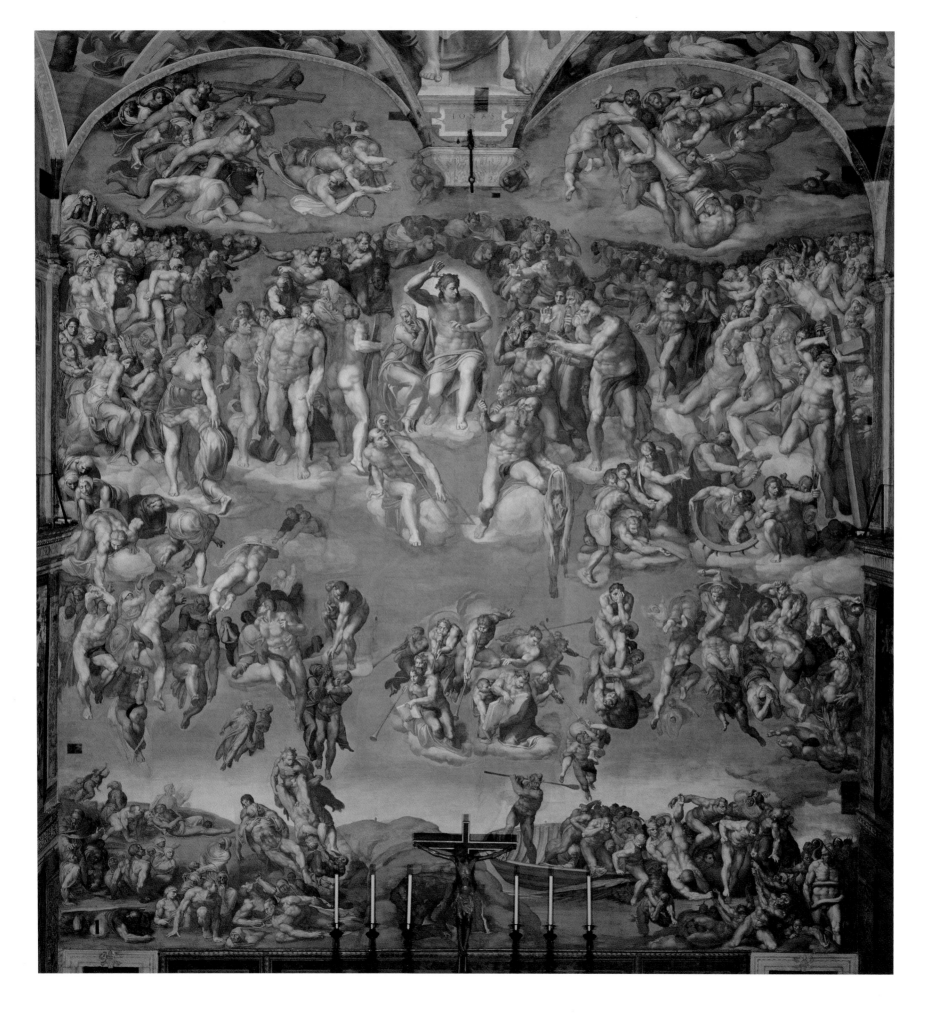

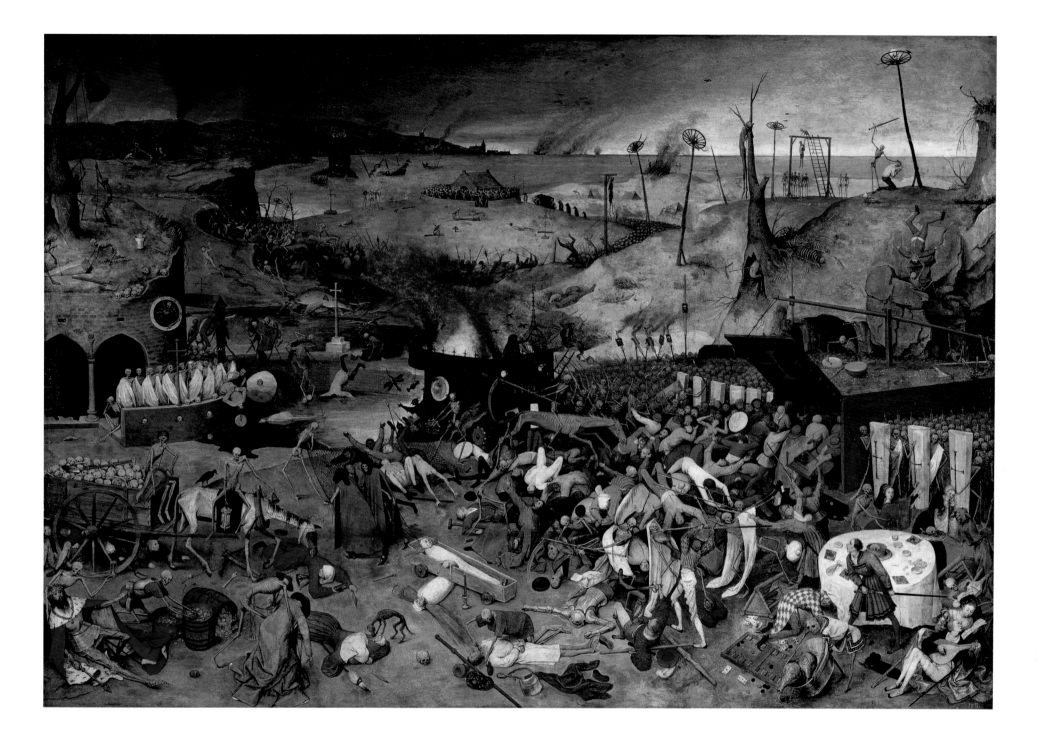

OPPOSITE
Michelangelo Buonarroti (1475–1564)
The Last Judgement

1536–41
Fresco
Rome, The Vatican, Sistine Chapel

ABOVE
Pieter Bruegel the Elder (*c.* 1525/30–1569)
The Triumph of Death

c. 1562
Oil on panel
117 × 162 cm (46 × 63¼ in.)
Madrid, Museo Nacional del Prado

other things, they agreed that religious art should be clear and faithful to scripture: anything tainted with artifice, pagan imagery and, naturally, genitalia was condemned.

These censures led to some drastic measures, including the over-painting of strategic areas in *The Last Judgement* (reversed only during the fresco's recent restoration) and the summoning of some artists, such as Paolo Veronese (page 118), to the tribunal of the Holy Inquisition. The council's decrees also encouraged a new generation of 'Counter-Reformation' painters, such as the Bolognese Lavinia Fontana, whose sweet, bright pictures were designed to help worshippers empathize with their subjects: *Noli me tangere* (page 48), for example, allows us to share the experience of Mary Magdalene by dressing the resurrected Christ as a gardener (for which she had initially mistaken him).

BELOW
Lavinia Fontana (1552–1614)
Noli me tangere

1581
Oil on canvas
80 × 65.5 cm (31 ½ × 25 ¼ in.)
Florence, Galleria degli Uffizi

OPPOSITE
Michelangelo Merisi da Caravaggio
(1571–1610)
The Calling of St Matthew

1598–1600
Oil on canvas
322 × 340 cm (126 ¾ × 133 ⅞ in.)
Rome, San Luigi dei Francesi, Contarelli Chapel

Fontana's luminous orange tones may not be to everybody's taste. Certainly, by the end of the sixteenth century some patrons were looking for something a little more bracing. As in the High Renaissance, it was in Rome that the most important innovations occurred. In 1592 a young artist, Michelangelo Merisi da Caravaggio, arrived there from the north of Italy. Initially, he specialized in still lifes and genre pictures (scenes of everyday life), before receiving a commission that was to begin a brief phase of spectacular activity. In *The Calling of St Matthew* (opposite), Caravaggio has drained away the pretty colours of late-sixteenth-century religious painting. A group of ne'er-do-wells are gambling around a table; two figures, Christ and St Peter, approach; and in a dramatic shaft of light the apostle's vocation is confirmed. Caravaggio has made a challenge to the conventions of Christian art: tender piety has been replaced by something rather more compelling.

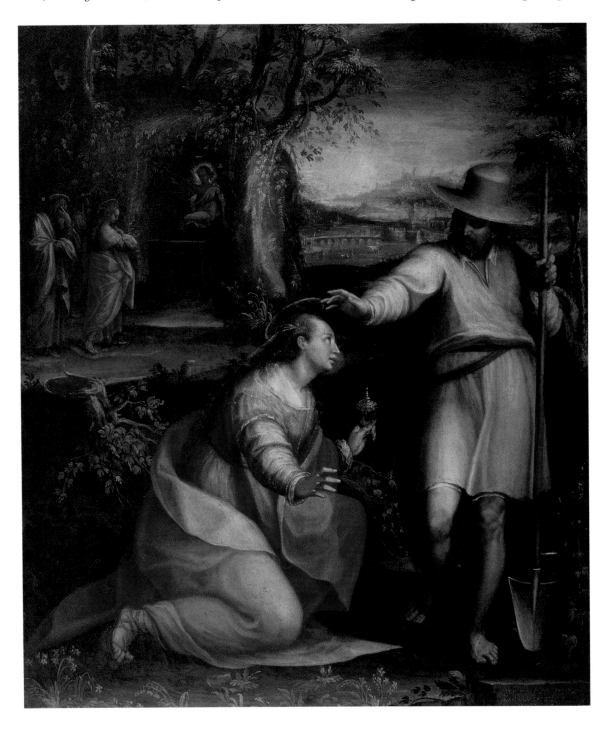

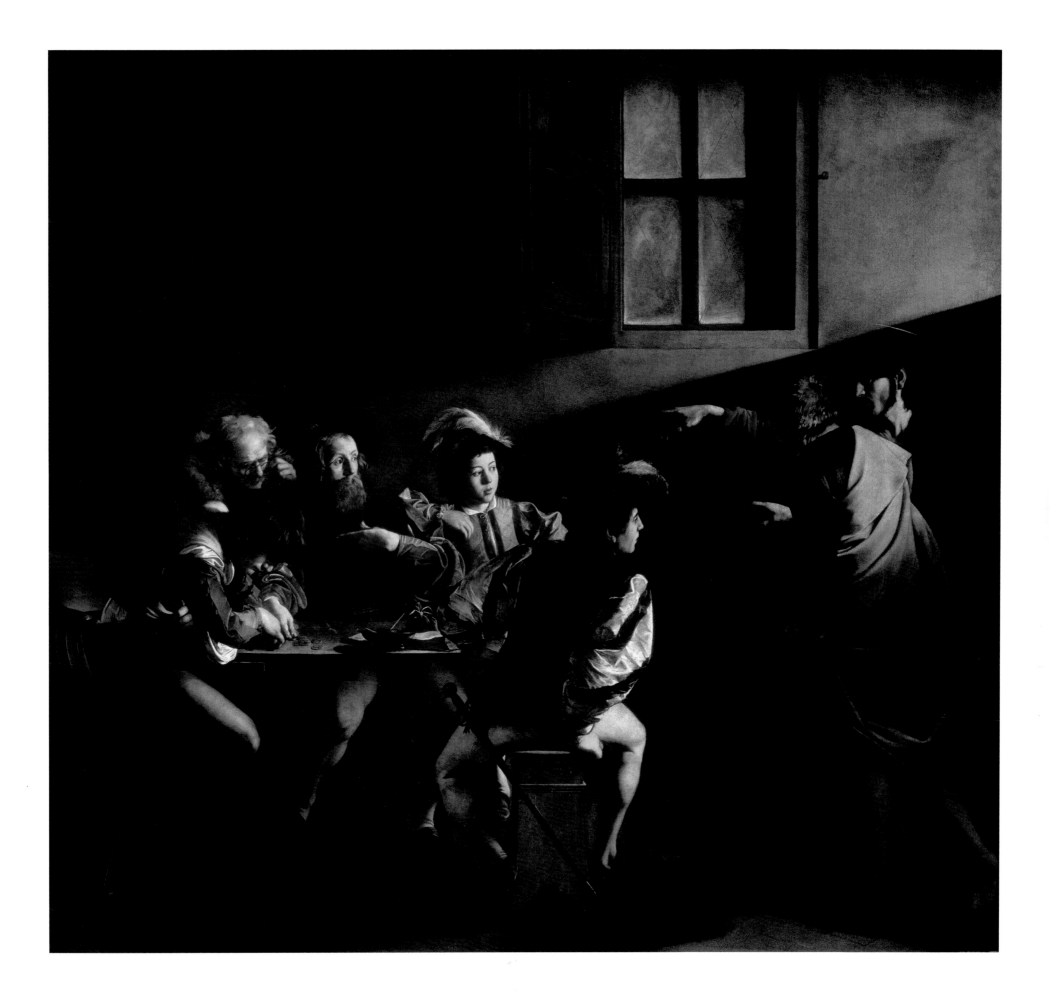

THE
ANCIENT
WORLD

When Sandro Botticelli painted *Calumny* (opposite), based on an ancient description of a picture by Apelles, he knew that his own work could not in fact resemble the original version. After all, this had been lost for more than a thousand years, and in the late fifteenth century none of the Classical paintings that we now know had been rediscovered. Moreover, even when Botticelli was influenced by Roman sculpture, as in *The Birth of Venus* (page 54), he changed both its proportions and mood to suit the idealized world that he was creating.

Botticelli was interested not in imitation but in 'invention' – the quality for which the humanist Leon Battista Alberti, writing in the 1430s, had recommended *Calumny* as a suitable theme for art. 'Invention' thrived on complex narratives with contrasting characters, often borrowed from Classical literature. Consequently, the ancient world became important to Botticelli more as a source of poetic themes than as a pattern book of gestures and anatomies.

Many artists, even great ones, were more prosaic, adapting specific poses in Classical sculptures for religious images, monuments and mythologies. Sometimes they would satisfy the taste of their rich patrons by making direct imitations. The sculptor Lorenzo Ghiberti, for example, was said even to have counterfeited Greek and Roman coins: the market was obviously tempting.

From where, then, did these models come? It can be hard to grasp the fact that during this period many of the ancient statues that we know today were still under the ground or in the sea. Artists often studied small objects – coins, medals and cameos – as well as larger reliefs on the sides of Roman sarcophagi (tomb chests). The city of Rome contained the most prominent works: as well as the decorations on triumphal arches and other monuments, there were a few free-standing figures outside the Lateran Palace, including the *Spinario* (page 56) and the equestrian portrait of Marcus Aurelius (page 60), which had been famous since the Middle Ages.

The influence of ancient sculpture may be seen in paintings, for example by Andrea Mantegna, which include brilliant imitations of marble reliefs (page 62). In contrast, later in the sixteenth century the Venetian Titian developed a far more sensual image of antiquity, combining references to ancient sculptures, such as the newly discovered *Laocoon* (page 64), with warm, vibrant colours, and including plenty of drinking and love-making (page 67).

Other artists exploited this potential even more brazenly, producing small, precious objects in which the gods were treated as erotic trifles, to adorn a salt cellar (page 69) or to be caressed like the statuette in Titian's canvas of Jacopo Strada (page 71). This painting and the self-portrait by Maarten van Heemskerck (page 73) show how Classical sculptures or buildings could function as symbols of taste: to depict yourself in the vicinity of the Colosseum conferred more distinction on you, especially if you actually lived in The Netherlands.

Van Heemskerck was certainly not the only northern artist to visit Italy. Pieter Bruegel the Elder stayed there for about three years, returning with an ambivalent view of antiquity, which turned the Colosseum into an absurd Tower of Babel (page 74), and Ovid's story of 'The Fall of Icarus' into a minor event on a glorious summer day (page 75). Lustful bacchanals, sexy salt cellars, preposterous ziggurats – all were made at a time when some of the finest Roman monuments were being demolished or despoiled. By the middle of the sixteenth century the ancient world had been mastered without too much solemnity, and the doors of the imagination were blown open.

Sandro Botticelli
(1444/45–1510)
Calumny

c. 1495
Tempera on panel
62 × 91 cm (24⅜ × 35⅞ in.)
Florence, Galleria degli Uffizi

In the painting there was a man with enormous ears sticking out, attended on each side by two women, Ignorance and Suspicion; from one side Calumny was approaching in the form of an attractive woman, … dragging by the hair a youth with his arms outstretched towards heaven. Leading her was another man, pale, ugly and fierce to look upon, whom you would rightly compare to those exhausted by long service in the field. They identified him correctly as Envy. There are two other women attendant on Calumny and busy arranging their mistress's dress; they are Treachery and Deceit. Behind them comes Repentance clad in mourning … and rending her hair, and in her train chaste and modest Truth.[1]

Botticelli has represented with remarkable accuracy the second-century writer Lucian's description of a lost work by the painter Apelles. Lucian's account was retold in Alberti's *De pictura* ('On painting') in the mid-1430s, but not until sixty years later was it used to re-create Apelles' picture.

As well as its fidelity to the text, Botticelli's panel has a few other Classical features. The composition is horizontal, as in an ancient relief, and the setting evokes Roman architecture and sculpture without actually resembling any specific examples. The figures, however, are startlingly original, their refined proportions and nervous gestures characteristic of Botticelli's later paintings.

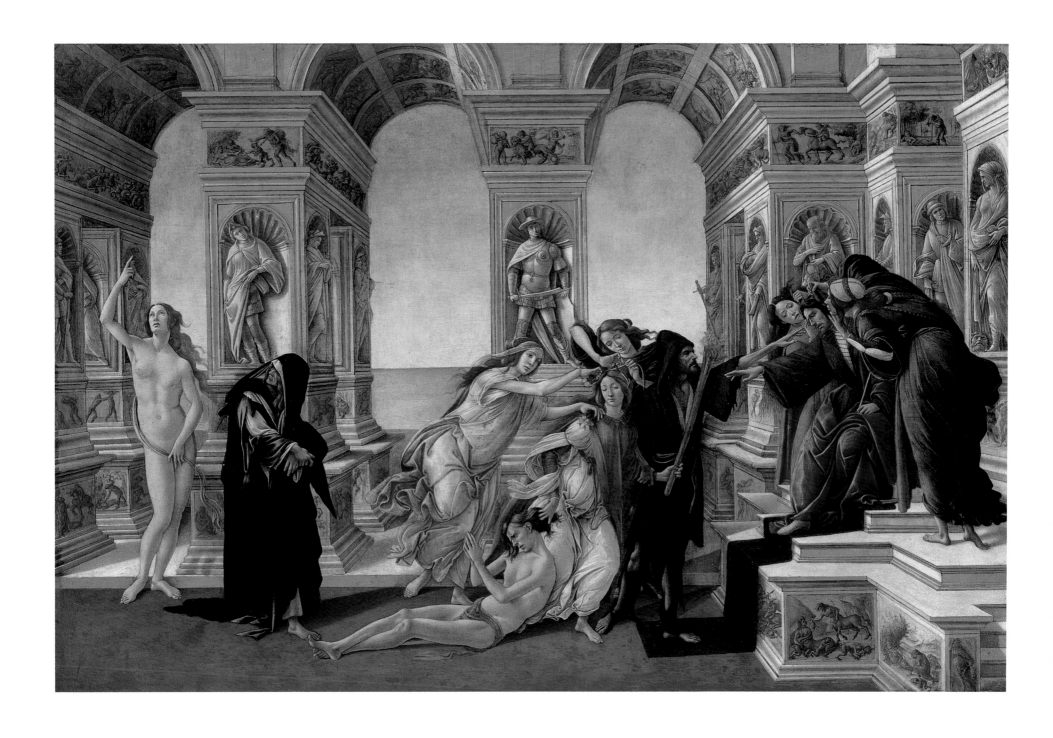

Sandro Botticelli
(1444/45–1510)
The Birth of Venus

c. 1484
Tempera on linen
172.5 × 278.5 cm (67⅞ × 109⅝ in.)
Florence, Galleria degli Uffizi

Venus, born out of the froth erupting from Saturn's severed genitals, sails to Cyprus in a shell. She is blown to her destination by Zephyr, the god of the West Wind, whose partner is probably his lover Chloris. On the right, a figure representing Spring reaches to dress Venus with a flowery mantle. However, at this moment she is still artlessly nude, although covering herself with her hands out of natural modesty.

The goddess's pose is undoubtedly inspired by Classical sculpture (opposite), while Zephyr and his companion may have been influenced by an ancient agate-and-sardonyx bowl depicting 'The Fertility of Egypt', which shows the two Etesian winds bringing the rains that annually flood the Nile. Now in the Museo Archeologico Nazionale in Naples, it was at one point owned by Lorenzo de' Medici, and so may have been seen by Botticelli in Florence.

Even more important, however, is the painting's celebration of the ideal of chaste love promoted by the Medici family's neo-Platonic poets and philosophers. Its style is appropriately refined and elegant, with elongated proportions and a strong sense of pattern. The outlines of the shore and shell, Venus' shoulders and her mantle, correspond with one another, while the sense of artifice is enhanced by the gilding in the wings and on the trees; as Vasari put it more concisely, 'all this work was executed with exquisite grace'.[2]

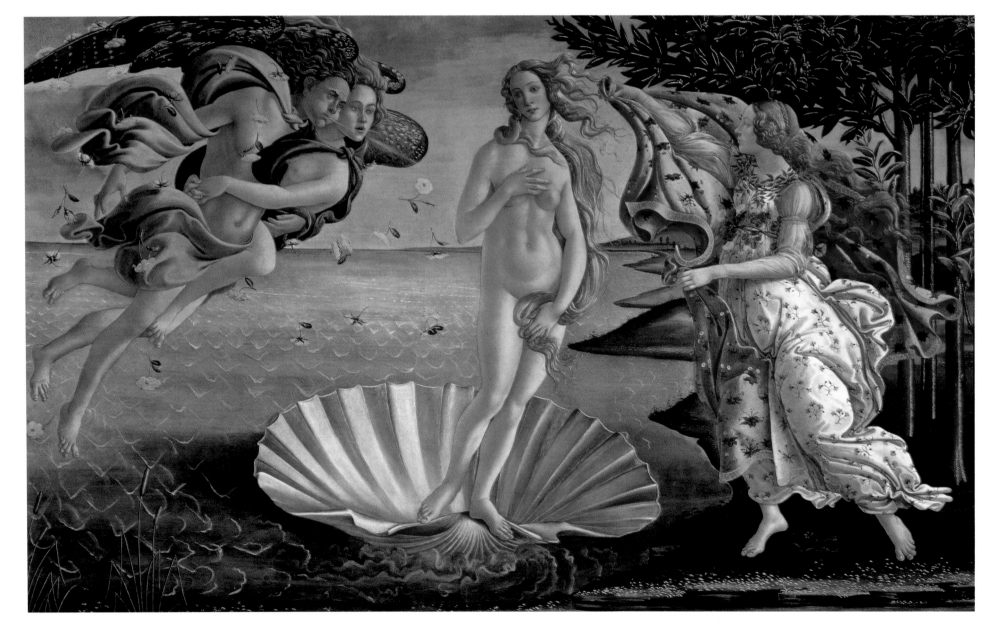

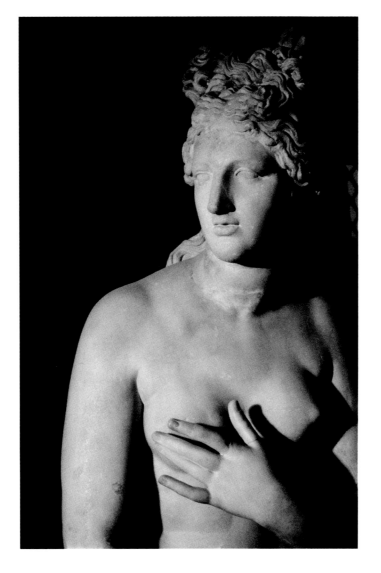

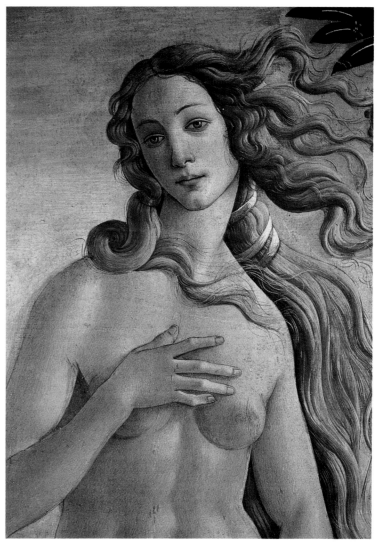

Roman sculpture of
Venus pudica (detail)

Marble
Paris, Musée du Louvre

This sculpture exemplifies one particular
way in which the Romans represented Venus,
with her hands covering her genitals and
breasts. Known as *Venus pudica*, this type of
image undoubtedly inspired Botticelli, as the
comparison of details demonstrates.

The Birth of Venus (detail)

This detail shows obvious similarities with
the gesture of the Roman sculpture on the
left, even though the anatomies are quite
different: the sloping shoulders and slender
proportions in the painting seem more
delicate, as if Botticelli cannot quite bear the
materialism of the ancient statue. Moreover,
Botticelli's Venus modestly tilts her head, like
one of his Madonnas (page 27), in contrast
to the other figure's more upright posture.

Spinario ('Thorn-Puller')

Probably 1st century BC
Bronze
Height (without plinth) 73 cm (28¾ in.)
Rome, Musei Capitolini, Palazzo dei
Conservatori

Like many Roman sculptures, this famous figure of a boy pulling a thorn out of his foot is probably a copy of an earlier Hellenistic work, which itself may have been at least partly based on an even older Greek statue: imitating the antique has a very long history.

This version was first recorded by an English traveller outside the Lateran Palace in Rome in the twelfth century, and was moved to the Capitoline Hill soon after 1471. Identified at different times as Priapus, the month of March or a shepherd, it was frequently copied or adapted by Renaissance artists. The precise identity or even the sex of the figure might change, but its basic pose would remain. The sculpture was admired as an example of how to make something complex and difficult seem graceful and easy, qualities held in particular esteem during the Renaissance.

Filippo Brunelleschi
(1377–1446)
The Sacrifice of Isaac

1401–03
Parcel-gilt bronze
45 × 38 cm (17¾ × 15 in.)
Florence, Museo Nazionale del Bargello

Brunelleschi's relief, made for a competition to design a set of bronze doors for the baptistery in Florence, has a figure in the bottom left that is clearly modelled on the *Spinario* (left). The key characters above have equally expressive poses. Abraham is being tested by God, who has commanded him to sacrifice his own son. At the last moment, however, an angel dramatically grasps Abraham's arm, while a ram appears nearby, in order to take Isaac's place.

Ultimately Lorenzo Ghiberti's relief (page 15) won the competition, and Brunelleschi took himself to Rome, principally to study architecture. This experience is reflected in the buildings that he constructed later in his career, above all the spectacular dome of Florence Cathedral (page 12).

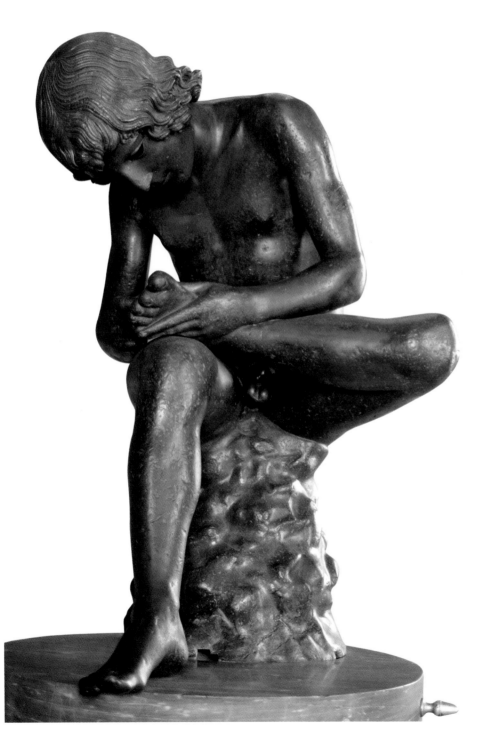

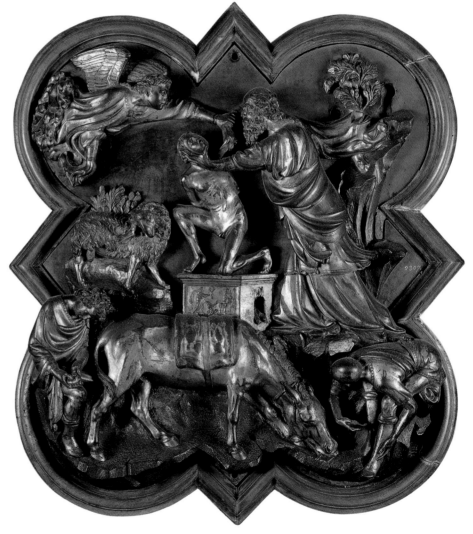

Antico (Pier Jacopo di
Antonio Alari-Bonacolsi)
(*c.* 1460–1528)
Spinario ('Thorn-Puller')

c. 1500
Bronze
Dimensions unknown
Italy, Modena, Galleria e Museo Estense

'Antico' worked in Rome restoring, buying
and copying ancient sculptures, the activities
from which he derived his name. We know
that by 1501 Antico had made a copy of the
Spinario for the collection of Isabella d'Este
in Mantua, and a couple of years later he sent
another statuette, probably the same figure
in reverse, as a companion: its decorative
qualities encouraged multiplication.
Moreover, Antico had developed a new
technique, whereby many moulds could be
taken from the original model before they
were finally cast in bronze. Nonetheless,
it is unlikely that he made more than a
few versions of this sculpture, since such
aristocratic patrons as the d'Estes and
Gonzagas valued unique objects, or at least
limited editions.

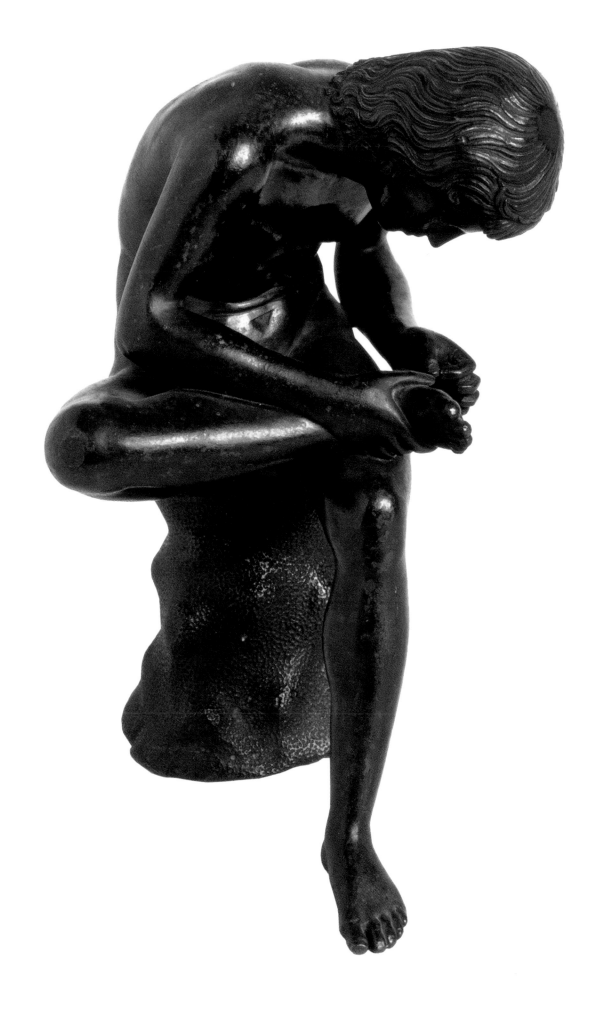

The horses of St Mark's

n.d.
Gilded bronze
Height 171 cm (67⅛ in.)
Venice, St Mark's Basilica

These horses have had a turbulent history.
They were taken to Venice in 1204, when
Constantinople was sacked during the Fourth
Crusade; removed to Paris in 1798 by
Napoleon's army; and returned to Venice in
1815 after his defeat. At no time in this history
have their origins been discovered: they have
been linked to the Greek sculptors Phidias
and Lysippos; to a triumphal arch built by
the Emperor Nero, who was supposed to
have been given them by Tiridates, king
of Armenia; and even now they are given
dates as varied as 300 BC and AD 400.

Widely reproduced during the
Renaissance in drawings, engravings and
small bronzes, the four directly influenced
the representation of the horse in many
monumental paintings and sculptures of
the period (opposite and page 61).

OPPOSITE, LEFT

Paolo Uccello (c. 1397–1475)
Equestrian monument to
Sir John Hawkwood

1436
Fresco, transferred to canvas
Florence Cathedral

The English knight John Hawkwood,
known in Italian as 'Giovanni Acuto',
played an important role in the defence of
Florence against the Milanese in the late
fourteenth century. The Florentine Republic
rewarded him with the promise of a marble
monument, but, after his death in 1394, the
project was reduced to the much cheaper
medium of fresco. The commission for this
was given to Agnolo Gaddi and Pesello
(Giuliano d'Arrigo), who duly executed
an equestrian figure, but by 1433 this must
already have seemed out of date, and Paolo
Uccello was asked to replace it.

Uccello's horse and rider are worthy
additions to the tradition that goes back
to Emperor Marcus Aurelius in Rome
(page 60), although the profile of the animal
owes more to the bronze horses of St Mark's
(below). In this case, the choice of a
Classical format has a political dimension.
Florentines associated their state with the
Roman Republic, in contrast to the
monarchical states in other parts of Italy,
including Milan. Consequently, in order
to play down the imperial associations
of equestrian sculpture, Hawkwood's
inscription very clearly identifies him as
eques britannicus ('a British knight') rather
than a ruler, while other parts of the text
are borrowed from Plutarch's description
of the Roman Republican hero Fabius
Maximus Cunctator.

The fresco's prominent site, high up inside
Florence Cathedral, has ensured its fame ever
since it was made, even though Giorgio
Vasari in the mid-sixteenth century wrote
that 'unfortunately, Paolo's horse has been
painted moving its legs on one side only,
and this is something which horses cannot
do without falling'. Vasari helpfully adds,
'Perhaps he made the mistake because he
was not in the habit of riding.'[3]

A surviving drawing of the composition
has a grid superimposed over the figures,
showing the care with which Uccello
squared up the design to the scale of a fresco.
The Classical sarcophagus underneath is a
masterful study in illusionistic perspective:
it is as if we really are looking up at the base
of the monument. The horse, however, is
represented to appear closer to the viewer's
eye-level so as to avoid the indignity of
looking at its underside rather than its
magnificent profile: even the rules of
perspective sometimes had to be bent.

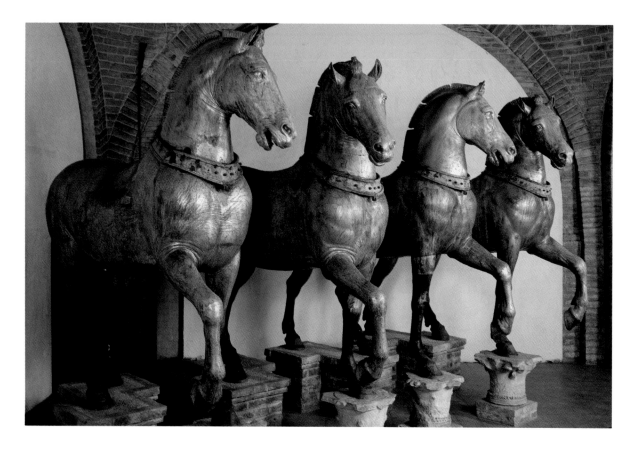

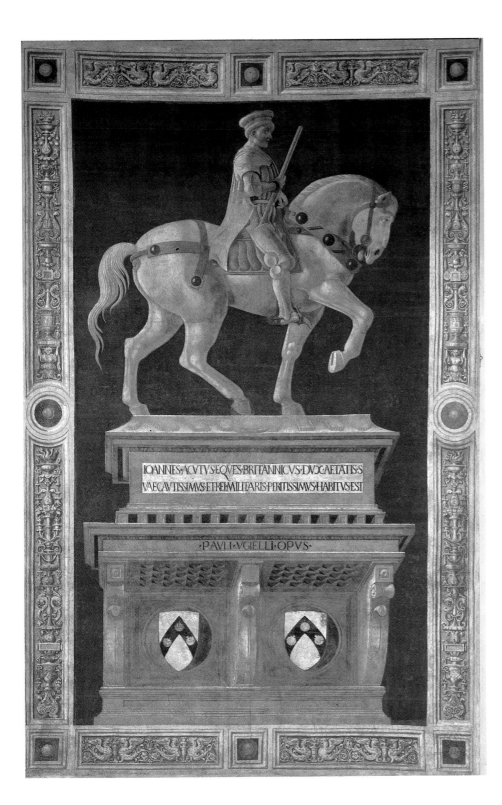

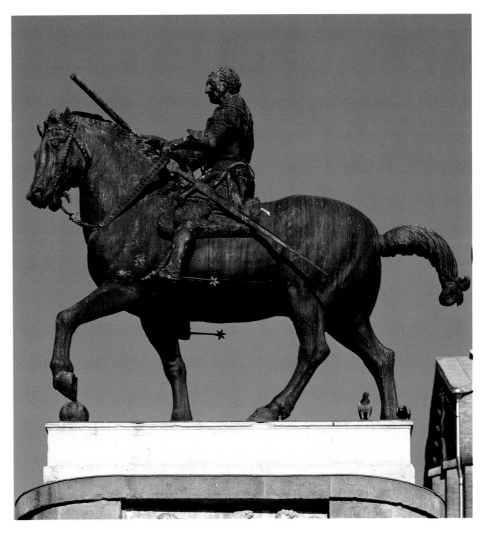

Donatello (1386/87–1466)
Equestrian monument to
Erasmo da Narni ('Gattamelata')

1447–53
Bronze
Height 370 cm (145 ⅝ in.)
Padua, Piazza del Santo

The bronze horses of St Mark's (opposite) are very close to Padua, and so it is natural that their pose and anatomy should be reflected, although not slavishly copied, in this famous monument. The military commander Erasmo da Narni (whose nickname Gattamelata, 'the honey cat', seems somehow more appropriate to a boxer than a leader of men) was a Paduan who led the Venetian army at a time when Venice was expanding its territory on the Italian mainland. The erection of the monument in Padua – paid for by the soldier's family but authorized by the Venetian Senate – was a political statement as well as an honour to this (moderately) successful general.

Donatello has taken inspiration from Roman equestrian sculpture, but, characteristically, has added his own incisive realism. Instead of the idealized features of Marcus Aurelius (page 60), Gattamelata's face is based on a death mask (a posthumous cast). Moreover, despite the Classical cut of his skirt and upper armour, Gattamelata wears a contemporary sword and spurs. Above all, the cannonball, supporting the horse's raised leg, places this magnificent memorial firmly in the world of the mid-fifteenth century.

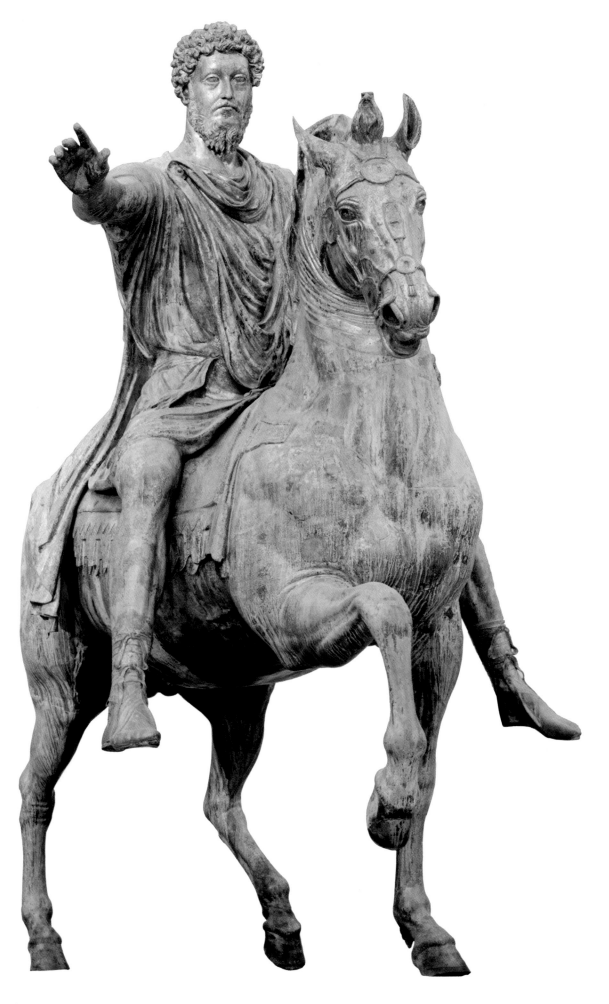

Marcus Aurelius

c. AD 176
Bronze
Height 424 cm (166⅞ in.)
Rome, Museo Capitolino

For centuries this famous monument owed
its survival, while many pagan bronzes were
being melted down, to the belief that it
represented the first Christian emperor,
Constantine. Although this belief was being
questioned by the late twelfth century, for
the next four hundred years other incorrect
subjects were proposed, ranging from the
Emperor Hadrian to a heroic peasant or
Theodoric the Great. Only since 1600 has
it been widely accepted that this bearded
rider is Marcus Aurelius, the emperor who
subdued the Germanic tribes in the second
century AD.

Like the *Spinario* (page 56), the sculpture
spent more than three centuries outside the
Lateran Palace in Rome, but in 1538 Pope
Paul III transferred it to the Capitoline
Hill (or Campidoglio). Michelangelo, who
designed a square around it, thought that 'it
looked better where it was',[4] and the canons
at the Lateran chapter were so annoyed by
its removal that they spent almost a century
trying to get it back.

Studied by many artists from the fifteenth
century onwards, the statue of Marcus
Aurelius has inspired a number of equestrian
monuments, even though these later works
(for example, page 59 and opposite) often
diverged significantly from their famous
predecessor.

Andrea del Verrocchio (1435–1488)
Equestrian monument to Bartolomeo Colleoni

c. 1479–92
Bronze
Height 395 cm (155½ in.)
Venice, Campo Santi Giovanni e Paolo

Giorgio Vasari, writing in the middle of the sixteenth century, recorded the acrimony that surrounded this commission. Summoned to Venice from Florence, Verrocchio completed a clay model of the horse before smashing it in anger when he heard that the commission for the figure had been reassigned to another sculptor. Safely back in Florence, he was advised not to return to Venice if he valued his head, a warning to which he gave a reply that was spirited, to say the least. This must have amused the Venetians, for they invited him back, on twice the pay, and he managed to complete and cast the model before his death in 1488.

The grimness of Colleoni's face, and indeed the finishing of the whole sculpture, reflect the work of Alessandro Leopardi, who completed the monument, including its base. However, the spirited, dynamic pose of both horse and rider is Verrocchio's invention. He has captured the swinging gait of Marcus Aurelius' horse (opposite) and, unlike Donatello's monument to 'Gattamelata' (page 59), has designed the composition so that the horse's raised hoof requires no external support.

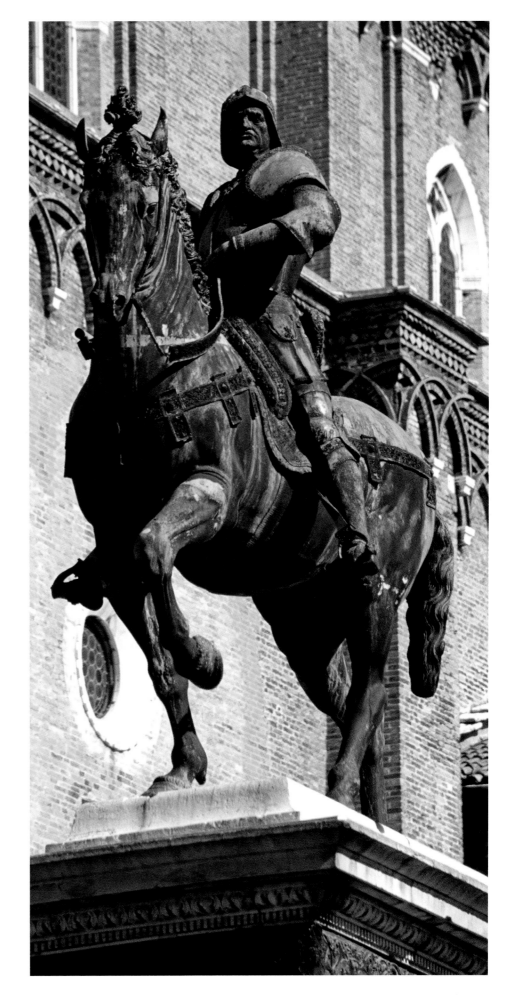

Andrea Mantegna
(1430/31–1506)
The Introduction of the Cult of Cybele at Rome

1505–06
Glue size on linen
73.7 × 268 cm (29 × 105½ in.)
London, The National Gallery

In Renaissance Italy, grand families often claimed Roman ancestry. The Venetian Francesco Cornaro traced his lineage back to Publius Cornelius Scipio Nasica (probably represented here by the erect figure extending his right arm), who in 204 BC was given the honour of welcoming to Rome the bust and sacred meteorite of the Asian goddess Cybele. Her arrival in the city was deemed to be vital to the success of the campaign against the invading Carthaginians.

Mantegna has not wasted the opportunity offered by this subject for exotic touches – turbaned priests, a kneeling eunuch, a drummer with a Phrygian cap – combined with more familiar Roman figure types and costumes. Above all, by creating such a spectacular illusion of grey and coloured marbles, Mantegna has shown that painting can outdo the richness and three-dimensionality of sculpture.

OPPOSITE

Andrea Mantegna
(1430/31–1506)
Parnassus

1497
Tempera on canvas
159 × 192 cm (62⅝ × 75⅝ in.)
Paris, Musée du Louvre

Like many Renaissance rulers, Isabella d'Este, the wife of Francesco Gonzaga, Marquis of Mantua, possessed a *studiolo*, a small room set aside for study and contemplation. In the 1490s she had it decorated with a series of paintings by Mantegna, Lorenzo Costa and Perugino. The first of these was *Parnassus*, a fitting image for a woman who was described by a contemporary as 'completely dedicated to the Muses'.[5]

The canvas depicts the nine Muses (mythological personifications of the arts), whose crisp drapery and frozen motion recall figures in ancient reliefs. They dance in a circle as Apollo, their master, plays the lyre. On the right, Mercury is accompanied by the winged horse Pegasus, from whose hoofs springs the fabled Hippocrene stream. Above, on the top of Mount Parnassus, are the adulterous Mars and Venus, accompanied by Cupid, who aims a blow-pipe at the goddess's enraged husband, Vulcan.

Despite the fact that they were respectably married, Isabella and Francesco seem to have identified with the amorous couple. As victor over the French at the Battle of Fornovo (1495), Francesco emulated Mars, while Isabella admired Venus as a goddess in whom love and art were harmoniously united.

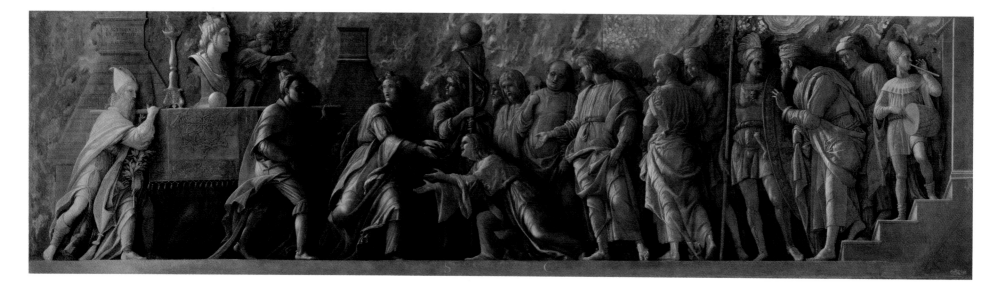

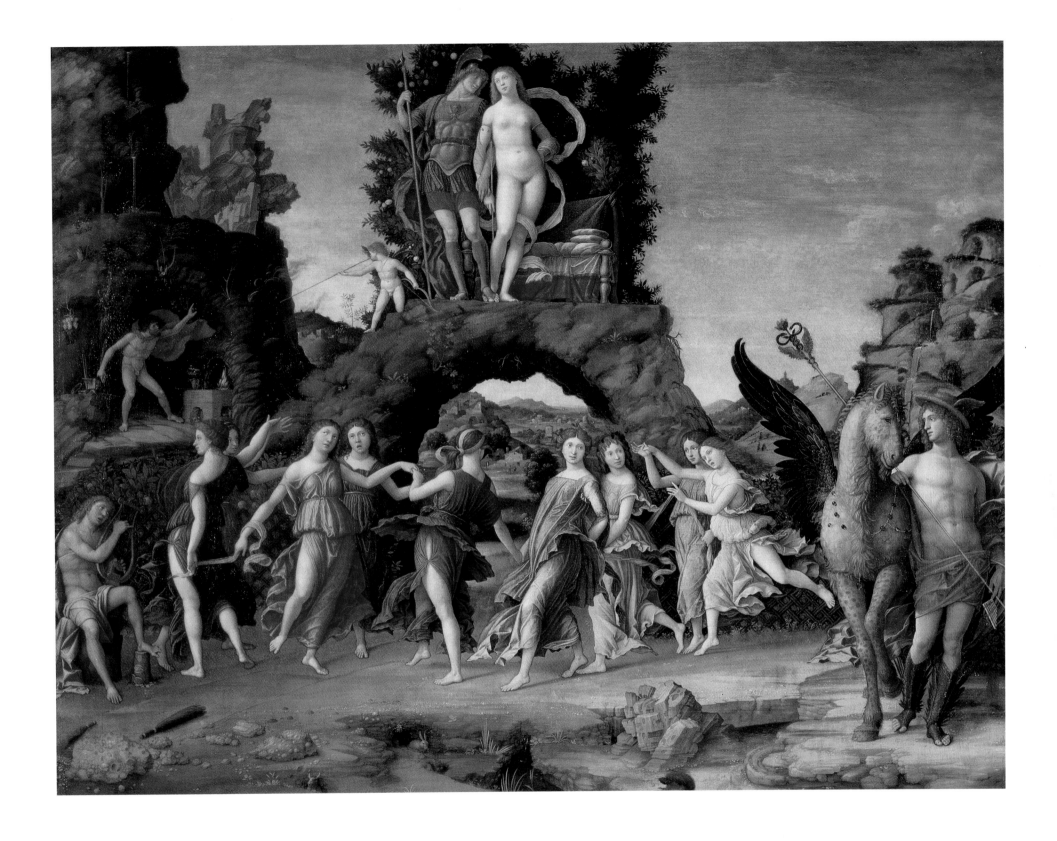

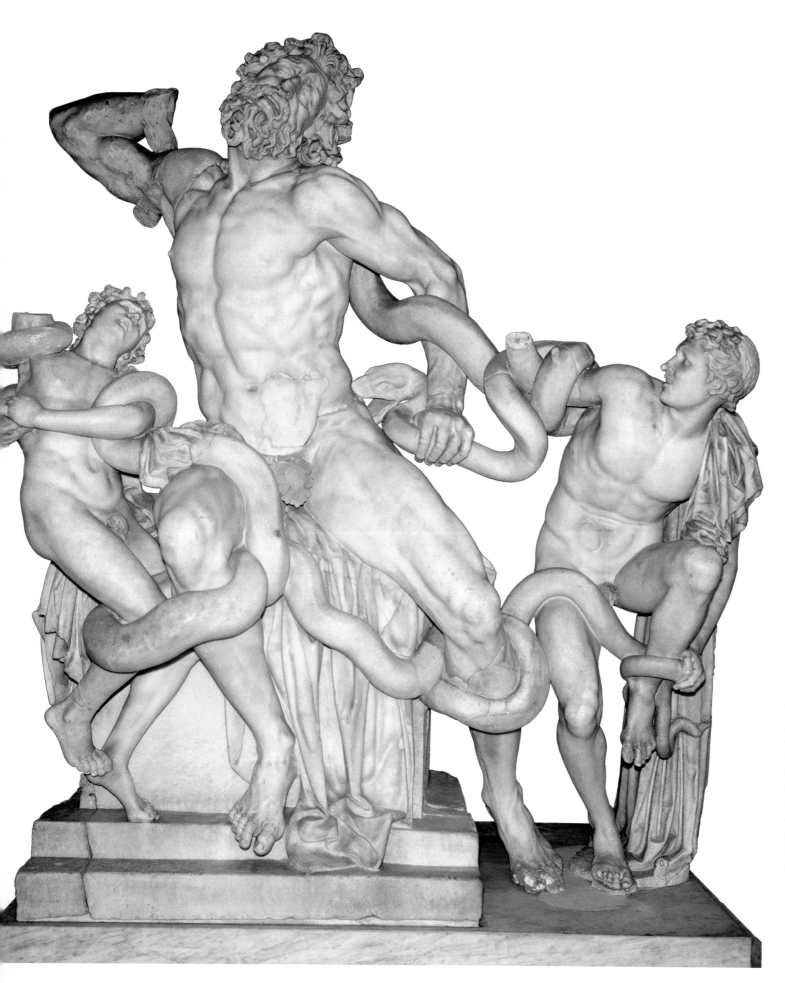

Hagesandros, Polydoros and Athenodoros
Laocoon

Second half of the 1st century AD
Marble
Height 242 cm (95 ¼ in.)
Rome, The Vatican, Belvedere Courtyard

Virgil tells us how Laocoon urged his fellow Trojans to distrust the wooden horse that suddenly appeared outside their city. The gods quickly silenced him by sending two immense snakes, which devoured his sons and then strangled him, drenching him with black venom.

As soon as it was discovered in 1506 on the Esquiline Hill in Rome, this sculpture was identified with a famous version of the subject described by the ancient writer Pliny the Elder. Michelangelo, who saw it when it was still in the ground, was particularly influenced by its expressive, twisted figures, while casts and engravings spread its influence across Europe.

OPPOSITE
Michelangelo Buonarroti (1475–1564)
The Sacrifice of Noah, with *Ignudi* (nude figures), from the Sistine Chapel ceiling

1509
Fresco
Rome, The Vatican

Noah and his family are preparing a sacrificial pyre, to thank God for saving them from the Flood. Seated on the frame surrounding the scene are four male nudes, two of whom (on the right of this photograph) are among the most significant, if not the most faithful, adaptations of the *Laocoon*. The legs of the figure at the bottom right, together with the torso and the raised arm of his companion, show the influence of the recently discovered sculpture. With their energetic, idealized forms, the youths provide a visual expression of something that is beyond human experience: the divine reality to which the Christian soul aspires.

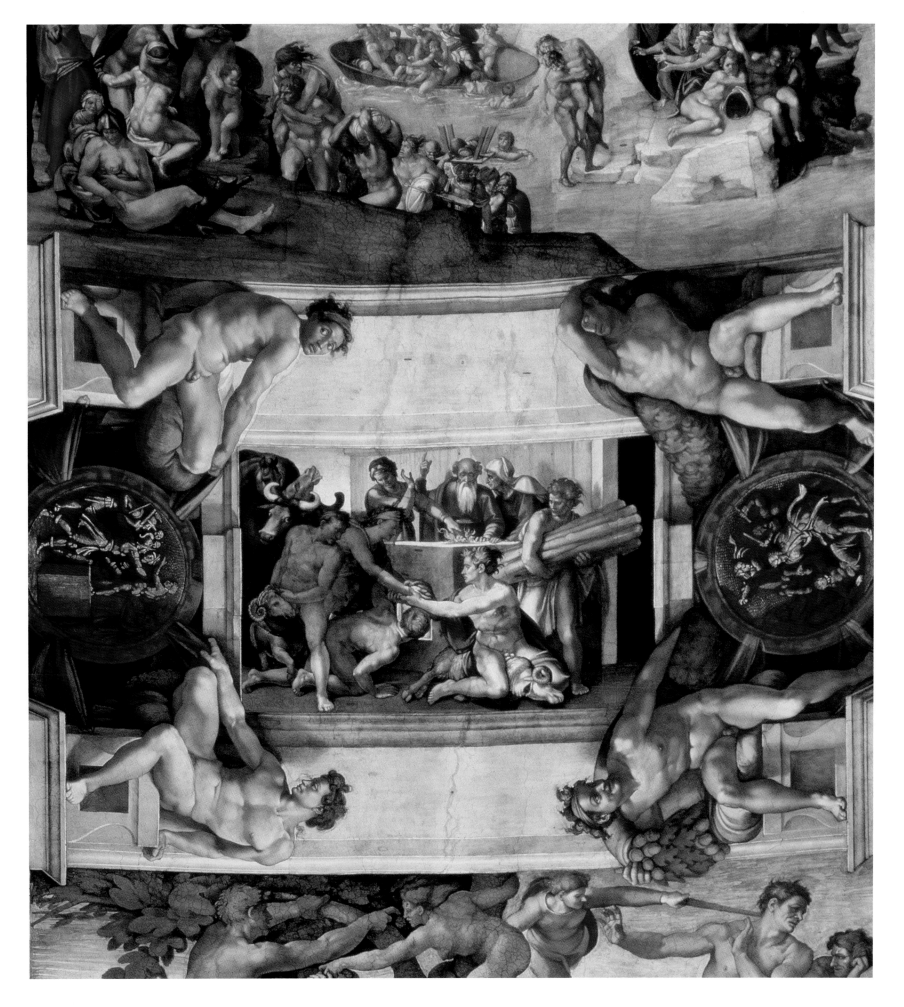

Antonio Lombardo
(c. 1458–?1516)
*The Birth of Athena
at the Forge of Vulcan*

c. 1508–16
Marble, inlaid with coloured stone
83 × 107 cm (32⅝ × 42⅛ in.)
St Petersburg, The State Hermitage Museum

Like his sister Isabella (page 63), Alfonso d'Este, Duke of Ferrara, commissioned a series of mythological scenes for a *studiolo*, or study. This relief, by one of the leading Venetian sculptors, has a suitably academic subject: the birth of Athena, the goddess of wisdom, from the head of Jupiter, the writhing character on the left. This figure is one of the earliest references to the *Laocoon* (page 64), and, with its bent legs and raised arm, accurately reflects the ancient statue's pose, if not its snakes.

As in the story originally told by the Greek poet Hesiod, Jupiter howls with pain as he waits to have his head split open with tools forged by Vulcan, the divine blacksmith. This is clearly a difficult delivery.

OPPOSITE

Titian (Tiziano Vecellio)
(c. ?1485/90–1576)
Bacchus and Ariadne

1520–23
Oil on canvas
176.5 × 191 cm (69½ × 75¼ in.)
London, The National Gallery

As well as decorating his study, Alfonso d'Este commissioned a series of paintings from different artists for the neighbouring Camerino d'Alabastro, a small room lined with alabaster sculptures by Antonio Lombardo. Despite their surroundings, the subjects of the pictures were not very contemplative. Instead of Athena, Apollo and the Muses, Alfonso chose an assortment of drunkards, lecherous gods and rioting cupids, brought to life so vividly that they transformed the representation of Classical mythology in art.

In this painting, now in London, Titian has represented the followers of Bacchus, the god of wine, at the moment when he leaps from his chariot towards the princess Ariadne. As the Roman poets Ovid and Catullus tell us, Ariadne has been abandoned on the island of Naxos by the hero Theseus, but is discovered by the god, who successfully woos her, turning her crown into a constellation.

Titian's depiction of the characters – from the sleeping Silenus in the background to the young satyr trailing a deer's head – is unique, and yet certain features are clearly borrowed from Roman sculptures. Bacchus' pose, with his head inclined, legs outstretched and arm sweeping back across his body, is taken from a second-century sarcophagus of Orestes, now in the Palazzo Giustiniani in Rome. More obviously, the character entwined with serpents is another reference to the *Laocoon* (page 64), although he seems to be having more fun than did the unfortunate Trojan. Apart from the presence of the snakes, Titian's quotation of the ancient sculpture is far freer than Lombardo's in *The Birth of Athena at the Forge of Vulcan* (left). This is Classicism taken out of the ground and into the sun. The change of temperature is overwhelming.

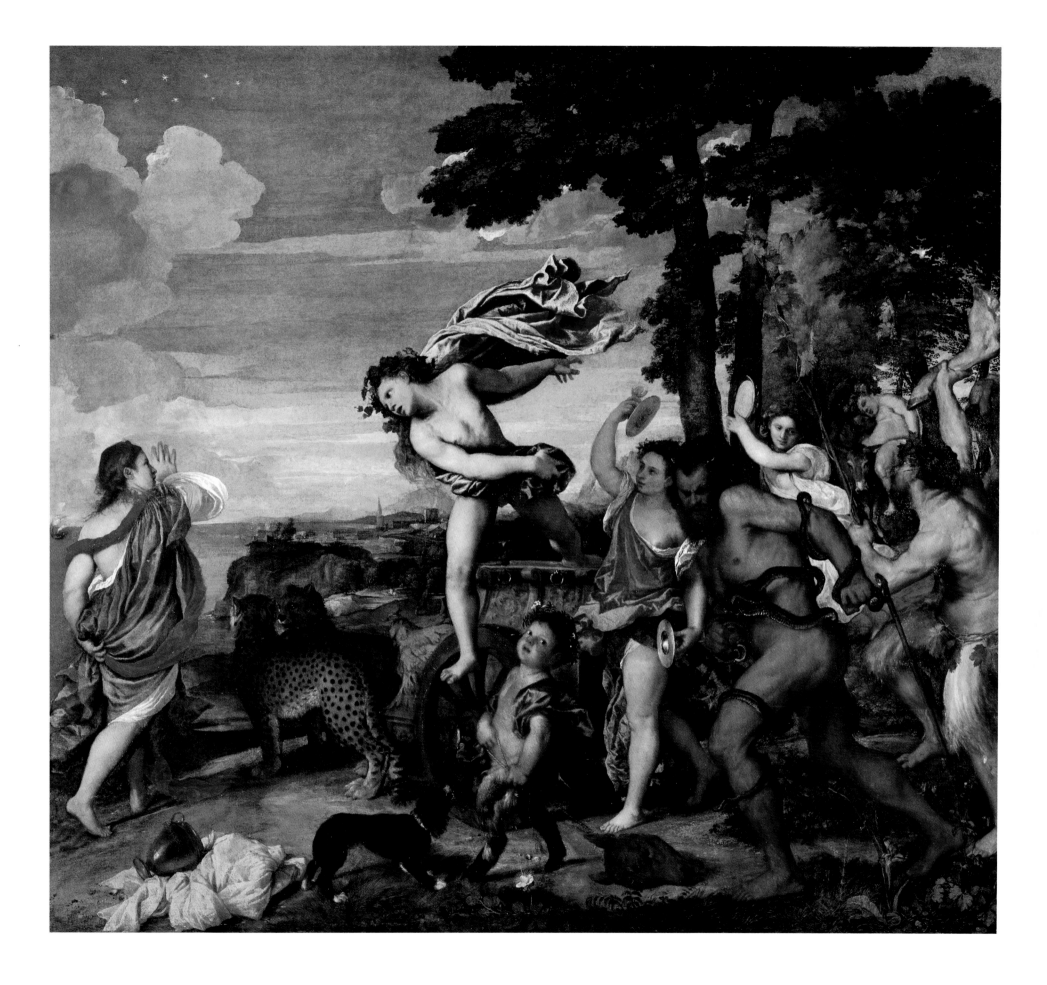

Lucas Cranach the Elder (1472–1553)
The Judgement of Paris

Possibly *c.* 1528
Oil on panel
101.9 × 71.1 cm (40⅛ × 28 in.)
New York, The Metropolitan Museum
of Art

The Trojan prince Paris adjudicates a beauty contest between Juno, Minerva and Venus, the goddess of love, who wins after promising him Helen, the most beautiful woman in the world. Unfortunately, she is already married to Menelaus, the king of Sparta. This will prove to be a problem, as Homer describes in *The Iliad*.

Characteristically, Lucas Cranach, whose religious work sets such a high theological tone (page 117), makes light work of this secular subject. The goddesses are lithe and lissom, in glorious disregard of Classical proportions; they are introduced by Mercury, who is dressed in fantastic golden armour. The ancient story takes place within a distinctively Germanic landscape, of great (and incongruous) beauty.

Jan Gossaert (also known as Mabuse) (*c.* 1478–1532)
Neptune and Amphitrite

1516
Oil on panel
188 × 124 cm (74 × 48⅞ in.)
Berlin, Staatliche Museen zu Berlin,
Gemäldegalerie

When the Flemish artist Jan Gossaert returned from a year-long trip to Rome in 1509, he did not immediately introduce to his painting the Classical influences that he had absorbed in Italy. However, a commission from Philip, Duke of Burgundy, in 1515 for a series of mythological paintings prompted an abrupt change of style.

In this painting the god of the sea is accompanied by his wife, Amphitrite. Their relationship was stormy – for example, she turned his lover, Scylla, into a barking monster with six heads and twelve feet – but Gossaert presents them as a model of marital bliss. Their superb bodies and dynamic *contrapposto* poses appear to reflect the ancient sculptures that he saw in Rome, although they probably owe more to prints by Albrecht Dürer and Marcantonio Raimondi (see pages 245 and 260).

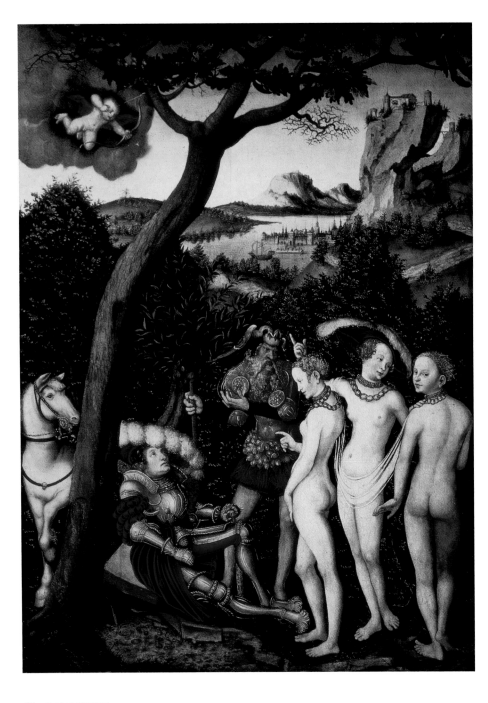

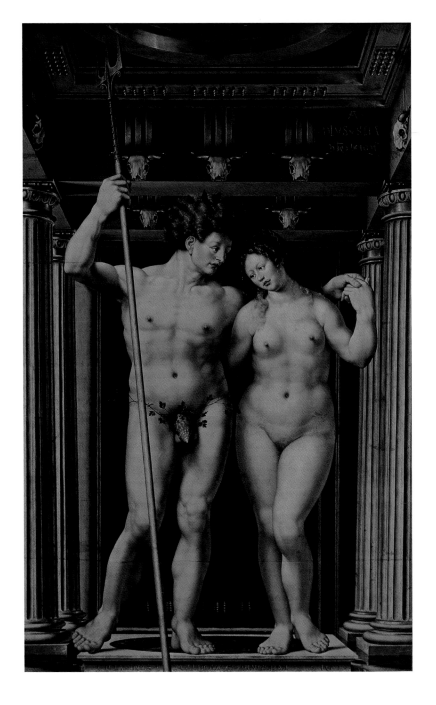

Benvenuto Cellini (1500–1571)
Salt cellar of Francis I

1540–43
Gold, partially enamelled on an ebony base
26 × 33.5 cm (10¼ × 13¼ in.)
Vienna, Kunsthistorisches Museum

In this extraordinary artefact, Neptune has been reduced to the status of a luxury condiment. As god of the brine, he guards the receptacle that acts as the salt cellar, while crossing legs with his counterpart, Earth, who presides over the pepper inside a miniature triumphal arch. As her salty companion raises his trident, surrounded by excited sea horses, it looks as if the perfect seasoning is only minutes away. The momentum is maintained around the elaborate concave base, where Times of the Day alternate with symbols of human activities and the Four Winds, their cheeks puffed out in excitement.

Created for the French king Francis I while Cellini was living in Paris, this object has had a chequered history. It has been in Austria since 1570, when it was given to the Archduke Ferdinand, Count of Tyrol, by one of Francis's successors, Charles IX, to thank him for acting as proxy during Charles's wedding to the Archduchess Elizabeth. Missing for several years after a burglary, in 2006 it was returned to its home in the Kunsthistorisches Museum in Vienna.

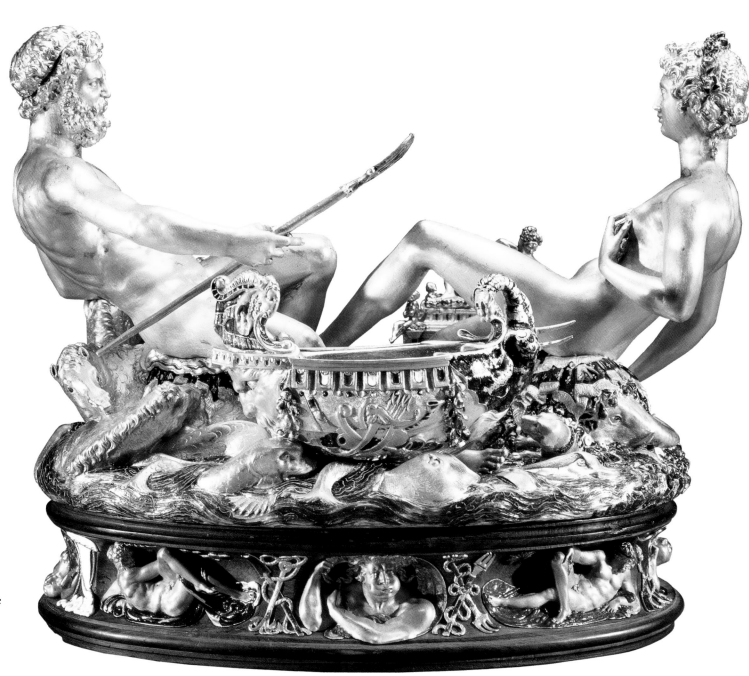

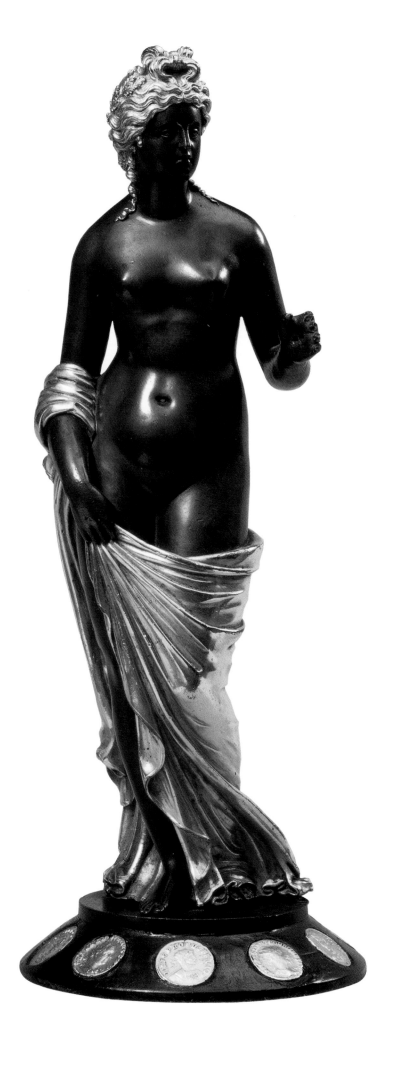

Antico (Pier Jacopo di Antonio Alari-Bonacolsi) (c. 1460–1528)
Venus Felix

c. 1500
Bronze, partly fire-gilt, on a limewood base
Height (without base) 29.8 cm (11¾ in.)
Vienna, Kunsthistorisches Museum

One of Antico's most important patrons was Bishop Ludovico Gonzaga of Mantua, for whom he probably created this exquisite, tactile sculpture. Small enough to be picked up and handled, it is beautifully polished and gilded, with inlaid silver eyes. The base, which is decorated with ancient Roman coins, was probably added later.

The pose – in which Venus is rescued from total nudity by a single draped leg – is taken from a Classical statue, located in the collection of Pope Julius II as early as 1509 but probably seen by Antico a few years earlier. Antico has removed the Cupid in the original sculpture but otherwise has modified little – apart from the fact that a figure originally more than two metres high has been shrunk to less than a sixth of that.

Titian (Tiziano Vecellio)
(c. ?1485/90–1576)
Jacopo Strada

1567–68
Oil on canvas
125 × 95 cm (49¼ × 37⅜ in.)
Vienna, Kunsthistorisches Museum

Here Titian shows the handling of a
Classical sculpture in vivid detail. Jacopo
Strada was a collector and scholar who at the
time of his death was preparing a dictionary
in eleven languages. He was also a dealer
employed by both the Habsburgs and the
ruler of Bavaria, Albrecht IV: it is in this
guise that Titian presents him, surrounded
by his wares.

 If we can believe a letter written by one
of Strada's rivals, Titian regarded him as an
ignorant confidence trickster. Certainly the
prosperous expert looks as if he is spinning
a tale while he paws the statuette, herself
bursting with life. Yet this combination of
antiquity, business and sensual gratification
was not unique to Strada. It was the rule
rather than the exception.

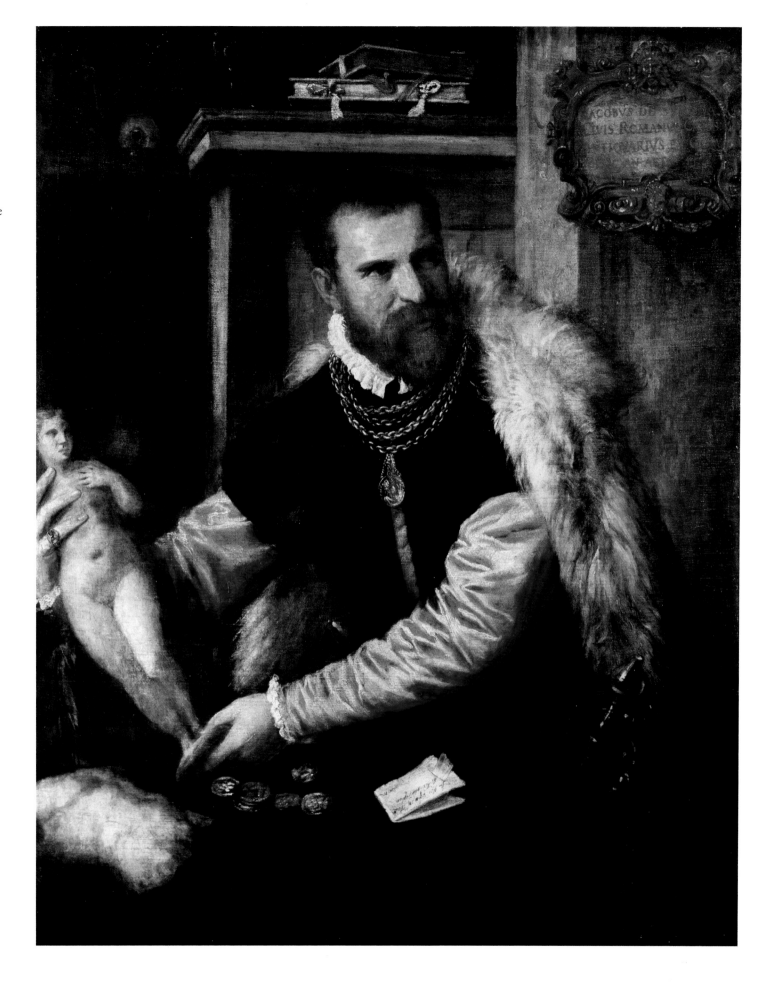

The Colosseum

AD 69–80
Travertine-faced brick, tufa and concrete
Rome

The Colosseum – the amphitheatre
constructed by the emperors Vespasian and
Titus – inspired and intrigued Renaissance
artists even as its materials were being
quarried to build new palaces. Its significance
was increased by the mistaken belief that
early Christians were martyred there, when
it was actually used for spectacles involving
gladiators or animals (as likely to be sheep
as wild beasts).

Architecturally, the amphitheatre's most
influential feature was its travertine façade,
in which different orders (recognized by the
varying designs of the columns) were used
for each storey, the decorative Corinthian and
Ionic orders being placed above the plainer
Tuscan. However, the network of vaulted
concrete corridors, which supported the tiers
of seats inside, also made a great impression
on artists and architects alike.

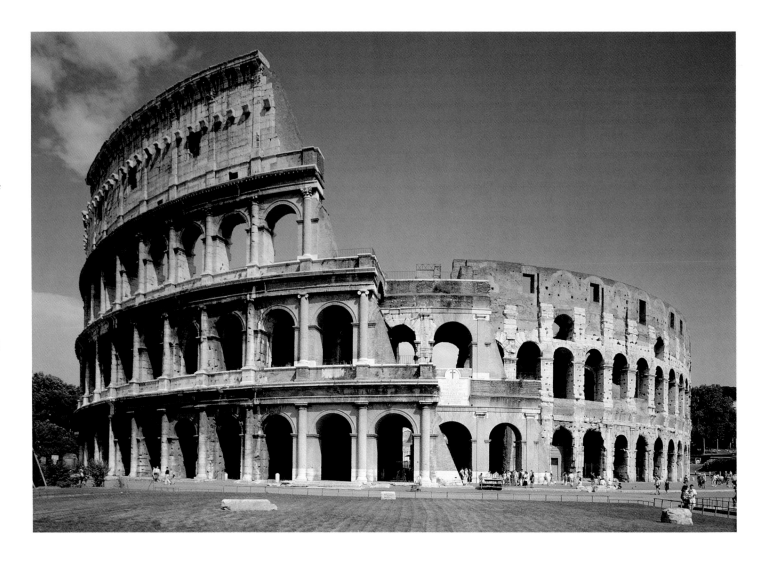

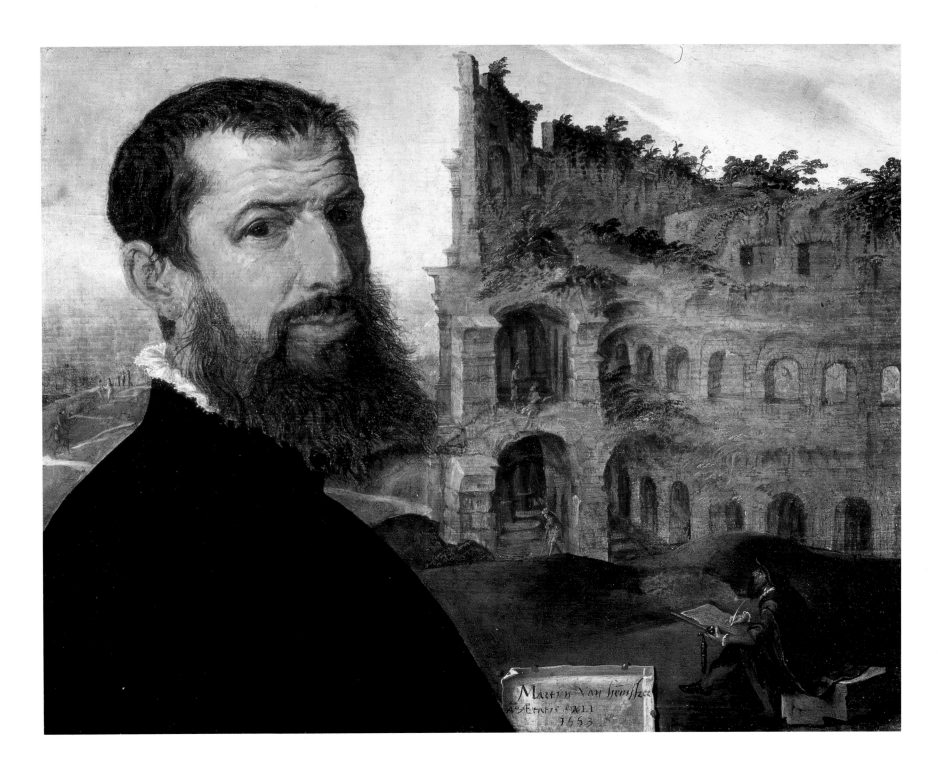

Maarten van Heemskerck
(1498–1574)
Self-Portrait with the Colosseum

1553
Oil on panel
42.2 × 54 cm (16⅝ × 21¼ in.)
Cambridge, Fitzwilliam Museum

The Dutchman Van Heemskerck is an early example of the northern Europeans who for several centuries flocked to Rome in order to study antiquity. In fact, this image is a strange kind of souvenir, painted many years after Van Heemskerck's stay in Rome during the 1530s.

While living in Italy, Van Heemskerck made many open-air sketches, from which he was still taking inspiration years later. His personal response to the evocative ancient ruins is emphasized by the unusual juxtaposition of the Colosseum with his own face, as well as by the image of himself working in the background. Van Heemskerck's antiquarianism was often rather fanciful: in 1552, for example, he depicted the dilapidated Colosseum as an ancient bullfighting ring, a purpose for which it was never used. However, his drawings remain important documents of Roman remains as they appeared in the sixteenth century.

Pieter Bruegel the Elder
(c. 1525/30–1569)
The Tower of Babel

1563
Oil on panel
114 × 155 cm (44⅞ × 61 in.)
Vienna, Kunsthistorisches Museum

Bruegel was in Rome from 1552 to 1553. A few of his paintings show the influence of such Italian artists as Raphael, and occasionally he refers to ancient Roman architecture. In this case he obviously thought that the Colosseum's wicked associations made it the perfect model for the biblical Tower of Babel, itself a symbol of man's arrogance.

God punished the inhabitants of Babel for their presumption by giving them different languages and scattering them before they could complete their city. Certainly in Bruegel's painting the lopsided structure does not look as if it could ever be finished. It appears to be totally illogical, as if the Colosseum has been turned inside out. The core looks like the exterior of the amphitheatre, while radiating from it are the vaults that support the seats inside the real building. The spiralling tiers on the outside seem unconnected with the rest of the tower, and the tiny human figures are unable to control the monster that they have created.

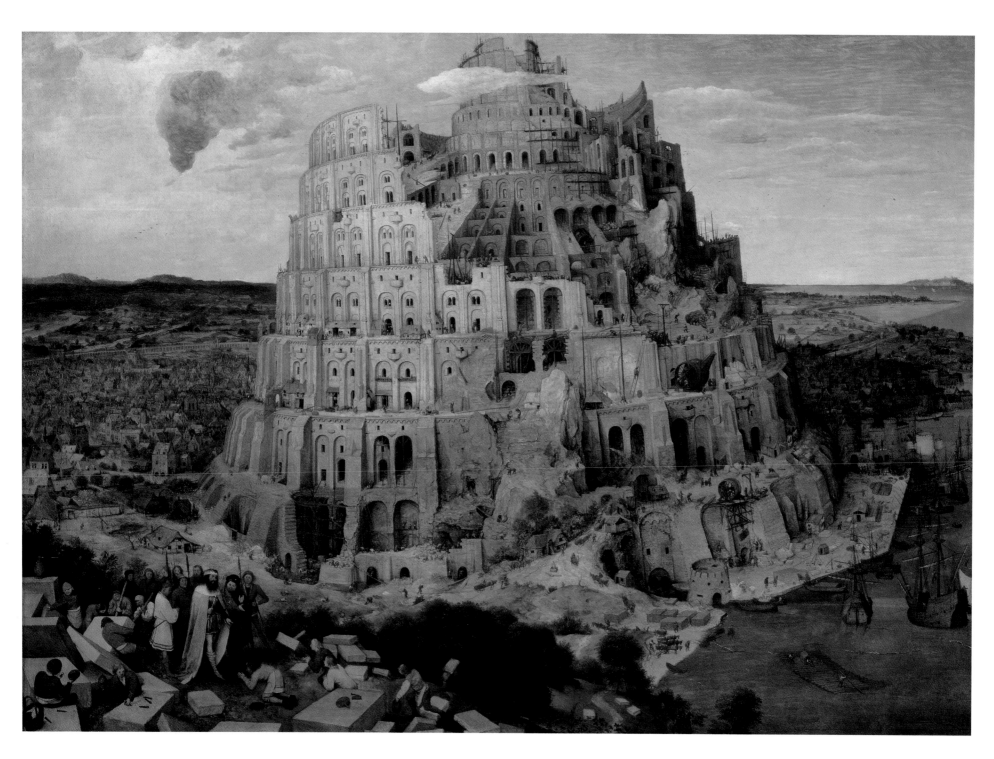

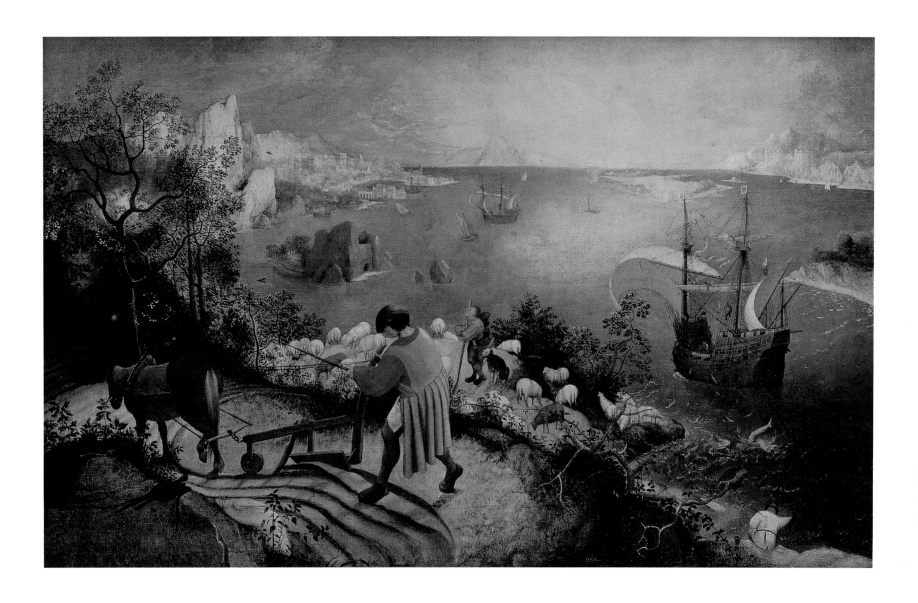

Pieter Bruegel the Elder
(c. 1525/30–1569)
The Fall of Icarus

c. 1555–58
Oil on canvas
73.5 × 112 cm (29 × 44⅛ in.)
Brussels, Musées Royaux des Beaux-Arts
de Belgique

In this mythological landscape, not only does
the tragedy take place in the distance, but the
viewer also has to look hard to find it. Ovid
tells us how the ancient inventor Daedalus
created wings for himself and his son, Icarus.
Unfortunately, Icarus failed to heed his father's
advice, and flew too close to the sun, the heat
of which melted the wax attaching the feathers,
causing him to plunge into the sea.

The characters in the foreground – the
ploughman, the angler and the shepherd – are
mentioned by Ovid, who describes their
astonishment at witnessing this event. Yet their
impassive behaviour in Bruegel's painting is
perhaps more convincing: for these bystanders,
the fall of Icarus is just another reckless joyride.

SACRED
THEMES

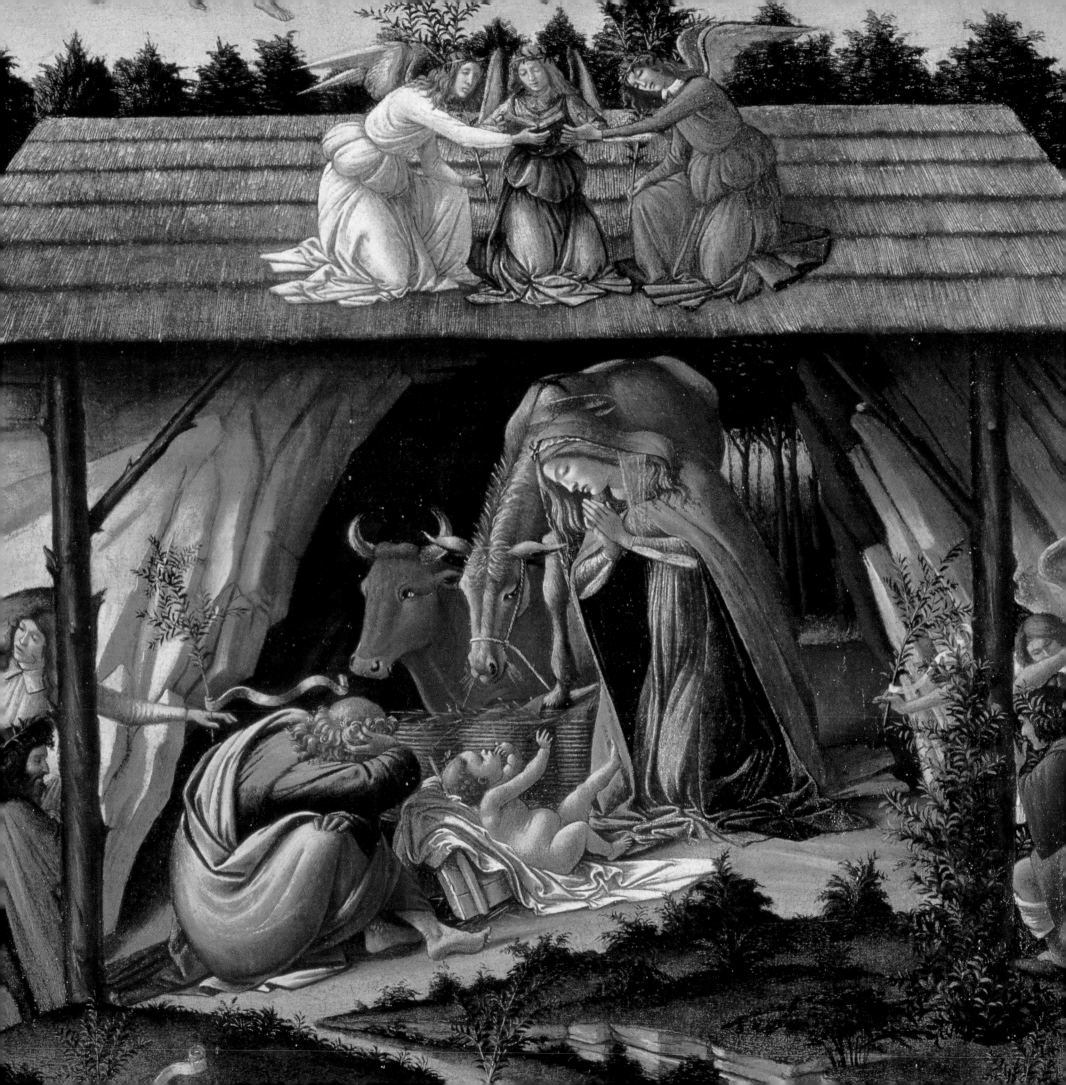

In Renaissance Europe, as in the Middle Ages, religious art was not confined to the interiors of churches. Figures of prophets and saints, the crucified Christ or the Virgin and Child were everywhere, from street corners and squares to private houses and palaces. As Rogier van der Weyden's painting shows (opposite), St Luke was supposed not merely to have written one of the Gospels but also to have drawn the Virgin: until the Reformation the visual image was regarded with as much reverence as the Word.

Van der Weyden's picture is strikingly naturalistic and contemporary in its setting and costumes. Not all Renaissance artists created such an illusion of reality: Masaccio's *Virgin and Child* come from a conventional polyptych (page 80), an altarpiece in which each of the accompanying saints (also placed on gilded backgrounds) are on separate panels. Soon afterwards, the figures began to be congregated in a single image (page 82), but it was not until later that the space in the picture began to be more credible as a continuation of the painting's actual surroundings (page 83).

In all these altarpieces the Virgin is grandly enthroned. However, smaller paintings, intended for devotion in the home, created varying degrees of intimacy: in some cases the Virgin is seated on the ground, in a meadow (page 84), while in others she is placed more formally, in front of a cloth of honour (page 85). Clearly, the sense of decorum allowed some room for manoeuvre, although each type of setting had a nuanced theological meaning.

Sometimes a remarkable sense of consistency can be seen across different decades and contexts, as in the depictions of the Expulsion from the Garden of Eden (pages 86 and 87), while other subjects are represented with amazing variety. Fra Angelico's *Annunciation* (page 94) was designed to prompt a genuflection and 'Hail Mary' from monks as they retired to their cells: consequently, the angel's pose — and the Virgin's reaction — have little in common with the billowing drapery and raised hands in Lorenzo Lotto's version of the same subject (page 95).

The most complex theme of all was the depiction of Christ's death. Some artists chose to stress the horror of the event, as in Matthias Grünewald's Isenheim altarpiece (page 104), while others depicted the body of Christ as an idealized nude (see Sebastiano del Piombo's *Pietà*, page 107).

Yet, for all this immense variety, at the beginning of the sixteenth century there was at least one consensus: religious art had a useful function as a focus for worship and devotion, as was recognized even by Martin Luther, the originator of the Protestant Reformation. Luther maintained that there were only two sacraments, baptism and the Eucharist, which consequently are important themes in paintings by his friend Lucas Cranach (page 117). There is no doubt, however, that he was appalled by the waves of iconoclasm that broke out in parts of Germany, Switzerland and elsewhere from the 1520s onwards.

The Catholic Church eventually responded to these events with a conference, the Council of Trent, which lasted almost twenty years and laid down that art should directly serve the requirements of the faith — a principle brilliantly promoted by the pious, tender images of Barbara Longhi (page 119). Yet, around 1600 an alternative appeared to this sweet, colourful style, in the dramatic paintings of Michelangelo Merisi da Caravaggio (page 49).

Rogier van der Weyden
(*c.* 1399–1464)
St Luke Drawing the Virgin

c. 1435–40
Oil and tempera on panel
137.7 × 110.8 cm (54¼ × 43⅝ in.)
Boston, Museum of Fine Arts

St Luke, possibly with the features of Van der Weyden himself, draws the Virgin and Child, in the company of his symbol, the ox, which is lying underneath the writing desk on the extreme right. There are numerous icons across Europe that claim to be images of the Virgin made by the Evangelist himself, and so it was natural that artists' guilds should be dedicated to him; indeed, this panel may have been intended for an altar patronized by the local guild of St Luke.

Mary sits, modestly, at the foot of the bench, in which a carving representing the Fall reminds us that the Virgin is the New Eve, who has redeemed humankind through the birth of Christ. For all her humility, she is set in a magnificent chamber above a terrace, from which two figures look down on a contemporary city — Van der Weyden's tribute to Jan van Eyck's celebrated *Virgin and Child with Chancellor Rolin* (page 10).

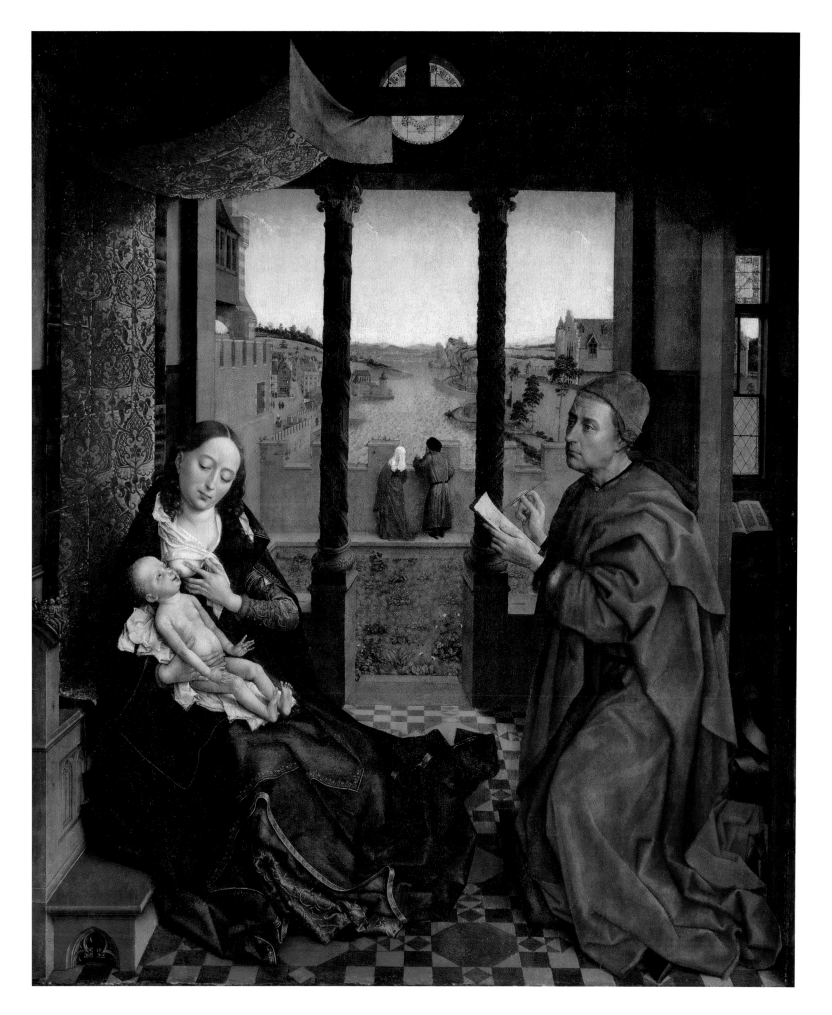

Masaccio (1401–1428)
The Virgin and Child, from the Pisa polyptych

1426
Tempera on panel
134.8–136 × 73 cm (53 ⅛–53 ½ × 28 ¾ in.)
London, The National Gallery

This is the central part of a large altarpiece or polyptych, originally in the church of Santa Maria del Carmine in Pisa but long since dismembered. As is conventional in altarpieces of this period, the pictures have gilded backgrounds and are set within pointed Gothic arches, although the elaborate frame no longer survives. In this panel, the artist has also followed the medieval practice of making the Virgin and Child very much larger than anyone else. Yet, despite these traditional features, the painting has a boldness that is unique to Masaccio. No other artist of this period would have used chiaroscuro (light and shade) to make the bodies look so sculptural: on the left, beneath the angel in blue, we can even see a thin cast shadow without the figure that created it, presumably because the panel has been cut down at this point.

The Virgin Mary sits on an austere Classical throne, the step of which is decorated with abstract patterns taken from ancient tombs, while its arms are architectural in scale. They add to the illusion of depth by partly concealing the angels to the side, while in front two heavenly musicians play instruments that are deftly foreshortened. Above all, an illusion of reality is created by the infant Jesus, who actually looks like a baby, with a jaunty halo. Naturalism and religious symbolism are perfectly combined, since the fruits that Christ so sweetly sucks are grapes, the source of the wine that miraculously becomes Christ's blood during the Mass.

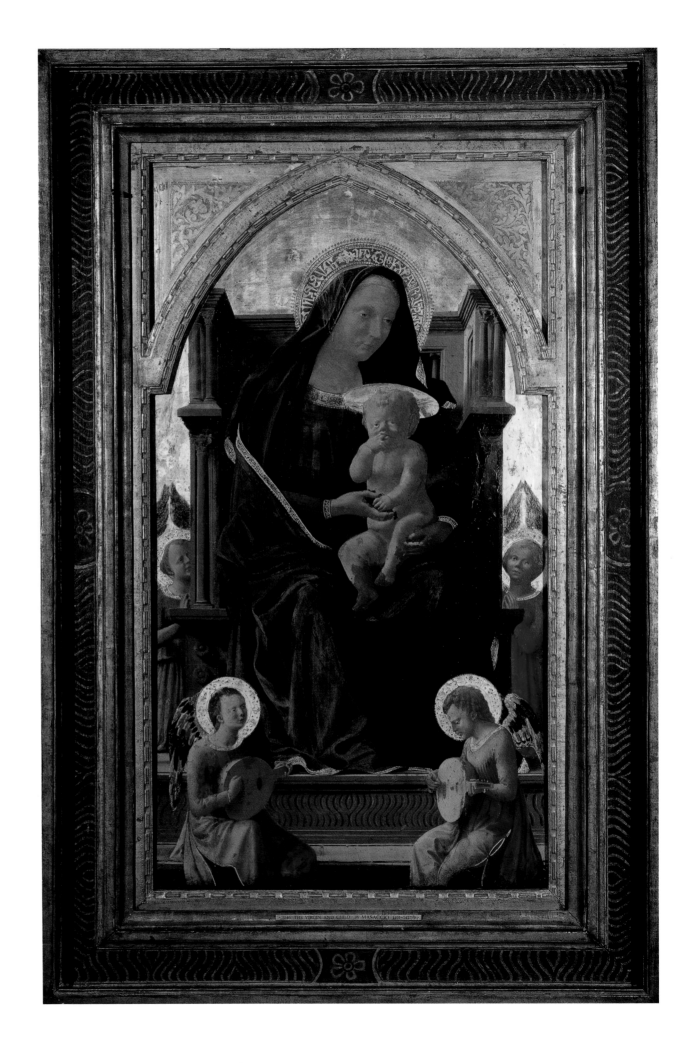

Jean Fouquet (*c.* 1425–*c.* 1478)
Virgin and Child with Angels

c. 1450
Oil on panel
94.5 × 85.5 cm (37¼ × 33⅝ in.)
Antwerp, Koninklijk Museum voor
Schone Kunsten

This is the right wing of the Melun diptych.
It has been separated from its companion
panel, now in Berlin, which shows the
patron Etienne Chevalier kneeling in prayer.
Described by a seventeenth-century writer
(1608) as 'la belle Agnès', the image of
the Virgin is almost certainly a disguised
representation of Agnès Sorel, the mistress
of the French king Charles VII, who had
died shortly before the painting was made.
Chevalier was the executor of her will,
and the intriguing network of associations
has been further complicated by X-ray
photographs of a version of this painting
beneath Fouquet's contemporary portrait
of the king (page 171).

Certainly Fouquet has transfigured his
model into one of the most remarkable sacred
images of the fifteenth century. With its
refined features, delicate outlines and
exquisite colours – at the extremities of
paleness and intensity – the painting has
little connection with mundane reality. Yet
the physical beauty of the body remains;
human desire has diminished, but not totally
passed away.

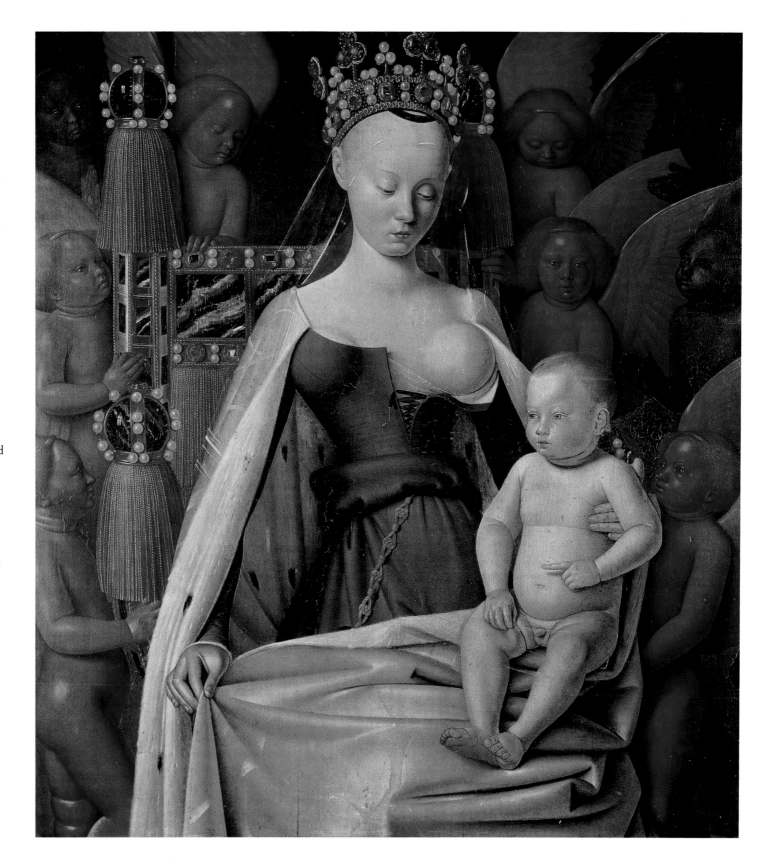

Domenico Veneziano
(active *c*. 1438–died 1461)
The St Lucy altarpiece

c. 1445
Tempera on panel
209 × 216 cm (82¼ × 85 in.)
Florence, Galleria degli Uffizi

This is an early example of a *sacra conversazione*, in which the Virgin and Child appear in the same space as the surrounding saints (in this case, Francis, John the Baptist, Zenobius and Lucy). In contrast, medieval polyptychs had separated the figures into numerous panels, set in elaborate gilded Gothic frames. Despite its name, a *sacra conversazione* did not necessarily involve a conversation, sacred or otherwise. Indeed, in this painting the figures do not even appear to be aware of one another, with the exception of John the Baptist, whose gesture leads us towards the Virgin.

The altarpiece was originally in the Florentine church of Santa Lucia dei Magnoli, the patron saint of which is recognizable from the dish containing her eyes, plucked out but miraculously restored before her eventual martyrdom. Like the other figures, she is dressed in colours that correspond with those in the architecture. Yet, despite this sense of pattern, we are still conscious of the depth suggested by Domenico's skilful use of perspective.

For all its innovations, this is a painting that appears still to be tied to the past. The architecture is a strange amalgam of Classical features – in particular, the columns and shell-like niche at the back – with Gothic vaults and pointed arches. The perspective represents three dimensions, yet the colours prevent it from becoming an illusion. Above all the Virgin presides on a throne: like many medieval Madonnas, she is far larger and more monumental than anyone else.

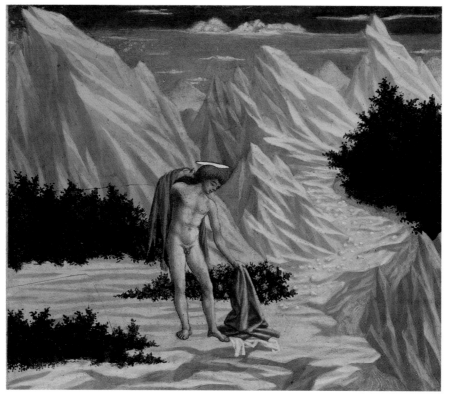

Domenico Veneziano
(active *c*. 1438–died 1461)
St John in the Desert

c. 1445/50
Tempera on panel
28.4 × 31.8 cm (11⅛ × 12½ in.)
Washington, D.C., National Gallery of Art

This is a scene from the predella of the St Lucy altarpiece (above). Most altar paintings had, at their base, a narrow strip of panels, usually depicting scenes from the life of the saints represented in the main image. Here John the Baptist goes into the desert, to live off locusts and wild honey: 'And John was clothed with camel's hair, and with a girdle of a skin about his loins' (Mark 1:6).

The brilliance of the *sacra conversazione* reappears in this image. Light is reflected off the stylized rocks of the desert, as the beardless, youthful John casts off his red cloak, to be transformed into the gaunt prophet, dressed in skins, in the main panel.

Giovanni Bellini
(?1431/36–1516)
The Virgin and Child with Sts Peter, Catherine, Lucy and Jerome

1505
Oil on canvas
500 × 235 cm (196⅞ × 92½ in.)
Venice, San Zaccaria

Still located in the Venetian church of San Zaccaria, this altarpiece is a particularly grand *sacra conversazione*. Two saints stand on each side of the enthroned Virgin and Child while, perching on a step, a musical angel delicately tunes a violin-like instrument. The monumental figures seem lost in thought, and their contrasting profile and frontal poses add to the air of formality.

For all its stillness, however, the painting bursts with light and warmth. The brilliant hues, especially the cardinal red of St Jerome and the warm gold of the mosaic niche, are complemented by the intriguing glimpse of sky at the side. This is truly a paradoxical image. The Classical arch and pilasters continue the Renaissance architecture of the church, and yet the perspective of the floor suggests an unrealistically high viewpoint, as well as, of course, adding to the impressive sense of space. This is, after all, another level of reality, revealed to us with all the intensity of a vision.

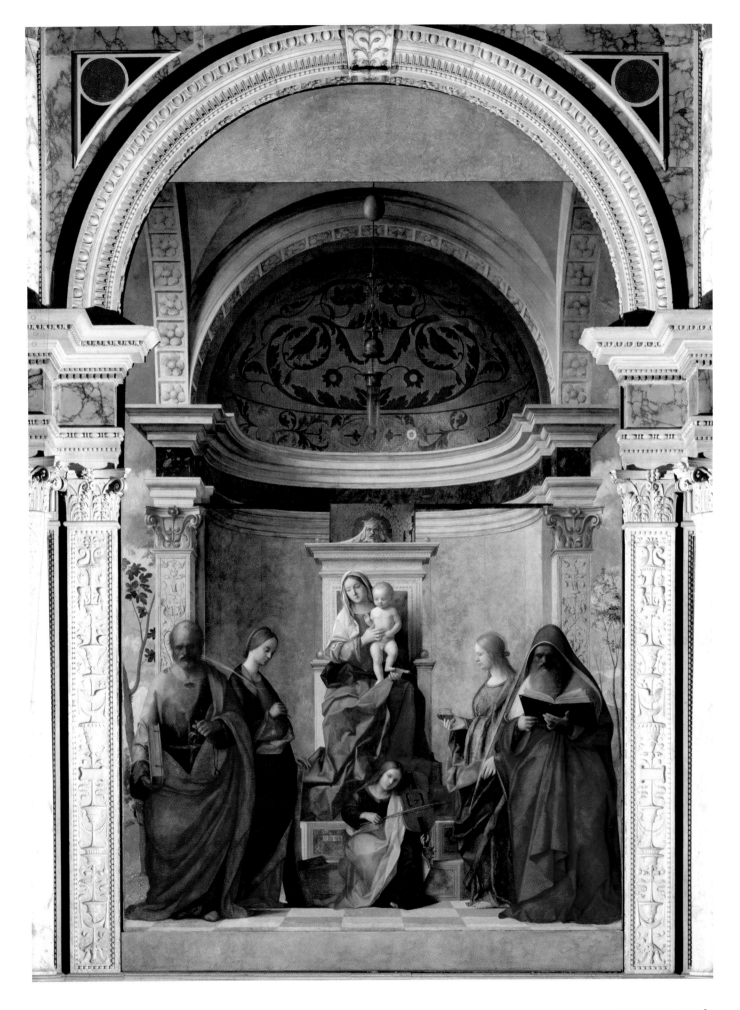

OPPOSITE

Raphael (1483–1520)
The Alba Madonna

c. 1510
Oil on panel transferred to canvas
Diameter 94.5 cm (37¼ in.)
Washington, D.C., National Gallery of Art

In this intimate picture, intended for private
devotion, the Virgin sits humbly on the grass,
while the infant Christ accepts the cross from
John the Baptist. In the background Raphael
has used the transparent glazes of oil paint to
create a landscape that almost shimmers.

 Yet this tender lyricism is combined with
a striking monumental quality. Together, the
figures form a pyramidal shape influenced by
Leonardo da Vinci (page 213). The matronly
Virgin, in her Classical robes and sandals, is
particularly imposing, her dynamic, bulky
figure clearly influenced by Michelangelo,
who was at that time working on the Sistine
Chapel ceiling. As well as these frescoes in the
Vatican, Michelangelo had previously made
some marble *tondi* (circular reliefs), which must
have also inspired *The Alba Madonna*: it is as if
Raphael were trying to challenge his rival by
endowing his statuesque forms with warmth
and colour.

Giovanni Bellini
(?1431/36–1516)
Madonna and Child

1509
Oil on panel
84.8 × 106 cm (33⅜ × 41¾ in.)
Detroit Institute of Arts

This image has certain characteristics typical
of Venetian devotional painting. Although
physically close to us, the Virgin and Child
are given an air of formality by the green cloth
behind them, and by their frontal poses and
solemn expressions. The infant Christ raises
his hand in blessing and points at his side,
where he is to receive the wound from the
lance during his Crucifixion. His nudity
emphasizes his physical incarnation: he is
flesh and blood, as is clear from the pressure
of his mother's fingers on his skin.

 Unusually, the cloth is arranged
asymmetrically, so that the landscape behind
can be seen only on the right. Although the
pastoral characters allude to Christ's role as the
good shepherd, the description of earth and sky
reflects the artist's intense observation of nature;
in this painting the sacred figures live in a world
that is continuous with our own reality.

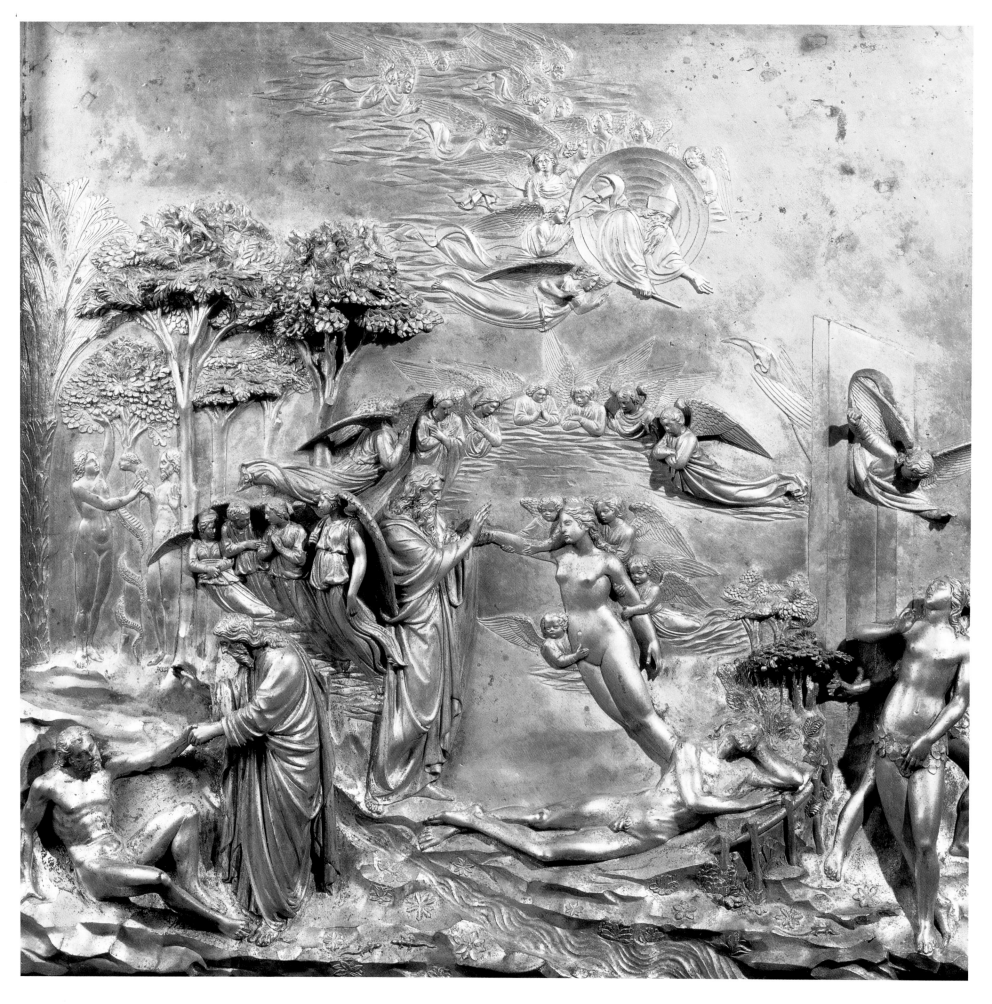

OPPOSITE

Lorenzo Ghiberti (1378–1455)
Genesis, from the 'Gates of Paradise'

c. 1435
Gilded bronze
79 × 79 (31⅛ × 31⅛ in.)
Florence, Museo dell'Opera del Duomo

This magnificent bronze panel is one of ten, representing Old Testament scenes, from the east doors of the baptistery in Florence. The area between the baptistery and the cathedral was a cemetery or *paradiso*, a rather prosaic explanation for the Gates' popular name. Decades after their creation, however, Michelangelo was said to have described them as 'so beautiful that they would grace the entrance to Paradise'.[1]

The *Genesis* relief, like others in the series, manages to depict simultaneously several episodes of a story. In the bottom left, the sluggish Adam is pulled into life by God, while in the centre Eve rises from his rib; the Fall, or eating of the forbidden fruit, is set far back on the left, while for the next episode, the Expulsion from Eden, we have to look to the right. Although the arrangement of the scenes does not follow a clear narrative order, it creates a satisfying, balanced composition. The two prominent groups in the foreground are particularly memorable. Indeed, it is plain that Ghiberti's design inspired Michelangelo in the Sistine Chapel almost a century later (page 35).

Masaccio (1401–1428)
The Expulsion from the Garden of Eden

c. 1424–28
Fresco
Florence, Santa Maria del Carmine, Brancacci Chapel

In contrast to Ghiberti's slender figures (opposite), Masaccio's Adam and Eve have the structure and proportions of real bodies, modelled with bold contrasts of light and shade. Masaccio also presumably studied ancient sculptures, including the type known as the *Venus pudica* (page 55), where the goddess of love conceals herself with her hands. Yet he has transformed this gesture of simple modesty into one of anguished shame: Adam and Eve weep and howl with grief as they are driven through the gate of Eden into a desolate landscape.

This fresco was placed on the entrance arch of the Brancacci Chapel opposite Masolino's fresco of *The Fall of Man*. Together, these images reminded the worshipper of the state of sin from which man can find redemption only through the Church, the founder of which, St Peter, dominates the scenes in the main body of the chapel (see page 161).

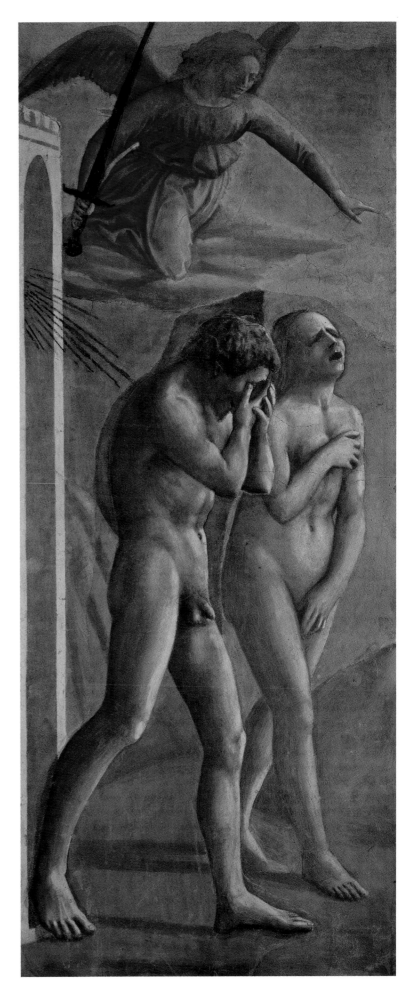

Claus Sluter
(active *c.* 1360–1406)
David, from the *Well of Moses*

1395–*c.* 1405
Asnières stone
Height 175 cm (68⅞ in.)
Dijon, Chartreuse de Champmol

Sluter's sculptures for the Carthusian monastery of Champmol – made at the behest of Philip the Bold, Duke of Burgundy – are among the most innovative works of the early fifteenth century. This figure of David, whose prophetic status is signified by his scroll, is one of six statues decorating a fountain known as the *Well of Moses*, in the monastery's cloister. They are arranged around a hexagonal pier, originally surmounted by a stone Calvary, or Crucifixion scene, of which only Christ's head and torso, and the crossed arms of Mary Magdalene, survive.

Despite his elaborate setting, David, together with his five companions, is so vigorously three-dimensional that he seems almost free-standing. The lifelike quality would have been even stronger before the figure lost its bright colours, but we can still admire David's expressive face and bulky form, in which the structure of the body can be easily sensed beneath the drapery.

OPPOSITE

Donatello (1386/87–1466)
David

Possibly 1430s
Bronze
Height 158 cm (62¼ in.)
Florence, Museo Nazionale del Bargello

Some biblical characters or symbols were appropriated by cities. Florence, for example, chose David as a symbol of its courage and resilience, to be represented in palaces and squares as well as churches. This would not in itself have seemed paradoxical, since at that time the concept of a purely secular space did not exist. However, it is undeniable that David has been drained of at least some of his traditional significance. Gone are the beard and scroll of the prophet; the youthful hero springs up to take his place.

Of all the versions of this subject, Donatello's bronze is the tenderest. While Michelangelo's immense marble statue (page 32) represents the moments before the battle with Goliath, some decades earlier (the date is very uncertain) Donatello created a figure of the victorious David that is touching because it is so vulnerable. The slender youth stands, a little precariously, on the giant's head, holding a sword that seems too heavy for him and wearing a hat that seems too wide. The shadow that falls over his downcast face adds to his detachment. What does his expression represent? Nonchalance, weariness, ennui? Rarely in Renaissance art is the question so interesting, and so difficult to answer.

Often the effeminacy of the figure is remarked upon. Yet the sculpture should be seen as a study in the nude form, experimenting with a particular type of complex, asymmetrical pose.

Donatello is also keen to exploit the special qualities of bronze: its lustrous colour and the relative softness that allows it to be polished or chiselled into different textures. The smoothness of David's skin is contrasted with the roughness of Goliath's beard and helmet, even with the plume that strokes the boy's leg. It is hard to deny that there is something at least a little risqué about that, and yet this sculpture was not intended for private pleasure. In 1469 it was documented during wedding festivities in the courtyard of the Medici Palace, before being moved to the Palazzo della Signoria, where Giorgio Vasari admired its 'vivacity' and 'softness'.[2] This work has always had a universal appeal.

Andrea del Castagno (before 1419–1457)
David with the Head of Goliath

c. 1450/55
Tempera on leather on wood
Width at top: 115.5 × 76.5 cm (45½ × 30⅛ in.); width at bottom: 115.5 × 40.6 cm (45½ × 16 in.)
Washington, D.C., National Gallery of Art

This heroic image is modelled on a statue (now in Copenhagen) of a 'pedagogue' or teacher of the Niobids, the children slaughtered by the goddess Leto after their mother, Niobe, had boasted of her fertility. The pose and fluttering drapery have been faithfully copied, even though David's victorious exultation is very different from the terror expressed by the original sculpture – and his skirt is shorter.

The mood of Castagno's *David* is also unlike that of Donatello's figure (opposite), which can perhaps be explained by their respective functions. Castagno's image is a ceremonial parade shield – the only painted example that can be attributed to a great artist – rather than a sophisticated adornment to a humanist's palace. Inevitably, it sets a different tone.

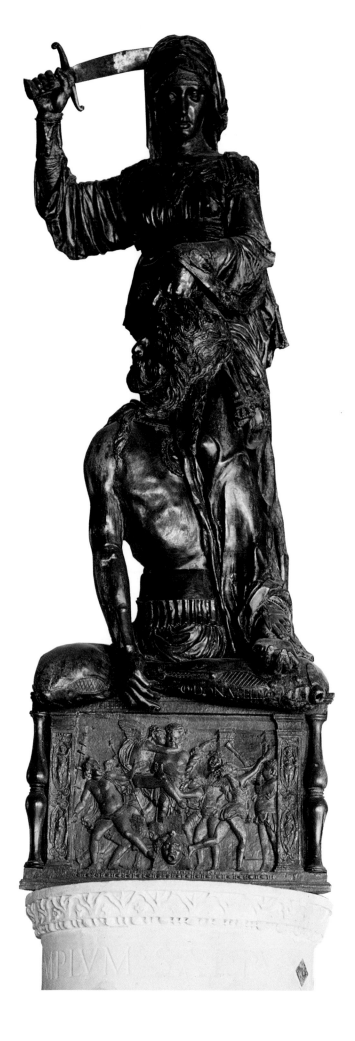

Donatello (1386/87–1466)
Judith and Holofernes

Late 1450s
Bronze
Height of figures: 236 cm (92⅞ in.)
Florence, Palazzo Vecchio

Judith is the female equivalent of David, and had a similar significance for the Florentine Republic, as well as being a personification of the Church Triumphant. She saved the Jewish people from foreign aggressors, slaying the Assyrian general Holofernes by visiting his tent and chopping off his head. In this sculpture she already seems to have struck one blow: her enemy's head looks rather unstable as it is twisted back for the *coup de grâce*.

This is not the most obvious subject for a fountain, even in the garden of the Medici palace – and Judith's harsh features and sharp drapery provide no relief from the gruesomeness of Holofernes' fate. Yet the corners of the cushion originally spouted water, and the whole composition encourages inspection from different angles: Holofernes' legs dangle over one corner of the triangular base, while Judith faces in the opposite direction.

For all its violence, the sculpture was meant to be edifying. If anyone had any doubt, he or she could read its original inscription, in which Judith's figure was dedicated to *that liberty and fortitude bestowed on the republic by the invincible and constant spirit of the citizens*.

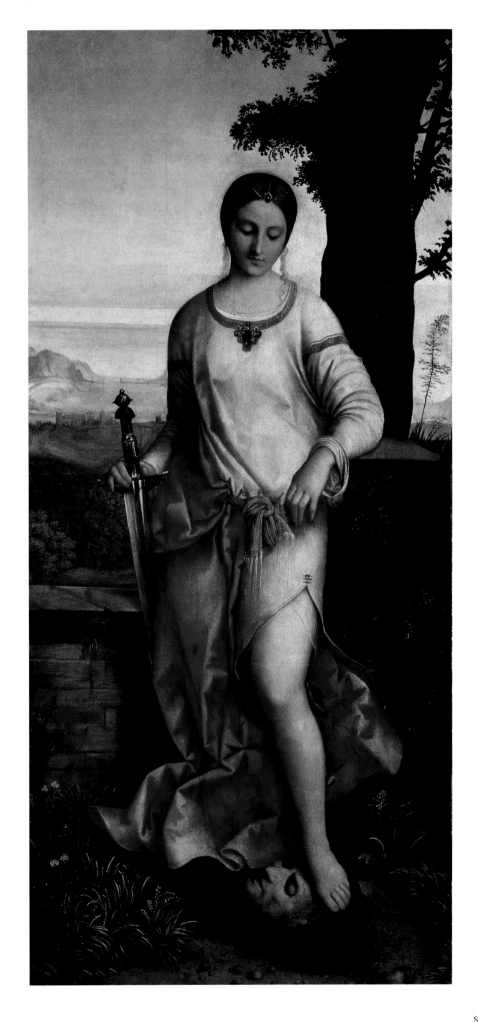

Giorgione
(?1477/78–before late 1510)
*Judith with the Head
of Holofernes*

1504
Oil on canvas
144 × 68 cm (56¾ × 26¾ in.)
St Petersburg, The State Hermitage Museum

Giorgione's Judith pours forth the warmth
and sensuality of Venetian painting, with
exquisite colours and soft lines that are
characteristic of the artist. The idealized oval
face and dreamy expression add to the lyrical
mood, while Judith's pose is almost balletic,
with the drapery elegantly arranged around
her partially bared leg. The composition is
also free and open: we can imagine the
naturalistic landscape extending beyond the
edge of the canvas, which appears not to have
been cut down. This is a slice of reality as we
would like to know it.

Filippo Lippi (*c.* 1406–1469)
The Feast of Herod

1452–66
Fresco
Italy, Prato Cathedral, choir

This famous scene, part of the most expensive fresco cycle in fifteenth-century Tuscany, depicts a particularly unpleasant episode. King Herod's wife, Herodias, hated John the Baptist for criticizing her marriage to the brother of her previous husband. Herod feared the Baptist but was tricked into ordering his execution by Herodias and her daughter, Salome, whose dancing filled him with such delight that he promised to give her anything she desired. Her answer cost John his life, and his head was presented to Herodias on a platter.

Successive episodes are represented simultaneously in this fresco. The one-point perspective of the elaborate room follows Leon Battista Alberti's treatise *De pictura* ('On Painting', 1435), as does the variety of characters with which Lippi animates the narrative. Salome, frozen in motion like a dancer on a Roman sarcophagus, and the icily composed Herodias contrast with the other figures. These include a giant on the left and, on the opposite side, a couple of ghoulish attendants, bystanders who are horrified but cannot help looking. By these means a biblical story is made to come alive.

Lucas Cranach the Elder
(1472–1553)
The Feast of Herod

1531
Oil on panel
81.3 × 119.7 cm (32 × 47⅛ in.)
Hartford, Connecticut, Wadsworth
Atheneum

This *Feast of Herod* dispenses with any architectural setting in order to concentrate on the narrative. Herod, dressed in the fur-lined robes of a contemporary prince, gazes at John the Baptist's head: only his outstretched arms convey emotion, while Herodias, in her jewelled choker and headdress, demurely looks away. The callous attendants make a pattern of hats.

We are so close to the scene that the macabre details of John's decapitated head, with its eyes and mouth still open, are clearly visible. Meanwhile, the bowl of fruit — disturbingly similar in shape and size to

Salome's platter — reminds us of the story's theological significance. The apples recall the Fall of Man, while the grapes refer to the wine of the Eucharist and the shedding of blood on the cross: John the Baptist was the messenger who had prepared the way for Christ.

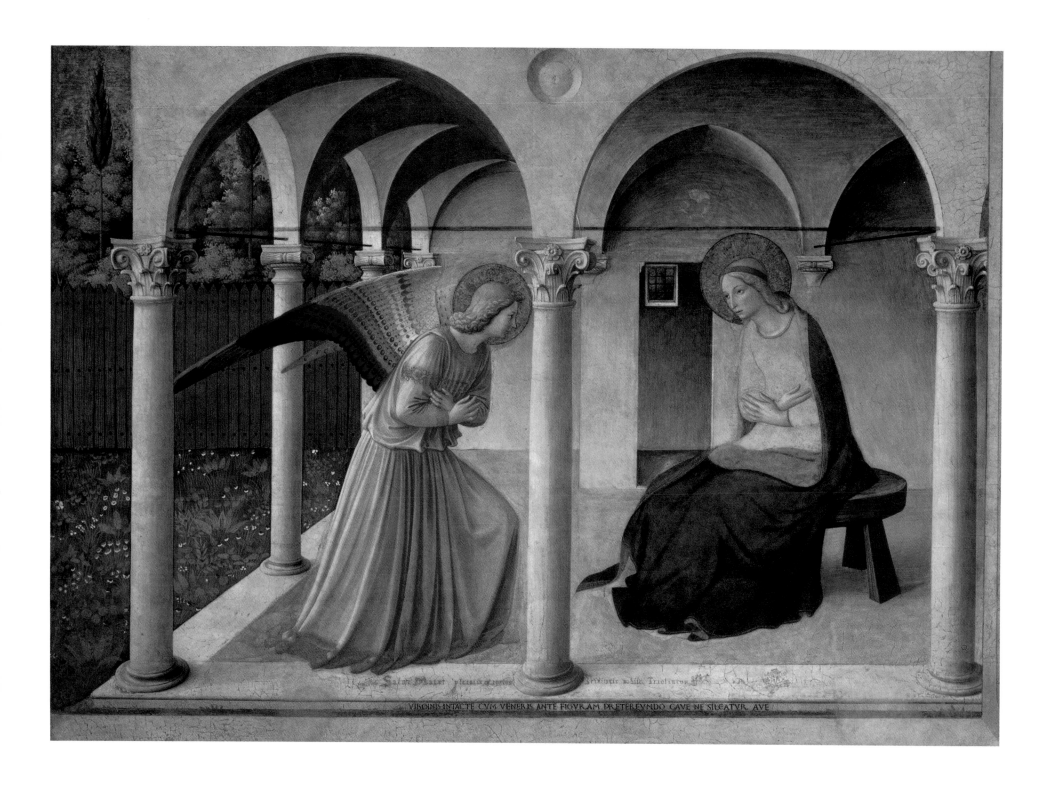

Fra Angelico (1395/1400–1455)
The Annunciation

c. 1440
Fresco
Florence, Museo di San Marco

As the Dominican friars reached the top of the stairs leading to their cells, they would see this exquisite fresco, with an inscription on the bottom reading *When you come before the figure of the intact Virgin, do not fail to say a Hail Mary.* The response expected is indicated by the pose of the genuflecting angel.

The direct relationship between the imagery of the fresco and the life of the friars is also clear from the painted architecture. The simple Classical arcades and whitewashed walls, not to mention the cell-like room beyond, reflect the monastery's actual buildings, designed shortly before by Donatello's friend Michelozzo. Yet, despite the credible space around her, the Virgin herself is a remote figure, disproportionately large, with a graceful, linear form that recalls the earlier style sometimes known as International Gothic.

Lorenzo Lotto (*c.* 1480–1556)
The Annunciation

c. 1526
Oil on canvas
166 × 114 cm (65 ⅜ × 44 ⅞ in.)
Italy, Recanati, Museo Civico Villa
Colloredo Mels

Lotto has transformed the traditional image of the Annunciation. Instead of the demure, restrained Virgin of earlier paintings, we see a dynamic figure, directly gazing towards us. Her upturned hands convey the excitement of the moment, even though her expression remains calm and self-possessed. Only the cat, a symbol of evil, is terrified by the heavenly messenger, who, dressed in icy-blue robes, with his blond locks streaming behind him, really looks as if he has tumbled out of the sky, propelled to earth by God the Father high above.

To be sure, Lotto has borrowed some of the conventions of this period. The scene is set in a contemporary room as calmly domestic as those in paintings by Flemish artists or Lotto's fellow Venetian Vittore Carpaccio. The opaque window, the subtle shadows cast by the candle on to the wall, even the neatly hanging nightcap and towel, are all luminously realistic. Yet this serenity only offsets the amazing supernatural drama that has burst like a thunderbolt into the maiden's bedroom.

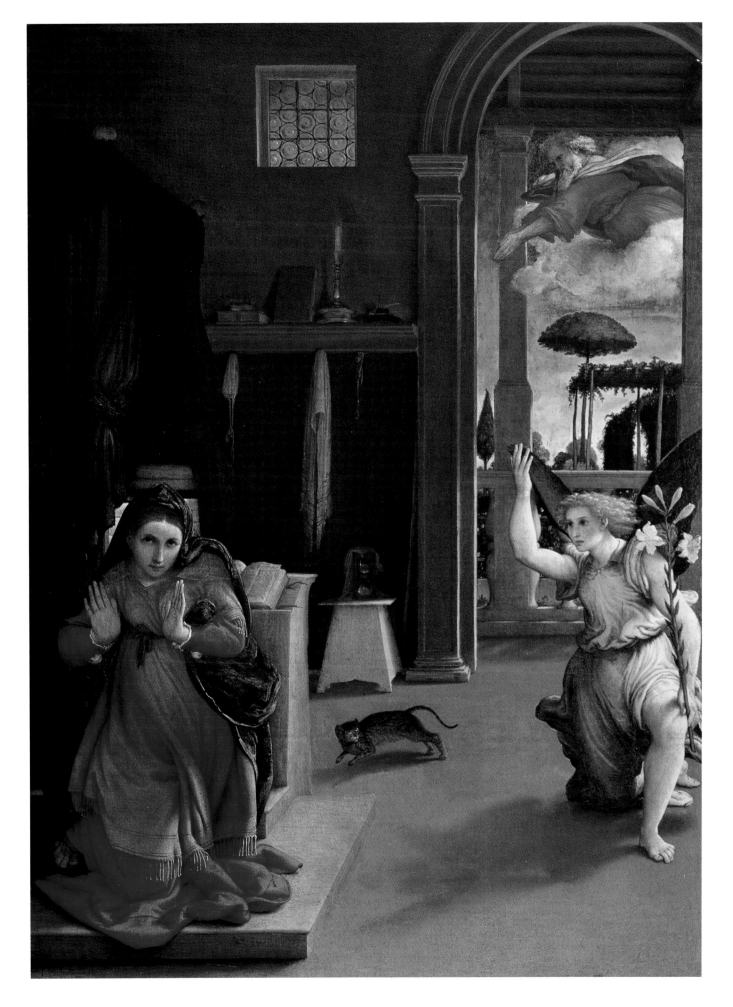

OPPOSITE

Filippo Lippi (*c.* 1406–1469) and another artist, perhaps Fra Angelico (1395/1400–1455)
The Adoration of the Magi

c. 1440/60
Tempera on panel
Diameter 137.3 cm (54 in.)
Washington, D.C., National Gallery of Art

This is a very early example of a *tondo*, a circular painting intended for devotion in a private house. The curved frame determines the curling line of the Magi's procession as it makes it way through the city gate, past almost naked bystanders, into Bethlehem. The perspective is not consistent, and even the scale of the peacocks – conventional symbols of immortality – seems out of control. Yet it is hard to deny the beauty of this panel, with its vibrant colours and picturesque details.

Surprisingly, closer inspection reveals a real disparity between the elegant, two-dimensional style of certain figures, such as the Virgin and Child, and the more naturalistic Magi and St Joseph. It has been suggested that the picture was begun by Fra Angelico, and then finished around 1460 by Filippo Lippi, after the older painter had moved to Rome. Others have suggested that it is simply an early work by Lippi, or that he began it and left it for a long time in his studio. In the meantime, another more old-fashioned artist worked on it, before Lippi eventually got round to completing it. This hypothesis might explain the rather haphazard arrangement of the different styles across the panel. Whatever the truth, the painting must have been made speculatively, without a waiting customer.

Pieter Bruegel the Elder (*c.* 1525/30–1569)
The Adoration of the Kings

1564
Oil on panel
112.1 × 83.9 cm (44⅛ × 33 in.)
London, The National Gallery

A palpable air of menace hovers over this scene. Soldiers keep order, carrying jagged pikes and halberds; onlookers stare wild-eyed, perhaps coveting the presents; even the black king Balthazar's eyes are popping out, his clothing, boots and crown forming a pattern of uncomfortable, spiky shapes. The other kings, richly attired but haggard and unkempt after their long journey, offer gifts of frankincense and gold, from which the Child shrinks away.

Suspicion and incomprehension are the dominant moods: as well as glimpsing the mob that would condemn Christ at the end of his life, we are presented with an image of the everyday meanness and avarice that Bruegel satirized throughout his career.

Perugino (Pietro di Cristoforo Vannucci) (c. 1450–1523)
Christ Giving the Keys to St Peter

1481–82
Fresco
Rome, The Vatican, Sistine Chapel

Perugino, an Umbrian painter who later taught Raphael, was one of the most successful artists of his generation. In 1479 he was summoned to Rome, where he joined the team of artists decorating the walls of the recently built Cappella Sistina, the private chapel of Pope Sixtus IV. His *Assumption of the Virgin* above the altar was later covered by Michelangelo's *Last Judgement* (page 46), but his graceful style can still be admired in this fresco.

The scene is particularly suited to its setting, since it depicts the moment at which Christ gives the keys of heaven to St Peter, the first pope. Christ's body is powerfully modelled beneath his clinging toga, while St John, to the right, has a *contrapposto* pose that shows the influence of Roman sculpture. The Classical imagery is continued by the triumphal arches behind, while the perspectival lines lead directly to a symmetrical, domed edifice – the ancient temple in Jerusalem, the proportions of which were supposedly reproduced in the structure of the Sistine Chapel itself. Yet, as an inscription above the fresco points out, the dispensation of the Old Testament has been superseded by the New Law, of which Sixtus, as St Peter's successor, is the earthly representative.

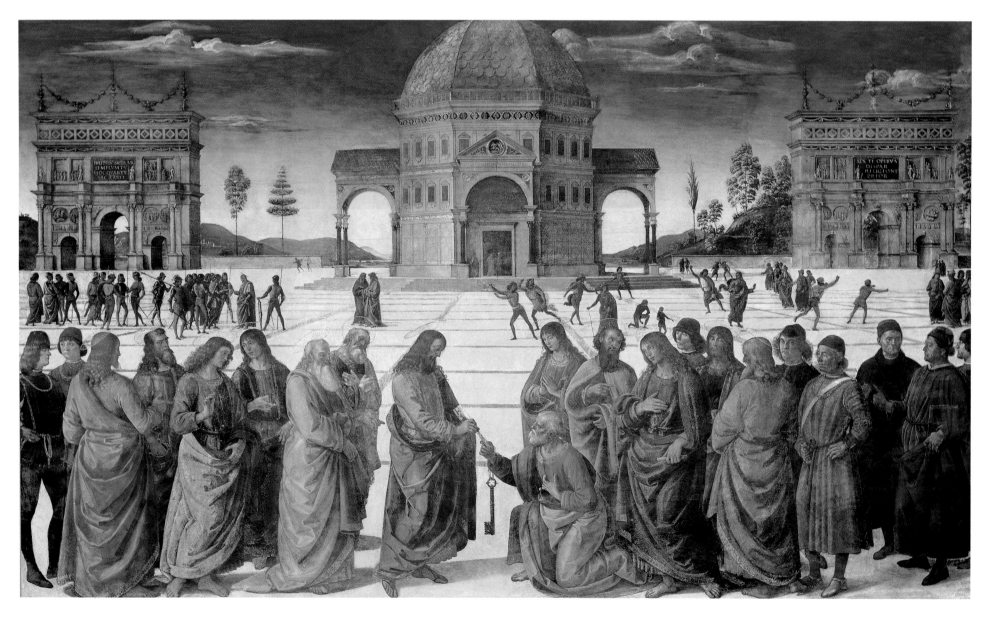

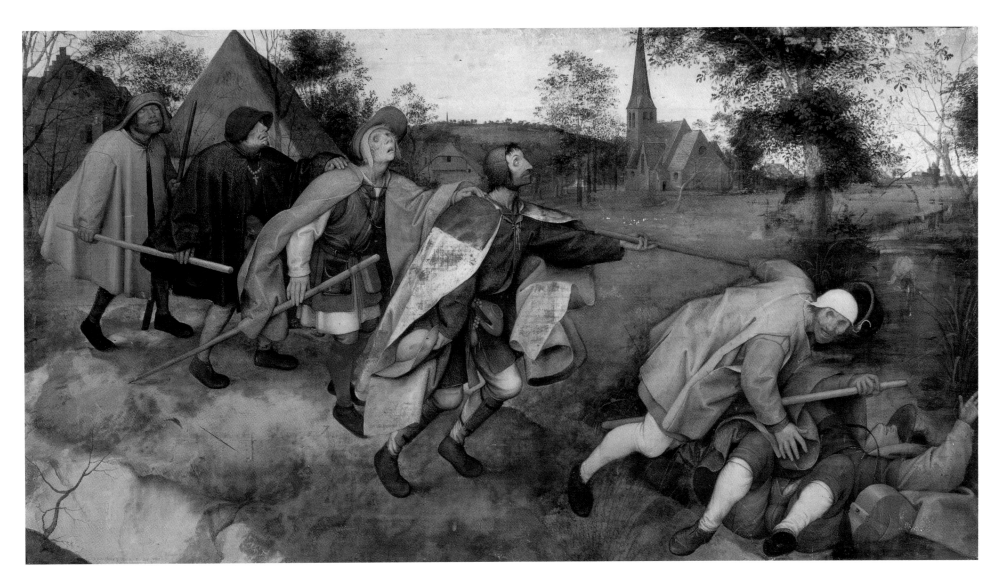

Pieter Bruegel the Elder
(c. 1525/30–1569)
Parable of the Blind

1568
Tempera on linen
86 × 154 cm (33⅞ × 60⅝ in.)
Naples, Museo Nazionale di Capodimonte

'And if the blind lead the blind, both shall fall into the ditch' (Matthew 15:14). During his ministry Christ frequently expressed his teaching through fables or parables, which were common subjects for artists in northern Europe. The men, all doomed to tumble into the mire, symbolize spiritual blindness, but their physical afflictions – cataracts, leucomas and other eye diseases – are depicted with great realism. The diagonals in the composition – the rooftops and the line of men themselves – emphasize the tumble on the right, which the men's sticks cannot prevent. Above all, the painting's muted greys, browns and greens subtly express the pathos of the scene.

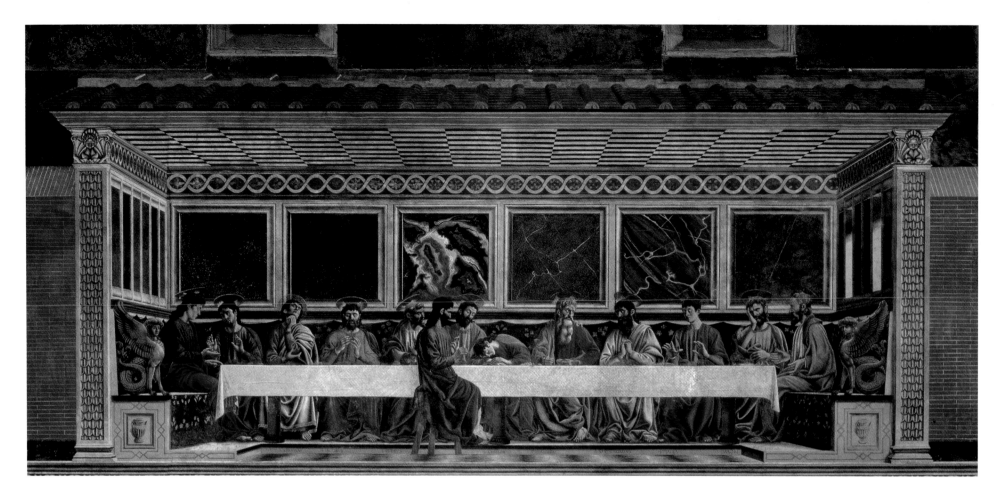

Andrea del Castagno
(before 1419–1457)
The Last Supper

c. 1447
Fresco
Florence, Sant'Apollonia, refectory

The Benedictine nuns of Sant'Apollonia commissioned this painting for their dining-room, so that, as they ate, they could meditate on Christ's institution of the Eucharist at the Last Supper. Christ is shown blessing the bread, while Judas, isolated on the other side of the table, looks on. The Apostles' reactions are carefully differentiated: St John rests his head on Christ's arm; St Peter watches intently; the others turn away, in contemplation or conversation. Further up the wall, the story continues with the Crucifixion, Entombment and Resurrection.

In *The Last Supper*, the perspective of the room is arranged so that it seems actually to continue the space of the refectory: even the windows in the fresco are in line with those outside. Yet the image has a cold, lapidary quality that creates a sense of distance. The walls are adorned with coloured marbles; even the bench-ends are ornately carved; the hard, brittle figures look more like painted sculptures than living people. Castagno has clearly maintained the distinction between reality and art.

OPPOSITE

Leonardo da Vinci (1452–1519)
The Last Supper

1495–97/98
Tempera on plaster
Milan, Santa Maria delle Grazie, refectory

Leonardo's *Last Supper* is, like Castagno's (above), a painted extension of a monastic refectory. The chamber depicted is far deeper and taller than in the earlier fresco, and appears to represent the 'large upper room' described in St Mark's Gospel. Unusually, we are shown not the institution of the Eucharist, but the far more dramatic moment when Christ reveals that he is about to be betrayed. Naturally, the Apostles look taken aback, with the exception of Judas, who is distinguished by his slumped posture to the left of Christ.

The arrangement of the figures into four groups of three, around the calm, central figure of Christ, seems neat enough. However, there is in fact great variety in their poses: Leonardo has managed to produce a balanced, unified composition while creating characters who are far more expressive than in earlier versions of the subject. This still impresses viewers even though the mural is in very poor condition. Instead of using a conventional fresco technique, Leonardo applied tempera over dry rather than moist plaster, and the result is the ruin that we see today, since the pigment did not bind with the surface beneath and quickly began to flake off. Yet, despite this technical incompetence, the grandeur of the conception cannot be denied; nor does the painting's mystique show any sign of diminishing.

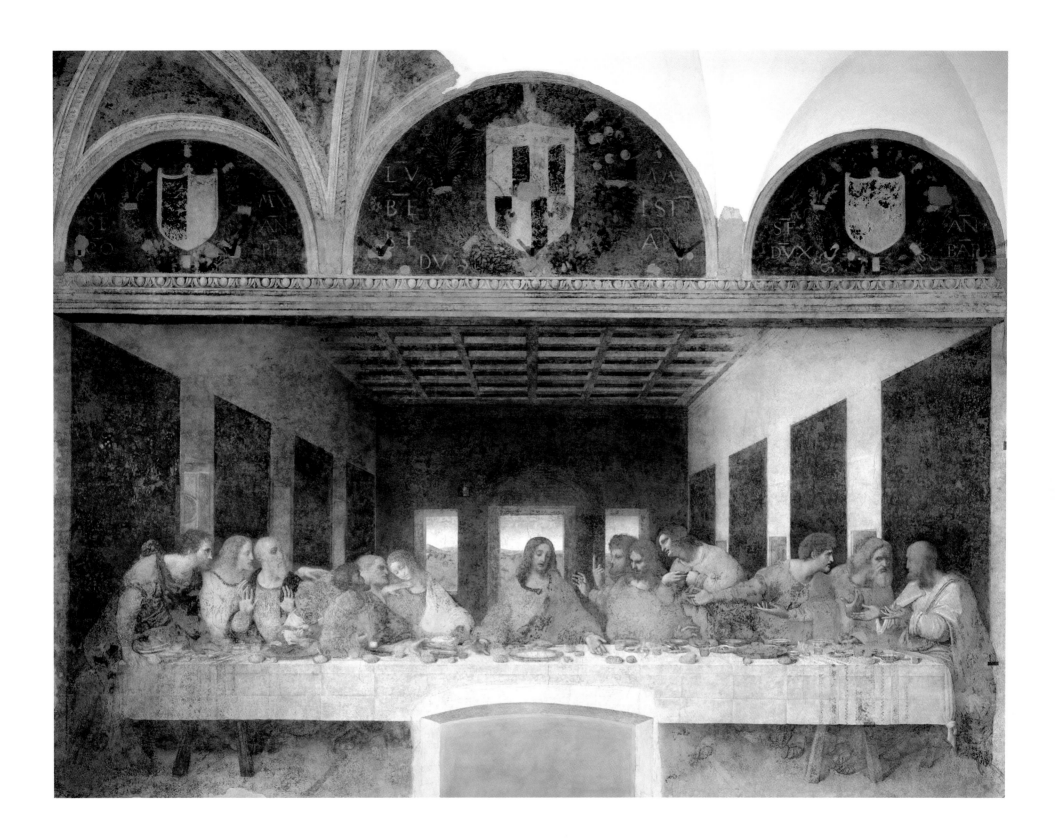

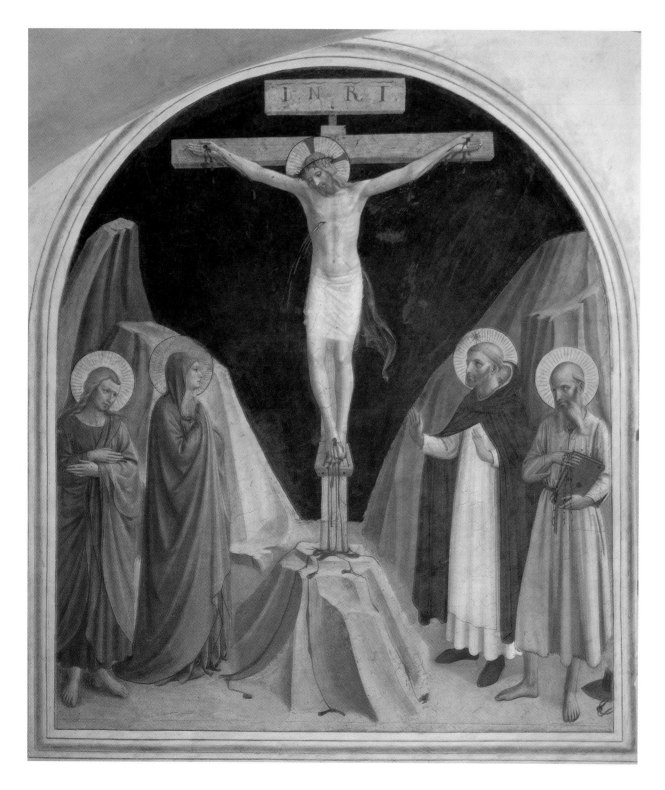

Fra Angelico (1395/1400–1455)
The Crucifixion, with Sts Dominic and Jerome

c. 1440
Fresco
Florence, Museo di San Marco

There could hardly be a greater contrast between the serenity of this image and the excitement of Tintoretto's painting (opposite). In addition to St John and the Virgin Mary, two other saints contemplate the mystery of Christ's sacrifice as they gaze at the idealized figure on the cross. The choice of witnesses was made very carefully. Jerome (*c.* 341–420) was a Doctor of the Church, who translated the Bible into Latin, while Dominic (*c.* 1170–1221) established the monastic order for which the fresco was made.

During the early 1440s Fra Giovanni da Fiesole, later known as 'Angelico' ('the angelic one'), created a series of wall paintings inside the priory of San Marco in Florence, where he was a friar. As with all the images, *The Crucifixion* has a very specific function – to aid the monks' meditations, an exercise in which the order's founder leads the way.

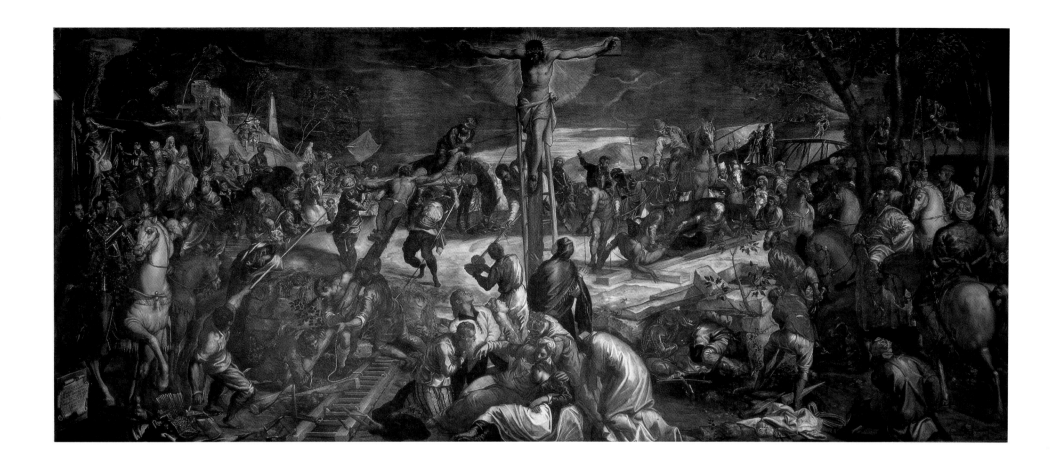

Jacopo Tintoretto
(Jacopo Robusti) (1519–1594)
The Crucifixion

1565
Oil on canvas
5.36 × 12.24 m (17 ft 7 in. × 40 ft 1 ⅞ in.)
Venice, Scuola Grande di San Rocco,
Sala dell'Albergo

The nineteenth-century English critic John Ruskin wrote of this painting that it was 'beyond all analysis, and above all praise'.[3] He was exaggerating. In fact, the canvas has very concrete qualities: immense scale, strident colours and a dynamic composition, dominated by diagonal forms arranged around the central image of the crucified Christ. His radiant figure, dramatically set against the dark sky, is flanked by the two thieves, whose contrasted poses clearly express their different responses to the Saviour. The bystanders range from the crouching soldiers playing dice for Christ's clothes on the right to the touching group of his followers in the central foreground. Unusually, the Virgin Mary is shown slumped to the ground instead of standing by the cross.

Tintoretto's picture is part of a series that he made over two decades for the religious confraternity known as the Scuola Grande di San Rocco. Tintoretto was himself a member of the Scuola, and there can be no doubt of his intense engagement with the decoration of its headquarters, his greatest project.

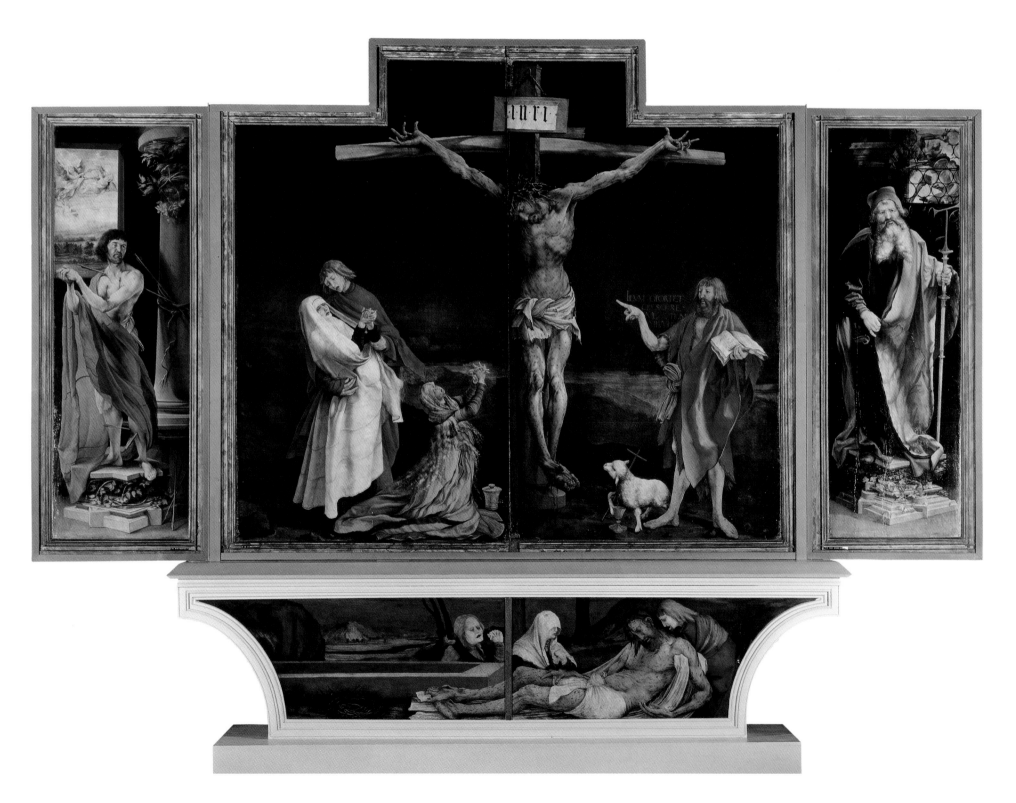

OPPOSITE

Matthias Grünewald
(c. 1475/80–1528)
The Isenheim altarpiece
(view with closed panels)

1512–16
Oil on panel
240 × 300 cm (94½ × 118⅛ in.)
France, Colmar, Musée d'Unterlinden

This overwhelming image is part of an
ambitious polyptych, originally located
in the hospital chapel of St Anthony at
Isenheim, consisting of nine folding panels
around a shrine (probably by Nikolaus
Hagenauer). As the wings of the altarpiece
unfold, different religious scenes appear,
until eventually the sculpted figures of
Sts Anthony, Augustine and Jerome are
revealed at the heart of the complex.

When the wings of the altarpiece are
closed, the Crucifixion appears, flanked
by Sts Sebastian and Anthony (on the left
and right, respectively), who were revered as
protectors against disease and as intercessors
at the hour of death. The Crucifixion itself
is a stark, expressive image, presenting
Christ's agony to the hospital's patients, who
were themselves suffering from the disease
known as St Anthony's Fire, contracted from
mouldy flour. Against a bleak background,
Christ's brightly illuminated body is
gruesomely distorted – even his fingers are
curled in pain – while St John the Evangelist
comforts the Virgin Mary, and Mary
Magdalene, with her pot of ointment, kneels
nearby. As in other altarpieces (see the
St Lucy altarpiece, page 82), John the
Baptist mediates for the worshipper, his
gesture emphasized by words, in red, from
the Gospel of St John (3:30): *He must increase,
but I must decrease.*

At the base of the altarpiece, the story
of Christ's Passion continues as figures
mourn over his broken body. The grief is
almost audible.

Hans Memling (1430/40–1494)
*The Man of Sorrows in the Arms
of the Virgin*

1475
Oil on panel
27.4 × 19.9 cm (10¾ × 7⅞ in.)
Melbourne, National Gallery of Victoria

Hans Memling, a German painter who spent
most of his career in Bruges, was heavily
influenced by an earlier generation of
Netherlandish artists, especially Rogier van
der Weyden. Here the illusionistic qualities
of oil paint are combined with complex
Christian imagery, superimposed on a
distinctly archaic gilded background.

The 'Man of Sorrows' refers to the figure
of Christ displaying his wounds. Unusually,
Memling has combined this motif with a
pietà, where the Virgin mourns over her
crucified son, although there is also a
reference to paintings of the Holy Trinity,
in which God the Father supports Christ
in a pose similar to the one shown here.

Around the central figures Memling
presents an extraordinary array of
instruments and individuals responsible for
Christ's suffering. In the top right are Herod
and Pilate, while Judas, with the money bag
tied around his neck, can be seen opposite.
Elsewhere, a column and scourge or a
hammer and nails are interspersed with a
hand pulling a clump of hair, an obscene
gesture, or a foot delivering a firm kick.
Together, these images stimulate a meditation
on every step of Christ's Passion.

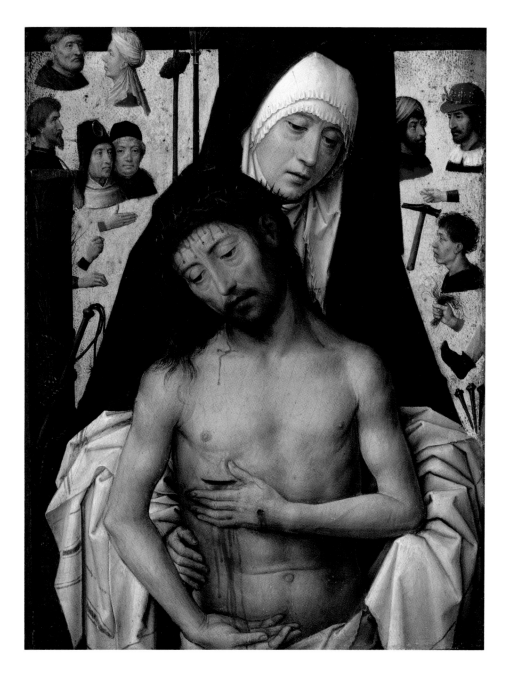

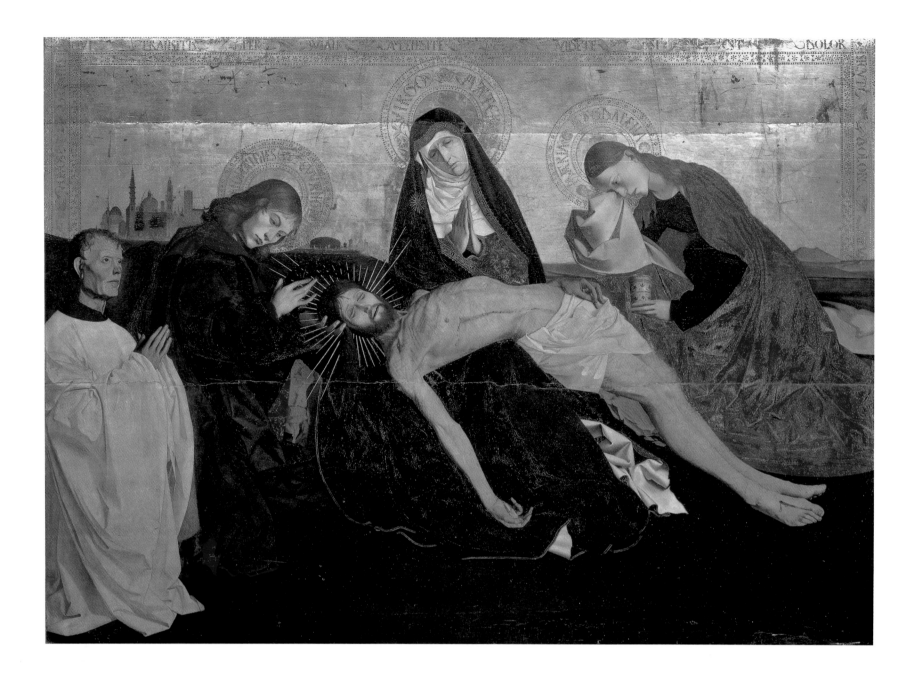

Enguerrand Quarton
(*c.* 1420–1466?)
The Pietà of Villeneuve-lès-Avignon

c. 1455
Oil on panel
163 × 218 cm (64½ × 85⅞ in.)
Paris, Musée du Louvre

The city of Avignon in France became an important artistic centre after the pope established his residence there in 1309, and the 'Avignon School' continued to flourish despite the permanent return of the papacy to Rome in the early fifteenth century.

Enguerrand Quarton's panel is a monumental pietà, in which Christ's body is stretched over his mother's lap, a type of image that originated in Germany. On either side of the central figures are Mary Magdalene and St John, who is delicately removing Christ's crown of thorns, while in the foreground the vividly portrayed donor, dressed in canon's robes, kneels in prayer. The visionary quality is enhanced by the gilded background, against which a cluster of domes and minarets evokes the skyline of Jerusalem.

Sebastiano del Piombo
(1485/86–1547)
Pietà

1513–16
Oil on panel
270 × 225 cm (106¼ × 88⅝ in.)
Italy, Viterbo, Museo Civico

In this magnificent altarpiece the only overt sign of grief is in the Virgin Mary's clasped hands. Sebastiano worked closely with Michelangelo, who provided the full-scale drawing, or cartoon, on which the painting is based. Although this does not survive, Michelangelo also made smaller drawings, now in Vienna, that show a male nude with exactly the same gesture as the Virgin. Other adaptations can be spotted: the pose of Christ's lower left leg is comparable to the figure of Adam in the Sistine Chapel ceiling (page 35), while his lifeless left hand recalls the sculpture of *The Dying Slave* (page 33).

Yet, for all its debt to Michelangelo, Sebastiano's painting is the opposite of a lifeless copy. The powerful figure of the Virgin and the idealized anatomy of Christ are set against a bleak, nocturnal landscape of great expressive power. In the painting's original location, the Saviour's body would have been on the level of the priest's gaze during the Mass, its deathly greyish-brown tone a potent image of his sacrifice.

Piero della Francesca
(*c.* 1415–1492)
The Resurrection

After 1458
Fresco
280 × 225 cm (110¼ × 88⅝ in.)
Italy, Sansepolcro, Museo Civico

Piero's magnificent fresco is located in a room
that was formerly the council chamber of his
native Borgo San Sepolcro. As a civic image,
it makes reference to another picture in the
city: a celebrated fourteenth-century altarpiece
in the cathedral, on which its composition
was modelled. Many other features are
inspired by antiquity, from the design of the
sarcophagus and soldiers' breastplates to
Christ's idealized torso and crisp drapery, as
if taken from a Roman statue. However, the
painting is also characteristic of Piero's own
unique style, with its refined colours, ideal
proportions and amazing sense of stillness,
the diagonal poses of the sleeping men merely
emphasizing the severe vertical of Christ's
body and banner. Above all, the landscape,
with its still, partly leafless trees and pale
morning light, complements the miracle
of the Resurrection. This is a dawn like
no other.

Andrea del Verrocchio
(1435–1488)
The Resurrection

c. 1470
Polychrome terracotta
135 × 150 cm (53 ⅛ × 59 in.)
Florence, Museo Nazionale del Bargello

Terracotta was a cheaper material than
bronze or marble, but provided plenty of
opportunity for vigorous modelling and
painting with bright, expressive colours.
Unfortunately, it was also easily broken,
as this example demonstrates.

Verrocchio's relief – originally above a
door in the Medici family's villa at Careggi,
near Florence – shows Christ not merely
climbing out of the tomb but actually rising
into the air, framed by angels and some rather
exotic-looking vegetation. Meanwhile, an
extraordinary range of reactions is revealed
among the attendants below, from deep sleep
to cowering, gasping fear.

Matthias Grünewald
(*c.* 1475/80–1528)
The Resurrection, from the
Isenheim altarpiece

1512–16
Oil on panel
269 × 142 cm (105 ⅞ × 55 ⅞ in.)
France, Colmar, Musée d'Unterlinden

When the outer panels of Grünewald's
Isenheim altarpiece (page 104) are drawn
back, they reveal images that contrast
startlingly with the anguish of the
Crucifixion on the exterior. A scene of the
Virgin and Child serenaded by a choir of
angels is flanked by an Annunciation and,
most memorably, this remarkable figure of the
Resurrection. Christ's pure-white body is no
longer covered with the sores visible in the
Crucifixion. Instead, the wounds on his feet
and hands, which he raises to our view, are
neat and clean. Above all, an incredible
luminosity radiates into the starry night sky,
painted with colours of an intensity matched
by Christ's penetrating, hieratic stare.

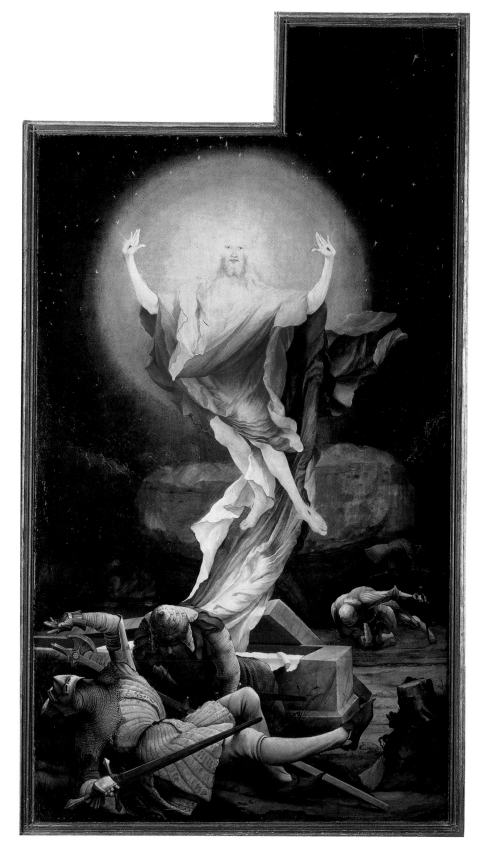

Rogier van der Weyden
(*c.* 1399–1464)
The Last Judgement
(The Beaune altarpiece)

1443–51
Oil on panel
220 × 545 cm (86⅝ × 214⅝ in.)
France, Beaune, Hôtel-Dieu

This *Last Judgement* was originally placed in
a chapel at the end of a hospital ward, and
would have been visible from the beds of sick
and dying patients. It is dominated by the
solemn, frontal figure of Christ, seated on
a rainbow, with his feet resting on a golden
globe. He is accompanied by the Apostles,
the Virgin Mary and John the Baptist,
while judgement is delivered by the priestly
St Michael. In the scales is a figure
symbolizing virtue, on the left, with vice,
grosser and heavier, weighing down the
pan on the right. All around, the earth is
erupting with the resurrected, rising to meet
their fate. Remarkably, the condemned fall
without any help from the hideous demons
that usually appear in paintings of this
theme: it is as if their own sin drags them
down to hell, which is represented as a pit
licked by flames. On the other side, the
blessed, still naked, are guided by an angel
to the Gothic portal of heaven.

 Van der Weyden has represented
individual figures with striking realism – the
woman pulled to damnation by her hair, for
example, not to mention the portrait of the
donor, Chancellor Rolin, which is visible
when the wings are closed. Yet overall the
composition has a symbolic, hierarchical
structure that is even more marked than
in other fifteenth-century paintings of
this subject. Above all, Christ's direct,
unrelenting gaze fixes the viewer's attention.
This remarkable image was intended to
concentrate the mind.

Luca Signorelli (*c.* 1450–1523)
Paradise

1499–1503
Fresco
Italy, Orvieto Cathedral, Cappella Nuova

The cathedral at Orvieto, in central Italy, has two magnificent depictions of the Last Judgement: an enormous relief on the fourteenth-century façade supervised by Lorenzo Maitani, and a fresco cycle in a chapel, begun in 1447 by Fra Angelico and completed more than half a century later by Luca Signorelli. The murals show the events associated with the end of the world, from the Preaching of the Antichrist to the Resurrection of the Flesh and the consignment of the blessed and the damned. Here we are looking at Paradise: Inferno is on the opposite wall.

Signorelli's representations of heaven and hell are undoubtedly influenced by Dante's *Divine Comedy*, written in the early fourteenth century, as well as perhaps by the more recent apocalyptic sermons of the Dominican Girolamo Savonarola (see pages 114 and 115). However, the style is unique to Signorelli: in Paradise, idealized, muscular figures, their modesty protected by strategic drapery, gaze up at the descending angels, who honour them with crowns. The celestial music is played by even grander figures, in front of a firmament made with dazzling gold leaf.

Lucas van Leyden
(*c.* 1494–1533)
The Last Judgement

1527
Oil on panel
Central panel 269.5 × 185 cm
(106⅛ × 72⅞ in.); side panels
265 × 76.5 cm (104⅜ × 30⅛ in.) each
The Netherlands, Leiden, Stedelijk Museum
De Lakenhal

This triptych was commissioned in memory
of Claes Dircksz, a lumber merchant and
burgomaster of Leiden, by his children.
It originally hung in the church of St Peter,
above seats occupied by the city's magistrates,
before being moved to the town hall; the
subject-matter would, no doubt, have been
regarded as providing a good example to the
local judges.

The imagery is conventional, with the
blessed, on Christ's right, transported to
heaven, while the damned are hurled into the
(particularly monstrous) jaws of hell on the
opposite side. As in Rogier van der Weyden's
Last Judgement (pages 110–11), a lily and a
sword (signifying innocence and guilt) float
on either side of Christ, who, somewhat
unusually, is represented without the Virgin,
John the Baptist and St Michael.

One of the artist's greatest achievements
has been to combine the Last Judgement's
traditional hierarchical structure with an
effective use of perspective: the beautiful nude
figures of the resurrected, for example, recede
into the far distance. Above all, Lucas has
represented the scene with pure, luminous
colours, which help to distinguish the
painting's different zones, up to the golden
light around God the Father and the Holy
Spirit at the top of the central panel.

Sandro Botticelli
(1444/45–1510)
Mystic Nativity

1500
Oil on canvas
108.6 × 74.9 cm (42¾ × 29½ in.)
London, The National Gallery

The highly personal nature of this painting is indicated by the Greek inscription at the top, which records that it was made at the end of 1500, 'in the troubles of Italy … in the half-time after the time … in the second woe of the Apocalypse during the release of the devil for three-and-a-half years' – a reference to the recent French invasion of Italy, which Botticelli seems to have regarded as a prelude to the end of the world.

It is often suggested that Botticelli's belief may have been influenced by Girolamo Savonarola, the visionary Dominican monk who had ruled Florence briefly before being deposed and executed in 1498. However, it may reflect a more basic obsession with round numbers, which encouraged many people in 1500, the half-millennium, to expect the Second Coming of Christ.

In this painting, Christ's Nativity, with the Magi and shepherds kneeling before the Holy Family, has been skilfully combined with portents of the Second Coming: angels carrying olive branches circle in heaven, while below they embrace men, as devils flee in panic through cracks in the ground. The visionary mood is enhanced by the unnatural, hierarchical composition and, above all, by the proportions and anatomies of the Holy Family, especially the stretched, arched body of the Virgin Mary.

Fra Bartolommeo (1472–1517)
Portrait of Girolamo Savonarola

c. 1498
Oil on panel
47 × 31 cm (18½ × 12¼ in.)
Florence, Museo di San Marco

Famously, at the carnival of 1497 Girolamo Savonarola ordered a 'bonfire of the vanities' in Florence's main square, Piazza della Signoria. Jewellery, fine clothes and, sadly, a few paintings by Sandro Botticelli were put to the flame. They were followed a year later by Savonarola himself, hanged and burned by his enemies in the same square.

Yet Savonarola's rhetoric against the corruption of priests and princes, and even writers and artists, had an impact that endured for a while after his death. 'You have made the Virgin appear dressed as a whore', he exclaimed against the fashionable religious art of the period. The effect that this had on Botticelli has already been discussed (opposite). Fra Bartolommeo actually renounced art altogether in 1500, when he retreated to San Marco, the monastery of which Savonarola had been prior. When he returned to painting in 1504, it was to create a series of intense, visionary altarpieces. In contrast, his portrait of Savonarola conveys the austerity of his subject in an old-fashioned profile format, with a grim, uncompromising palette.

Lucas Cranach the Elder (1472–1553) and workshop
The Wittenberg altarpiece

1547
Oil on panel
Dimensions unknown
Germany, Wittenberg, Stadtkirche
St. Marien (St Mary's Church)

Cranach was a close friend of the Reformation leader Martin Luther in Wittenberg, where he made this lucid exposition of Protestant doctrine. The altarpiece's side panels depict a baptism and the hearing of confession, a practice that remained important to Lutherans, even though they did not regard it as a true sacrament. Luther himself makes two appearances: in the predella he delivers a sermon on the Crucifixion, stressing the importance of the Word in Protestant worship, while above he participates in the Last Supper, taking wine from the cup-bearer on the right. This omnipresence was not mere presumption: Luther's identification with the Apostles was a genuine conviction, and emphasizes the believer's experience rather than re-creating the event, on the eve of Christ's arrest, in which he instituted the Eucharist.

Plain, even austere in style, the altarpiece also expresses the artist's association with the new reformed religion, which was transforming the development of sacred art in northern Europe as profoundly as it affected religious practice and politics.

Albrecht Dürer (1471–1528)
The Four Horsemen of the Apocalypse

1498
Woodcut
39.2 × 28.2 cm (15⅜ × 11⅛ in.)
London, The British Museum

As 1500 approached, Dürer published his own illustrated edition of Revelation, the Bible's final, prophetic book, amid widespread fears that the end of the world was indeed nigh. The text, which was produced in both Latin and German versions, was illustrated by fifteen woodcuts. They include this vivid image of the terrifying figures that appear as the first four seals of the apocalyptic scroll are broken: the Conqueror, with a bow and crown; War and Famine, brandishing a sword and a pair of balances, respectively; and Death, with his pitchfork, riding a sickly jade, as men of all classes fall before him. Although the Book of Revelation describes them separately, seal by seal, Dürer follows a medieval convention by representing the horsemen together, racing across the page, with the flaming jaws of hell visible behind them.

The Dutch humanist Erasmus clearly valued Dürer's prints even more than his paintings: 'what does he not express in monochromes, that is, in black lines? Light, shade, splendour, eminences, depressions … Nay, he even depicts that which cannot be depicted: fire, rays of light, thunder, sheet lightning …'[4] It is this ability to fix the transitory and immaterial that makes *The Four Horsemen* one of the most memorable, and influential, images in Western art.

Paolo Veronese (Paolo Caliari) (1528–1588)
The Feast in the House of Levi

1573
Oil on canvas
128 × 556 cm (50⅜ × 218⅞ in.)
Venice, Gallerie dell'Accademia

This vibrant, theatrical painting caused something of a stir in the devout atmosphere of Venice during the Counter-Reformation. Originally intended to represent the Last Supper, it was made for the refectory of the monastery of Santi Giovanni e Paolo. In July 1573, however, Veronese was summoned by the Holy Tribunal of the Inquisition to explain the presence of 'buffoons, drunkards, Germans, dwarfs and similar vulgarities' in such a solemn subject. Veronese argued that 'we painters take the same licence the poets and the jesters take …', and that the offending characters were there because it seemed 'fitting, according to what I have been told, that the master of the house, who was great and rich, should have such servants'.[5] The Inquisition was not impressed.

Given three months 'to improve and change his painting', Veronese did so simply by giving it a new title. He hoped that the story, in St Luke's Gospel, of Christ's visit to a tax collector would justify the disreputable characters (although not perhaps the Germans, who are the soldiers in the bottom right). Surprisingly, the Inquisition agreed.

Barbara Longhi (1552–c. 1638)
Self-Portrait as St Catherine of Alexandria

c. 1598
Oil on canvas
Dimensions unknown
Bologna, Pinacoteca Nazionale

It would have been easier to understand Longhi's reasons for making this unusual self-portrait if her own name had been Catherine. Yet there is little doubt that the various versions of this image record her features, which also appear in an altarpiece by her father, Luca; moreover, the length and angle of the pose recall the format of a portrait even though the saint is recognizable from her palm of martyrdom and the broken, spiked wheel on which she was tortured.

The picture fully justifies the judgement of the Florentine art historian Giorgio Vasari, who praised Longhi for her purity of line and soft colours. Trained by her father in Ravenna, Longhi created gentle, delicately executed figures, which perfectly complemented her works' devotional function, as, of course, does her direct identification with the subject of this painting.

LOVE

When Paolo Veronese painted four allegories of love, he naturally included *Unfaithfulness* (opposite), as well as *Scorn*, *Respect* and *Happy Union*. This may seem comprehensive enough, but, as with many other themes, Renaissance artists greatly expanded the range of imagery to embrace extremes of pathos, humour and sensuality, and to present every stage of love, from courtship and weddings to consummation, disillusion and despair.

It was, naturally, in Classical mythology that artists found the broadest scope for romantic, and frankly erotic, subjects. Raphael's *Banquet of the Gods* (page 124) is in fact relatively restrained, since it depicts a wedding celebration – a rare moment of divine respectability – but the Venetians Veronese and Titian retold the conquests of Jupiter in pictures that leave only a little to the imagination (pages 127 and 128).

Even Renaissance patrons sometimes got married, and for these occasions they required something a little more edifying. By far the most famous example, Sandro Botticelli's *Primavera* (page 131), was probably commissioned to celebrate the nuptials of Lorenzo di Pierfrancesco de' Medici: its elegant mythological characters, dressed in a kind of Classical fancy dress, celebrate love and fertility as spring unfolds across the painting.

Love, of course, has its nastier side. At first glance, this seems to be missing in the final two paintings of this section. Botticelli's *Mars and Venus* (page 132) comes from the same imaginative world as the figures in *Primavera*, while Bronzino's *Allegory with Venus and Cupid* (page 133) radiates the cool sophistication of a Renaissance court. But looks can be deceptive. Adultery has unmanned the god of war, and incest and child abuse follow in its wake.

Paolo Veronese (Paolo Caliari)
(1528–1588)
Allegory of Love I (Unfaithfulness)
Probably late 1570s
Oil on canvas
189.9 × 189.9 cm (74¾ × 74¾ in.)
London, The National Gallery

This figure, showing love's less attractive aspect, was perhaps intended for Emperor Rudolph II in Prague, where it was first documented in 1637. Rudolph had a great appetite for allegory, the obscurer or more fantastic the better. Indeed, in comparison with some of his commissions, this canvas seems relatively straightforward.

Unfaithfulness, with her back turned (clearly up to no good), skilfully manipulates a pair of men, in a composition of elegant complexity. The adept foreshortening indicates that it was originally set into a ceiling, perhaps even a marriage chamber. Fortunately, its companion pictures include more positive aspects of love. Although the grey and brown tones were originally brighter, this is, by Venetian standards, a crisp painting of cool colours and neat lines, a style admirably suited to representing the machinations of love.

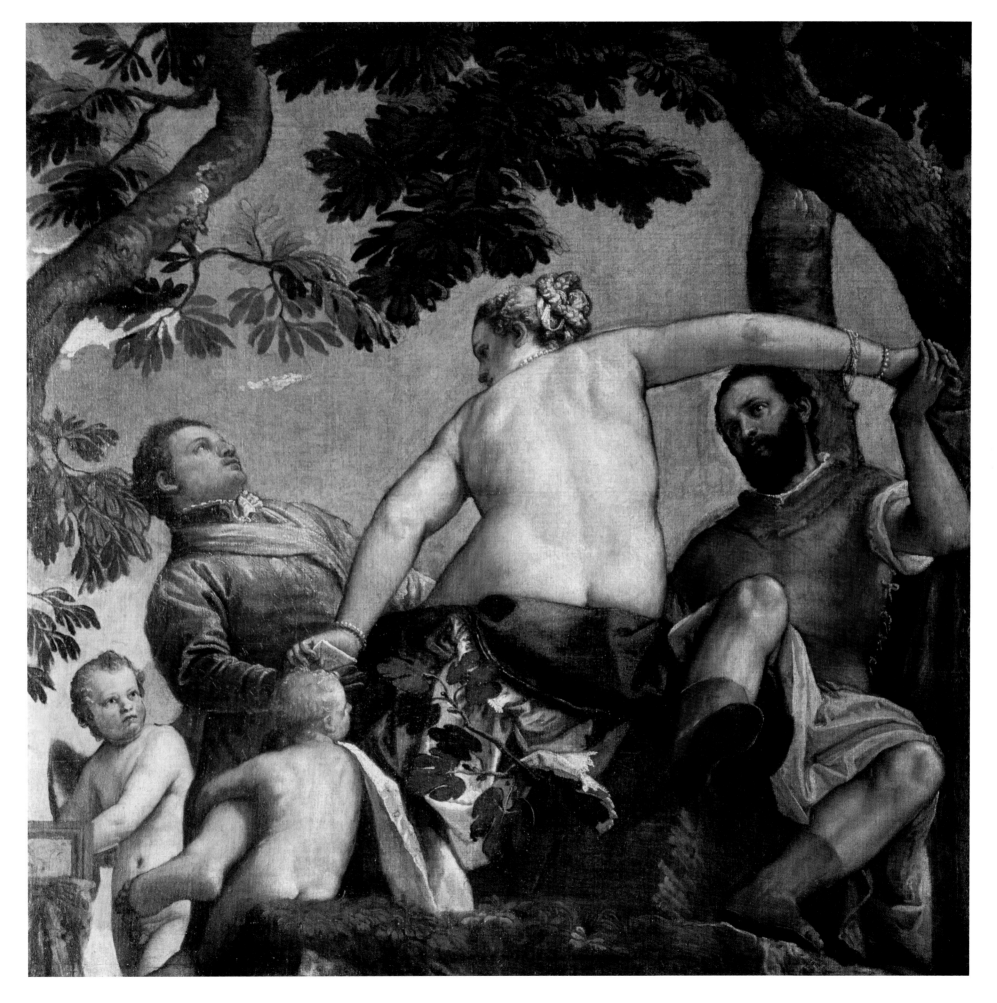

Raphael (1483–1520) (and assistants)
The Banquet of the Gods, from *The Courtship and Marriage of Cupid and Psyche*

1518–19
Fresco
Rome, Villa Farnesina, Loggia di Psiche

There were many twists and turns before Cupid and Psyche were able to enjoy anything as conventional as a wedding breakfast. The Latin writer Apuleius relates how the beautiful princess Psyche was visited by her lover, Cupid, at night, in total darkness. When, in disobedience of his order, she lit a lamp in order to see him, he fled in anger. The distraught Psyche roamed the earth, harassed by Cupid's jealous mother, Venus, until she was eventually rescued, made immortal, and married – a happy ending, after all.

This tale was often seen as an allegory of the soul guided by love, and this intellectual dimension would have been appreciated by Agostino Chigi, the Villa Farnesina's original owner. Chigi, a wealthy banker, was also a hedonist who, like Jupiter, threw marvellous parties, serving dinner on golden crockery that was then thrown into the Tiber (only to be fished out later by the servants).

In this environment, it is not surprising that Raphael extracts the maximum of sensual pleasure from this cheerful scene. Winged attendants hover as Jupiter presides over a divine banquet perched on fluffy clouds. Even Venus seems to be enjoying herself.

The viewer's pleasure is enhanced by the realization that this is not just a fresco, but a painted tapestry, suspended from a pergola luxuriant with flowers and fruit. And, between the clusters of vegetation, a blue sky gleams intensely, whatever the weather outside.

Annibale Carracci (1560–1609)
Polyphemus and Galatea, from the Galleria Carracci

1597–1604
Fresco
Rome, Palazzo Farnese

The Bolognese painter Annibale Carracci led a movement that reacted against the artificial Mannerist style of the mid-sixteenth century. In his frescoes at the Farnese Palace in Rome, he created figures that may improve nature, but do not ever forget it: Carracci was a dedicated advocate of studying the nude from life.

In this image of failed seduction, the brawny Polyphemus woos the sea nymph Galatea with his panpipes as she emerges dripping from the ocean. Being a one-eyed Cyclops, he is perhaps doomed to failure, and eventually kills Galatea's lover, Acis, in a fit of jealousy, before himself being blinded by the Greek hero Ulysses. So, at least, the Roman poet Ovid retold the story in the *Metamorphoses*, a source of erotic subject-matter that was much plundered during the Renaissance.

Carracci's version is clearly indebted to Raphael's inventions in the Villa Farnesina (opposite), especially since he creates pictures within pictures: here the frame of the canvas functions like the border of the tapestry in Raphael's fresco. Layers of illusion are created, enriching the viewer's experience, as well as showing off the artist's skill. The effect is made even more satisfying by the painted sculpture and architecture behind, which divide the ceiling in a manner reminiscent of Michelangelo's work at the Sistine Chapel (page 34). With their sensuality and drama, Carracci's frescoes mark the beginning of the new Baroque style, while building on the achievements of the early sixteenth century.

Titian (Tiziano Vecellio)
(c. ?1485/90–1576)
Danaë and the Shower of Gold

1544–46
Oil on canvas
120 × 172 cm (47¼ × 67¾ in.)
Naples, Museo Nazionale di Capodimonte

This was not Titian's first erotic painting. Yet, as a contemporary told the picture's patron, an earlier nude, *The Venus of Urbino* (page 262), was like 'a Theatine nun'[1] in comparison – a comment that is perhaps surprising in a letter from a papal nuncio to a cardinal. But then the cardinal, Alessandro Farnese, was himself no paragon of virtue: he had sent Titian a portrait of his own mistress as the model for Danaë, and obviously was hoping for something stimulating in return.

Farnese certainly got it. Danaë, the daughter of the king of Argos, is being visited by Jupiter, the king of the gods, in the form of a shower of gold. Cupid, whose arrows normally arouse lovers' passions, is not required – this pair need no encouragement – and, with bow unstrung, he hastily departs, treading clumsily on Danaë's discarded dress.

Danaë does not mind, as she gazes distractedly at the golden cloud casting a warm shadow on her face. Meanwhile, the bedclothes flow around her legs and through her fingers, while the swell of her stomach and her parted limbs point towards the inevitable conclusion: the union that will lead to the birth of the great hero Perseus.

OPPOSITE

Paolo Veronese (Paolo Caliari)
(1528–1588)
The Rape of Europa

1580
Oil on canvas
240 × 307 cm (94½ × 120⅞ in.)
Venice, Palazzo Ducale, Anticollegio

Here the seduction appears to have been successful. The story of the princess Europa, carried off by Jupiter in the guise of a bull, is a familiar one in Renaissance art. As Ovid describes in the *Metamorphoses*, the creature's 'horns were small, it is true, but so beautifully made …'. Eventually Europa overcame her fear, 'went closer, and held out flowers to his shining lips. The lover was delighted and, until he could achieve his hoped-for pleasure, kissed her hands. He could scarcely wait for the rest, only with great difficulty did he restrain himself.'[2]

Veronese's version is particularly light-hearted. The heroine and her companions gaily decorate the bull, and in the background the happy couple reappear, with Europa sitting sedately on the creature's back. This is a gentle, if unorthodox, seduction.

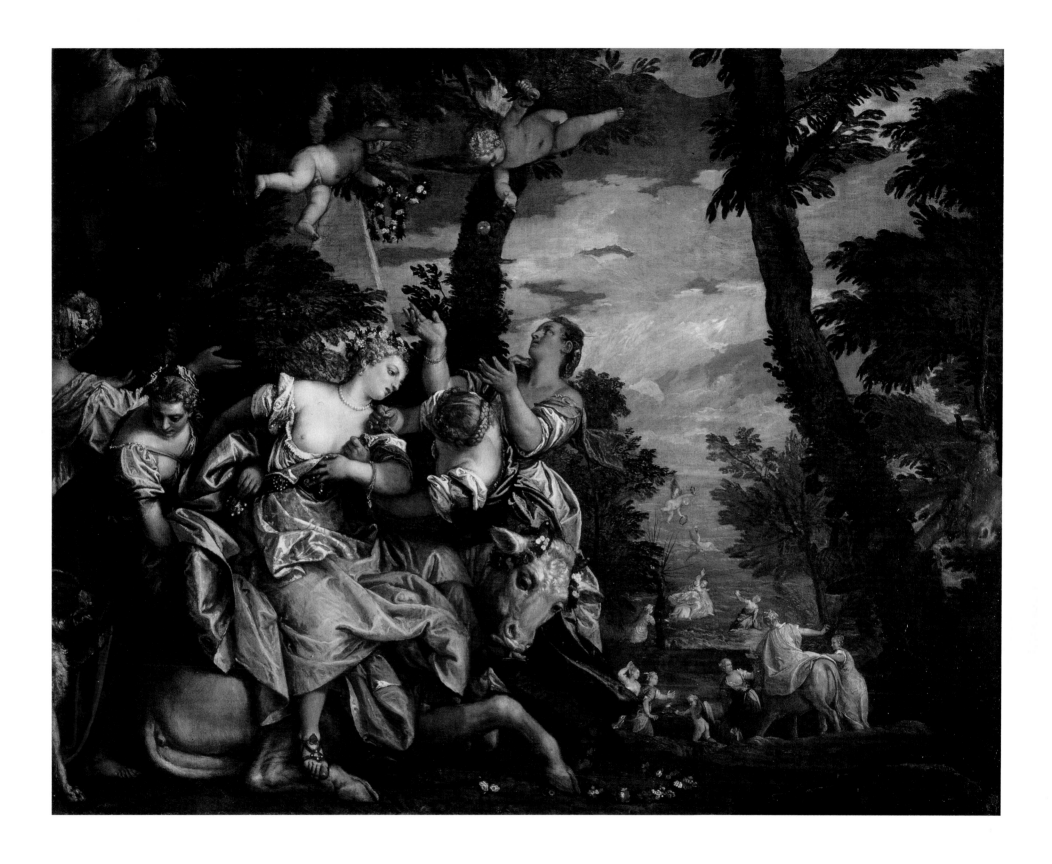

Titian (Tiziano Vecellio)
(c. ?1485/90–1576)
The Rape of Europa

1560–62
Oil on canvas
178 × 205 cm (70⅛ × 80¾ in.)
Boston, Isabella Stewart Gardner Museum

This picture, commissioned by the Spanish king Philip II, shows how bold Titian's erotic tales had become by the end of his career. In comparison with Veronese's version (page 127), Titian expresses far more vividly the story's potential for sex and violence. Ovid proceeds to describe how Jupiter, in the form of the bull, gradually carries Europa into the sea: 'The girl was sorely frightened, and looked back at the sands behind her, from which she had been carried away. Her right hand grasped the bull's horn, the other rested on his back, and her fluttering garments floated in the breeze.'[3]

In Titian's painting, Europa's legs wave wildly in the centre of the canvas as her blood-red scarf flutters above her. Cupids chase after the couple, while Europa's companions, who thought that she was just decorating the bull with flowers, look on in consternation. Meanwhile, the sea, painted with the loose brushwork typical of the aged Titian, froths suggestively. This is an abduction; the painting's title approaches its modern meaning.

Correggio (Antonio Allegri)
(c. 1489–1534)
Venus with Mercury and Cupid
(The School of Love)

c. 1525
Oil on canvas
155.6 × 91.4 cm (61 ¼ × 36 in.)
London, The National Gallery

In some accounts Cupid's father was
Mercury; in others he was Mars or even
Jupiter himself. Here Mercury, identifiable
by his winged shoes and helmet, has been
selected, since, as the messenger god, he makes
the most convincing teacher of writing. He
also may have had an astrological significance
for the painting's patron, Federico Gonzaga,
the ruler of Mantua.

This is an image of family love, but
Venus' sensuous, twisted body is still the
main object of attention. Her face, with its
enigmatic smile borrowed from Leonardo
da Vinci, was originally bent towards her
son, as X-rays have revealed: it is now more
conveniently presented for our inspection.
Above all, the warm, misty tones and soft
textures of flesh and feather – Venus is not
usually shown with wings – create an
overwhelming impression. Although
influenced by the colours and technique
of Venetian painters, Correggio creates a
flickering, transitory effect that is unique. A
moment in the life of ordinary immortals has
been captured and magnified for our leisure.

Piero di Cosimo
(1461/62–?1521)
A Satyr Mourning over a Nymph

c. 1495
Oil on panel
65.4 × 184.2 cm (25 ¾ × 72 ½ in.)
London, The National Gallery

Ovid tells how Procris spied on her husband, Cephalus, out of jealousy when he was on a hunting expedition. Hearing some rustling nearby, he threw his javelin, killing his wife by mistake. It is plausible that this is the story represented here since, although Ovid does not mention a satyr (half-man, half-goat), such a creature did appear in a fifteenth-century play based on this story. If so, this luminous, poignant image was probably intended to decorate a chest or bench in a marriage chamber as a warning against the perils of jealousy.

Filippo Lippi (*c.* 1406–1469)
Portrait of a Woman with a Man at a Casement

c. 1440
Tempera on panel
64.1 × 41.9 cm (25 ¼ × 16 ½ in.)
New York, The Metropolitan Museum of Art

Unlike most of the images in this chapter, this painting keeps desire on a leash. It is in effect a double portrait, with both the man and the woman in a conventional profile format. Yet the arrangement of the two faces, gazing at each other through a window, is highly original, while the domestic setting, with a landscape glimpsed at the back, shows the influence of Netherlandish painting.

Although a coat of arms is visible under the man's hand, there is still some uncertainty as to the subjects' identities. It is possible that they were betrothed – certainly, the painting would make an eloquent description of the rituals of courtship – but it has also been argued that they were in fact already married. Why, then, was it necessary to separate them physically by the insertion of the casement? The answer may be that the woman had died. If that is so, then, far from being an image of formality, the window becomes an emblem of the couple's closeness, an association that continues beyond the grave.

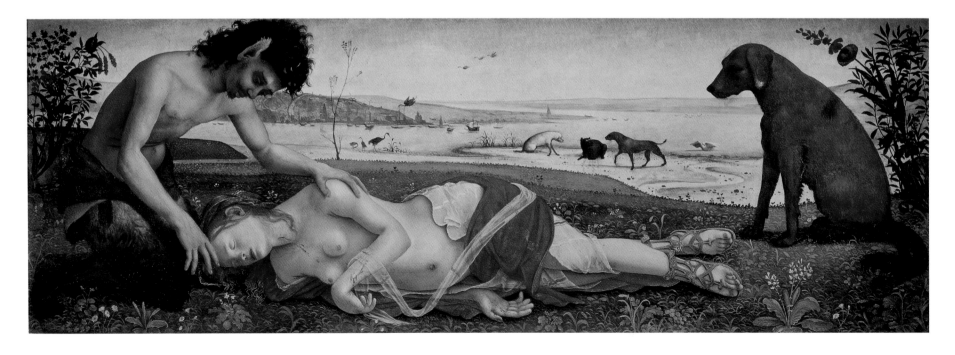

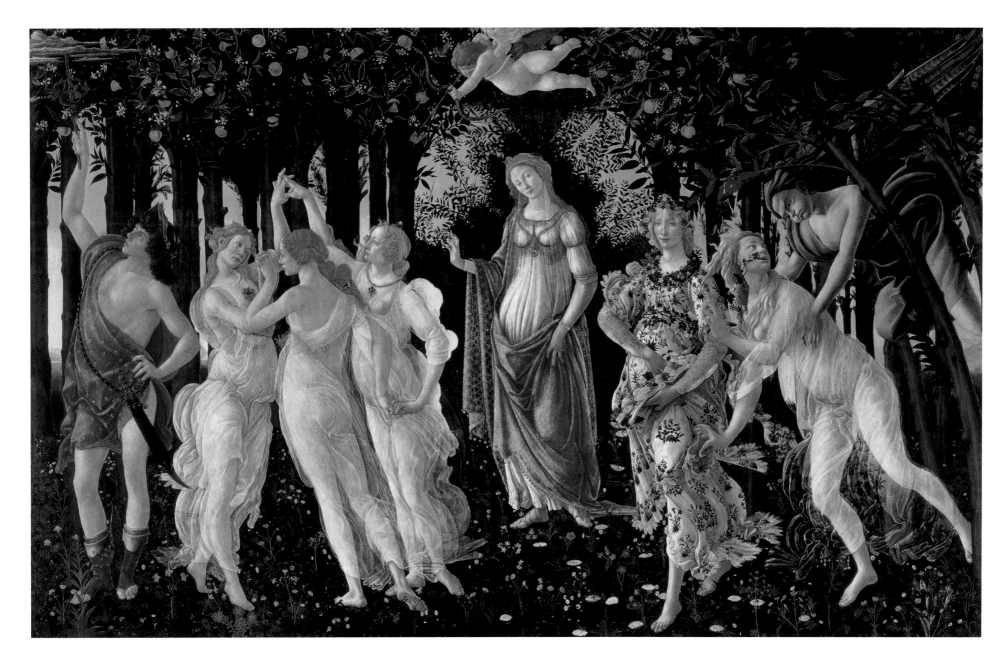

Sandro Botticelli
(1444/45–1510)
Primavera

c. 1482
Tempera on panel
203 × 314 cm (79⅞ × 123⅝ in.)
Florence, Galleria degli Uffizi

Sandro Botticelli's famous painting of spring presents an image of love as a divine, life-giving force. Venus, modestly inclining her head, stands in the middle of an orange grove, through which Flora strides, casting blossoms on to the earth. She has recently been transformed from the virginal nymph Chloris, who is clasped by Zephyr, the god of the West Wind, on the right. It is as if we are seeing the unfolding of spring, which continues on the left, as Mercury, a god

associated astrologically with May, chases away the last clouds with his wand, or *caduceus*. Meanwhile, one of the Three Graces looks at him longingly, while Cupid fires at her from above.

The ideal of love in Botticelli's picture was probably influenced by the Neo-Platonic philosopher Marsilio Ficino, although the poet Angelo Poliziano may have devised the painting's imagery. Both men were in the circle of Lorenzo de' Medici, 'the Magnificent', the most important man in Florence, although this panel was perhaps made for the wedding of his cousin, Lorenzo di Pierfrancesco de' Medici.

The painting certainly is well suited for such a celebration. Not only does it celebrate fertility and sexual love in its purest form, but it has a festive quality, as if the characters' costumes were modelled on the elaborate

masquerades that were frequently held at a Renaissance court. Even the Three Graces, dressed in diaphanous drapery, are adorned with jewelled brooches and fashionable coiffures, while Mercury combines his mythological attributes with a magnificent contemporary sword.

For all its complex cultural associations, the picture has an appeal that derives principally from the refinement with which it is composed. The characters are placed in a shallow, irrational space appropriate to the poetic atmosphere; their poses are echoed by the stylized trees and foliage around them; above all, their supple, slender bodies and delicate features have a beauty that reflects descriptions of women in contemporary literature but is, nonetheless, unique to Botticelli.

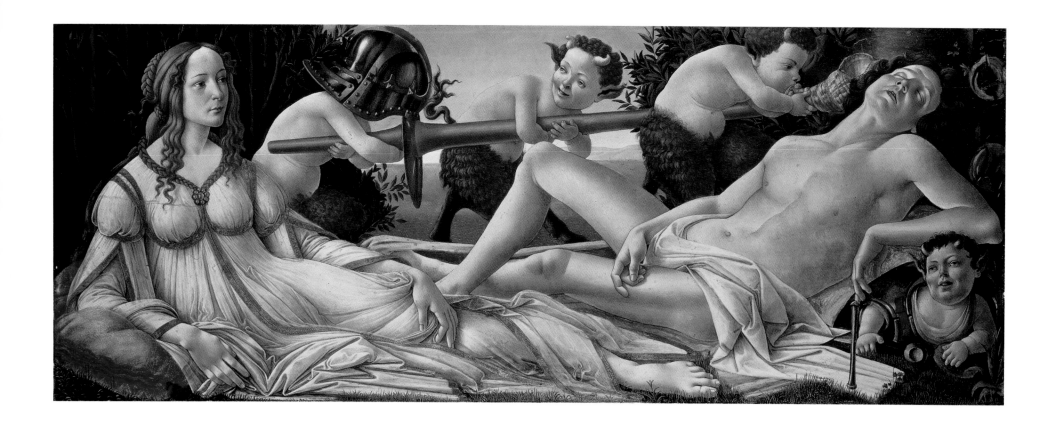

Sandro Botticelli
(1444/45–1510)
Mars and Venus

c. 1485
Tempera and oil on panel
69.2 × 173.4 cm (27 ¼ × 68 ¼ in.)
London, The National Gallery

This painting probably decorated a chest or
bench: its composition is brilliantly adapted
to its horizontal setting. With its amorous
content, it was probably made on the occasion
of a marriage. The wasps (*vespe* in Italian)
suggest that the patrons may have been
members of the Vespucci family, for whom
Botticelli certainly worked.

The panel must have been meant as an
elaborate joke, since here we are not presented
with an image of ideal love, but with
something a little murkier. Mars and Venus
were an adulterous couple, who were
eventually humiliated in front of the other
gods. The warrior Mars seems to be exhausted
by his passion: in contrast to his self-possessed,
clothed lover, he has collapsed, asleep and
almost naked. Infant satyrs, with goats'
legs and horns, play suggestively with his
armour and try to wake him with a conch
shell. He can, however, no longer be roused.

Agnolo Bronzino (1503–1572)
An Allegory with Venus and Cupid

Probably 1540–50
Oil on panel
146.5 × 116.8 cm (57 ⅝ × 46 in.)
London, The National Gallery

Venus, the goddess of love, and her winged son, Cupid, are locked in an illicit embrace, apparently unaware of the strange figures around them. The painting is an allegory in that most of the characters symbolize abstract qualities, in this case the vices of the incestuous couple: the little boy pelting the couple with petals represents Folly, while the monster behind him, with a fair face and a reptilian tail, is Deceit. In the background, the old man is undoubtedly Father Time, preparing to tear down the veil hiding the goddess's obscenity. He tussles with Oblivion, open-mouthed and vacant in the top left corner, who is trying to maintain the concealment, but the fallen masks diagonally opposite show that the deception cannot last. The wages of sin are most dramatically expressed by Despair, the sallow old woman on the left, howling and grimacing behind Cupid's shoulder, while he squeezes his mother's nipple and she plays with his arrow.

It has taken art historians centuries to tease out these meanings, and still they disagree – Despair, for example, might depict Jealousy or even the effects of syphilis – and so it is easy to imagine how much fun the painting might have given its original owner, the king of France, and his witty, educated courtiers. Of course, they would also have relished the picture's less intellectual pleasures – above all, its sinuous, alabaster figures, bathed in glacial light, who make the foulest acts seem elegant and refined.

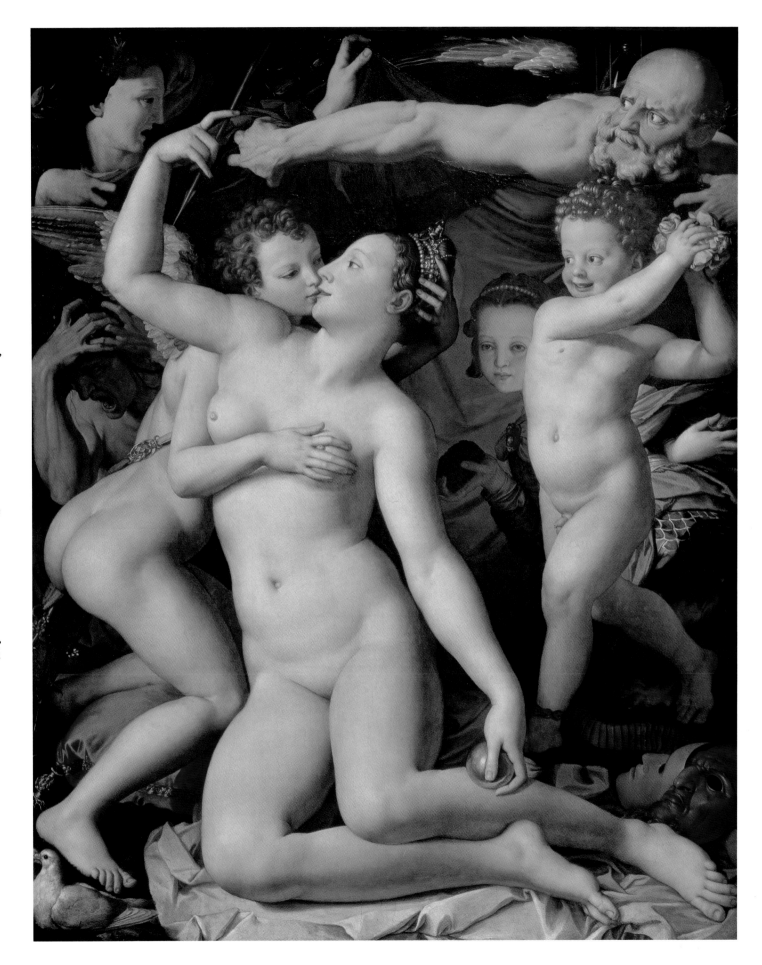

WAR

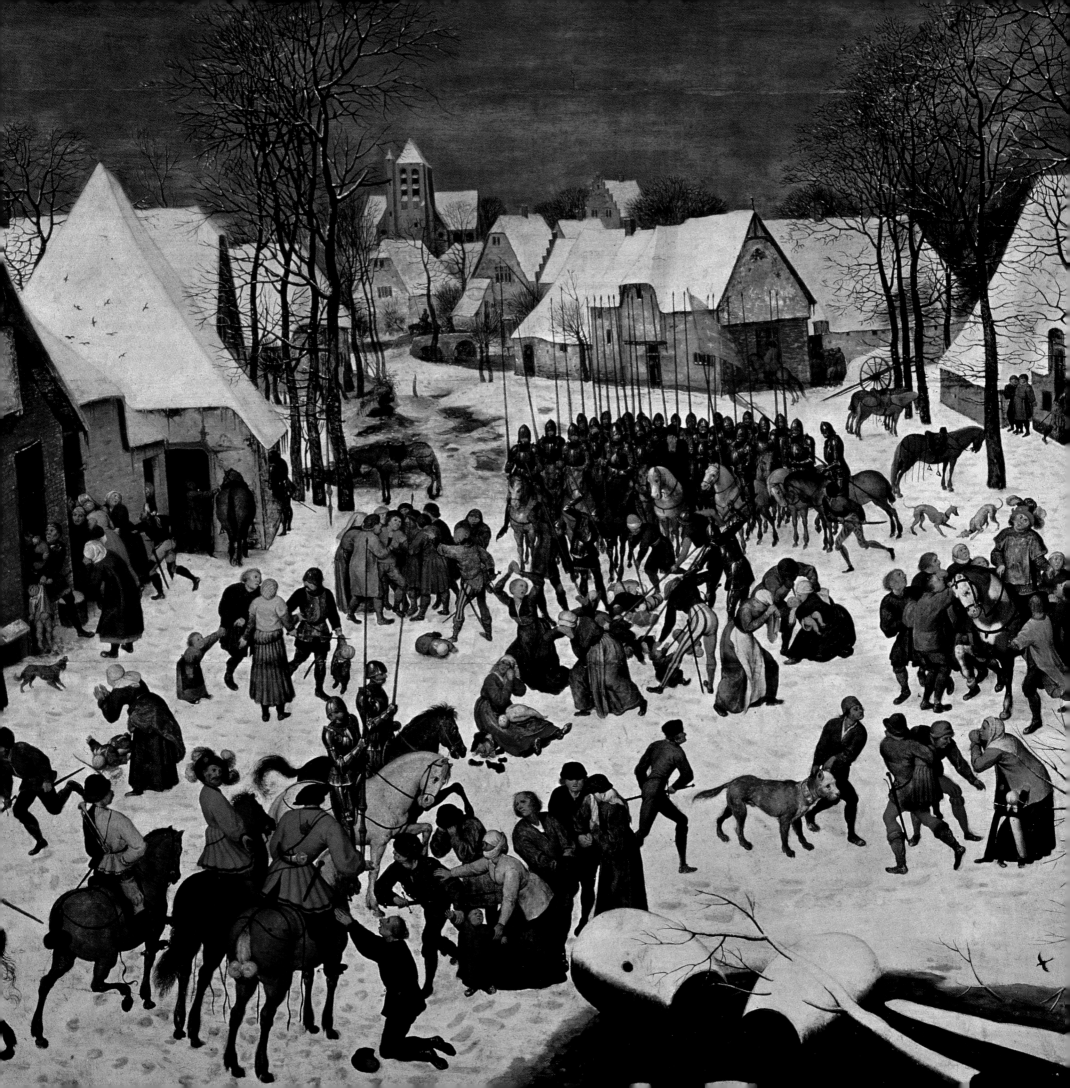

One of the most significant battles of the sixteenth century took place at Mühlberg, in eastern Germany, where the army of the Catholic emperor Charles V defeated the Lutheran Schmalkaldic League in 1547. Shortly afterwards Titian celebrated the victory by painting Charles in armour (opposite) as he rides alone across a peaceful landscape. Bartholomew Sastrow, a lawyer who witnessed the aftermath of the battle, told a different story: 'All along the road soldiers were dying from their wounds and from want of sustenance. Around Wittenberg all the villages were deserted; the inhabitants had taken flight without leaving anything behind them. Here the corpse of a peasant, a group of dogs fighting for the entrails; there a Landsknecht with just the breath of life left to him, but the body putrefying ...'[1]

Art rarely follows reality; this is never more true than when it concerns itself with war. A century before Mühlberg, Paolo Uccello had depicted a skirmish between the Florentines and the Sienese as a kind of jousting tournament, with a single casualty (page 138). Other conflicts demanded something more serious. Alexander the Great's victory over the Persians at Issus in 333 BC was an event of great importance to the history of Europe, and so Albrecht Altdorfer gives it an epic dimension (page 140), representing it as seen from a great height, with much of the Mediterranean extending into the distance. Even the clouds, fantastically reflecting the shapes of the mountains below, seem caught up in the excitement.

It was, characteristically, Pieter Bruegel the Elder who introduced an element of reality into the depiction of war. In *Massacre of the Innocents* (page 142), irregular militia and mounted soldiers butcher the inhabitants of a village: we are closer now to the actual experience of conflict in the turbulent sixteenth century, despite the mask provided by the biblical theme.

The painting is also the sort of image beloved by historians of arms and armour: Bruegel depicted the weapons of the recent past, omitting, of course, the gunpowder that would hardly be appropriate even for an updated version of the subject. Leonardo da Vinci also made studies of contemporary pikes and halberds, on occasion contrasted with the spears and lances of antiquity, yet it is his magnificent inventions – from chariots equipped with revolving scythes to armoured cars (page 143) – that grip us today. In fact, he shared his interest in military design with scores of other artists who would happily shift from painting or sculpture to the construction of castles and fortified walls, if a city's ruler employed them to do so. Leonardo was not alone in showing off his skills in the arts of war; it was only his degree of invention that was unique.

Titian (Tiziano Vecellio)
(c. ?1485/90–1576)
Charles V in Mühlberg

1548
Oil on canvas
335 × 283 cm (131⅞ × 111⅜ in.)
Madrid, Museo Nacional del Prado

Titian travelled to Mühlberg in 1547 to meet Emperor Charles V. Within months he had produced this commanding image, which belongs to a tradition of equestrian portraiture extending back at least as far as the ancient sculpture of Marcus Aurelius (page 60). Despite its Classical reference, Titian's painting is firmly rooted in the here and now. Charles's armour, and that of his horse, can still be seen in the Royal Armoury at the Royal Palace in Madrid. It is, of course, entirely ceremonial, protected from the blows and buffets of a real combat. The emperor looks ready for action, although we know that the battle is already won, and he rides off through a landscape empty and serene.

Paolo Uccello (*c.* 1397–1475)
The Battle of San Romano

Probably *c.* 1438–40
181.6 × 320 cm (71½ × 126 in.)
Tempera with oil on panel
London, The National Gallery

This is one of three panels (the others are in
Paris and Florence) depicting a battle that
took place between Florence and Siena in
June 1432. The Florentines charge from the
left across a stage-like battleground, the light
colour of which shows up the broken lances
and armour strewn across it. Uccello displays
his skill in perspective, the technique of
creating an illusion of depth – for example,
the legs of the corpse on the left appear
much longer than its torso – but is totally
uninterested in representing the grimness of
war. Despite the carnage on the ground, the
painting's colours are festive and decorative,
the horses and knights beautifully adorned.
Above all, the scene is dominated by the
brilliant white charger of the Florentine
commander, Niccolò da Tolentino, who
himself wears a magnificent red-and-gold
damask cap, while his comrades' plumed
helmets are more appropriate to a jousting
ground than a battlefield.

Andrea del Castagno
(before 1419–1457)
Equestrian monument to Niccolò da Tolentino

1456
Fresco, transferred to canvas
Florence Cathedral

Niccolò da Tolentino died in 1435. As we
have seen (opposite), the Florentines lost
little time in celebrating the victory at San
Romano, over which he presided. However,
it took almost another twenty years to
commemorate the dead commander. The
city saved money by commissioning a
frescoed rather than a sculpted monument,
and yet this vast image, on one of the interior
walls of Florence Cathedral, is still a
magnificent tribute. It is also far more
flamboyant than Paolo Uccello's nearby
painting of Sir John Hawkwood (page 59),
and further from the Classical prototypes
of which both artists were aware. Niccolò's
characteristic hat has migrated from
Uccello's depiction of the battle, and fits in
well with the exuberant architecture of the
painted tomb, with its fulsome inscription.

It would be pleasing to imagine that
the honour shown to the commander was
intended also as a tribute to the valour of
his troops. This is probably not the case.
Nonetheless, by preserving the memory
of a military leader, the monument provided
a focus for civic pride at a time when the
Florentine state was expanding, at times
painfully, at the expense of its neighbours.

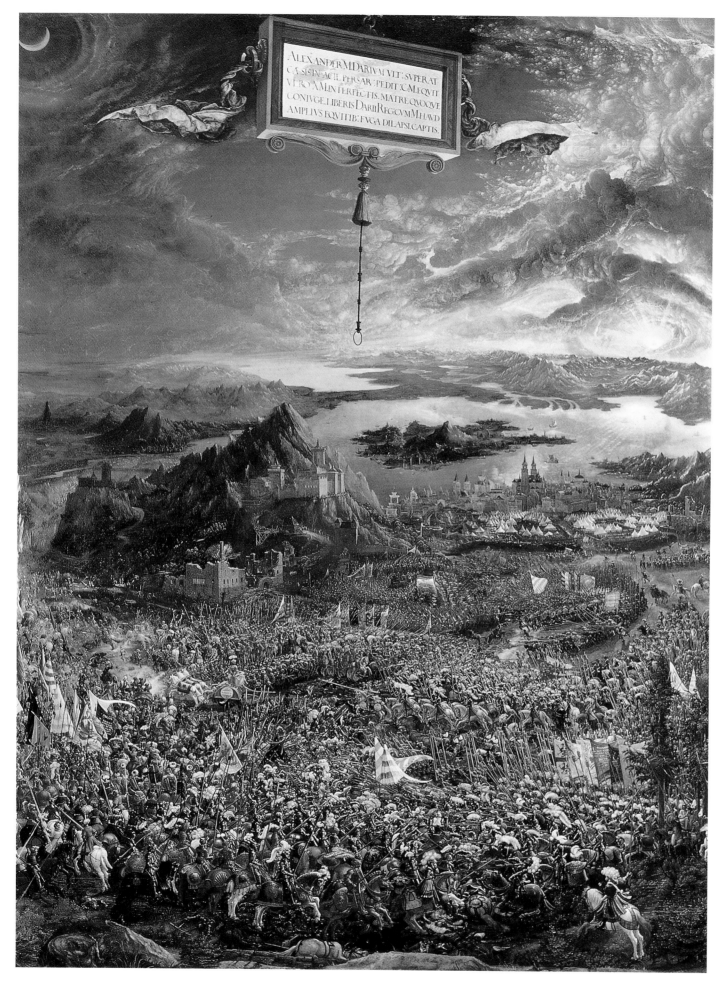

ALEXANDER MDARIVM VLT SVPERAT
CASISIN ACIE PERSAR PEDIT CM EQVIT
VERO A MIN TERFECTIS MATRE QVOQVE
CONIVGE LIBERIS DARII REGCVM MH AVD
AMPLIVS EQVITIB FVGA DILAPSI CAPTIS

Albrecht Altdorfer
(*c.* 1480–1538)
The Battle of Issus

1529
Oil on panel
158 × 120 cm (62¼ × 47¼ in.)
Munich, Alte Pinakothek

In 333 BC Alexander the Great won a
decisive victory against the Persian king,
Darius, at Issus in Asia Minor. This famous
story took its natural place among the sixteen
pictures of heroic deeds commissioned from
various painters by the Duke of Bavaria,
Wilhelm IV, in the early sixteenth century.
The project was so important that Altdorfer
gave up a term as mayor of Regensburg in
order to complete it.

Altdorfer's representation of the ancient
battle looks remarkably contemporary – the
Persian soldiers, for example, resemble the
turbaned Ottoman Turks feared across
Europe at that time – but is by no means
consistent. Darius, fleeing in his chariot
from the advancing Alexander, looks every
inch an Eastern potentate, while the ladies
of his court (towards the bottom left) display
the most up-to-date Western fashions,
especially in their flamboyant headwear.

Altdorfer's greatest achievement is to
combine these personal details with a sense
of the battle's epic scale and significance.
The panoramic viewpoint allows us to see
not only the two vast armies but also the city
of Issus, much of the Mediterranean and
indeed both day and night simultaneously.
Above all, a vast tablet floats in the sky,
bearing a Latin inscription by the Bavarian
court historian Aventinus: ... *Of the Persian
army, 100,000 foot soldiers were killed, and more
than 10,000 horsemen. The fleeing Darius could
save no more than 1000 of his knights* ... We are
left in no doubt as to the extent of
Alexander's accomplishment.

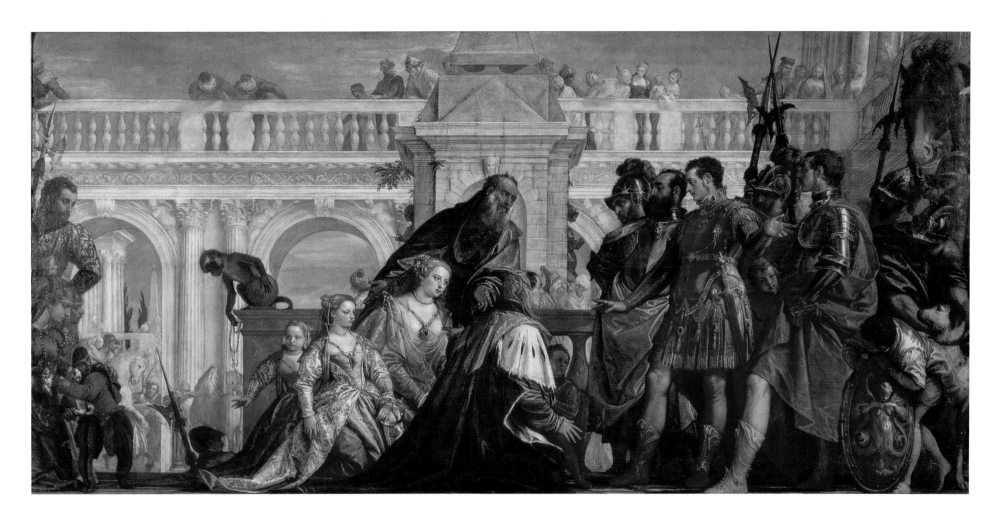

Paolo Veronese (Paolo Caliari) (1528–1588)
The Family of Darius before Alexander

1565–70
Oil on canvas
236.2 × 474.9 cm (93 × 187 in.)
London, The National Gallery

After the Battle of Issus, the victorious Alexander magnanimously visited Darius' family to assure them of their safety. Darius' mother, Sisygambis, knelt in front of Alexander's general, Hephaestion, whom she confused with his commander on account of his height. When an attendant told her of her mistake, Alexander spared her embarrassment by saying that the valiant Hephaestion was indeed also an Alexander.

Like Sisygambis, viewers are still often confused as to the identity of the two magnificently dressed soldiers in this scene. Surely, however, Alexander is the figure in imperial red, Classical battledress (although with some more modern chain mail in his sleeves), addressing his compliment to the slightly taller man in sixteenth-century armour. All the fighting men carry contemporary weapons: pikes, halberds, and, in Alexander's case, a sword that lacks any visible support. The mother of Darius wears an ermine-topped velvet robe like the Venetian doge's wife, while in the background turbaned men add a suitably exotic touch. Most important of all, however, are the painting's extraordinary, vibrant colours, radiating warmth in front of the much cooler architectural backdrop.

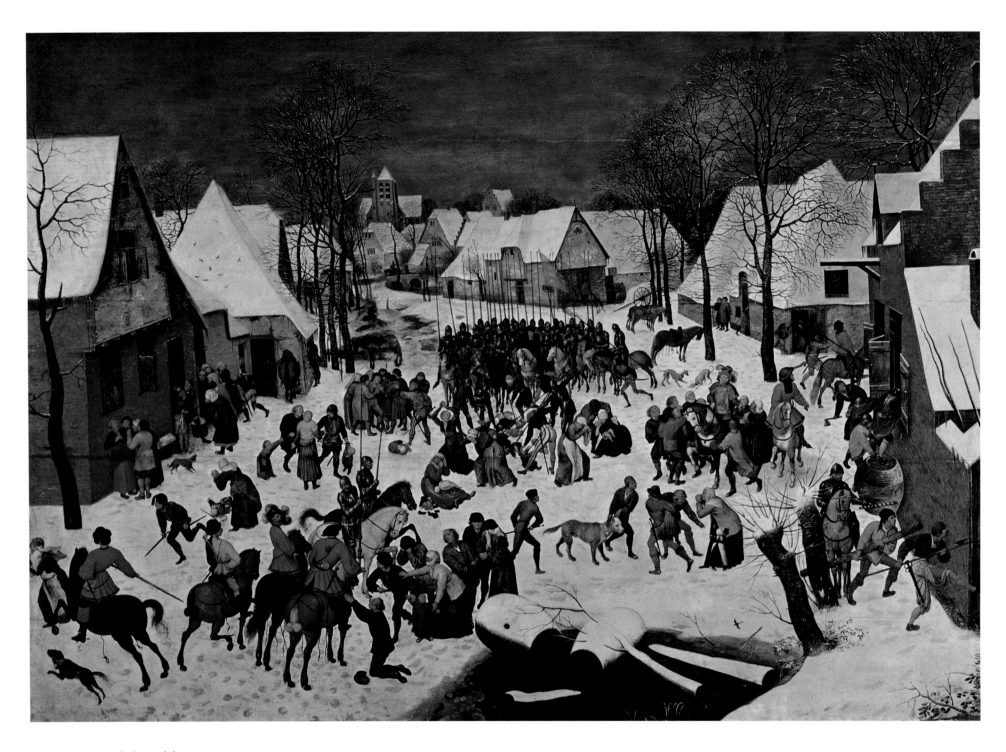

Pieter Bruegel the Elder
(c. 1525/30–1569)
Massacre of the Innocents

c. 1566
Oil on panel
116 × 160 cm (45⅝ × 63 in.)
Vienna, Kunsthistorisches Museum

When King Herod was told of the birth of a boy who was to be king of the Jews, he ordered all male children up to the age of two to be slaughtered. Bruegel's representation of this event, which takes place in the bleak period after Christmas, is made more shocking by its sixteenth-century Flemish setting, particularly since Flanders was disturbed at this time by unrest against Spanish rule. Mounted soldiers in the background, with a standard bearing a cross, have clearly been sent by a Christian monarch rather than the king of Judaea. Indeed, it has been suggested that their bearded commander in black resembles the

dreaded Duke of Alba, whose arrival from Spain was imminent at the time that this picture was made. In the painting, he watches as local horsemen in red jackets and their henchmen on foot do the dirty work. This is a stark image of the ugly side of war, in the guise of an episode from the New Testament.

Closer inspection reveals, however, that this scene is not as contemporary as it first appears. Most of the swords, helmets and breastplates have designs from more than half a century before the date of the painting. Even the peasants' clothes are deliberately old-fashioned. Is Bruegel trying to protect

himself by masking the subject's relevance to his own time? Perhaps he simply preferred the imagery of his father's generation. In reality, we cannot tell for sure, but it is unquestionable that, however antiquated their equipment, the soldiers fulfil their function: to create the strongest possible impression of violence and fear.

Certainly, this painting is more effective than Bruegel's other version of this subject, at Hampton Court Palace near London, where the slaughtered children have been replaced by farmyard animals.

Leonardo da Vinci (1452–1519)

Military machines

c. 1487
Pen and ink and brown wash on paper
17.3 × 24.6 cm (6¾ × 9⅝ in.)
London, The British Museum

When, around 1482, Leonardo advertised his services to Ludovico Sforza, the Duke of Milan, he wrote a letter outlining his skills as a military engineer. Plans for ladders and portable bridges, and for burning those of the enemy; for cutting off the water supply during a siege; or 'for arriving at a certain fixed spot by caverns and secret winding passages' were lucidly described. However, the most memorable passage concerns 'armoured cars, safe and unassailable, which will enter the serried ranks of the enemy with their artillery, and there is no company of men at arms so great that they will not break it. And behind these the infantry will be able to follow quite unharmed and without any opposition.'[2]

 The strange, tortoise-like structure on the bottom right of this drawing is unquestionably an example of the proto-tanks that Leonardo so optimistically proposed. Next to it is a similar contraption seen upside-down with its wheels visible; yet the most striking image of all is the design for a set of vicious scythes, to be pulled by a horseman across the battlefield – a grim reaper indeed. In comparison, the halberd on the extreme right seems relatively harmless.

Leonardo da Vinci (1452–1519)

A giant crossbow on wheels

c. 1485–88
Pen and ink and wash on paper
20 × 27 cm (7⅞ × 10⅝ in.)
Milan, Biblioteca Ambrosiana

In his letter to the Duke of Milan, Leonardo also described the 'catapults, mangonels, trabocchi and other engines of wonderful efficacy' that he was able to supply.[3] *Trabocco* is the Italian word for the device known usually by its French name *trébuchet*: like a mangonel, it consists of a pivoted beam, with a weight at one end, that releases the sling holding the missile. In contrast, the giant crossbow represented in this meticulous study drives a dart out of a bow-like structure powered by twisted cord. Characteristically, the explanatory text is written in the back-to-front 'mirror writing' that appears in so many of Leonardo's drawings.

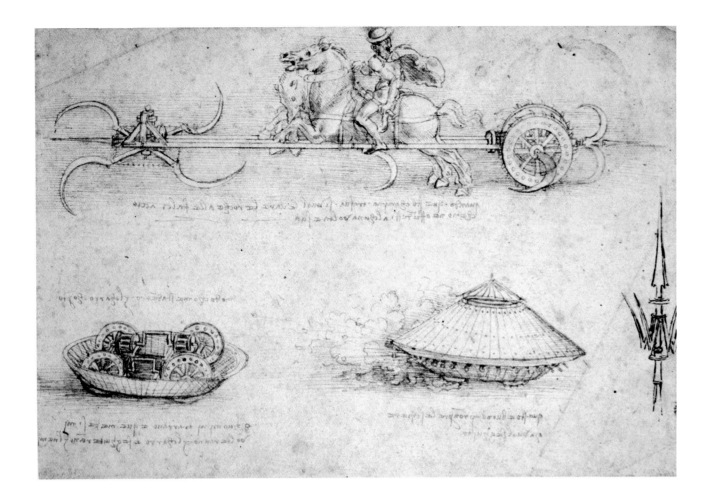

HOME

Flemish artists were the first to represent convincingly the interiors of the houses in which their patrons lived. Into these pleasing, urbane rooms they usually placed the figures of saints or the Virgin and Child, although Jan van Eyck also created a memorable setting for his extraordinary double portrait of Giovanni Arnolfini and his wife (opposite). This painting is distinguished by the brilliant use of its oil medium, which allowed Van Eyck to represent subtle effects of tone and texture, a skill mastered forty years later by Antonello da Messina (page 149), probably as a result of studying Netherlandish pictures at the court of Naples.

Antonello's painting of St Jerome sets his subject in a neat but austere study. A far more significant area, at least in the eyes of most well-to-do Italians, would be the *camera* (chamber), in which the main events in a family's life – above all, birth and infancy – would take place. Given that Christ was delivered in a stable, it is hardly surprising that artists seized on his mother's own nativity as an opportunity to represent this important room in all its contemporary detail.

Of the examples illustrated here, Filippo Lippi's version (page 152) is perhaps the most ingenious, since in its small, circular format it manages to include the infant Christ, the infant Virgin Mary, and, in the far distance, her miraculous conception at the Golden Gate. In comparison, Andrea del Sarto and Domenico Beccafumi (page 154) have been far more straightforward, concentrating on providing the Virgin's mother with a team of reliable attendants and a very grand bed.

Despite all this domesticity, the genre of the pure interior took even longer to develop than did that of the landscape. By the end of the sixteenth century, however, some artists, especially in northern Europe, were offering their public images of everyday life, often set on the street but occasionally located inside. Yet Joachim Beuckelaer's kitchen scene (page 155) is not as simple as it seems. As well as symbolizing the element of fire, it also allows a little space for an appropriate religious story, which can be seen taking place in the next room. Housework may have taken centre stage, but the prevailing Christian subject-matter has not yet retreated to the wings.

Jan van Eyck (*c.* 1395–1441)
Portrait of Giovanni (?)
Arnolfini and His Wife
(*The Arnolfini Portrait*)

1434
Oil on panel
82.2 × 60 cm (32 3/8 × 23 5/8 in.)
London, The National Gallery

The subjects of this portrait are probably Giovanni Arnolfini, an Italian merchant living in Bruges, and his wife, whose identity is uncertain. They stand, with their faithful dog, in the upper floor of a brick house: we can see the top of a cherry tree through the window. On the ledge and chest are a few oranges, and on the other side of the room a big red bed. At the back is a bench adorned by a carving of St Margaret, the patron of childbirth, with a brush hanging below it. In the centre of the wall is an opaque mirror, with a tiny reflection of the artist and another man standing in the door; a Latin inscription declares that Van Eyck *was here* in 1434. To the left, amber rosary beads glisten faintly. The use of oil paint has enabled all the different textures and tones to be represented with striking accuracy.

Images of piety, fidelity and fecundity (although the woman is not pregnant); a witness's florid signature; and, above all, Arnolfini's solemn gesture have led some scholars to regard this as a kind of painted certificate, testifying to a private wedding or betrothal, with God's presence symbolized by the lit candle in the chandelier. Yet all these objects, from the bed to the small luxuries, would be expected in the reception room of a prosperous family; the script and wording on the wall have no legal significance; and the raised hand may simply be a greeting to Arnolfini's visitors.

Such is the current wisdom about this picture, and yet it is hard to renounce the idea that the grave merchant is making some sort of vow. It seems likely that new theories will eventually appear.

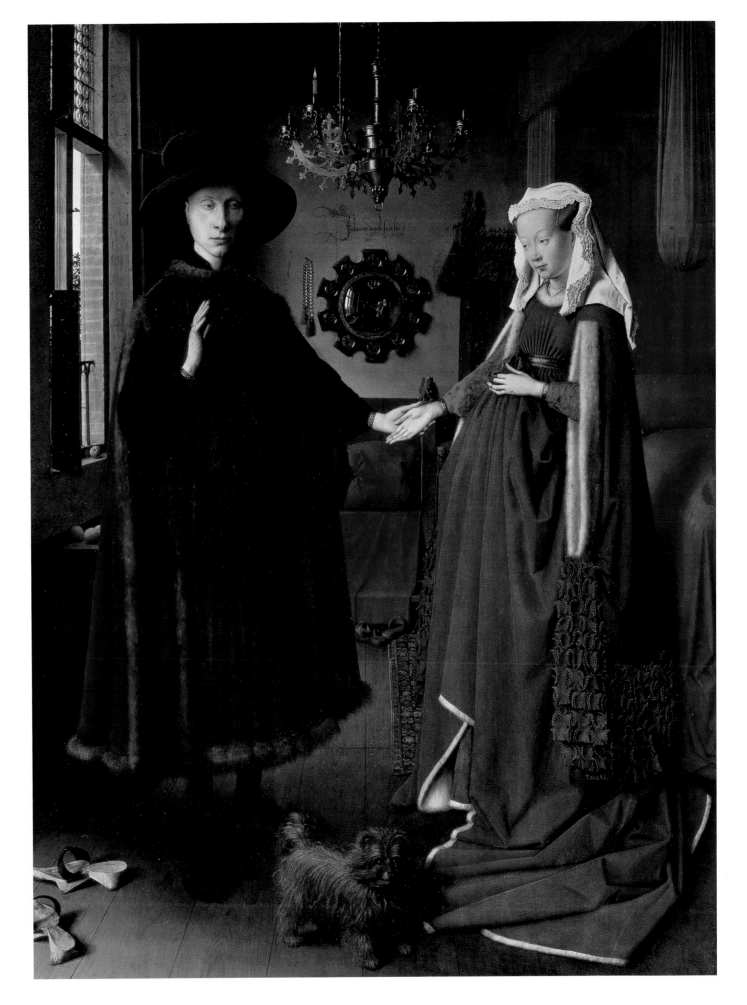

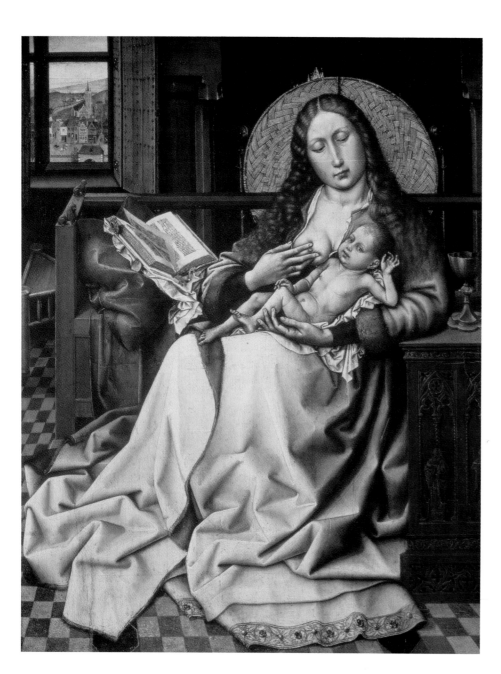

Follower of Robert Campin
(c. 1375/79–1444)
The Virgin and Child before a Firescreen

c. 1440
Oil with some tempera on panel
63.4 × 48.9 cm (25 × 19 ¼ in.)
London, The National Gallery

In this painting the Virgin and Child inhabit the upper storey of a comfortable Flemish house, probably similar to the one for which this panel was made. The artist Robert Campin lived in Tournai, a thriving commercial city, and his work, and that of his followers, would have been produced for local merchants rather than aristocrats. Consequently, the setting is affluent without being ostentatious. The most lavish piece of furniture, the Gothic cabinet with the chalice on the right, was added by a nineteenth-century restorer, probably after fire damage, and there is no reason to believe that it records the picture's original appearance. Perhaps the later owner found the room just a little too mundane.

Certainly, the everyday surroundings contrast sharply with the bejewelled dress and prayer book of the Virgin Mary, who is no ordinary housewife. Her presence and that of Christ transform the domestic setting: the flame above Mary's head recalls the fire of the Holy Spirit, which descended on the Virgin and Apostles at Pentecost, while the circular wicker firescreen becomes an immense halo, a humble object miraculously turned into a sacred symbol.

Antonello da Messina
(*c.* 1430–1479)
St Jerome in His Study

c. 1475
Oil on panel
45.7 × 36.2 cm (18 × 14¼ in.)
London, The National Gallery

As his name suggests, Antonello was from
Messina in Sicily, although he worked as far
north as Venice. This panel's rich colours
and subtle shadows display his mastery of
the oil medium; indeed, in 1529 the Venetian
connoisseur Marcantonio Michiel was so
impressed that he found it impossible to
judge whether the picture was by Antonello
or Jan van Eyck.

Like his Netherlandish contemporaries,
Antonello has re-created a domestic setting,
in this case a study, with a tiled corridor on
the left leading to a window seat, from which
can be seen a walled city. Surrounded by
humble potted plants, earthenware vessels,
books and a clean, white towel, Jerome,
dressed as a cardinal, is comfortably settled
in his task of translating the Bible into
Latin. However, despite the realism of the
individual objects, an air of artificiality is
maintained. The arch in the foreground
is patrolled by a peacock (symbolizing
immortality) and a partridge (truth), while
the lion, which Jerome befriended in the
desert, wanders around like a household pet.

The study itself has been opened up like
a doll's house: this is merely a segment of a
room, on a little stage, inside a much larger
ecclesiastical building. It is as if the
architecture gives physical expression to the
painting's different layers of meaning.

Vittore Carpaccio
(?1460/66–1525/26)
St Augustine in His Study

c. 1502–07
Oil and tempera on canvas
141 × 211 cm (55 ½ × 83 ⅛ in.)
Venice, Scuola di San Giorgio degli
Schiavoni

The apocryphal life of St Jerome tells us that, as St Augustine prepared to write a letter to Jerome, 'an indescribable light, not seen in our times, and hardly to be described in our poor language, entered the cell in which I was, with an ineffable and unknown fragrance, of all odours, at the hour of compline'.[1] At this moment Augustine realized that his correspondent had just died – a moment of insight that, in this canvas, he seems to be sharing with an exceptionally alert dog.

The members of the Dalmatian confraternity in Venice included this story about their compatriot Jerome among the images that they commissioned from Carpaccio for their headquarters. St Augustine himself is probably portrayed with the features of Cardinal Bessarion, who came to Venice after the collapse of the Byzantine Empire, donating his library of Greek manuscripts to the city in 1468. Certainly, apart from the ecclesiastical apse

at the end, the setting is an accurate record of a humanist's study in Renaissance Venice; it is not the 'cell' to which St Augustine refers.

The influence of antiquity pervades the room, from its cornice and coffered ceiling to the Classical statuettes, including a miniature horse, lined up against the wall. Moreover, references to the Liberal Arts appear, not only in the many neatly bound manuscripts but also in the sheets of music and astronomical instruments: a quadrant (for measuring the angles of the stars) in the cabinet at the back, and an armillary sphere (representing the cosmos) suspended near the window on the right. This is the study of a fifth-century Doctor of the Church in the guise of a Renaissance man.

Vittore Carpaccio
(?1460/66–1525/26)
The Dream of St Ursula

1495
Oil on canvas
274 × 267 cm (107 ⅞ × 105 ⅛ in.)
Venice, Gallerie dell'Accademia

Ursula was a fourth-century British princess who was martyred by the Huns in Cologne, together with more than 11,000 other virgins. Her story is a complicated one – she had sailed off with her companions in order to delay marrying a pagan Breton prince – but was very popular in certain areas of Europe, including Venice. Carpaccio's painting is one of a series commissioned by a confraternity that was dedicated to her cult.

Carpaccio has set the scene in a patrician palazzo, in which an angel carrying the palm of martyrdom appears as Ursula sleeps in her luxurious four-poster bed. The chamber is filled with domestic details, such as the pestle and mortar hanging from a nail beneath the candelabrum. Most memorably, thanks to his skill with oil paint, Carpaccio is able to represent the opaque glass in the windows and the subtle shadows cast on to the walls. In his hands, the interior becomes not only a record of contemporary life, but also a study of the play of light.

Filippo Lippi (*c.* 1406–1469)
Virgin with Child with the Birth of the Virgin and the Meeting of Joachim and Anne

Mid- to late 1460s
Tempera on panel
Diameter 135 cm (53 ⅛ in.)
Florence, Palazzo Pitti, Galleria Palatina

The symbolism of the pomegranate has a long heritage: from its association with the pagan Greek goddess Persephone, who returned to earth from the underworld every spring, it became a Christian symbol of resurrection. Here the infant Christ is eating from the fruit, holding a seed as he looks up at his mother.

Mary's 'Immaculate Conception' is the other main theme of the painting. At the time there was a controversy as to whether the Virgin Mary became free from sin at her birth or at her miraculous conception, which took place when her parents, Anne and Joachim, embraced at the Golden Gate in Jerusalem. As both events are depicted here, the painting does not clearly support one side or the other, although the nativity has been made more prominent.

Both scenes – even the meeting at the Golden Gate – take place in a contemporary interior, although one represented with some economy. Lippi focuses on a few details, above all the attendants gathered around St Anne's bed, while on the right a maid carrying a laundry basket combines her daily chores with a pose and clinging drapery that seem to be taken from a Classical relief. The room itself is a spacious chamber in a contemporary palace, its beams slightly distorted to correspond with the curved frame of the panel. This is one of the first painted *tondi* (circular pictures), and it looks almost as if Lippi has held a mirror to the reality outside. Yet the image that he presents is highly artificial and layered with complex meaning: this is not a straightforward reflection of domestic life.

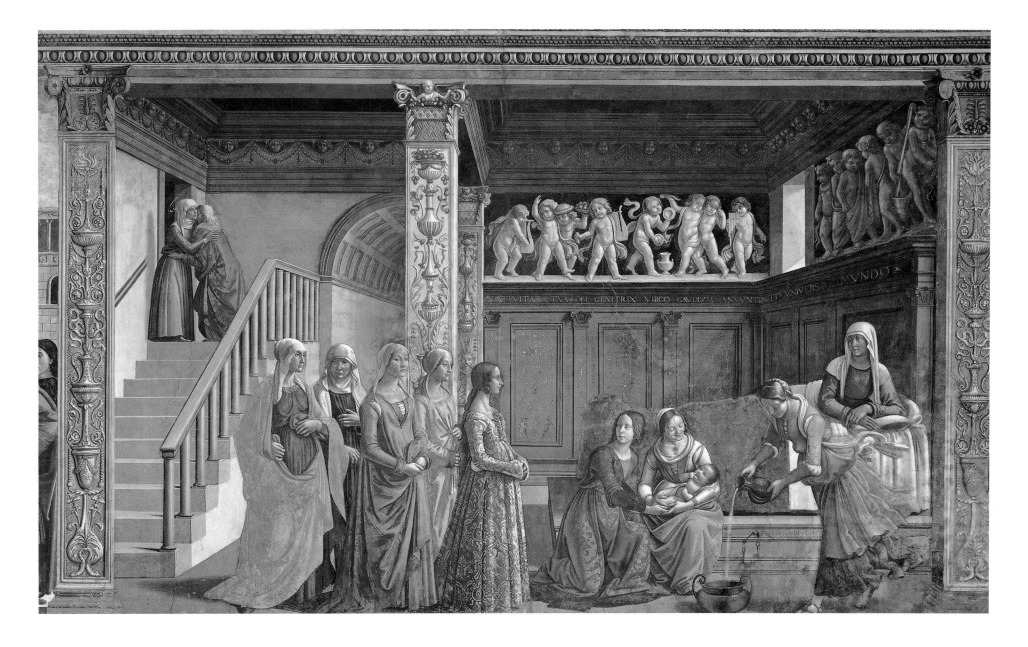

Domenico Ghirlandaio
(*c.* 1448/49–1494)
The Birth of the Virgin

1486–90
Fresco
Florence, Santa Maria Novella,
Tornabuoni Chapel

Ghirlandaio has set the birth of the Virgin in a particularly spectacular palace, adorned with Classical pilasters (flattened columns attached to the wall), wooden panelling and elaborate relief sculpture. Even the most intimate details in the painting accurately reflect contemporary homes and customs: the bed is uncanopied and raised on a platform, unlike the four-posters that became popular in the sixteenth century, while the birth is celebrated by a formal visit from the local ladies, who may well represent portraits of the patron's own family.

The pilaster near the middle of the painting marks the division between the private realm of the bedroom and the public world from which the guests have emerged. More significantly, however, it creates a distinction between two separate incidents in the story: the actual nativity of the Virgin, and her conception, at the meeting of her parents at the Golden Gate in Jerusalem. This event, shown at the top left of the fresco, transforms a Renaissance home into the Holy Land, where miracles coexist with the routines of life.

Andrea del Sarto (1486–1530)
The Birth of the Virgin

1514
Fresco
Florence, Santissima Annunziata, atrium
(cloister)

Andrea del Sarto has taken a familiar subject and placed it in a room of the grandest proportions. There is an impressive sense of space and air, even though parts of the composition are filled with figures or pieces of Classical architecture and sculpture. Resting on top of the bed there are even cherubs, who look like animated versions of the carvings over the fireplace.

The mortal characters are similarly lively. A child, warming herself at the fire, talks to the nursemaid, while the servant on the right engages us with a look over her shoulder.

For all this vitality, however, many of the characters have a strong, monumental quality. The central figure in red assumes a *contrapposto* pose, with her right leg visibly bent forward under her drapery, while Anne's husband, Joachim, demoted to the back of the room, recalls the portrait of Michelangelo in the foreground of Raphael's *School of Athens* (page 8). In this fresco Andrea del Sarto has depicted the minutiae of everyday life, and turned them into classic art.

Domenico Beccafumi
(1484–1551)
The Birth of the Virgin

c. 1540–43
Oil on panel
233 × 145 cm (91¾ × 57⅛ in.)
Siena, Pinacoteca Nazionale

The Sienese painter Domenico Beccafumi has also situated the Birth of the Virgin in a magnificent chamber, with a coffered ceiling and an immense four-poster bed. Unlike Andrea del Sarto's fresco (left), however, the composition is extremely asymmetrical, with St Anne's attendants immersed in pools of light, in contrast to the dark, empty space on the left. The Virgin's father, Joachim, once again appears, with his head resting on his hand, but here he has been banished to an outer room. This is, plainly, a woman's realm.

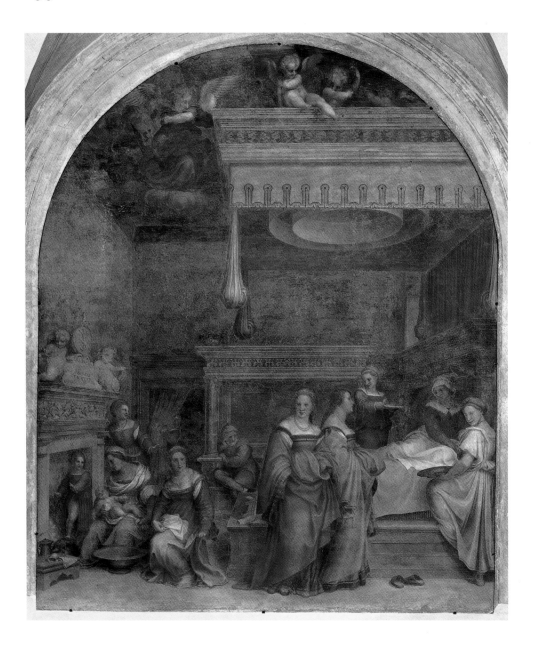

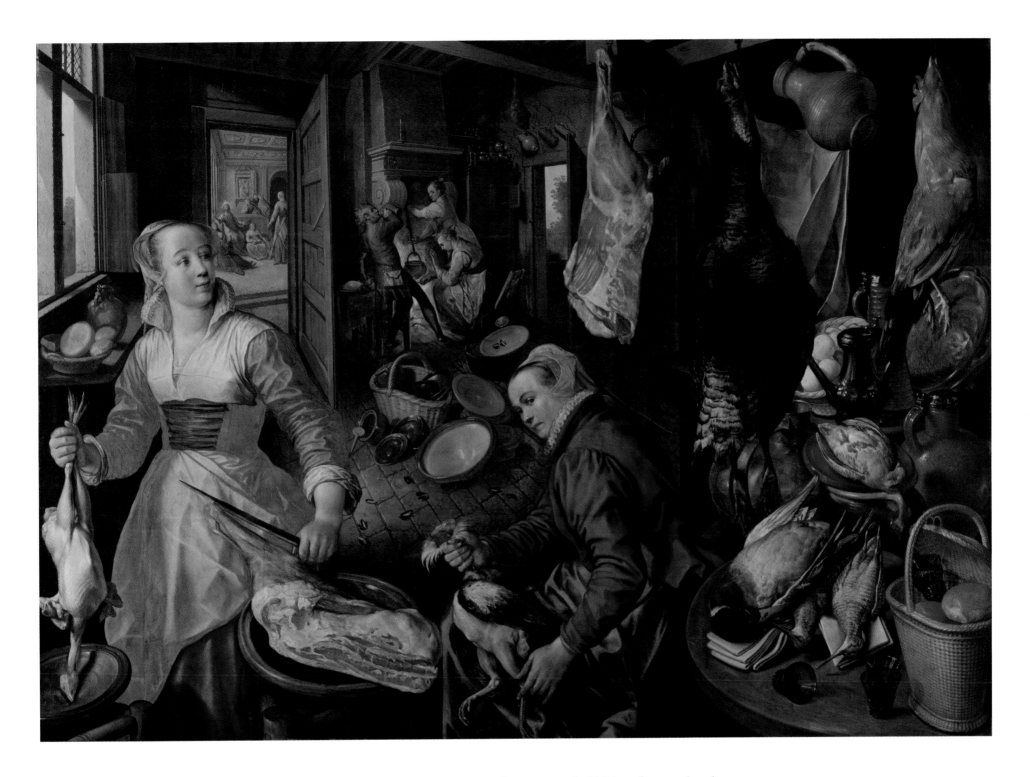

Joachim Beuckelaer
(c. 1534–c. 1574)
*The Four Elements: Fire.
A Kitchen Scene with Christ
in the House of Martha and
Mary in the Background*

1570
Oil on canvas
157.5 × 215.5 cm (62 × 84⅞ in.)
London, The National Gallery

Beuckelaer was one of the greatest pioneers of genre painting, the representation of everyday life, which was generally practised more in northern Europe than in Italy: this example may in fact have been made in Antwerp for an Italian patron. The artist managed to transfer his subject-matter to a scale normally devoted to religious or mythological painting, representing vigorous working women with complex poses at least vaguely reminiscent of Michelangelo.

In this picture we are given a view 'downstairs', into an area of the home often neglected in Renaissance art. The kitchen is

crammed with joints of meat and poultry, and the scene is made even more complicated by the use of multiple viewpoints. Added significance comes from the fire at the back. The flame alludes to one of the four elements, out of which all matter was supposed to be created (the others were earth, air and water). Moreover, in the next room we see an appropriate biblical episode: Christ is upbraiding Martha for worrying more about her sister Mary's chores than the teaching that he is giving her. Beuckelaer perhaps feels that he needs to justify his subject by giving it an edifying story.

THE
CITY

The town seen through the window of *The Virgin and Child before a Firescreen* (opposite), attributed to a follower of Robert Campin, includes tall brick houses with large windows and ornamental gables. The artist is offering us a view of a commercial Flemish city, with a glimpse of ordinary human activity. However, the emphasis in the painting is on the interior (page 148): this is, after all, a place for living in.

The ideal Renaissance city in the panel designed by Luciano Laurana (page 160) is rather different. We can see a wide, symmetrical square, a circular temple and arcaded palaces, with no one visible at all. The picture is clearly influenced by Leon Battista Alberti's architectural treatise *De re aedificatoria* ('On Building', 1452), the rational, Classical principles of which are also demonstrated by Laurana's actual buildings.

Real cities were, of course, thriving, bustling places. Something of their atmosphere can be imagined from the backgrounds of certain Florentine frescoes, where the squares and streets are the settings for the deeds of saints, as in the Brancacci Chapel in Santa Maria del Carmine (page 161). While Masolino's scene is set in a spacious piazza, populated by elegant citizens oblivious of the miracles nearby, Masaccio manages to evoke the squalor of a side street, where the poor and maimed gather to be healed by St Peter. Masaccio achieves a realism unparalleled even in Flemish art, not only by the naturalism of his figures but also by the close-up representation of an alley, a reminder that Florence was still substantially a cramped medieval city.

It was not, of course, only in Florence that religious stories unfolded on the street. Carlo Crivelli, working in the east of Italy, located his *Annunciation, with St Emidius* (page 164) amid magnificent Renaissance façades, at a time when this subject was usually enclosed inside walled gardens and chambers (pages 94 and 95). And a few years later the Venetian Vittore Carpaccio enjoyed the luxury of depicting a miracle that had actually taken place on the Grand Canal (page 165).

In most of these images, the town is primarily a kind of stage set for important dramas; even the 'Ideal City' is merely a fabric of buildings rather than an organism in its own right. We are given little sense of a town's overall structure either from these paintings or from the period's more conventional urban views, in which a skyline of pinnacles and towers usually rises up above a fortified wall. In contrast, Jacopo de' Barbari's woodcut of Venice (page 165) shows 'La Serenissima' from an extraordinary vantage point. We are able to grasp the city as a whole, to admire its shape, given life by the marvels of perspective. Jacopo's incredible feat of measurement and imagination endows Venice with a new grandeur, and reveals the civic pride of the Renaissance at its most magnificent.

Follower of Robert Campin
(*c.* 1375/79–1444)
The Virgin and Child before a Firescreen (detail)
c. 1440
For full details, see page 148

The view in this painting probably does not record an actual Flemish town. However, it is still a vivid evocation of fifteenth-century urban life. The activity is not confined to the streets: men repair a roof, a woman stands at the door of a house, while two figures hold a conversation through a window on the far right.

Although the inhabitants of this neighbourhood are, inevitably, tiny spots of colour, the architecture is painted in considerable detail. Handsome brick mansions alternate with elaborate half-timbered houses, the overhanging upper storeys of which make maximum use of the narrow space available. The largest building is, of course, the church, a Gothic structure with tracery in the windows and a soaring spire.

In contrast to the crowded town, the countryside is a solitary place, with a single house next to a road. Numerous brightly dressed figures walk along the winding street on the right towards one of the city gates, and yet few seem to pass into the landscape beyond. Town and country are neatly defined, in a city without suburbs.

Attributed to Luciano Laurana (birth date unknown–1479) and Piero della Francesca (c. 1415–1492)
View of an Ideal City

Third quarter of the 15th century
Tempera on panel
60 × 200 cm (23 ⅝ × 78 ¾ in.)
Urbino, Galleria Nazionale delle Marche

This city was never constructed. Indeed, it has been suggested that, together with its companion in Baltimore, the painting represents a description of ancient stage scenery by the Roman architect Vitruvius. However, it relates more clearly to the writings of the architect Leon Battista Alberti, who proposed a rational, regular approach to urban planning. Alberti's ideas influenced the construction of the small Tuscan town of Pienza in the early 1460s, but larger projects, such as that depicted here, remained ideals.

Although the spacious square in this picture is imaginary, the individual buildings are comparable to actual Renaissance structures. Certain features, such as the

triangular pediments over some of the palace façades, anticipate the sixteenth century, but the general sense of lightness and openness reflects the work of the Dalmatian architect Luciano Laurana at the Palazzo Ducale in Urbino during the 1460s. Moreover, ruined Slavonic inscriptions have been traced on the panel, suggesting the artist's nationality. For this reason, the design of this painting has been attributed to Laurana, although it was probably executed by Piero della Francesca or one of his followers.

Close observation shows that the square is not completely symmetrical: there is, for example, a basilica in the background to the right, and the palaces have varied forms. It is highly geometric, however, with the coloured paving establishing the modules, or basic units, from which all the proportions derive. Above all, the two-storey edifice in the centre is a perfect circle, with architectural details, such as the small upper windows, that are influenced by Alberti's treatise. Yet, although Laurana's rigorous Classicism is obviously inspired by Alberti's analysis of the ideal 'temple', the building still proclaims its Christian character, with a tiny cross over the lantern at the top.

Masolino da Panicale
(1383–after 1435)
The Healing of the Crippled Man and the Raising of Tabitha

c. 1424–25
Fresco
Florence, Santa Maria del Carmine,
Brancacci Chapel

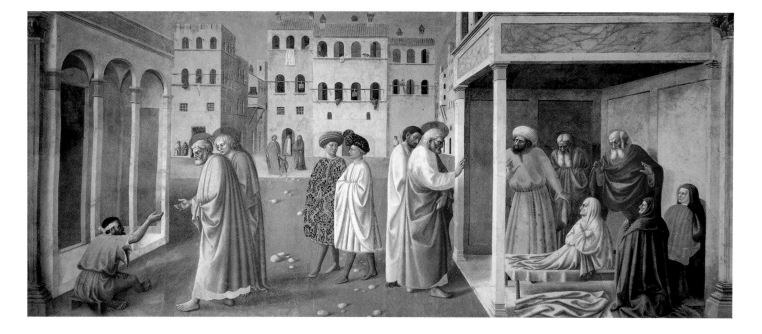

Masolino's composition combines two of St Peter's miracles in a single image. As Peter, accompanied by St John, heals a crippled man in Lydda, two elegant messengers approach to summon him to Joppa, where on the right he is shown raising Tabitha from the dead. The narrative is made more complex by the different costumes – contemporary European, Classical, even 'Oriental' – and by the setting, which is clearly fifteenth-century Florence.

The square in the background, crossed by a few figures, including a woman and a child, is lined by characteristically sturdy Florentine palaces. Although their structures have been simplified, there are a few lifelike details: bird-cages hanging from wooden bars, for example; laundry hanging out to dry; even a pet monkey walking along a window ledge. However, the cityscape is oddly dislocated from the events in the foreground. Physically separate and lacking any significant characters, it has no obvious narrative role.

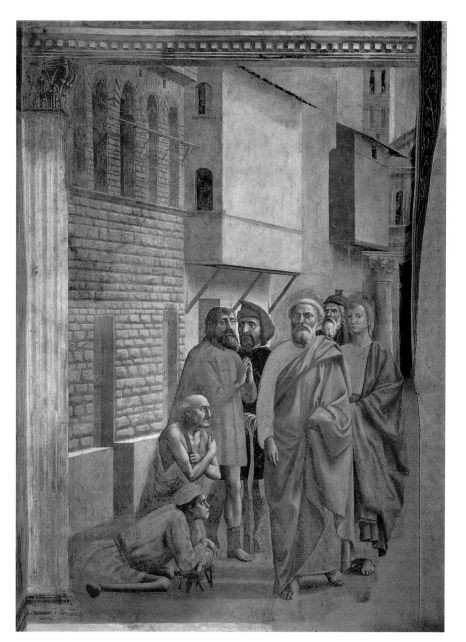

Masaccio (1401–1428)
St Peter Healing with His Shadow

c. 1424–28
Fresco
Florence, Santa Maria del Carmine,
Brancacci Chapel

Here we are plunged directly into a Florentine alley, hemmed in by the houses' projecting upper storeys. A grander building with rustication (roughly hewn blocks separated by deep grooves) can be glimpsed on the corner, but the street itself is crowded with the crippled and destitute, waiting to be healed by St Peter's shadow.

So vivid are these boldly modelled figures that they have often been regarded as portraits of specific individuals: the sculptor Donatello, for example, may be the standing man in the short blue stonecutter's smock, who has already been cured; Masaccio himself is perhaps the beardless St John on the right. The men are located in a convincing perspectival space. The fresco is paired with another scene, *St Peter Giving Alms*, with which it shares a vanishing point, situated behind the altarpiece that separates the two stories. In this way, a miraculous event has been given a tangible reality, inside an ordinary Florentine street.

Domenico Ghirlandaio
(1448/49–1494)
The Approval of the Franciscan Rule

1483–86
Fresco
Florence, Santa Trinita, Sassetti Chapel

When Francesco Sassetti, the manager of the Medici bank, commissioned a fresco cycle for his burial chapel, he naturally chose the life of his name saint, Francis of Assisi. In this scene Francis is received by Pope Honorius III, who gave his approval for the institution of a new monastic order in 1223.

Although the event actually took place in Rome, Ghirlandaio sets it in the political heart of Florence. In the background can be seen the Palazzo della Signoria, fronted by a column supporting a gilded lion, as well as the large arcade known as the Loggia dei Lanzi. On the right the balding Sassetti watches, standing between his employer, Lorenzo de' Medici ('the Magnificent'), and

one of his sons, while Lorenzo's offspring appear with their tutor, the poet Angelo Poliziano, at the top of the steps.

At times Ghirlandaio seems to be cramming too much into his paintings. Yet, through this mass of references, the various functions of the images – devotional, commemorative and political – are made clear, and a compelling image of the Renaissance city is preserved.

IPSVM QVEM GENVIT ADORAVIT MARIA

Domenico Ghirlandaio
(1448/49–1494)
The Raising of the Notary's Son

1483–86
Fresco
Florence, Santa Trinita, Sassetti Chapel

Franciscan fresco cycles rarely included
this story, in which St Francis appears
posthumously to revive a boy who has fallen
out of a window after his mother left home
for Mass. The theme of resurrection had
particular significance for the patrons, the
Sassetti family, since they had recently
celebrated the birth of a child, named
Teodoro after a grown-up son who had died
shortly before. The scene was, therefore, given
a prominent place above the altarpiece of
their chapel.

As he did with *The Approval of the
Franciscan Rule* (opposite), Ghirlandaio has
transferred to contemporary Florence an
event that actually took place in Rome. Here,
however, the setting is not the city centre but

the family's immediate neighbourhood, the
square outside the church in which this
fresco is located. Santa Trinita, without its
sixteenth-century façade, is visible on the
right; the old medieval bridge, named after
the church, can be seen in the background;
while, on the left, the unfortunate boy
plunges from the Palazzo Spini.

As in so many of Ghirlandaio's
paintings, the fresco is filled with portraits of
actual individuals, from the black slave on the
left to the artist himself, who is probably the
figure looking out at us from the opposite
side. Among the other spectators are several
of Francesco Sassetti's daughters, including
Maddalena, who kneels with the streaming
hair and impassioned expression of her
patron saint, Mary Magdalene. Domestic life
has here been taken into the street, without
straying too far from home.

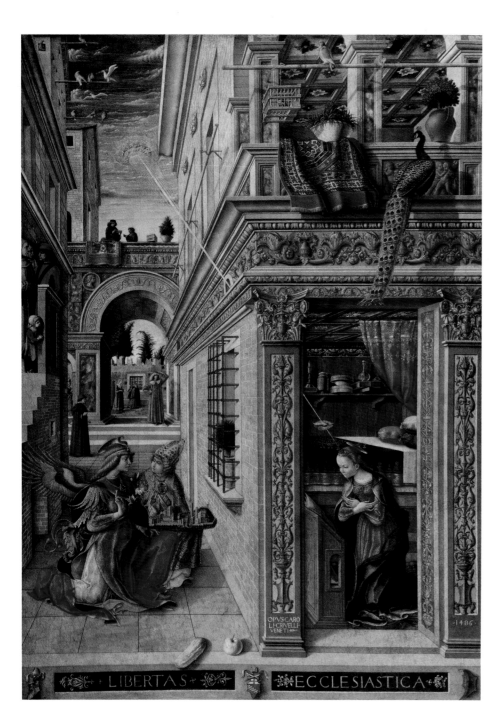

Carlo Crivelli (?1430/35–1495)
The Annunciation, with St Emidius

1486
Tempera, with some oil, on wood transferred
to canvas
207 × 146.7 cm (81½ × 57¾ in.)
London, The National Gallery

This painting was originally in a church
dedicated to the Annunciation (Santissima
Annunziata) in Ascoli Piceno, near Italy's
Adriatic coast. It was commissioned to
celebrate the self-government granted to
the city by Pope Sixtus IV in 1482: as the
news of this arrived on the Feast of the
Annunciation (25 March), the subject
chose itself.

Civic pride also accounts for the
appearance of Ascoli's patron saint,
Emidius, holding a model of the city, and for
the setting – an idealized view of the town,
its clean, straight streets lined with marble-
clad palaces and a triumphal arch, all in the
most up-to-date Classical style. Crivelli has
included the odd realistic detail: the brick
steps on the left, the wooden bars outside
the windows (for hanging blinds), and the
mortar dribbling down the walls in the
distance. Even the Oriental carpets would
have adorned buildings at the time of public
festivals, such as the one that took place
every year on 25 March.

Yet this is a spacious, prosperous city of
the imagination, its citizens serenely going
about their business. Only a monk, a child
and a man in the street look in the right
direction, as the bright ray descends towards
the Virgin.

OPPOSITE, TOP

Vittore Carpaccio (?1460/66–1525/26)
The Miracle of the Relic of the True Cross on the Rialto Bridge (The Healing of the Possessed Man)

1494
Oil on canvas
365 × 389 cm (143¾ × 153⅛ in.)
Venice, Gallerie dell'Accademia

This canvas was one of a series inside the
headquarters of the Venetian religious
confraternity known as the Scuola Grande
di San Giovanni Evangelista. The paintings'
subjects are all connected with a fragment
of the True Cross (on which Christ was
crucified), donated to the Scuola in 1369.
Here the Patriarch of Grado uses the relic to
heal a possessed man: the miracle takes place
in the loggia of his palace on the Grand
Canal, one of the most prominent locations
in the city. In this way, the confraternity's
most precious possession, usually hidden
from view, is made public, in image at least.

From the fall of light, it is also possible
to work out that the story takes place in the
morning, at the peak of the city's activity.
Both the canal and its embankment are
crowded with people of different
nationalities: Armenians or Greeks in tall
brimmed hats (in the bottom left); turbaned
Turks in the background; an African
gondolier; and, of course, local people,
observing the miracle, conducting their
business, repairing tiles, or even beating a
carpet at a window. Most importantly, a
procession of confraternity members can
be seen crossing the bridge. More are visible
in the loggia itself.

Carpaccio has probably embellished
certain features: the loggia is adorned with
gilded medallions, and even the chimney
pots are extravagantly ornate. However, he
has also captured the city's genuine grandeur,
and has created a fitting setting for an
extraordinary event.

BELOW

Jacopo de' Barbari
(c. 1460/70–1516)
Perspective View of Venice

1497–1500
Woodcut
134.5 × 281.8 cm (53 × 111 in.)
Venice, Museo Correr

This magnificent print, made with six woodblocks that still survive at the Museo Correr, was published by Anton Kolb, a merchant from Nuremberg, who probably also helped Jacopo to gain the post of Habsburg court artist soon after it was made. At the top, Mercury, the messenger god, appears, holding his wand, or *caduceus*, which was also Jacopo's symbol, while Neptune rides a dolphin near the clusters of ships below. A few people are barely visible on the quays, but the main character is the city itself, extending in perspective around the serpentine Grand Canal.

This is not a perfect map of Venice, although Jacopo must have based it on many careful studies. Certain details are of great historical interest: the old timber Rialto Bridge can be seen across the Grand Canal, while the top of St Mark's bell tower still shows the damage caused by a thunderbolt in 1483. However, the main appeal of the print lies in the grandeur of its vision, which allowed Kolb to sell it for three ducats a copy, publicizing in other lands 'the fame of this exceedingly noble city'.[1]

PRINCES
&
COURTIERS

Andrea Mantegna's frescoes in the Camera Picta of the Palazzo Ducale in Mantua (opposite) are among the most vivid images of courtly life made in any period. The scenes combine business and pleasure, diplomacy and family life, no doubt reflecting the varied activities that took place in a fifteenth-century palace. Like Piero della Francesca's contemporary portrait of the Duke of Urbino (page 170), they provide a civil, peaceful image of a Renaissance prince, even though war was never far away, as is revealed by the duke's armoured figure in a slightly later altarpiece (page 171).

It is also very striking that in the altar painting, as in the murals, the artist was able to represent his patron in full length, while the smaller panel is merely a head in profile, as if taken from a Roman medal or bust. Eventually, Italians adopted the more naturalistic poses of their counterparts in northern Europe, revealing their sitters' upper bodies and arms, but it was not until the early sixteenth century that full-length portraits became common.

Hans Holbein (pages 175, 177 and 184) and Titian (pages 181 and 183) were among the most spectacular exponents of the new portraiture. Their male subjects – especially monarchs and their representatives – often stand confidently, surrounded by emblems of their power, wealth and education. Of course, even in the sixteenth century artists chose formats that were appropriate to their subject: Giovanni Bellini uses an old-fashioned bust-like format for a Venetian doge (page 179), while Raphael gives a seat to the elderly Pope Julius II (page 178), who is lost in contemplation.

Yet how different all these male rulers are from the demure women of the period, sitting doll-like in their finery (page 174) or, at best, playing chess (page 185). This does not mean that female aristocrats and courtiers were all painted in the same way. The Duke of Milan's mistress (page 172) is an epitome of elegance; the king of France's (page 187) is bereft of clothes. The possibilities were endless, but rarely were women credited with the intellectual sophistication or authority of men.

A Renaissance court did not, of course, simply consist of nobility. The entertainment was elaborate and home-made, embracing midgets, madmen, clowns and hirsute women. This chapter closes with images of these minor courtiers, ranging from the comic to the poignant and downright cruel (pages 188, 190 and 191).

Andrea Mantegna
(1430/31–1506)
The Court of Ludovico Gonzaga

1465–70
Tempera on plaster
Mantua, Palazzo Ducale, Camera Picta
(or Camera degli Sposi)

Mantegna worked for the Gonzaga family for more than forty years. His most remarkable painting was the decoration in their palace of a room known as the Camera Picta ('Painted Chamber'). Its alternative name, Camera degli Sposi, or 'Chamber of the Spouses', reflects its celebration of the two principal characters, Ludovico Gonzaga and his wife, Barbara of Brandenburg, the two seated figures in this scene. They are surrounded by a dense cluster of their household – three sons, two daughters, a dog, a wet nurse, a midget and other functionaries – while on the right attendants in gold brocade and the Gonzaga colours escort an ambassador from another court.

Perched on a narrow ledge above the fireplace and theatrically revealed by the painted curtain, most of the characters seem stiff and formal, although they are actually far more varied than in most portraits of this period. The liveliest interaction is between Ludovico and his secretary, who has just handed him a letter. Some art historians have argued that this alludes to a specific event, such as the news of the Duke of Milan's sickness in 1461, although it may just as well refer to the business that would have taken place routinely in this room.

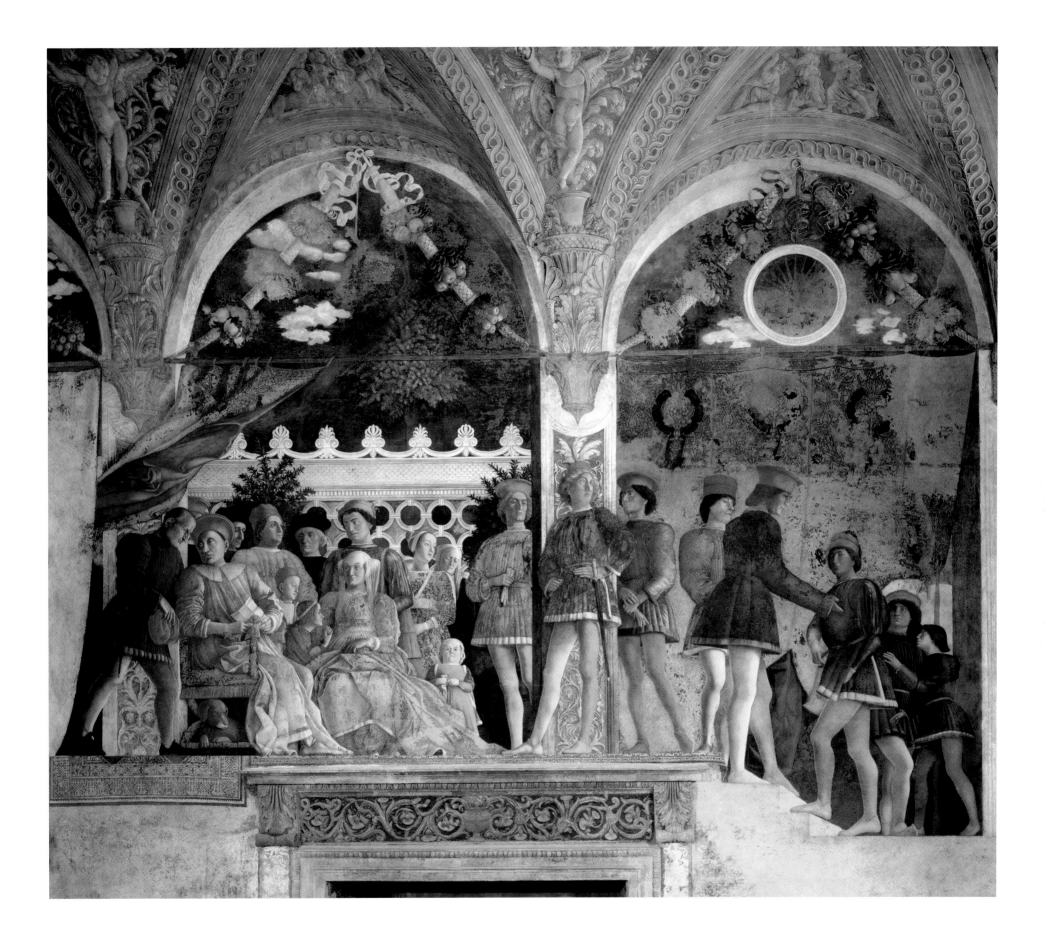

Piero della Francesca
(*c.* 1415–1492)
Battista Sforza and Federico da Montefeltro

c. 1467–70
Tempera on panel
47 × 33 cm (18½ × 13 in.) each
Florence, Galleria degli Uffizi

Piero used a traditional profile format for these portraits of the Duke of Urbino and his wife, Battista Sforza, who had recently died. Conveniently, this view hides the duke's disfigurements, in particular the eye destroyed in a jousting tournament in 1450; it also creates an air of formality, even as the couple gaze at each other across the picture frame.

The couple's heads are silhouetted against the sky, while their collars are aligned with the horizon. The countryside behind the duchess is neat and agricultural, while in the duke's portrait the scenery is made more irregular by the open expanse of water. These landscapes, melting in the far distance, reappear on the reverse of each panel, where Battista and Federico are driven on triumphal chariots, their virtues extolled through allegorical figures and Latin inscriptions.

Jean Fouquet
(c. 1425–c. 1478)
Charles VII, King of France

c. 1445/50
Oil on panel
85 × 70 cm (33 ½ × 27 ½ in.)
Paris, Musée du Louvre

The most extraordinary feature about this picture is that X-rays have revealed beneath its surface an unfinished version of the *Virgin and Child with Angels* (page 81), a painting that is generally thought to contain the disguised features of Charles VII's mistress. Although this gives us an insight into Fouquet's workload, it is perhaps wise not to read too much into it. Ultimately, the portrait of Charles VII is a straightforward court commission, for which Fouquet happened to reuse a suitable oak panel.

Charles is shown in three-quarter view, resting his hands on a ledge. It seems as if it is a good likeness: Fouquet has exploited the slow-drying qualities of oil paint to represent Charles's features and skin in remarkable detail. Most notably, he presents the king in luxurious but relatively informal clothes. As the inscription suggests, Charles had recently vanquished the English. Yet he is also a modern monarch, a man of civility, who is able to put aside, at least for a time, the trappings of a medieval warrior king.

Piero della Francesca
(c. 1415–1492)
Madonna and Child with Saints (The Brera altarpiece)

1472–74
Tempera on panel
248 × 170 cm (97 ⅝ × 66 ⅞ in.)
Milan, Pinacoteca di Brera

This altarpiece presents an impressive array of saints: John the Baptist, Bernard of Siena and Jerome on the left; Francis, Peter Martyr and Andrew on the right. They stand underneath an ostentatious Classical barrel vault, from which hangs an ostrich egg, symbolizing both the Virgin Birth and the Resurrection. To the right, the patron, Federico da Montefeltro, kneels in adoration – full-length but still confined to a profile view. His armour reveals the burden of his earthly responsibilities, while at the same time he is physically linked with the divine presence by the diagonal of his sword, which corresponds with the corpse-like body of the infant Christ. A chain of associations has been created, to which the Duke of Urbino has been carefully connected.

Leonardo da Vinci (1452–1519)
The Lady with an Ermine

c. 1485–90
Oil on panel
55 × 40.5 cm (21 ⅝ × 16 in.)
Poland, Cracow, Muzeum Książąt
Czartoryskich

The identification of the woman in this
painting depends on the animal that she
holds so tenderly; sadly, the inscription is not
original. The creature is usually deemed to be
an ermine, the symbol of the Milanese duke
Ludovico Sforza, known as *il moro* ('the
Moor') on account of his dark complexion.
Some scholars have insisted that it is not an
ermine – a stoat in its white winter coat – at
all, but a ferret. It makes little difference,
since the ancient Greeks, who were not so
particular, had one word for this type of
animal, and this puns (approximately)
with the surname of Cecilia Gallerani,
Ludovico's mistress from the age of sixteen.

As well as being half-length, this portrait
is remarkable for its sense of movement and
style. The anatomical distortions – the
sloping shoulders and elongated hand –
accentuate the girl's sinuous elegance. As she
evades our glance demurely, we can almost
believe in the purity that is another symbolic
meaning of the ermine. The mysterious dark
background (in fact repainted over a shade
of grey-blue) only adds to the allurement.

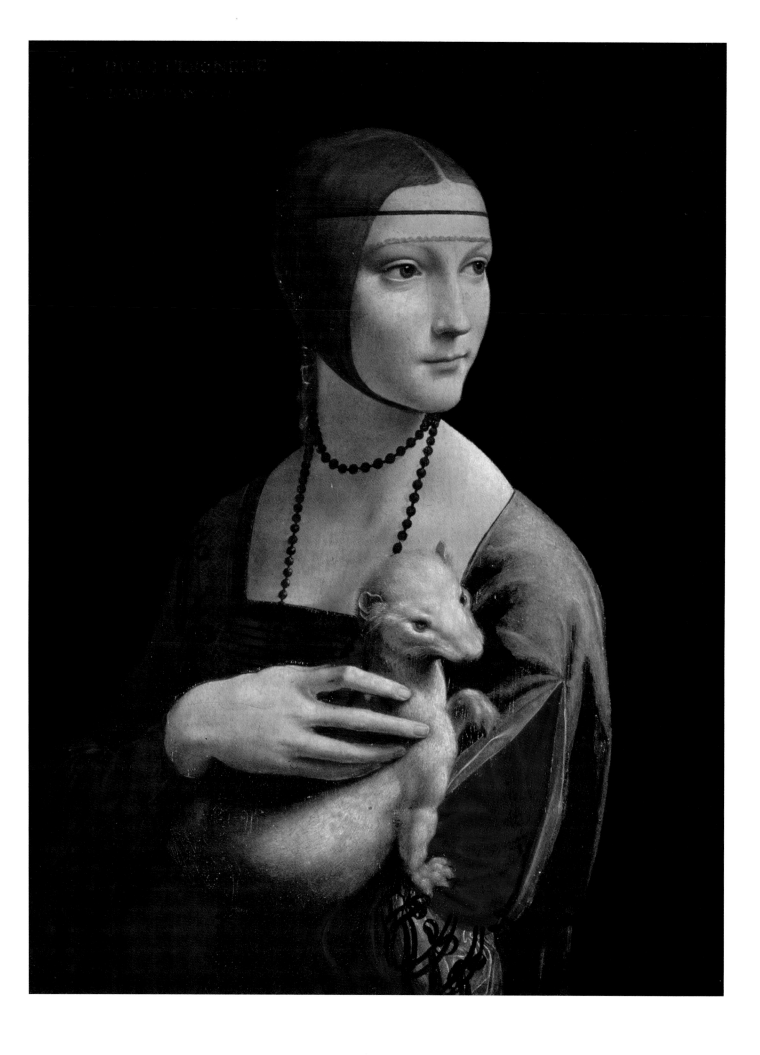

Pisanello (Antonio Pisano)
(by 1395–1455)
Ginevra d'Este

c. 1435–40
Tempera on panel
43 × 30 cm (16 ⅞ × 11 ¾ in.)
Paris, Musée du Louvre

Here the sitter's profile is animated by the carnations, columbines and roses in the background, as well as by the red admiral, scarce swallowtail and clouded yellow butterflies. Together they form a delicate pattern that harmonizes with the beautiful colours of the sitter's costume.

Nothing in this painting is accidental: the embroidered vase with protruding roots on the woman's sleeve is an emblem of the Ferrarese d'Este family, while the juniper (*ginepro*) attached to her shoulder identifies her as Ginevra, who had the fate of being married in 1433 to the unsavoury ruler of Rimini, Sigismondo Malatesta.

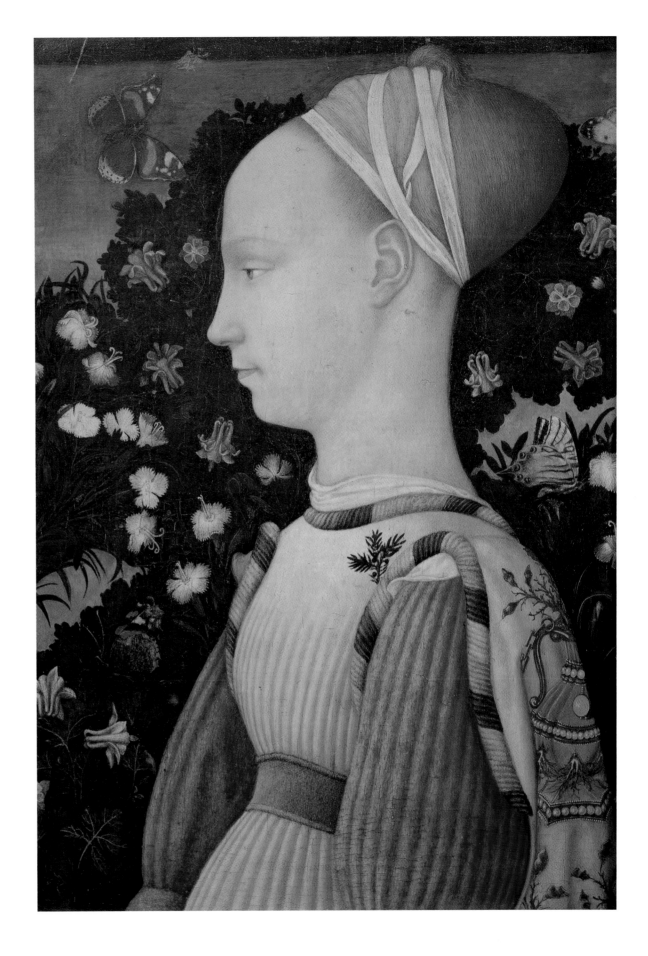

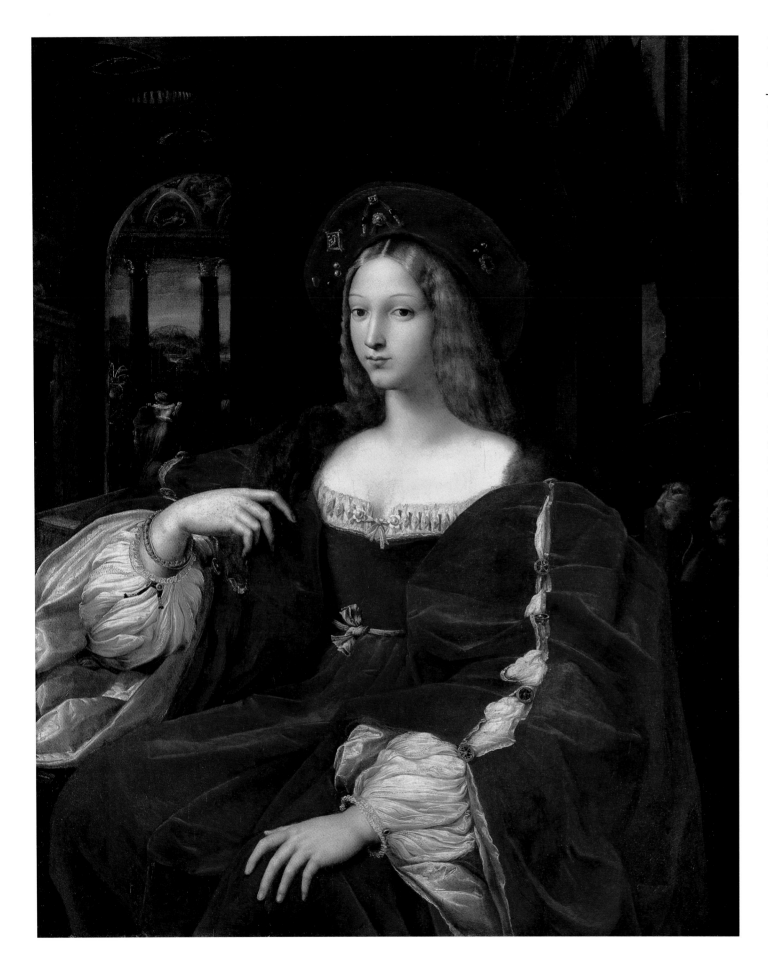

Raphael (1483–1520) and Giulio Romano (?1499–1546)
Joanna of Aragon

1518
Oil on panel transferred to canvas
120 × 95 cm (47 ¼ × 37 ⅜ in.)
Paris, Musée du Louvre

The sitter, granddaughter of the king of
Naples, was a famous beauty. Consequently,
in the year of Joanna's betrothal, the French
king, Francis I, was sent this portrait so that
he could see for himself how she had gained
her reputation, even though she was actually
marrying somebody else (the Constable of
Naples). There is perhaps more life in the
curl of Joanna's fingers than in her doll-like
face, which was not painted from life: in
order to avoid travelling from Rome to
Naples, Raphael sent a pupil, who brought
back a full-scale drawing, or cartoon, on
which the master based his picture.

Thanks to the cartoon, which remained
in Italy after the painting had left for France,
the image was hugely influential. Unusually
for a seated portrait at this time, it extends
beyond the knees, and is composed so as to
show to maximum effect the magnificent
dress, with its wide bejewelled sleeves and
layers of fabric. The deep, rich colours
are offset by the dark room, which leads
to the painted loggia and intriguing
landscape beyond.

Hans Holbein the Younger
(1497/98–1543)
Anne of Cleves

1539
Parchment mounted on canvas
65 × 48 cm (25 ⅝ × 18 ⅞ in.)
Paris, Musée du Louvre

Henry VIII was, famously, unsuccessful at
marriage. This was not for want of trying.
In 1539 he sent Holbein to Düren in north-
western Germany to paint the two sisters of
the Duke of Cleves. In Germany Holbein
began the picture on parchment, which
could easily be rolled up and transported,
but probably finished the clothes in England,
using a cartoon. A frontal view may have
been demanded by the king as being more
revealing than any other format: with no
obvious deformity, Anne was chosen as
his bride instead of her sister, Amelia.
Unfortunately, a profile portrait would have
displayed more clearly the length of her nose.
The marriage took place in January 1540.
It was annulled in July.

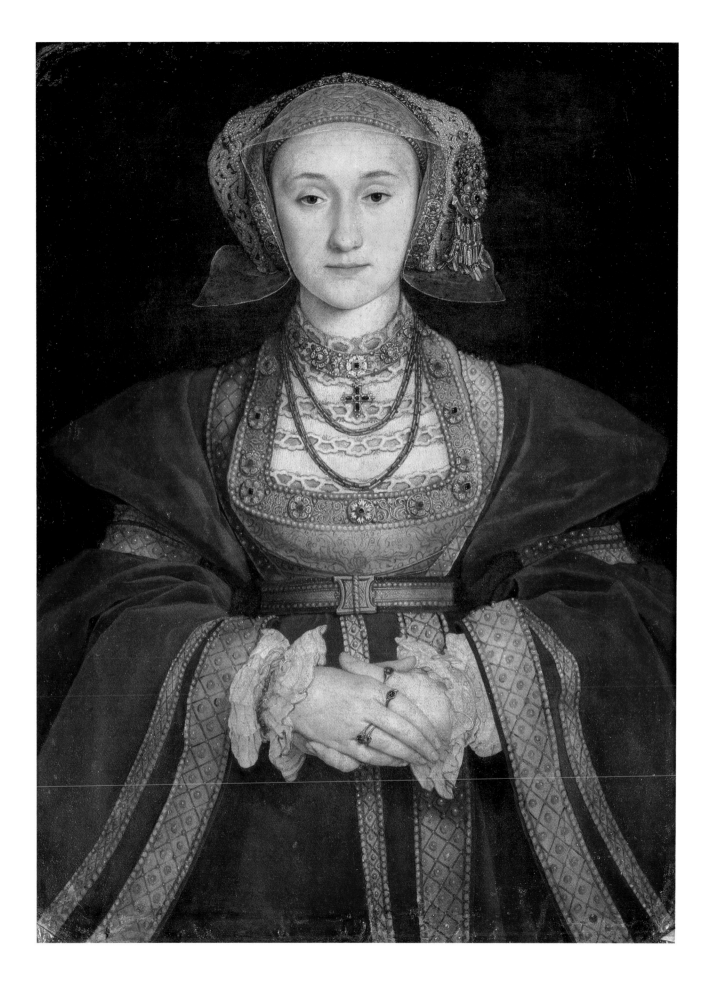

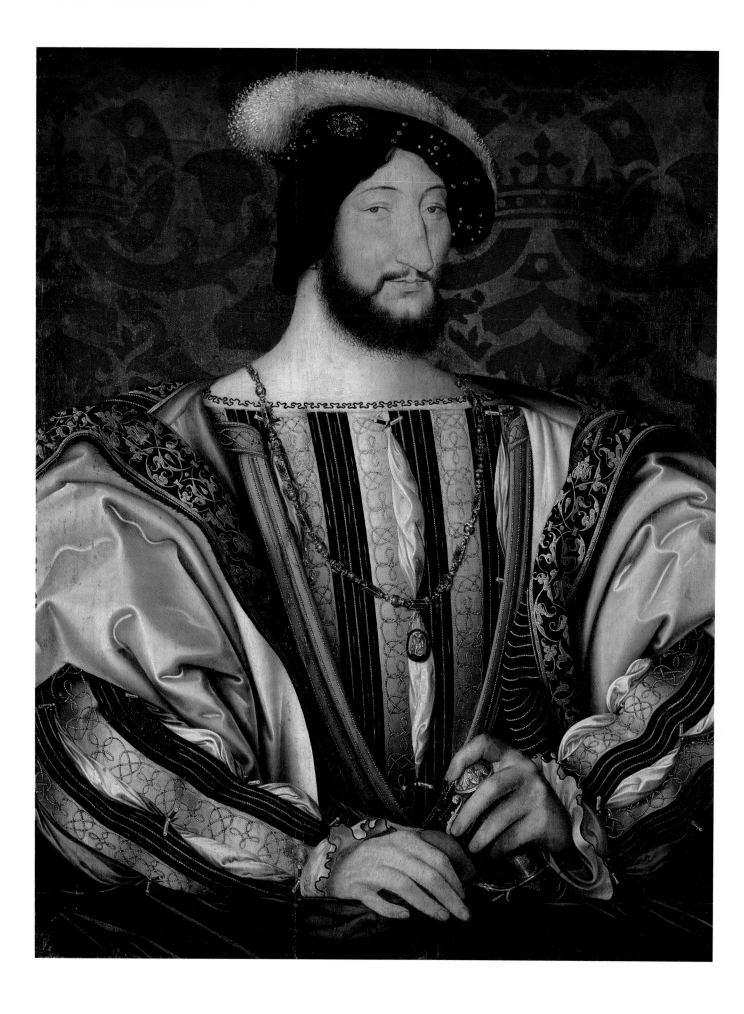

Jean Clouet (*c.* 1485–*c.* 1540/41)
and François Clouet
(*c.* 1516–1572)
Francis I, King of France

c. 1530
Oil on panel
96 × 74 cm (37 ¾ × 29 ⅛ in.)
Paris, Musée du Louvre

It is possible that Jean Clouet, the French
king's court painter, executed Francis's face
after his own drawing (which survives),
leaving the body and clothing to his son
François. Alternatively, François may have
made the whole picture, using his father's
study as the model for the head.

The half-length format, the hand with a
glove resting on the parapet and the three-
quarter view of the face are features typical of
Renaissance portraiture. However, the broad
body, with its frontal pose, and the lavishly
embroidered costume signify that this is
someone of exceptional power and wealth.
The specific identity is indicated by the
medallion of the Order of St Michael, of
which Francis was the grand master, and
by the crowns in the red cloth behind.
The modern monarch's courtly costume
did not preclude more conventional symbols
of royalty.

Hans Holbein the Younger
(1497/98–1543)
Edward VI as a Child

Probably 1538
Oil on panel
56.8 × 44 cm (22⅜ × 17⅜ in.)
Washington, D.C., National Gallery of Art

This is undoubtedly the New Year's present that Holbein gave to Henry VIII in 1539. The compliment is compounded by the elaborate inscription, encouraging the young prince, then fifteen months old, to emulate his father.

The painting is based on a careful drawing, inscribed *Edward Prince*, at Windsor Castle. As in other portraits of this period, the subject was set in front of a blue background that has gradually darkened. Indeed, in many respects it is a highly conventional image, except that, instead of a sword hilt, Edward clasps an elaborate gilded rattle.

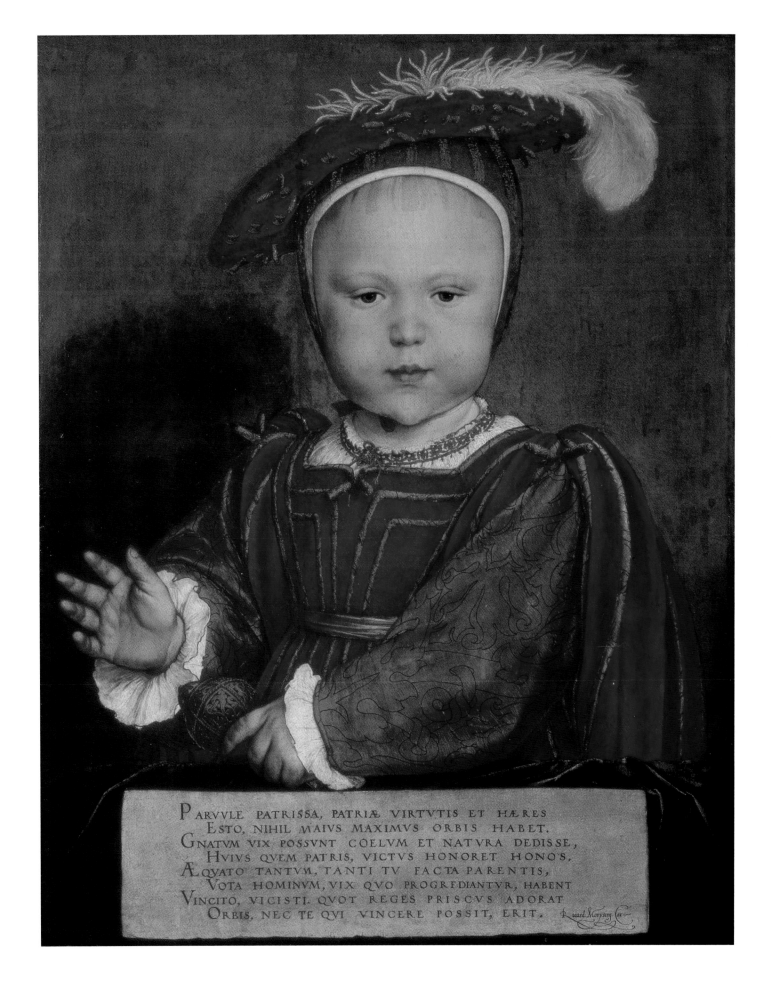

PARVVLE PATRISSA, PATRIÆ VIRTVTIS ET HÆRES
ESTO, NIHIL MAIVS MAXIMVS ORBIS HABET.
GNATVM VIX POSSVNT CŒLVM ET NATVRA DEDISSE,
HVIVS QVEM PATRIS, VICTVS HONORET HONOS.
ÆQVATO TANTVM, TANTI TV FACTA PARENTIS,
VOTA HOMINVM, VIX QVO PROGREDIANTVR, HABENT
VINCITO, VICISTI. QVOT REGES PRISCVS ADORAT
ORBIS, NEC TE QVI VINCERE POSSIT, ERIT.

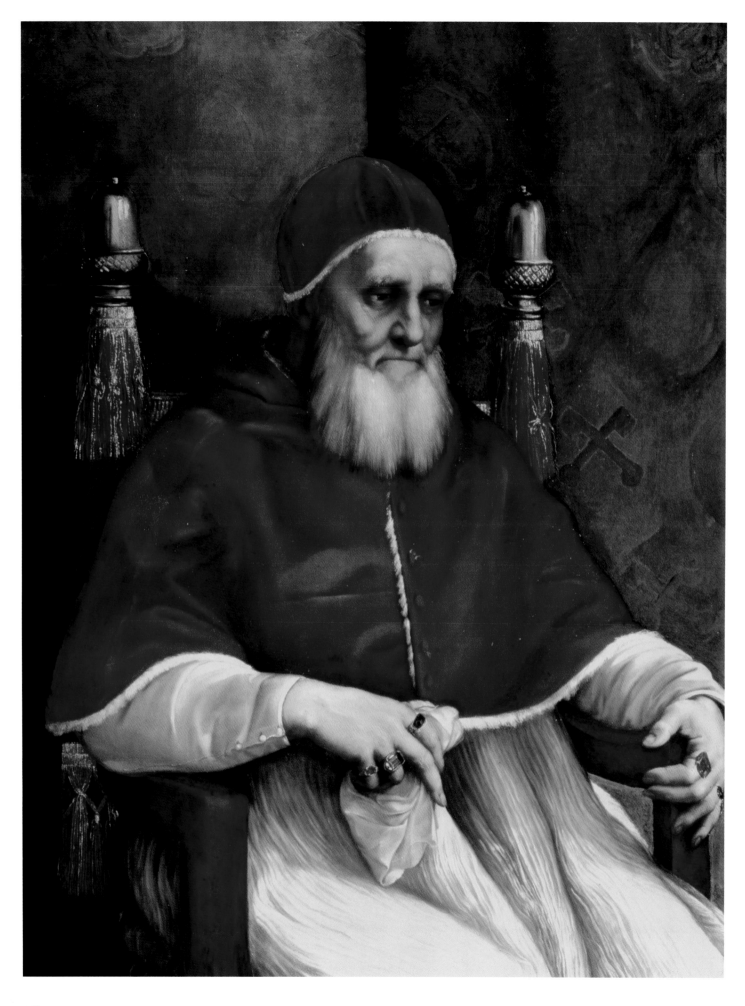

Raphael (1483–1520)
Portrait of Pope Julius II

1511
Oil on panel
108.7 × 81 cm (42¾ × 31⅞ in.)
London, The National Gallery

An apparent intimacy is created by the
pope's thoughtful, downward gaze and the
angle of our view. It is as if he is unaware
that we are watching him. Of course, this is
a fiction. Although not wearing a mitre or
ceremonial robes, Julius sits amid the symbols
of his high birth and office: the acorns on his
throne are emblems of his family, the della
Rovere, while in the curtain above his head
can still be seen the papal keys, which
Raphael painted over before completing
the portrait.

Despite this formality, the psychological
insight is remarkable. The pope is represented
with a melancholy expression, emphasized
by the beard that he grew in mourning for
the loss of Bologna by papal forces in 1511.
Yet his continuing strength and magnificence
are made clear, even by his fingers firmly
grasping the chair, their jewelled rings in
harmony with the rich palette of gold, red
and green that dominates the painting.

Giovanni Bellini
(?1431/36–1516)
The Doge Leonardo Loredan

c. 1501–04
Oil on panel
61.6 × 45.1 cm (24¼ × 17¾ in.)
London, The National Gallery

The head of the Venetian Republic was the doge, who was elected for life on the death of his predecessor. His duties were mostly ceremonial, although he could exert influence as chairman of the decision-making bodies, the Senate, the College and the Council of Ten.

Loredan would have commissioned this work shortly after his election. Bellini has provided a suitably formal, bust-like portrait, placing the doge behind a coloured marble parapet, to which is attached a paper inscribed with the artist's name. The blue in the background varies in intensity like a real sky, while Bellini has fully exploited the special qualities of oil paint: its slow-drying nature, which allowed him to paint Loredan's wrinkles and other features in minute detail; and the ability to use glazes to represent subtle effects of light and shade.

Above all, Bellini has captured a remarkable ambiguity of mood. The illuminated side of the face is stern and unyielding, while in the shadows a faint smile plays on the lips and in the eyes: this is a figurehead with a human side, after all.

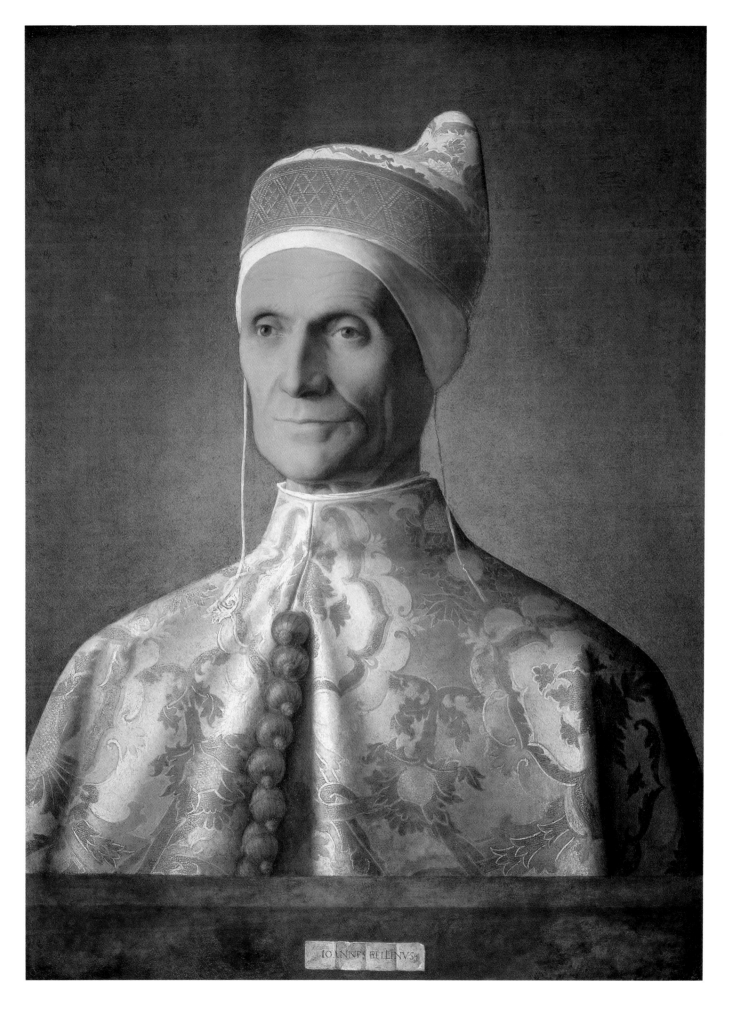

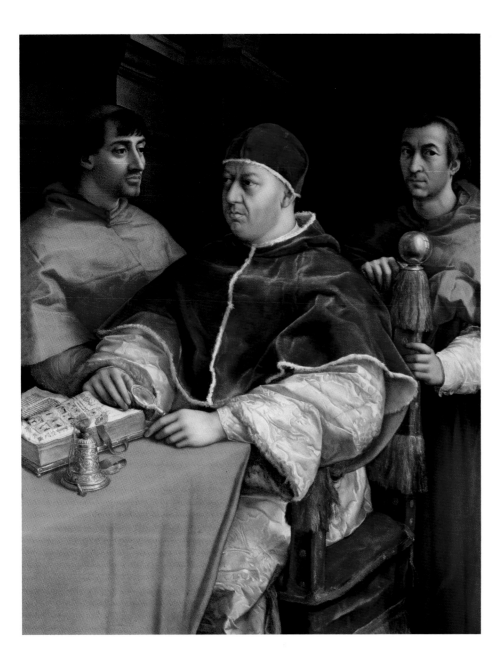

Raphael (1483–1520)
Portrait of Pope Leo X with the Cardinals Giulio de' Medici and Luigi de' Rossi

1518
Oil on panel
155.5 × 119.5 cm (61¼ × 47 in.)
Florence, Galleria degli Uffizi

Julius II's successor, Leo X, is accompanied by two cardinals, one of whom, his cousin Giulio de' Medici, was subsequently to become Pope Clement VII. While the cardinals are stiffly posed, the pope is represented as if he has just stopped reading: he is still holding a magnifying glass in his left hand. Being a Medici, the pope is obviously something of a connoisseur. As well as the illuminated manuscript on the table – presented so accurately that it has been identified with a surviving example – he has an exquisite gold-and-silver bell, wrought with Classical vine scrolls. Its surface catches the light from the window, which itself is reflected on the ball of the chair. The description of the material world is completed by the rich colours and textures of the men's robes, in damask, velvet and fur. As Giorgio Vasari simply put it, 'everything in this picture is executed so diligently that no other painter could ever possibly surpass it. The pope was moved to reward him very generously'.[1]

OPPOSITE

Titian (Tiziano Vecellio)
(*c.* ?1485/90–1576)
Pope Paul III with His Grandsons Alessandro and Ottavio Farnese

1545–46
Oil on canvas
210 × 174 cm (82⅝ × 68½ in.)
Naples, Museo Nazionale di Capodimonte

In Titian's unfinished portrait, executed during a trip to Rome, the seated pose used by Raphael (left) is transformed into an image of wily alertness. Paul III's relatives include (on the left) Cardinal Alessandro Farnese, the patron of Titian's *Danaë and the Shower of Gold* (page 126), and the bending Ottavio, who is not represented any more flatteringly than is his grandfather. Perhaps this is why the painting was never completed, although, having acquired an ecclesiastical benefice for his son Pomponio, Titian may simply have decided that he had achieved all his goals in Rome.

Titian certainly seems to have had a satisfying time. Welcomed at the papal court in October 1545, he was introduced to the leading Roman artists of the day – above all, Michelangelo – and, as he wrote to Emperor Charles V, he went about studying antiquity, 'among these marvellous antique stones'.[2] After receiving Roman citizenship a few months later, he returned home to Venice.

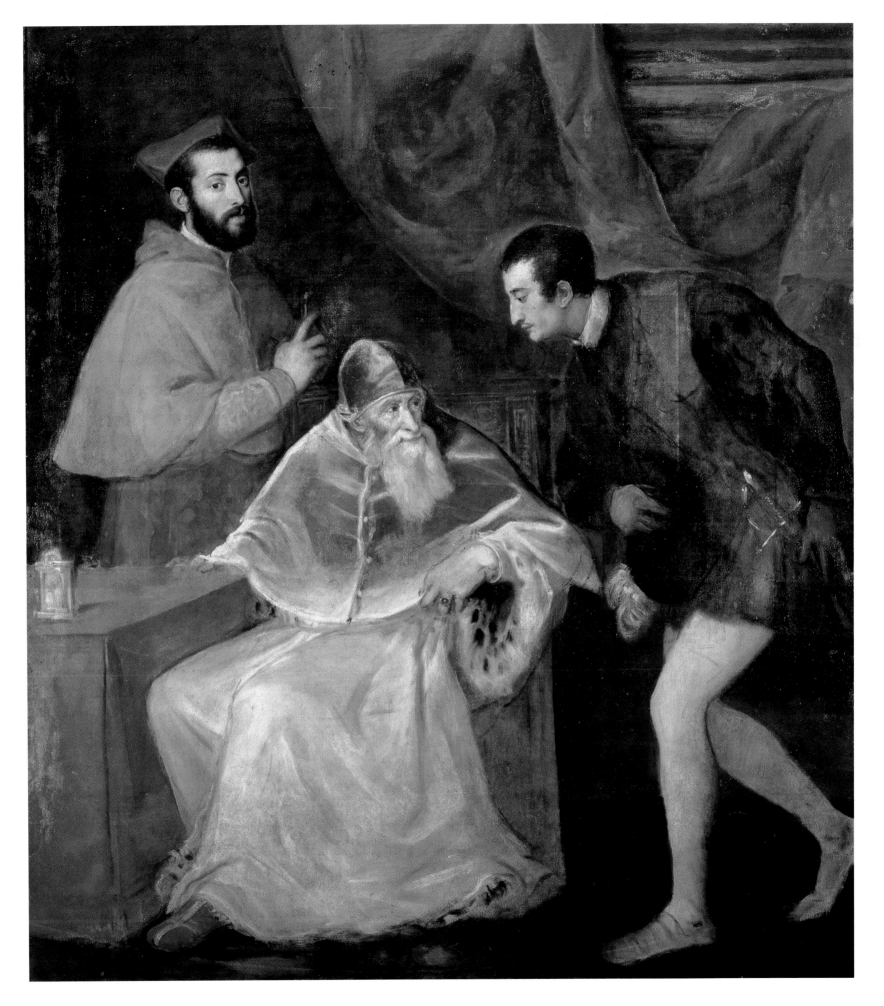

Lucas Cranach the Elder (1472–1553)

Henry the Pious, Duke of Saxony, and his wife, *Catherine, Duchess of Mecklenburg*

1514
Oil on panels transferred to canvas
184.5 × 83 cm (72 ⅝ × 32 ⅝ in.) each
Dresden, Gemäldegalerie Alte Meister

The Duke of Saxony, who was far from pious, was particularly fond of large bronze cannons, for which Cranach supplied him with diverting erotic designs. Here he swaggers in a flashy, striped costume that flatters his long, slender limbs.

It is likely that these two panels were originally a single picture: Cranach's monogram, the winged serpent, appears only once. Unlike her expansive husband, Catherine is demure and self-contained, although her clothing has also been highlighted with liberally applied gold leaf. She was in fact the dominant force in the marriage, driving the couple towards Martin Luther, although initially the German Masses at their castle in Freiburg were held in secret.

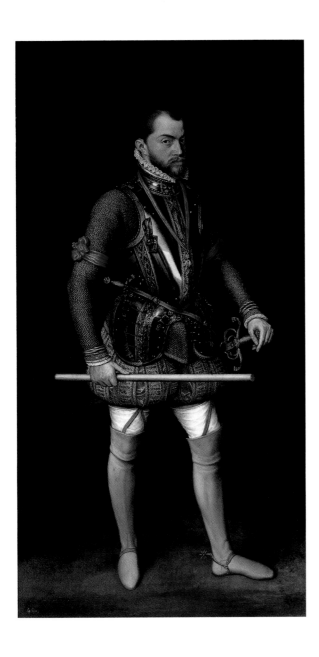

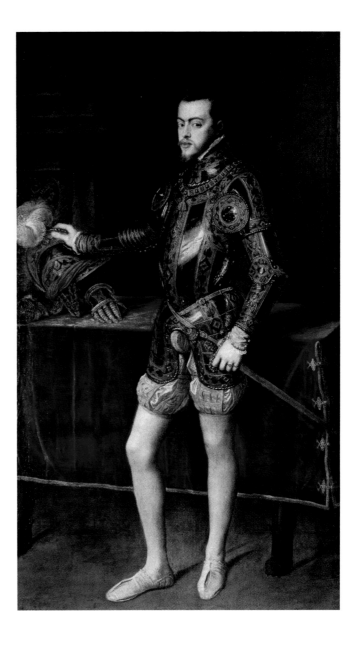

Antonis Mor (1516/20–?1576)
Philip II of Spain

1557
Oil on canvas
138 × 125 cm (54⅜ × 49¼ in.)
Spain, El Escorial, Monasterio de
San Lorenzo

The Dutch painter Antonis Mor owed his
success largely to his strong association with
Philip II, the king of Spain and The
Netherlands. Indeed, in 1558 Mor made a
self-portrait, to which was attached a verse
comparing their relationship to that between
Apelles and Alexander the Great.

Philip II undoubtedly felt a personal
attachment to Mor, whom he took with
him to Spain in 1559. He had reason to be
grateful, since Mor gave his patron a valorous
image, which he did not always deserve.

When, in 1576, Philip gave this picture
to the monastery of El Escorial, it was
inventoried as representing the king as he
was during his victory over the French at
St Quentin. The implication was that he had
actually fought at the battle, in 1557. In fact,
although he had worn his armour, he had
carefully kept his distance from the fighting.

This element of fiction is complemented
by the artifice of Mor's composition.
Although he is often described as a master of
naturalism, Mor was in fact as accomplished
as Titian at creating a visual order that his
subject may not originally have had. The
crimson armbands and other regalia form
a lively pattern of diagonals, closed off by the
horizontal line of the baton. Philip's symbol
of military command could not have been
more effectively portrayed.

Titian (Tiziano Vecellio)
(c. ?1485/90–1576)
Philip II of Spain

1550–51
Oil on canvas
193 × 111 cm (76 × 43¾ in.)
Madrid, Museo Nacional del Prado

Titian travelled from Venice to Milan in
1548, in order to meet the young Prince
Philip, the heir of Emperor Charles V.
This resulted in one of the most productive
partnerships in Renaissance art: over the
next two decades Titian sent Philip a
regular supply of religious and mythological
pictures, as well as this flamboyant portrait,
painted over an earlier image of his father,
Charles.

According to a letter that he wrote to his
aunt, Philip seems to have thought that the

painting looked unfinished, even though
by Titian's standards the brushwork is tight
and controlled. The full-length format
shows that the artist was adapting himself
to the conventions of Habsburg portraits.
Nonetheless, the deep red of the fabric
and the thick, juicy oil paint, especially
in the glinting armour, are very much
Titian's trademarks.

Philip is presented as a true Renaissance
prince, his military trappings – the
ceremonial armour and helmet – combined
with elegant court clothes. Crowns and coats
of arms are absent, but the brilliant light,
shining on his face and on the wall behind,
prefigures the coronation that is to come.
In 1556 Charles V abdicated, dividing the
Habsburg possessions between his brother
Ferdinand, who was to rule Central Europe,
and Philip, who became king of Spain and
The Netherlands.

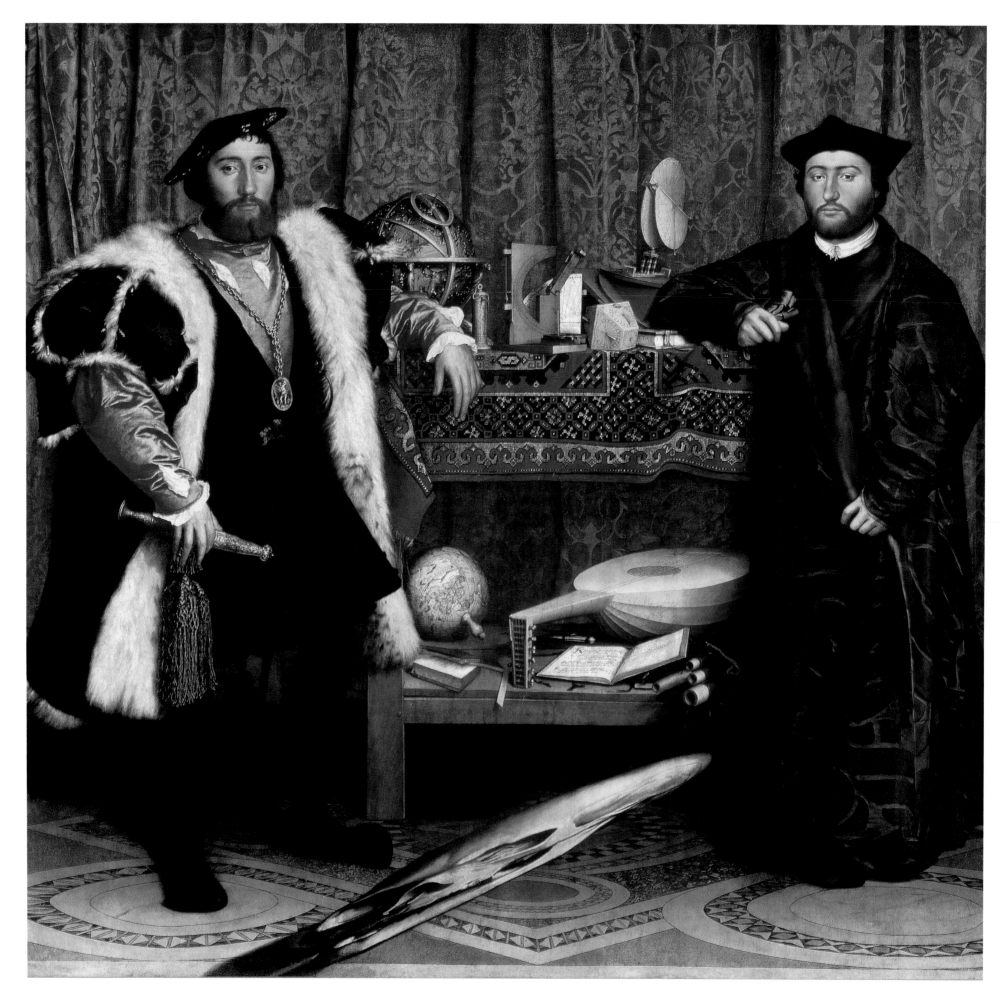

OPPOSITE

Hans Holbein the Younger
(1497/98–1543)
Jean de Dinteville and Georges de Selve (The Ambassadors)

1533
Oil on panel
207 × 209.5 cm (81½ × 82½ in.)
London, The National Gallery

This portrait of the French ambassador Jean de Dinteville, on the left, and his friend the Bishop of Lavaur is anything but modest. The two men were both in London in 1533, and it is, of course, a sign of their grandeur that they were able to employ the court painter himself. Indeed, de Dinteville's expansive, full-length pose, with legs wide apart, recalls Holbein's lost portrait of Henry VIII.

Here Holbein has added a wealth of extra information in order to emphasize his patrons' distinction. De Dinteville's wealth is displayed not just by his luxurious costume, but also by the globe on the lower shelf, which is marked with his estate at Polisy in France. The lute and recorders nearby suggest musical prowess, while the mathematical treatise in front of the globe is complemented by the navigational and astronomical instruments on the carpet above. Both subjects rest their arms casually next to these devices: these are modern men, at ease with the technology of the age of exploration.

These men are also suitably pious: in front of the lute is a book opened at the page of a hymn by Martin Luther, while a crucifix can be glimpsed in the top left. Most important is the large object on the mosaic floor, itself modelled on the pavement at Westminster Abbey. This is a skull, a spectacular example of 'anamorphic' perspective, so deformed that it can be seen properly only at an oblique angle. It also reminds us that death is at the bottom of everything, and that even the courtier's accomplishments, and the painter's skill, will pass away.

Sofonisba Anguissola
(*c.* 1532–1625)
Sisters Playing Chess

1555
Oil on canvas
70 × 94 cm (27½ × 37 in.)
Poland, Poznań, Muzeum Narodowe

A noblewoman from Cremona, Anguissola was praised by the Florentine art historian Giorgio Vasari for showing 'deeper study and greater grace than any woman of our times',[3] in her art at least. As a woman, however, she could not practise drawing from life, and had to base her subjects on her immediate circle, in this case, her sisters Lucia, Minerva and Europa playing chess, a game praised by sixteenth-century writers on etiquette for its cultivation of intellectual skill and civilized behaviour. This is a pastime fit for ladies.

Beautifully dressed, with fashionable braided hair, the sisters are differentiated by age, gesture and expression. Their pale complexions contrast with the darker face of the maidservant, who is following the game intently while the young woman on the left, who has just taken a piece, looks up. Whose gaze is she meeting, Sofonisba's or our own? The idyllic pastoral scene behind adds to the air of artifice. This is no ordinary family portrait.

François Clouet (c. 1516–1572)
A Lady in Her Bath

Probably *c.* 1571
Oil on panel
92.3 × 81.2 cm (36⅜ × 32 in.)
Washington, D.C., National Gallery of Art

The bather's identity remains mysterious,
although suggestions have included Diane
de Poitiers, mistress of King Henry II of
France, and Mary, Queen of Scots. Clouet,
the French court painter, has created the
format imitated in the double female portrait
(opposite), although the iconography of this
image is more complicated. The woman is
writing a letter, presumably to a lover, while
the wet nurse and the bowl of fruit are
allusions to maternity and fertility. The
spacious room behind includes a picture
of a unicorn, a symbol of purity, in striking
contrast to the parted legs above the fireplace
in the later painting.

OPPOSITE
French painter of the Fontainebleau School
Gabrielle d'Estrées and One of Her Sisters

c. 1594
Oil on panel
96 × 125 cm (37¼ × 49¼ in.)
Paris, Musée du Louvre

In this painting the two sisters are stretching
the boundaries of respectability. However,
they do at least have royal approval: by
comparison with other inscribed portraits, the
blonde lady has been identified as Gabrielle
d'Estrées, the mistress of the French king
Henry IV. The woman on the left is almost
certainly her sister, whose gesture probably
indicates that Gabrielle is pregnant with one
of the three children that she bore during the
1590s. To emphasize the point, the picture
over the fireplace concentrates on the body's
lower regions.

Audacious as this image is, it is clear that
the women's anatomies are so generalized
that they could not possibly have posed for
them. They are 'fakes', loosely copied from
François Clouet's *Lady in Her Bath* (left), and
given a titillating twist by the addition of
recognizable features. Originally made for
the royal palace of Fontainebleau, outside
Paris, they would have been appreciated as
much for their artfulness as for their slender
connection with reality.

Dosso Dossi
(c. 1486–1541/42)
Buffoon

c. 1515–20
Oil on canvas
60.5 × 53 cm (23 ⅞ × 20 ⅞ in.)
Italy, Modena, Galleria e Museo Estense

In contrast to the sober courtier opposite, this clown is dressed in scarlet, has long, straggling hair, and is laughing so broadly that we see his teeth. Instead of decorously folding his hands, he grasps a particularly earnest-looking sheep: maybe that is what makes him laugh. Perhaps the inscription *Sic Gi*[…]*ius* would have helped us to tease out a more specific meaning, but, as it is almost illegible, we shall never know.

The man and his sheep are set in front of a suitably pastoral landscape, the hazy atmosphere of which recalls the paintings of the Venetian Giorgione (page 38). However, the buffoonery that Dossi is celebrating reflects life in the humorous, hedonistic court of Ferrara, where he spent much of his career.

Raphael (1483–1520)
Portrait of Baldassare Castiglione

1514–15
Oil on canvas
82 × 67 cm (32¼ × 26⅜ in.)
Paris, Musée du Louvre

When I am alone, the portrait by Raphael's hand
Recalls your face and relieves my cares,
I play with it and laugh with it and joke, …
I speak to it, and, as though it could reply,
It often seems to me to nod and motion,
To want to say something and to speak your words.[4]

Thus Baldassare Castiglione imagined his
wife writing to him when he was away.
The words reveal one of the more personal
functions of portraiture. Yet the painting
also presents an image of the perfect courtier,
as described in Castiglione's contemporary
Il libro del cortegiano ('The Book of the
Courtier'), published in 1528 but first drafted
around the time of this painting. The sitter's
restrained gestures and air of reserve are
carefully cultivated without seeming
unnatural, a combination of apparently
contradictory qualities that was known as
sprezzatura. The effect is enhanced by the
austere, elegant clothes, which, together with
the skin, create harmonies of tones that are
both rich and sombre.

Lavinia Fontana (1552–1614)
Tognina Gonzales

c. 1595
Oil on canvas
57 × 46 cm (22½ × 18⅛ in.)
France, Blois, Château Royal,
Musée des Beaux-Arts

The most prolific woman artist of the
Renaissance, Lavinia Fontana was the
daughter of an ambitious Bolognese painter.
Although she inherited the versatility of her
father, Prospero, she became particularly
well known for her portraits, especially those
of women.

This must be Fontana's strangest
commission. Tognina Gonzales suffered from
hypertrichosis or hirsutism, a condition that
made her and her family famous across the
courts of Europe. She is depicted in the
format of a conventional portrait, holding up
a paper that associates her with the Marquis
of Sovragna, to whom she had been passed
by the Duke of Parma. In a drawing of the
same period, Fontana tilted Gonzales's head,
so as to emphasize her girlish nose and pony-
tail. In contrast, the painting's frontal pose
gives her face a more shocking, mask-like
quality, its hairiness dramatically contrasted
with the delicacy of her costume and hands.

OPPOSITE

Agostino Carracci (1557–1602)
Hairy Harry, Mad Peter
and Tiny Amon

c. 1598
Oil on canvas
101 × 133 cm (39¾ × 52⅜ in.)
Naples, Museo Nazionale di Capodimonte

Agostino Carracci has made Lavinia
Fontana's portrait of Tognina Gonzales (left)
look like an epitome of political correctness.
Clothed in furs, Tognina's brother Arrigo is
represented with a midget, a madman and a
small menagerie of dogs and exotic beasts,
the playthings of the Farnese court in Rome,
for which the Carracci family produced some
of their most spectacular work (see page 125).

THE
LURE
OF
THE
EAST

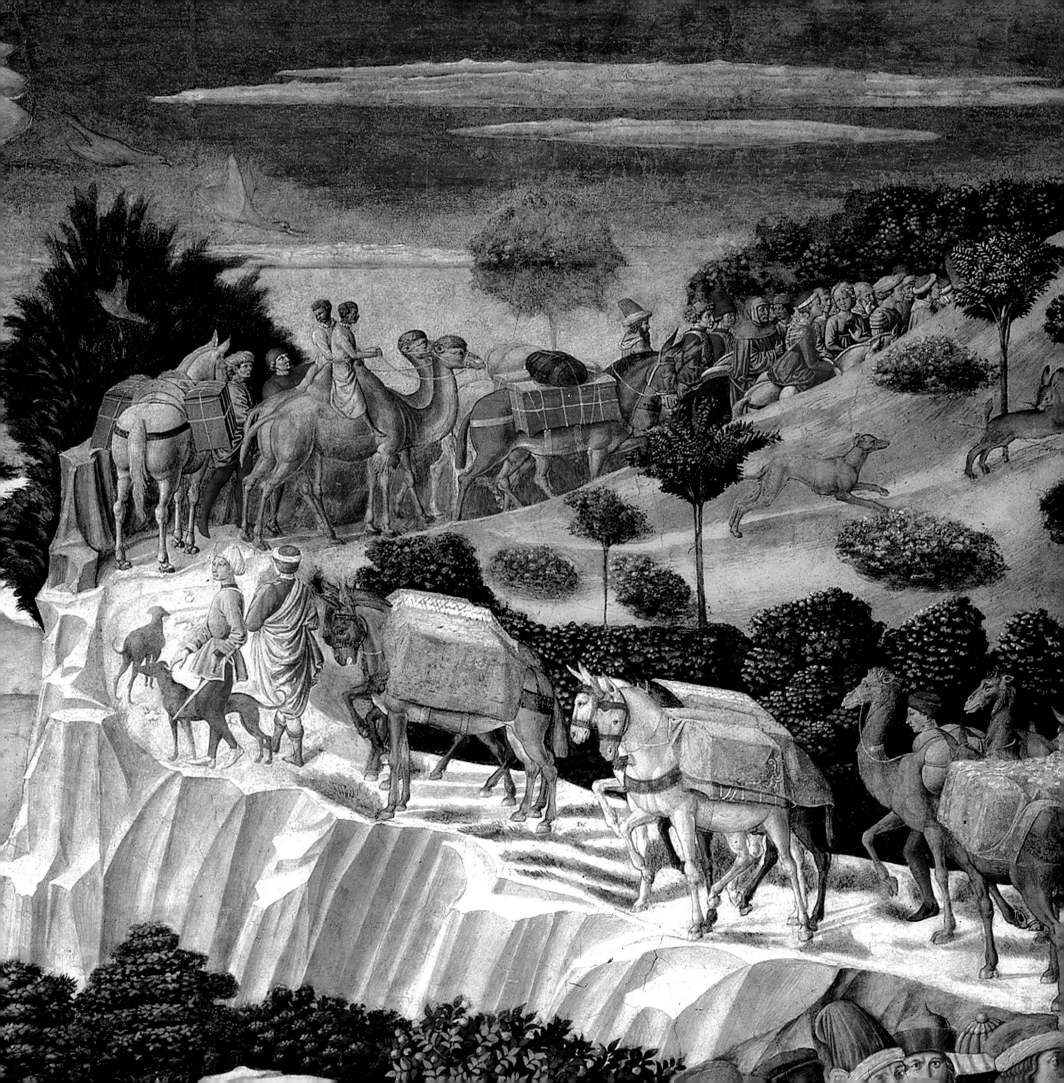

When the Umbrian painter Pinturicchio represented the pope blessing a crusade in 1464 (opposite), he was reflecting one of the great preoccupations of his age – the obsession with the threat of conquest by 'the Turk'. Europe had proved unable to prevent the loss of Constantinople in 1453, despite the diplomacy of the Byzantine emperor John VIII Palaeologus, who had visited Florence fourteen years earlier in a desperate attempt to cement a Christian alliance.

This failure was a trauma. Yet, despite the Ottomans' relentless advance, and the shocking stories of anal impalement, rape and other Turkish atrocities, Italian Renaissance artists revealed a fascination with the East that sometimes seemed stronger than their fear. Often they seized with enthusiasm the opportunity to introduce 'Oriental' costumes or artefacts, especially in depictions of the Adoration of the Magi (pages 196, 197 and 198), where the subject positively demanded it.

It was in Venice, in particular, that the lure of the East was at its strongest. Founded as a Byzantine colony, the city later became the home of the relics of St Mark, brought from Alexandria in the ninth century. Images of the saint's life were frequently filled with exotic turbaned figures, as in Mansueti's painting (page 200), even though few artists had personal experience of the region.

Some Venetians, however, did visit the Levant. Despite the obvious distress at the Turks' conquests, Venice maintained trade with the Ottoman and Mamluk empires for large stretches of the Renaissance period. Ambassadors travelled east (page 199), and, most surprisingly of all, one of Venice's most celebrated painters, Gentile Bellini, spent more than a year at the court in Istanbul. Bellini returned home with a gold wreath and the rank of knight; and his Turkish portraits (pages 202 and 203) – so exquisite that, as Vasari tells us, the sultan thought that he must be divinely inspired – influenced artists from Italy to Iran.

Bernardino Pinturicchio
(c. 1452–1513)
Pope Pius II, at Ancona, Blesses the Fleet about to Leave on a Crusade, 15 August 1464
1505–07
Fresco
Siena Cathedral, Piccolomini Library

Giorgio Vasari's comment that Pinturicchio 'kept many workers continuously employed upon his projects' sounds like damning someone with faint praise. Indeed, Vasari believed that this painter from Perugia had a greater reputation than he deserved: 'Fortune … likes to raise up some with her own favour who would never have been recognized through their own merits.'[1]

This judgement seems a little harsh. In 1502 Cardinal Francesco Piccolomini commissioned scenes from the life of his uncle Aeneas Silvius, Pope Pius II. The scenes that Pinturicchio produced in the library of Siena Cathedral still beguile visitors with their freshness and vitality, even if they are a little old-fashioned in comparison with some central Italian painting of this time.

One of the most evocative of Pinturicchio's frescoes shows the pope at Ancona, raised on a litter, blessing the forces about to leave for a crusade against the Ottomans; this conflict was obviously still regarded as a work in progress. Of the two turbaned Turks on the right, the standing man is based on a drawing made in the workshop of Gentile Bellini after his return from Istanbul in 1481. This figure was obviously a favourite of Pinturicchio, who had already used him in *The Disputation of St Catherine of Alexandria* (1492–94) in the Borgia Apartments in the Vatican. Pinturicchio did not miss an opportunity to depict an exotic figure, even at the cost of repetition.

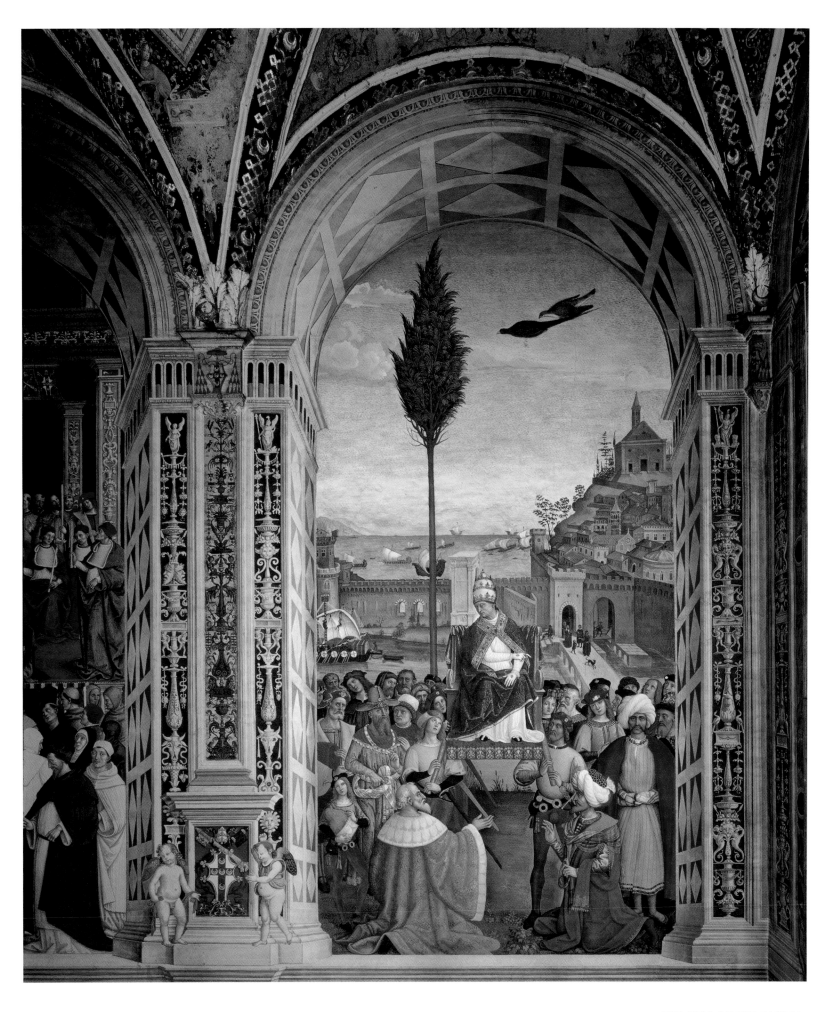

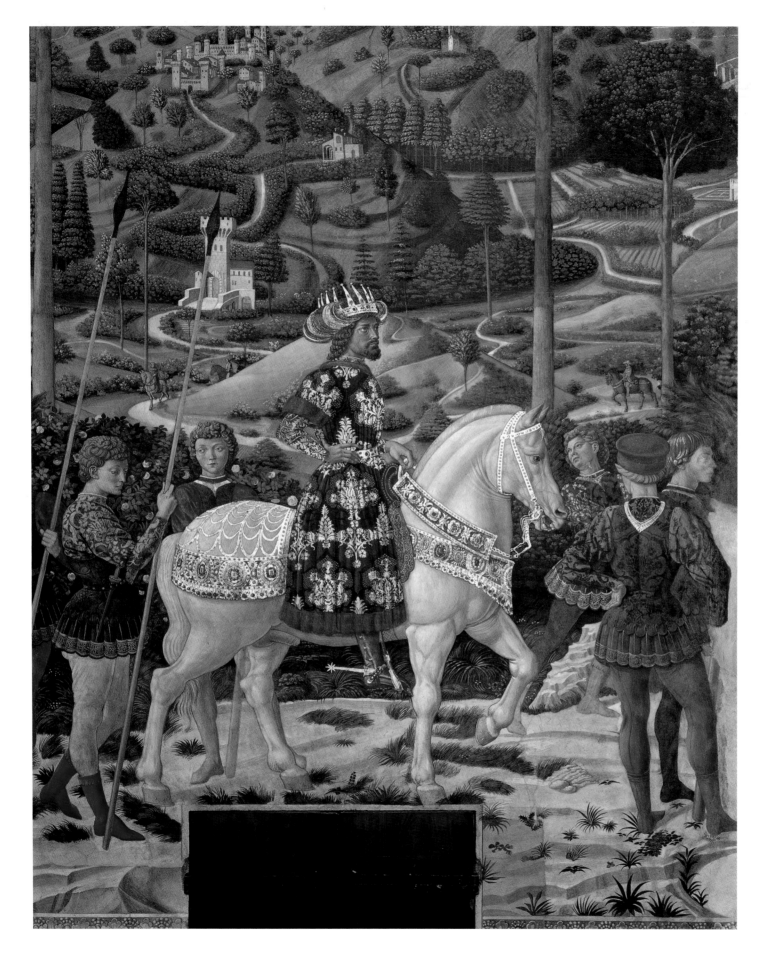

Benozzo Gozzoli
(c. 1420/22–1497)
The Procession of Balthazar,
from *The Adoration of the Magi*

c. 1460
Fresco
Florence, Palazzo Medici Riccardi, chapel,
south wall

Benozzo Gozzoli's frescoes depicting the
Adoration of the Magi in the chapel of the
Medici palace are among the most sumptuous
decorations of the Florentine Renaissance.
The south wall depicts Balthazar, a mature
man somewhere between the ages of the
other two Magi, Caspar and Melchior: he is
dressed in green, the colour of summer, as is
appropriate to his years. The figure of the
page bearing Balthazar's gift to Jesus was lost
during later amendments to the chapel, but
the background, depicting the tranquil
Tuscan landscape, is well preserved.

It has often been thought that Balthazar
is a portrait of the Byzantine emperor
John VIII Palaeologus, who attended the
Council of Florence in 1439. The council
sanctioned the union of the Western and
Eastern churches, and tried to prepare against
the threat from the Ottoman Turks, although
their conquest of Constantinople in 1453
rendered it ineffectual. At the time, the
emperor was depicted in a medal by Pisanello
showing him with a high conical hat and
pointed beard – in other words, nothing like
Balthazar in this fresco. However, the
Magus's gold-threaded gown and jewelled
headdress may more generally reflect
Florentine memories of this momentous
meeting between East and West.

Benozzo Gozzoli
(*c*. 1420/22–1497)
The Procession of Melchior,
from *The Adoration of the Magi*

c. 1460
Fresco
Florence, Palazzo Medici Riccardi, chapel,
west wall

The west wall of the Medici chapel
represents Melchior, the eldest of the
Magi, on a luxuriously harnessed mule
(unfortunately cropped by a door inserted in
the seventeenth century). Melchior's velvet
gown is red, the colour of autumn, fitting
for his age, and he wears a splendid jewelled
crown. He is sometimes linked to Joseph,
the Patriarch of Constantinople, who died
during the Council of Florence in 1439.
Unfortunately, Joseph's painted effigy in
Santa Maria Novella represents a bald man,
lacking Melchior's luxurious mane. Yet the
fresco's Oriental tone is undeniable, and is
continued in the procession, with its African
slaves and richly laden dromedaries, winding
into the distance.

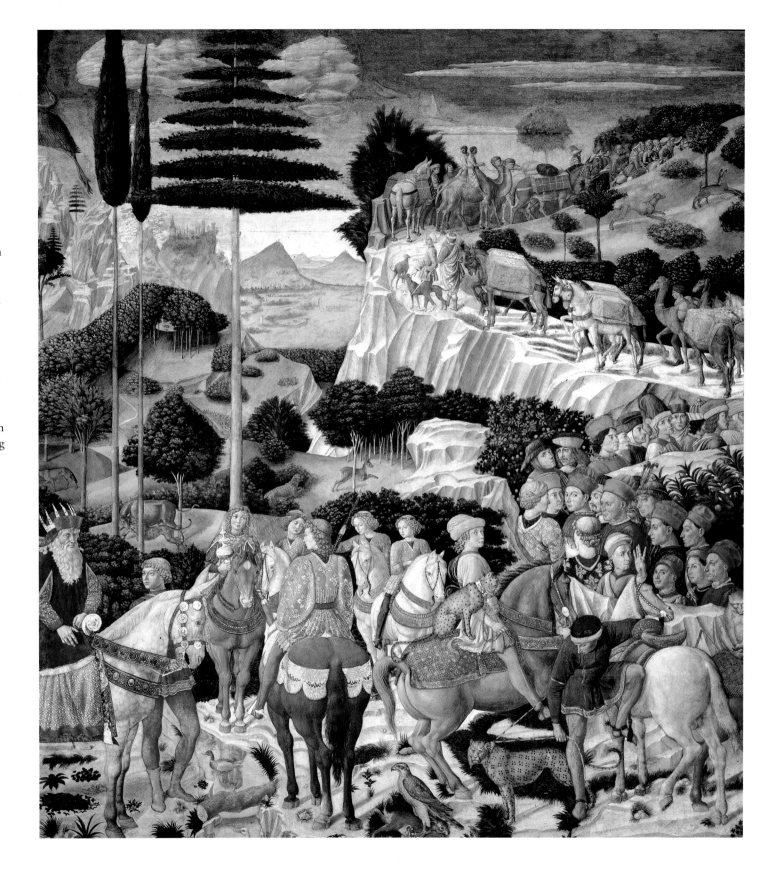

Andrea Mantegna
(1430/31–1506)
Adoration of the Magi

c. 1495
Distemper on linen
48.5 × 65.5 cm (19 ⅛ × 25 ¾ in.)
Los Angeles, J. Paul Getty Museum

Andrea Mantegna and his brother-in-law Giovanni Bellini pioneered a type of painting in which the infant Christ is shown with half-length figures in front of a dark background. This enables the artist to focus on the characters' expressive faces, as well as, in this case, on the luxurious furs and fabrics worn by the Magi.

While Caspar is giving frankincense, in recognition of the Child's divinity, Balthazar, here represented as black, has brought myrrh, as preparation for Christ's death. The infant is looking down at the gold, symbol of royalty, which is offered by the elderly Melchior in a Chinese porcelain cup, a kind of ware that came to Italy via Arab traders. Meanwhile, the Virgin is shown wearing an elaborate costume, with Kufic-looking script woven around the cuff and collar. The illusion of the Orient is complete.

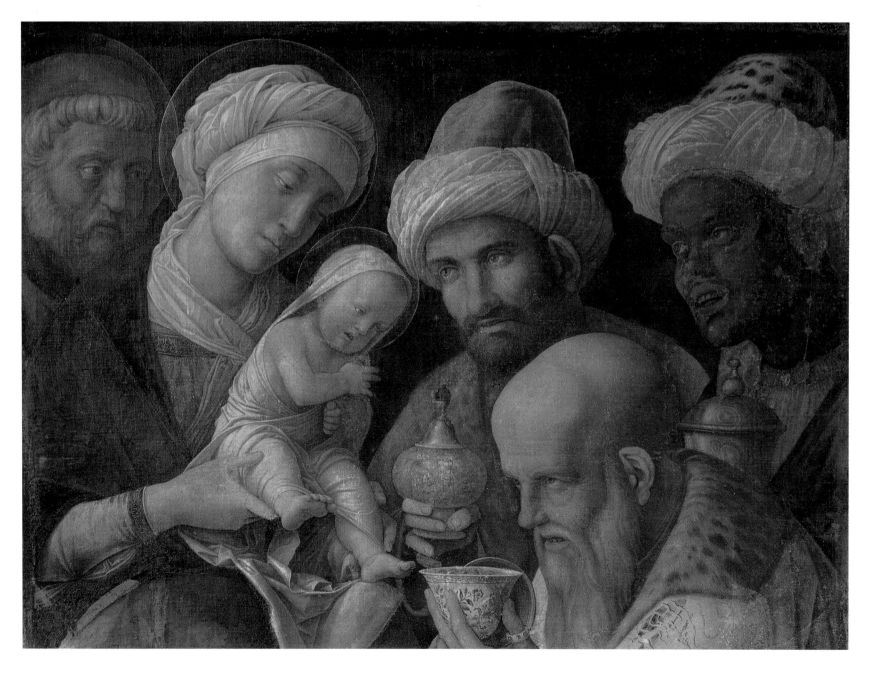

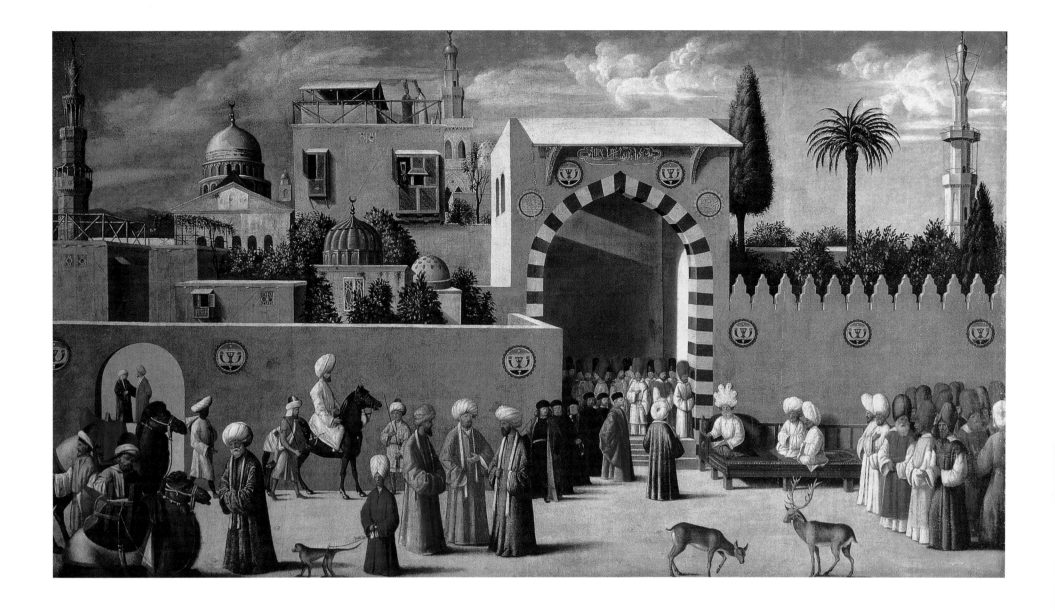

Follower of Gentile Bellini
(?1429–1507)
The Reception of the Venetian Ambassadors in Damascus

1511
Oil on canvas
118 × 203 cm (46½ × 79⅞ in.)
Paris, Musée du Louvre

The Mamluk viceroy of Damascus, in a magnificent white horned turban, sits on a dais, receiving a delegation of Venetians. The exotic animals in the foreground – a couple of camels, a monkey on a leash – offer light relief, yet the painting was in fact made after a dark period in the relations between Venice and the Mamluk dynasty. In 1510 the Venetian consuls in Alexandria and Damascus, Tommaso Contarini and Pietro Zen, were arrested for espionage. Eventually, after their compatriot Domenico Trevisan petitioned the sultan in Cairo, both men were released, although Zen had to leave prison in chains.

It is clear from the minaret on the left that we are looking towards the Great Mosque in Damascus, although we can also see private houses and the baths in the grain market. There are many inaccuracies – for example, the inscription *There is no God but Allah* over the arch is back to front – and the painting was almost certainly made in Venice. It seems to be based on the experience of life in an Arab city, however, and was probably made for Zen after his release, as a souvenir of his time in the East, before relations with his hosts started to sour.

Giovanni Mansueti
(*fl.* 1485–1526/27)
Episodes from the Life of St Mark

c. 1518–26
Oil on canvas
376 × 612 cm (148 × 241 in.)
Venice, Gallerie dell'Accademia

Giovanni Mansueti developed a profitable business producing views of the East, while probably never actually having been there. In this painting he has depicted episodes that took place in Alexandria almost fifteen centuries earlier. However, the architecture, with its Classical columns, arches and domes, is far more evocative of Venice than Egypt.

St Mark appears twice, arrested while celebrating Mass on Easter Day at the back, and visited by Christ in prison on the left. Meanwhile, members of the Scuola Grande di San Marco, the confraternity that paid for the painting, mill around in the foreground, together with crowds of turbaned Arabs. Clearly, Mansueti has used sources similar to those found by the painter of *The Reception of the Venetian Ambassadors in Damascus* (page 199) – for example, the same Mamluk blazons appear on the wall – while for the veiled women he drew on a woodcut from Bernard von Breydenbach's *Pilgrimage to the Holy Land*, published in Mainz in 1486. Yet, despite their derivative qualities, Mansueti's figures created an evocative image of the Arab world that inspired other artists of the period.

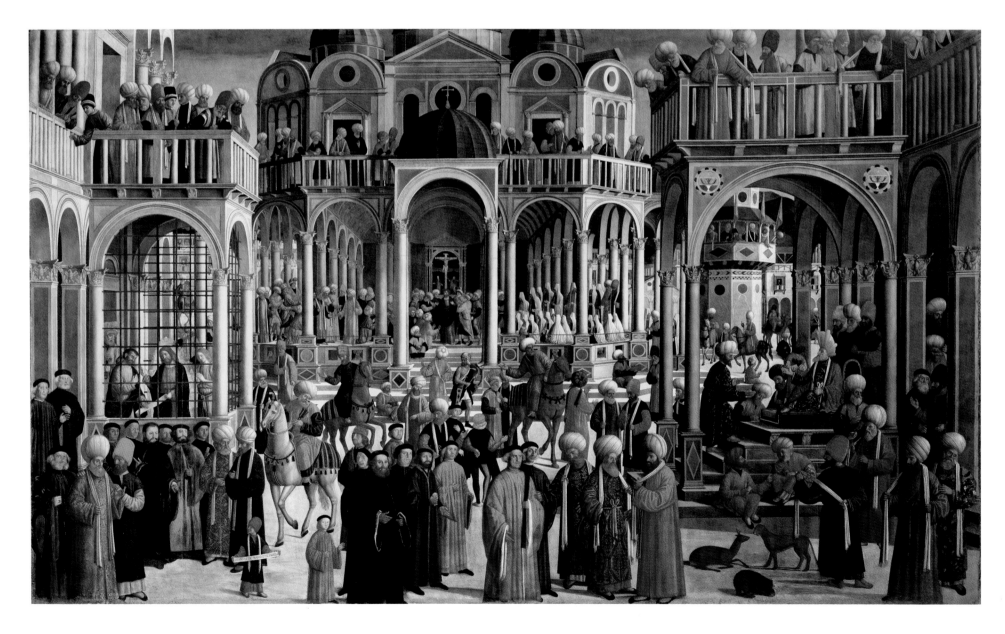

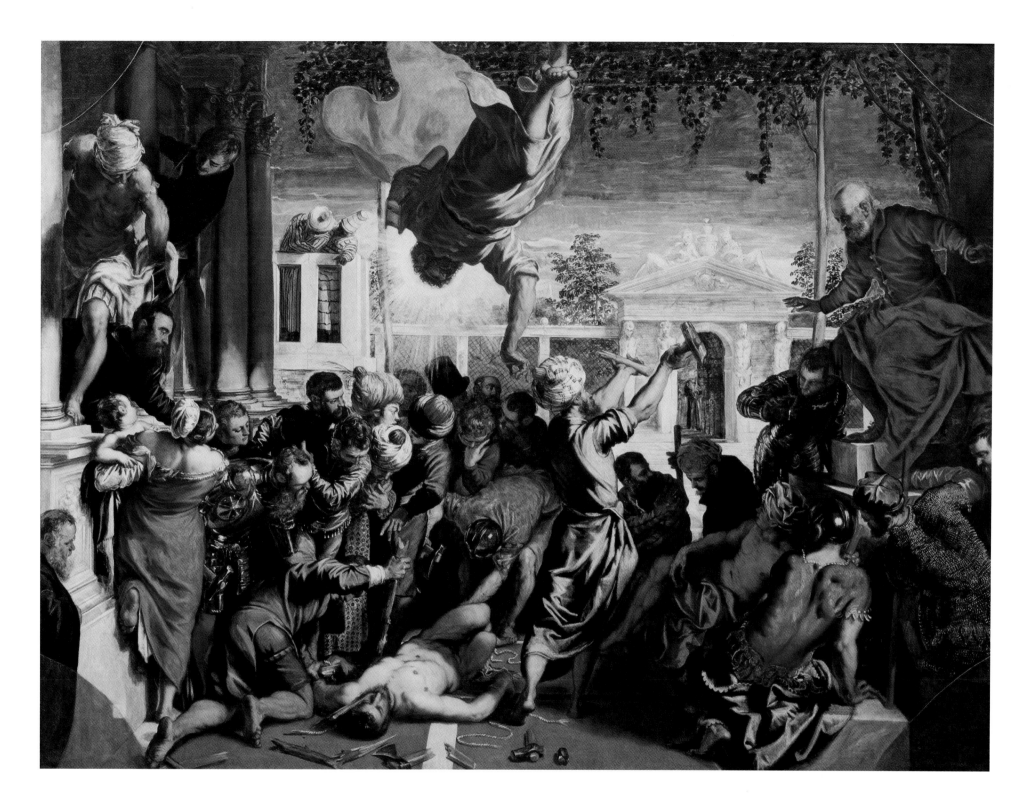

Jacopo Tintoretto
(Jacopo Robusti) (1519–1594)
*The Miracle of St Mark Freeing
a Slave*

1548
Oil on canvas
416 × 544 cm (163 ¾ × 214 ⅛ in.)
Venice, Gallerie dell'Accademia

The story of a Christian slave from Provence, condemned by his Saracen master for his devotion to St Mark, was chosen for the headquarters of the confraternity known as the Scuola Grande di San Marco. Executioners with prodigious turbans hold up the shattered tools of their profession, as Mark plunges headlong to save his follower, who had just returned from a pilgrimage to the saint's tomb in Alexandria. The slave himself is the foreshortened nude at the bottom of the painting: his pallor contrasts with the strident hues of the bystanders, and of St Mark himself.

With its Oriental atmosphere and vivid dramatization, this painting marked a turning point in the career of the young Tintoretto. Its twisted, muscular figures, obviously inspired by Michelangelo, and its clashing colours were new to Venetian painting. The conservative members of the Scuola did not accept it, however, until 1562, when it was followed by a commission for yet more images of the story of St Mark and his relics.

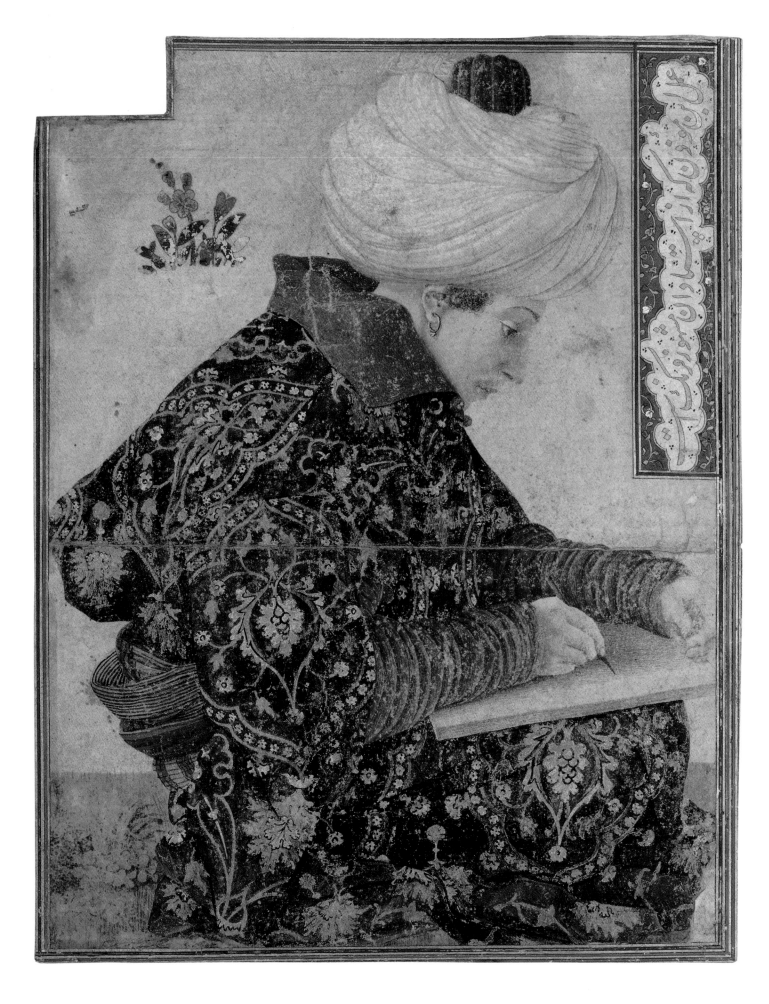

Gentile Bellini (?1429–1507)
Seated Scribe

1479–80
Gouache and pen and ink on paper
18.2 × 14 cm (7⅛ × 5½ in.)
Boston, Isabella Stewart Gardner Museum

Gentile Bellini made this exquisite study of a young scribe in Istanbul, following Ottoman conventions, with the outlines drawn in ink, followed by fields of luminous colour. The boy's beautiful blue coat, patterned with gold, echoes the flatness of Turkish art, although it also recalls the decorative style of International Gothic painting.

Soon after it was made, the *Seated Scribe* was sent to the court of the Aqqoyunlu dynasty in Tabriz, and in the 1540s it was acquired by the Safavids in Isfahan. There it was mounted in an album, which also contained figures from the Ming dynasty, as well as a sixteenth-century oil painting of a boy and a text asserting that 'the custom of portraiture flourished so in the lands of Cathay and the Franks [Europeans]'.[2] It seems that the *Scribe* made a particular impression, since there are at least two Persian watercolours that imitate its pose while lacking any vestiges of shading.

BELOW

Gentile Bellini (?1429–1507)
Portrait medal, obverse depicting Sultan Mehmed II; reverse depicting three crowns

c. 1481
Bronze
Diameter 9.4 cm (3 ¾ in.)
Venice, Ca' d'Oro

There had been a demand for images of the Ottoman sultan – 'The Great Turk' – ever since the conquest of Constantinople in 1453. Initially they were wildly inaccurate, giving him a headdress borrowed from an earlier representation of the Byzantine emperor John VIII Palaeologus. On returning to Venice in 1481, however, Bellini produced a series of vivid, crisp medals obviously influenced by his painted portrait (right), although the sultan's pose has been adapted to a profile format. The reverse shows the three crowns, symbolizing the territories that the Ottomans had captured, while Bellini's very prominent name testifies to his own prestige at this time.

Certainly these medals were regarded as valuable decorations by Bellini's contemporaries, since most of them had holes bored into them so that they could easily be suspended for display.

Attributed to Gentile Bellini (?1429–1507)
Sultan Mehmed II

1480(?)
Oil on canvas
69.9 × 52.1 cm (27½ × 20½ in.)
London, The National Gallery

This painting, probably made during Bellini's stay in Istanbul, is a marvellous adaptation of European portrait conventions to an alien context. The sultan, shown at an angle to the picture plane, is placed behind an arch, which has a striking resemblance to the portal of the church of San Zaccaria in Venice, while a luxurious Oriental fabric, adorned with tulips and gems, hangs over the parapet.

We are left in no doubt as to the sultan's might. The damaged inscription on the left may originally have lauded the sultan as *VICTOR ORBIS* ('Conqueror of the Globe'), while the three crowns in both of the top corners allude to the three realms – Asia, Trebizond and Greece – that he had conquered.

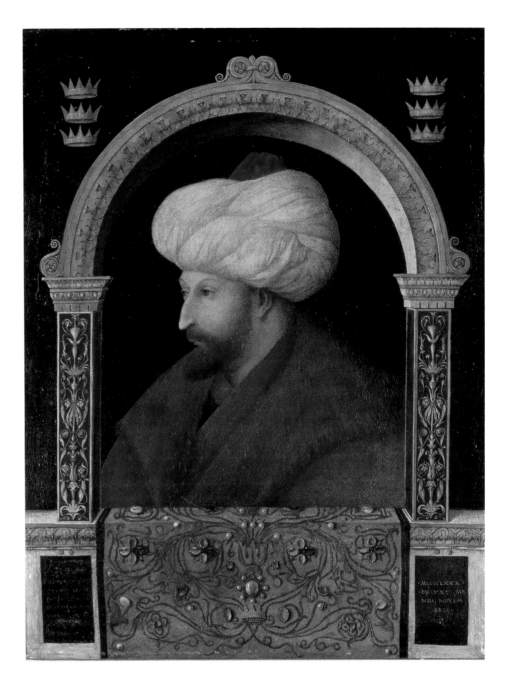

LANDSCAPE

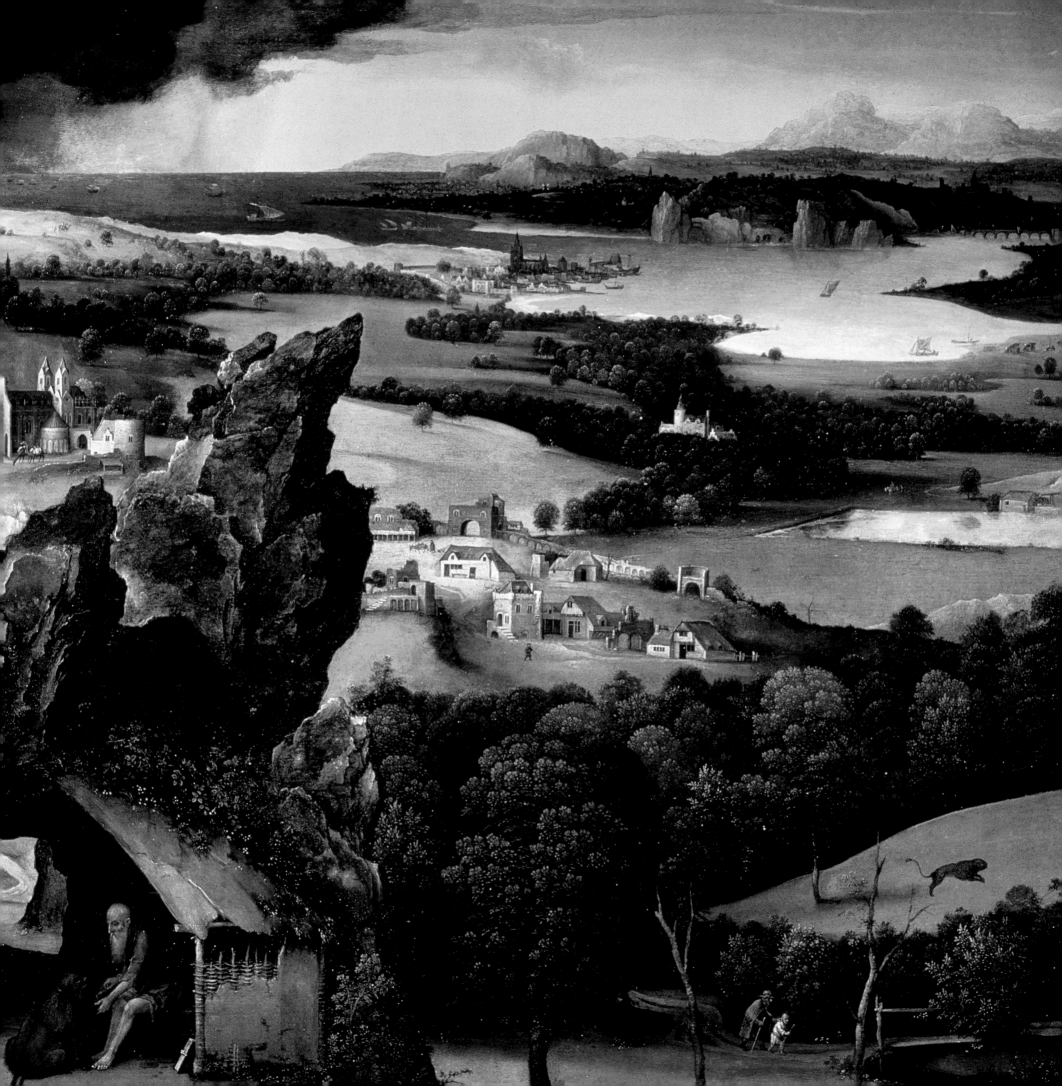

In *Landscape with a Footbridge* (opposite), by the Bavarian artist Albrecht Altdorfer, not a single person disturbs the scene. The painting is an imaginary evocation of the lush Danube Valley and its forests, which were celebrated by German writers of the period as places untainted by civilization, even as they were being cut down for timber and agriculture.

Landscapes are, of course, ripe for corruption: even the Garden of Eden had a serpent. In a famous triptych, now in Madrid, Hieronymus Bosch placed Paradise next to the Garden of Earthly Delights, where countless people sin wildly in an excessively fertile land (page 208). Hell awaits them nearby.

These images represent the extremes of landscape painting in this period, in which nature is given an extraordinary power for good or evil. More typical are the sacred scenes in which recognizable places, from Lake Geneva to Tuscany (pages 210 and 211), become mere backdrops, complementary to the story but not the main event. In Leonardo da Vinci's *Virgin of the Rocks* (page 213), mysterious caverns and peaks provide an imaginary, poetic setting, but they still remain subordinate to the figures in the foreground.

The artist who perhaps did the most to liberate landscape from its secondary status was Joachim Patinir (page 214), whom Albrecht Dürer described in 1525 as a good 'landscape painter', the first time that this term is recorded. In truth, Patinir's pictures are dramatic but far from naturalistic – much less so indeed than Dürer's own watercolours (page 215), made in the open air, or the canvases of Giorgione (page 216) and Titian (page 217), infused with the sultry atmosphere of summer.

Patinir was, however, very influential, inspiring vast 'world-view' panoramas, especially in Flanders. The most spectacular examples, by Pieter Bruegel the Elder, form a kind of calendar (page 219), and so continue a genre popular since the Middle Ages. A century and a half earlier, the Limbourg brothers had produced exquisite images of the months in a prayer book made for the Duke of Berry (page 218). Bruegel's paintings are also filled with people engaged in seasonal activities, but are set amid vast swathes of country. The intimate details of rural life have been translated to an epic scale.

Albrecht Altdorfer
(*c.* 1480–1538)
Landscape with a Footbridge

c. 1518–20
Oil on parchment attached to panel
42.1 × 35.5 cm (16 ⅝ × 14 in.)
London, The National Gallery

Here, perhaps for the first time, an artist is bold enough to paint in oil a pure landscape, a scene without a story or even a human figure. Altdorfer presents a vision of the Danube Valley in southern Germany, with a battlemented castle, its drawbridge raised, and a footbridge in steep perspective. This is an imaginary amalgamation of different features of the Bavarian countryside, with an intriguing view, framed by the building and trees, towards a church spire and Alpine peaks.

The composition carves up space in a way that would become familiar in later centuries, but was still audaciously original in the 1510s. An air of informality is created by the half-obscured trees behind the corner of the castle and the partial screening of the background by the bridge. Indeed, the crowding of the foreground is striking. Perhaps Altdorfer felt uncomfortable with the apparent emptiness of nature after all.

Hieronymus Bosch
(*c.* 1450–1516)
The triptych of *The Garden of Earthly Delights*

1500–05
Oil on panel
220 × 389 cm (86⅝ × 153⅛ in.)
Madrid, Museo Nacional del Prado

In this remarkable triptych, Bosch presents the moral history of mankind with horrifying precision. The so-called *Garden of Earthly Delights* in the centre depicts a host of men and women luxuriating amid gigantic strawberries and monstrous birds. This landscape, too lush for its own good, is almost certainly the sinful world that God destroyed with the Great Flood. In the Garden of Eden, on the left, God converses with Adam and Eve in an equally fertile, though less populous landscape. Here Bosch has exploited all his skill with oil paint and, above all, transparent glazes, to create an effect of rich luminosity. The idyllic quality is compromised, however, by the weird fountain in the background, which is ominously similar to the grotesque structures at the top of the central panel.

In contrast to these disturbing, yet beautiful landscapes, hell is a nocturnal wasteland lit by flame. In the centre, a hollow man, with leafless trees for legs, shelters inside his bottom an array of damned souls, while hideous torments, corruption and defecation take place all around.

Hieronymus Bosch
(*c.* 1450–1516)
The Garden of Earthly Delights
(view with wings closed)

1500–05
Oil on panel
220 × 195 cm (86⅝ × 76¾ in.)
Madrid, Museo Nacional del Prado

When the wings of the triptych are closed,
the earth is shown as a disc partly submerged
in water, surrounded by a transparent sphere.
The subject is usually described as the
Creation of the World, and the curved
white line on the left is interpreted as simply
representing the fall of light on a convex
surface. It has been argued, however, that it
may be a monochrome image of the rainbow
sent by God when the biblical Flood began
to recede. The Flood would relate to the
theme visible in the central panel when the
triptych is open (opposite). Moreover, the
presence of farms and buildings seems
inconsistent with the alternative subject, the
Creation, unless, of course, we allow Bosch
a certain poetic licence.

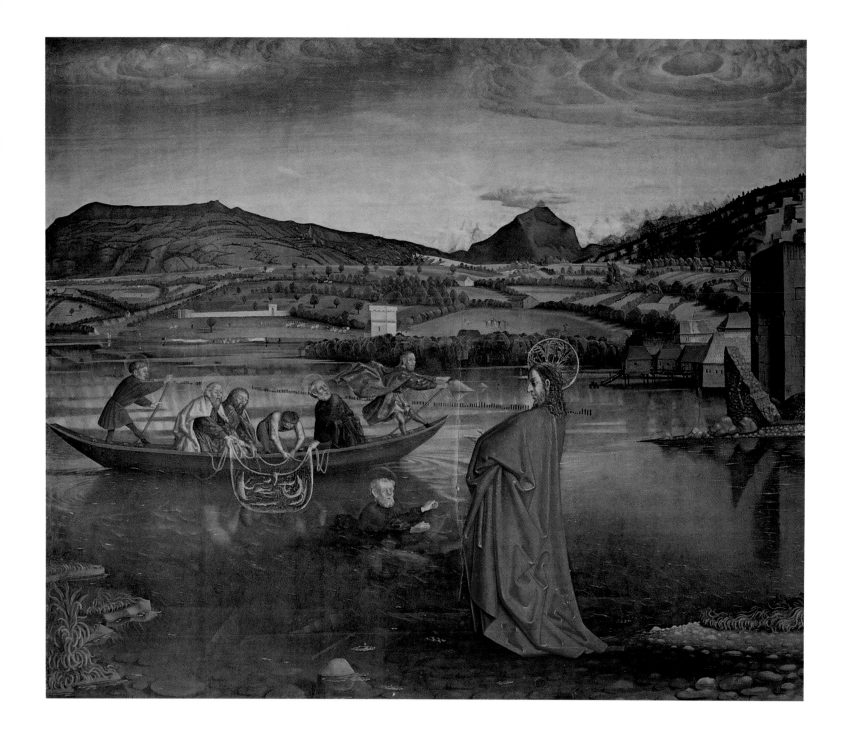

Konrad Witz
(c. 1400/10–1445/46)
The Miraculous Draught of Fishes

1444
Oil on panel
132 × 155 cm (52 × 61 in.)
Geneva, Musée d'Art et d'Histoire

When Konrad Witz painted this New
Testament story, for an altarpiece in Geneva
Cathedral, he changed the Sea of Galilee
into his native Lake Léman (Lake Geneva).
The northern climate is brilliantly evoked
by the clouds, tinged with pink, and by the
green fields at the foot of the mountains.

Using the special qualities of oil paint, Witz
was able to represent in great detail the stones
and vegetation at the lake's edge, as well as
the reflections of the apostles hauling in the
miraculously large catch. Meanwhile, St Peter,
attempting to copy Christ's steps across the
lake, plunges into the water, an event that was
probably seen as prefiguring the inappropriate
ambitions of his successors as pope. It is no
coincidence that Le Môle, the peak in the
background, is aligned not with the
floundering Peter (whose name means 'rock')
but with the upright figure of Christ himself.
Here the landscape provides not just a
backdrop but also a means of interpreting
the events that take place within it.

Piero della Francesca
(c. 1415–1492)
The Baptism of Christ

1450s
Tempera on panel
167 × 116 cm (65 ¾ × 45 ⅝ in.)
London, The National Gallery

In Piero della Francesca's panel, the valley of the River Jordan resembles the verdant countryside of his native Tuscany, with his home town, Borgo San Sepolcro, in the distance. In certain areas, such as the wing of the angel standing behind the tree, Piero has painted over the landscape with pigments that have now faded to reveal the hills behind. Elsewhere, the natural forms play an important role in defining the composition: the vertical line of the tree on the left corresponds with the upright body of Christ, while the horizontal plane of the dove, symbolizing the Holy Spirit, is continued by the cloud on the right.

As well as capturing the subtle tones of the sky, Piero has also represented the optical qualities of the water – both the reflections on its surface and the point at which it becomes transparent, clearly revealing the river bed on which Christ stands. Most significant, however, is the pale light modelling the figures, which gives the painting its ethereal mood.

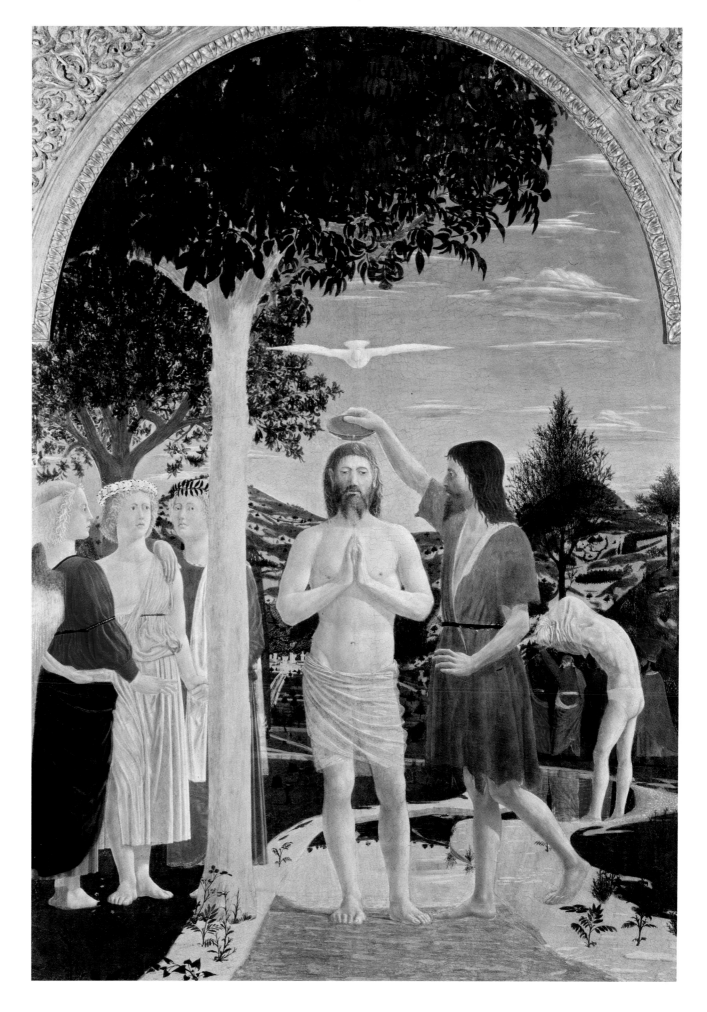

Andrea Mantegna
(1430/31–1506)
The Agony in the Garden

c. 1460
Tempera on panel
62.9 × 80 cm (24¾ × 31½ in.)
London, The National Gallery

A grim, arid landscape, with a bare tree supporting a vulture, provides a suitable setting for this episode in Christ's Passion. While the apostles sleep, angels appear to Christ, showing him the instruments with which he will be tortured and crucified. The Mount of Olives, on which he kneels, and the peaks beyond are strange, contorted formations, creating a pattern of twisting, wiry lines, continued by the path along which his enemies approach.

Yet even in this desert there is hope of new life. Fresh growth sprouts from the rocks and from the bare branches on the right; rabbits bound along the path; and spotless white egrets in the water symbolize the purification achieved through baptism in Christ.

Leonardo da Vinci (1452–1519)
The Virgin of the Rocks

c. 1491–1508
Oil on panel
189 × 120 cm (74⅜ × 47¼ in.)
London, The National Gallery

It is remarkable that Leonardo, who famously
failed to complete many of his projects,
managed to produce two examples of this
composition. The earlier version, now in the
Louvre, was painted in the 1480s. It was
the later picture, illustrated here, that was
installed in the Milanese church of San
Francisco Grande, where it remained until
the nineteenth century.

The altarpiece is dominated by the Virgin
and Child, the infant John the Baptist and a
particularly graceful angel, who together form
a pyramidal shape at the centre of the painting.
Around this monumental group, Leonardo
has created a fantastic structure of rocks and
crevices, with delicate flowers growing in
the foreground and precipitous crags in
the distance.

The sense of isolation and enclosure may
have been regarded as appropriate to the Virgin
Mary, and the Franciscan patrons would also
have been conscious that both John the Baptist
and St Francis spent crucial periods in the
wilderness. There is, therefore, a theological
context for this landscape, even though it has
no precedents in the art of the time.

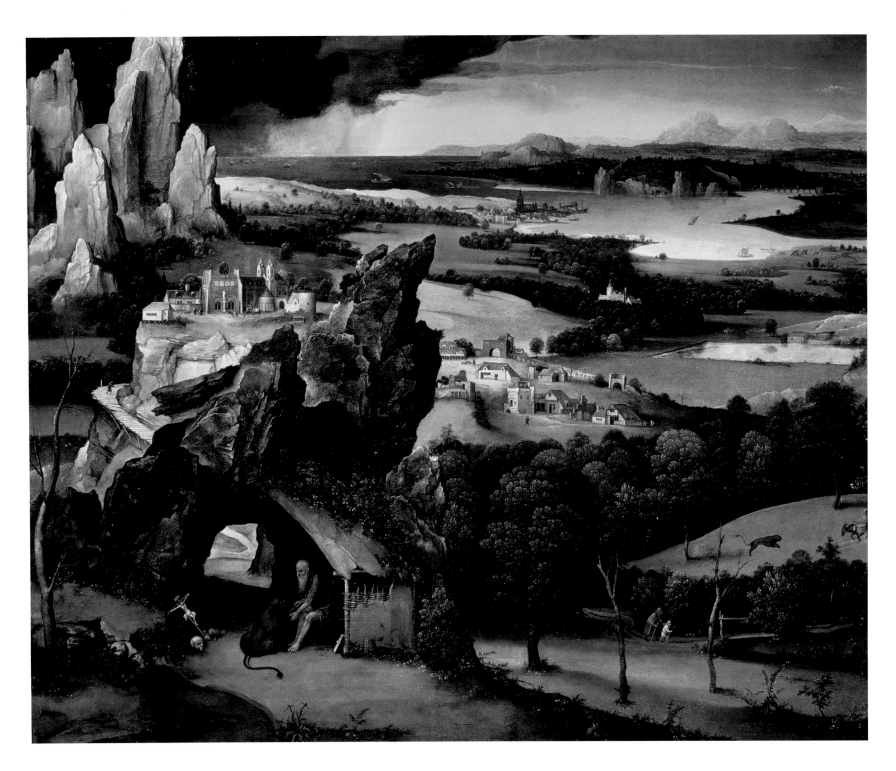

Joachim Patinir (*c.* 1480–1524)
Landscape with St Jerome

1515–19
Oil on panel
74 × 91 cm (29 ⅛ × 35 ⅞ in.)
Madrid, Museo Nacional del Prado

Although Patinir's landscapes always include a character or story, usually religious in nature, they are dominated by panoramas seen from exceptionally high viewpoints. These allow the eye to swoop across whole countries towards distant seas and mountains, the cool-blue tones of which set off the warmer browns and greens in front.

St Jerome famously went to meditate in the desert, where, among other things, he tamed the lion with which he shares his cave. The countryside beyond is not exactly arid: indeed, its pastures and settlements look unmistakably Flemish. This is the mundane

world, contrasted with the bizarre rock formations based on the landscape of the Ardennes, near Patinir's home town of Dinant. Together with the dark clouds, they create a suitably austere setting for Jerome's hermitage. Meanwhile, in the lowlands on the right a blind man and his guide travel forthrightly, in the wrong direction.

Leonardo da Vinci (1452–1519)
Arno Valley landscape

1473
Pen and ink on paper
19 × 28.5 cm (7 ½ × 11 ¼ in.)
Florence, Galleria degli Uffizi

This famous drawing has an inscription (in the back-to-front script characteristically used by Leonardo) bearing the date *5 August 1473*. Does this mean that the study is of a particular view as it appeared to the artist on that day? This assumption has often been made, yet, as Ernst Gombrich pointed out, Leonardo's image in fact has artificial features inspired by Northern paintings.[1] The rocky crags frame a spectacular vista, but we are not shown how the distant plain is related spatially to the pool nearer the foreground, while the trees above the waterfall on the right are in a scale that does not seem consistent with their surroundings. Even the cliffs are based on examples in Netherlandish art rather than on direct observation.

It is as if the drawing is a montage of several views: rather than holding a mirror to nature, Leonardo is in fact creating a landscape in his mind's eye, just like most other artists of this period.

Albrecht Dürer (1471–1528)
A Pond in the Woods

c. 1495
Watercolour and gouache on paper
26.2 × 37.4 cm (10 ⅜ × 14 ¾ in.)
London, The British Museum

Watercolour and gouache (an opaque form of water-based paint) were brilliantly used in this luminous landscape, made in the open air rather than the workshop. The painting's spontaneity is clear from the expanses of uncoloured paper and the stumps of the trees on the left. Dürer has deliberately left them unfinished in order to leave space for the marvellous inky clouds, their undersides stained by low sunlight. Despite the fine grasses in the foreground, there are few outlines in this image: the forest is made from wavering coloured strokes, the water permeates its surroundings, and the horizon is a broken streak of wash.

The monogram in the top centre is a later addition: this was a private study, an inspired exercise in trial and error.

Giorgione
(?1477/78–before late 1510)
The Tempest

c. 1509
Oil on canvas
83 × 73 cm (32 ⅝ × 28 ¾ in.)
Venice, Gallerie dell'Accademia

No Renaissance picture has aroused more scholarly argument than this small canvas. Various subjects have been proposed, from 'Mars and Venus' to 'Adam and Eve after Their Expulsion from Eden'; from 'The Infant Paris Nursed by the Shepherd's Wife' to 'Fortitude and Charity Threatened by the Storm of Fortune'. The image has even been linked to Venice's recapture of Padua from imperial troops in 1509.

Whatever the painting's subject-matter, it had been forgotten by 1530, when the connoisseur Marcantonio Michiel described it in the collection of the Vendramin family as 'the little landscape on canvas with the tempest, with the gypsy and soldier'.[2] A little later the man with the staff had become a shepherd, an ambiguity that has troubled scholars ever since. To complicate things further, an X-ray made in 1939 revealed that originally there was a seated nude woman where the man now stands.

The Tempest is not unique among Giorgione's works in causing such problems. In the sixteenth century his most prominent pictures were some frescoes on the outside of the headquarters of the German merchants, near the Rialto Bridge in Venice; yet even by 1550 the historian Giorgio Vasari, while marvelling at their beauty, had to admit that 'I for my part have never been able to understand his figures nor, for all my asking, have I ever found anyone who does.'[3]

It is hard to believe that the murals did not have some sort of subject-matter, but perhaps such an intimate painting as The Tempest did not have to tell a specific story. Lightning flickers over the city walls, and the clouds are reflected in the water beneath; a breeze picks up; the atmosphere is heavy and humid; and a man and a woman await the approaching storm. Maybe this poetic evocation of a sultry summer day was enough for the sophisticated Venetian client for whom this canvas was made.

Titian (Tiziano Vecellio)
(c. ?1485/90–1576)
The Death of Actaeon

c. 1565–76
Oil on canvas
178.4 × 198.1 cm (70 ¼ × 78 in.)
London, The National Gallery

This is a hunting scene with a difference: the Theban prince Actaeon, who accidentally witnessed the goddess Diana while she was bathing, has been vengefully transformed into a stag. Torn apart by his own hounds, the hunter has become the quarry.

Significantly, Actaeon's horrific end takes place in the interior of the landscape rather than the foreground: he is lost in a wilderness that violently claims him. All the natural features in the painting – the woodland, the stream in which Actaeon has seen his bestial reflection – refer to the story as described in Ovid's Metamorphoses. However, the incredible sense of energy and movement is unique to Titian, the product of an increasingly free technique in which he sometimes left a painting for months before returning with furious activity, often using his fingers as well as a brush, sometimes without actually ever finishing. The picture's appearance also reflects the fact that many of the colours in the vegetation and sky have darkened with age. Savagely beautiful as this work remains, it is probably not what Titian ever saw or intended.

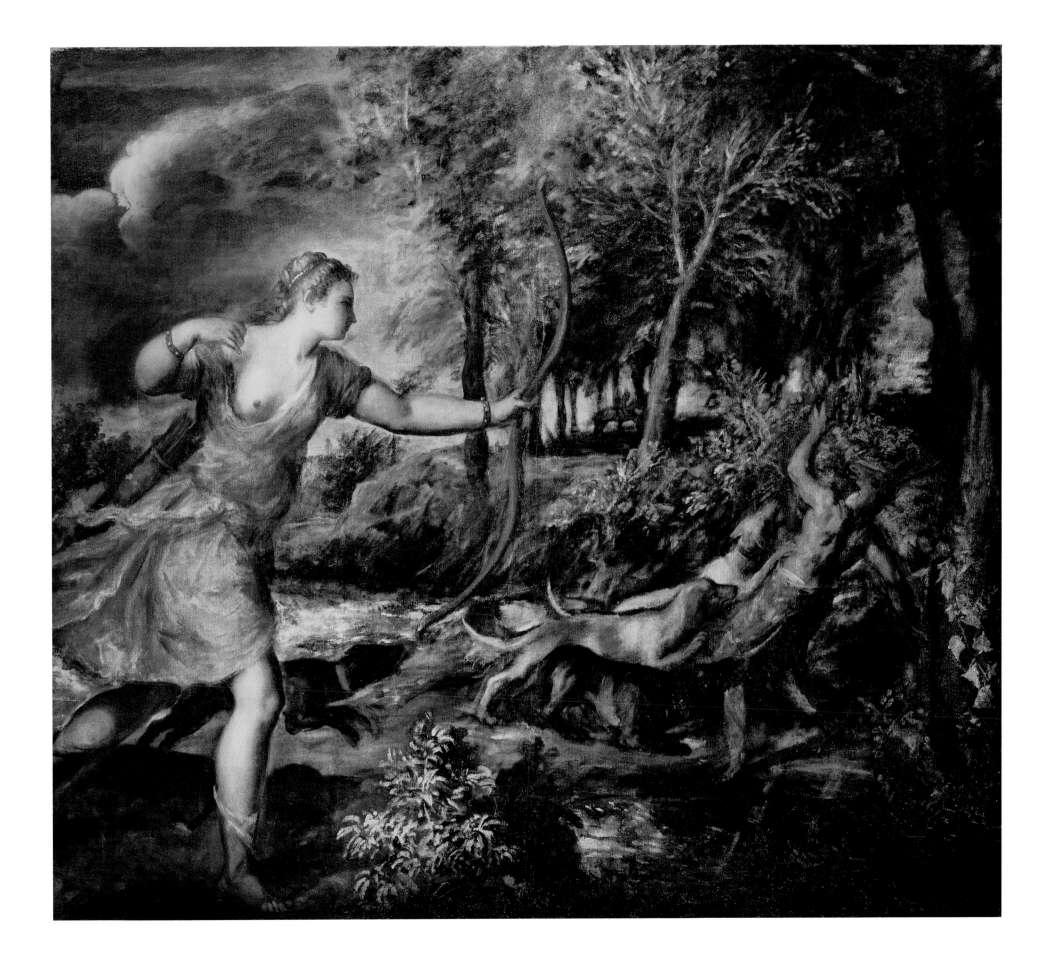

Pol, Jean and Herman de Limbourg (active *c.* 1400–1416)
June, from Les Très Riches Heures du Duc de Berry

c. 1411/13–*c.* 1416
Illuminated parchment
29 × 21 cm (11⅜ × 8¼ in.)
France, Chantilly, Musée Condé

Although representations of seasonal activities were common in medieval art, *June* is an exceptional example. It is part of a series of illuminated pages representing the months (with their relevant zodiac signs), which were made for a 'Book of Hours', or private prayer book. The owner, John, Duke of Berry, was the brother of Charles V, the king of France; Louis I, Duke of Anjou; and Philip the Bold, Duke of Burgundy. Most of the scenes include a depiction of one of the family's castles.

June is set in front of the royal palace and garden on the Île de la Cité in Paris. It is a remarkably detailed view with, on the right, the soaring form of the Sainte-Chapelle, the spectacular chapel built by Louis IX in the 1240s, to house the relic of the Crown of Thorns and fragments of the True Cross. In contrast to the dense cluster of buildings in the background, the panorama in front represents the River Seine, outside the city walls, with peasants making hay on a slightly sloping field. This is an image of a realm at peace, in fact created during a turbulent period that culminated in the Battle of Agincourt in 1415.

The artists Pol, Jean and Herman de Limbourg, from Nijmegen in the northern Netherlands, arrived in Paris around 1400, but had all died, probably from the plague, by 1416. They clearly assimilated influences from a wide variety of sources – Netherlandish, French and central Italian – although an analysis of this is complicated by additions made to the manuscripts later in the fifteenth century. *June* has certain naturalistic features, for example, the varying tones in the sky, but in general the style is one of grace and artifice, with the elegantly proportioned figures arranged in a decorative, rhythmic composition. Above all, the image is lit up by intense, expensive pigments, which proclaim the manuscript's status as a luxury object, made for one of the great collectors of the fifteenth century.

OPPOSITE

Pieter Bruegel the Elder
(*c.* 1525/30–1569)
The Gloomy Day (February), from the 'Panels of the Months' cycle

1565
Oil on panel
118 × 163 cm (46½ × 64⅛ in.)
Vienna, Kunsthistorisches Museum

Painted calendars often took the form of manuscript illuminations, such as those made by the Limbourg brothers (left) in the early fifteenth century. Later examples by Simon Bening seem to have directly influenced Bruegel's series of the 'Months', now divided between Vienna, Prague and New York, originally made for the Antwerp banker Niclaes Jonghelinck. These magnificent paintings transferred the genre from a miniature format to the scale of large panels, which allowed Bruegel to include complex, expansive landscapes.

In *The Gloomy Day* we are shown a panorama extending from icy mountains to a hill on the right, via a windswept river: a grand view, which allows Bruegel to represent a succession of different light effects. The snow has melted from the lowlands, although the branches are still bare, implying that we are seeing the final blast of winter. In the bottom right, the child in a paper hat and the man eating a waffle are enjoying the carnival before the beginning of Lent, while other peasants prune trees – activities that identify this panel with the month of February. Bruegel's landscape manages to be both symbolic and naturalistic at the same time.

BIRDS
&
BEASTS

Of the Four Evangelists, the writers of the Gospels, three were represented by animals: Mark by a winged lion (opposite), Luke by an ox, and John by an eagle. Matthew had to make do with an angel. Yet these were not the only beasts to be endowed with Christian significance: as is illustrated by Leonardo's tender painting (page 224), the Lamb has a particular importance as a symbol of Christ's sacrifice on the cross. More generally, pastoral imagery complemented the notion of Christ the Good Shepherd, although the sheep are given less prominence than the other furry white animal in Titian's *Madonna of the Rabbit* (page 225).

Secular decorations of this period also brimmed with animals: horses, hounds and, of course, their prey dominate Paolo Uccello's *Hunt in the Forest* (page 227), which would originally have been set into the furnishing of a Florentine reception room. Equestrian imagery was popular with aristocratic patrons, who were in a position to indulge their interests. Giulio Romano's magnificent chestnut horse (page 228) decorated a room in the palace next to the Gonzaga family's stud farm on the outskirts of Mantua. Even the grottoes of princely villas required adornment, which Giambologna achieved in the 1560s with a flock of bronze birds (see page 229), more durable if less lively than the menageries of real creatures kept by his patrons, the Medici dukes of Tuscany.

Such images, especially those of the Gonzaga horse, illustrate one of the features of the Renaissance period, the pleasure in deceiving the eye. Yet a delight in the weird and fantastic was as important. This can be seen already in Botticelli's depiction of a centaur (page 231), the hybrid creature suggestive of man's animal nature. Still more extraordinary is the almost surreal painting created by Giuseppe Arcimboldo (page 233), a man whose parts are formed by a marvellous variety of fish and crustaceans. An element of illusionism lingers: from the right distance, a figure emerges from the forked tails and glassy eyes, and we enjoy the consciousness of artifice, based, nonetheless, on painstaking observation of the natural world. Above all, the picture is an imaginative representation of the contemporary belief in four elements – fire, earth, air and water – out of which everything, human or otherwise, was thought to be created.

A very different exposition of this concept is provided by the kitchen and market scenes of Joachim Beuckelaer (page 232), where the elements are symbolized by the everyday – a blazing fire or a table laden with vegetables, poultry or fish. Such paintings also illustrate a simpler truth: for most people, birds and beasts are interesting principally as something to eat. Here the allegorical significance seems less important than the direct observation of nature.

It is in the work of the German painter Albrecht Dürer that the most convincing studies of animals can be found, above all, perhaps, in the famous watercolour of a hare (page 234). The narrative or vaguely symbolic meaning of Titian's rabbit is absent; instead, the living reality of the creature, its texture, pose, even the tension of its body, are conveyed with arresting accuracy. How weak the specimen drawings of the English explorer John White (page 235) appear in comparison! Yet such images as these embody a new type of zoology, prosaic perhaps but with its own insights.

Vittore Carpaccio
(?1460/66–c. 1525/26)
The Lion of St Mark

1516
Oil on canvas
130 × 368 cm (51 ⅛ × 144 ⅞ in.)
Venice, Palazzo Ducale

The winged lion – the symbol of St Mark, one of the four writers of the Gospels – gained special significance for Venice in 829, when the saint's relics were brought to the city. Carpaccio's memorable canvas presents the lion striding on to the land, perhaps a reference to Venice's increasing domination of the northern Italian mainland. The beast holds the inscription PAX TIBI MARCE EVANGELISTA MEUS ('Peace unto you, Mark my Evangelist'), the greeting given to Mark by an angel, who identified Venice as his eventual resting place. The story is a thirteenth-century Venetian fabrication, which underlines the importance of St Mark to the city's identity. This particular image of his symbol was painted for a government office: the small shields at the bottom must be the arms of the officials who commissioned it.

The representation of the lion, with its anthropomorphic features and scrawny body, still follows medieval conventions. The view of the city behind, however, is remarkably up-to-date. In the background, beyond the magnificent state barge, is the bell tower of San Marco, with its recently completed spire (a replacement for one destroyed by lightning), while even further away is the new clock tower. Both structures are adorned with the winged lion, while to the right, beyond the Palazzo Ducale, or Doge's Palace, is the domed basilica housing the relics of the saint himself.

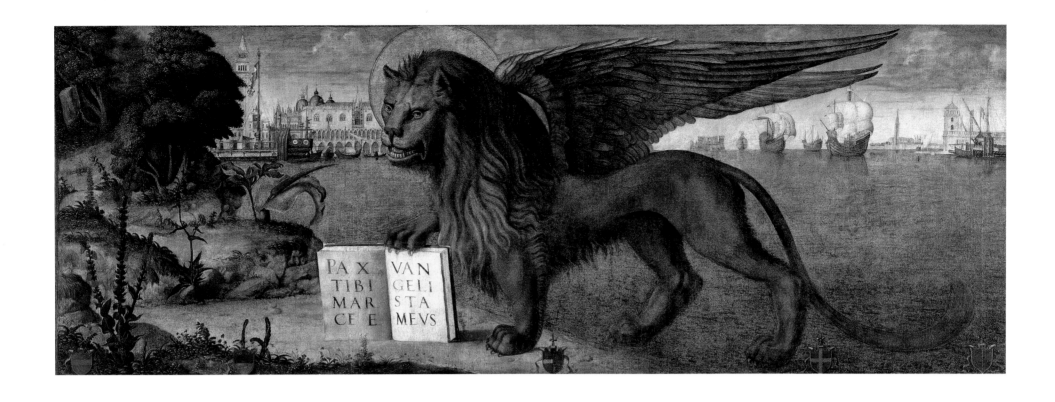

PA X VAN
TIBI GELI
MAR STA
CE E MEVS

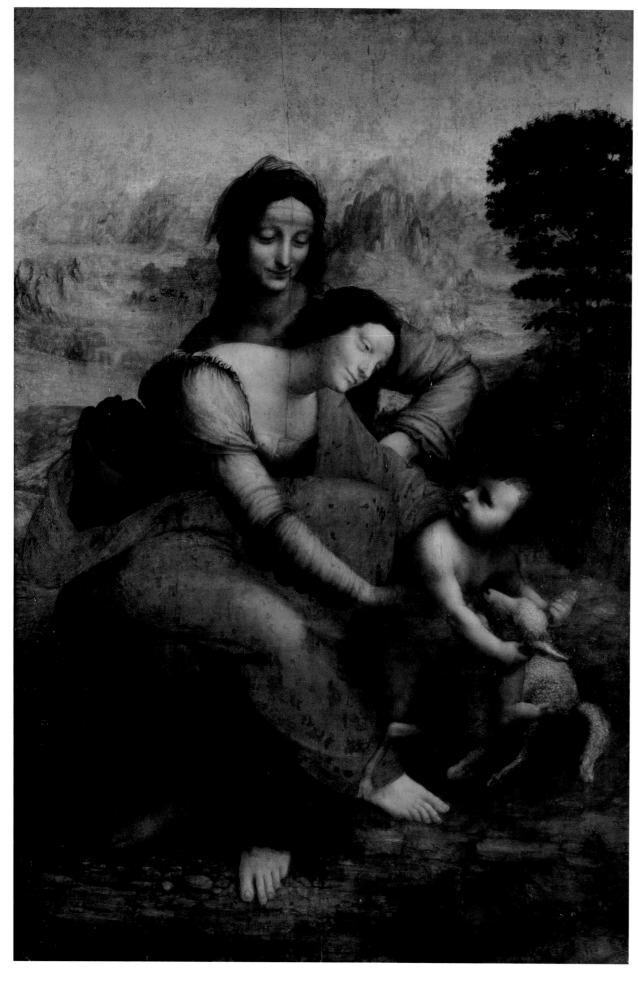

Leonardo da Vinci (1452–1519)
Virgin and Child with St Anne and a Lamb

c. 1508–17
Oil on panel
168 × 130 cm (66⅛ × 51⅛ in.)
Paris, Musée du Louvre

When Leonardo's cartoon (a full-scale drawing) of this subject was displayed in the Florentine church of Santissima Annunziata in 1501, crowds came to see it. An agent of Isabella d'Este, Marchioness of Mantua, wrote to her that Leonardo had represented 'a Christ Child about one year old who, almost slipping from his mother's arms, grasps a lamb and seems to hug it. The mother, half rising from the lap of St Anne, takes the Child as though to separate him from the lamb, which signifies the Passion. St Anne, also appearing to rise from a sitting position, seems to wish to keep her daughter from separating the Child and the lamb, and perhaps is intended to represent the Church, which does not wish the Passion of Christ to be impeded.'[1]

Although painted some years later – with certain areas of the drapery never finished – this panel clearly reflects the earlier design. The composition consists of a pyramid, formed by rhythmic figures, whose idealized features are characteristic of Leonardo. The poetic quality is enhanced by the slightly smoky atmosphere, or *sfumato*, which helps to integrate the figures with the background, a fantastic landscape, emphasizing the picture's degree of separation from the mundane reality of the observer.

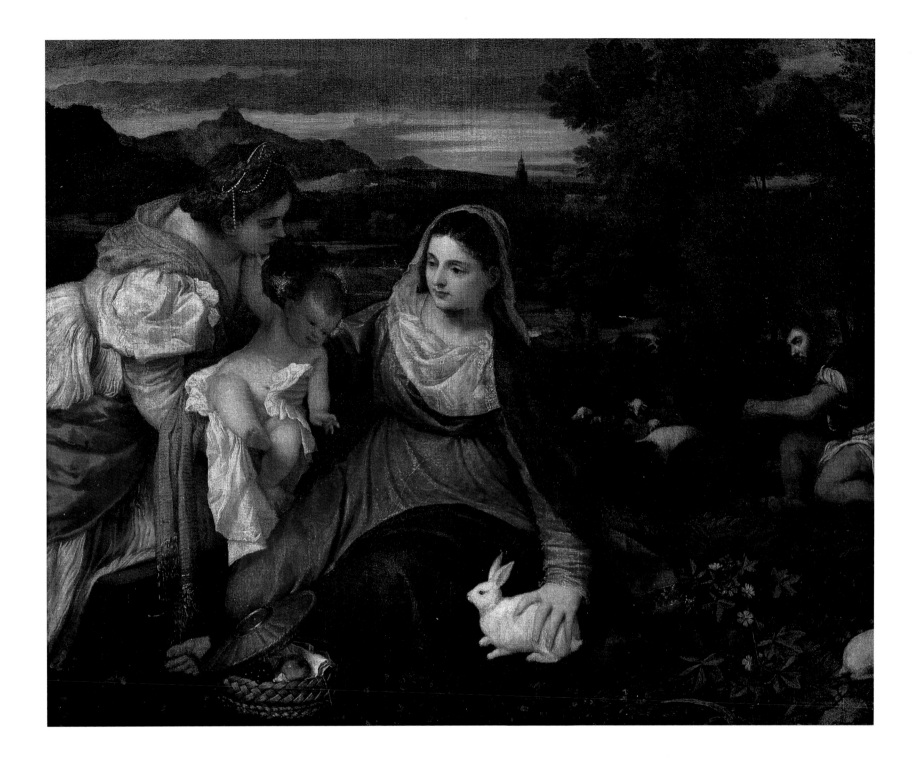

Titian (Tiziano Vecellio)
(c. ?1485/90–1576)
*The Virgin and Child with
St Catherine and a Shepherd
(The Madonna of the Rabbit)*

c. 1525–30
Oil on canvas
71 × 87 cm (28 × 34¼ in.)
Paris, Musée du Louvre

This painting is filled with small surprises. While St Catherine is holding Christ, the Virgin is stroking a rabbit. Mary sits modestly on the grass, in front of a humble shepherd, who may be a portrait of the patron, Federico Gonzaga, Duke of Mantua. He also pats an animal, which is often thought to be a sheep but, with its long tail, is more likely to be a dog.

The pastoral imagery, set within a luminous landscape, is not accidental: Christ, the Good Shepherd, has his representative looking after his flock, even though he himself is more interested in the equally innocent white rabbit, a symbol of the Virgin Birth, or parthenogenesis. The creature, alertly pricking its ears, is so vividly painted that the viewer can almost feel the touch of Mary's fingers on its body. The animals' postures – and the gestures of those handling them – brilliantly display Titian's powers of observation.

Meanwhile, an apple and some grapes in the basket refer to the Fall of Adam and Eve, and the wine that becomes Christ's blood in the Mass. This is no ordinary picnic.

Pisanello (Antonio Pisano)
(by 1395–1455)
The Vision of St Eustace

c. 1438–42
Tempera on panel
54.8 × 65.5 cm (21⅝ × 25¾ in.)
London, The National Gallery

This painting depicts the story of Eustace or (possibly) Hubert, both of whom had a vision of the crucified Christ between a stag's antlers: at this time, hunting was often seen as a metaphor for religious revelation. St Eustace is the more likely subject, since the legend of St Hubert probably developed later than the date of this picture. Although Eustace was a soldier, he is represented here as an elegant aristocrat, like those for whom Pisanello worked in the courts of northern Italy.

The animals are at least partly based on the life drawings for which Pisanello was famous. Eustace is accompanied by different breeds of hound, sniffing the ground (or one another) or chasing a hare with great vitality, even though the space in which they are situated defies analysis. The pose of the horse, with rear legs still in motion and front legs rooted like tree trunks, is less natural, but captures effectively the moment in which the worldly rider is arrested by his miraculous vision.

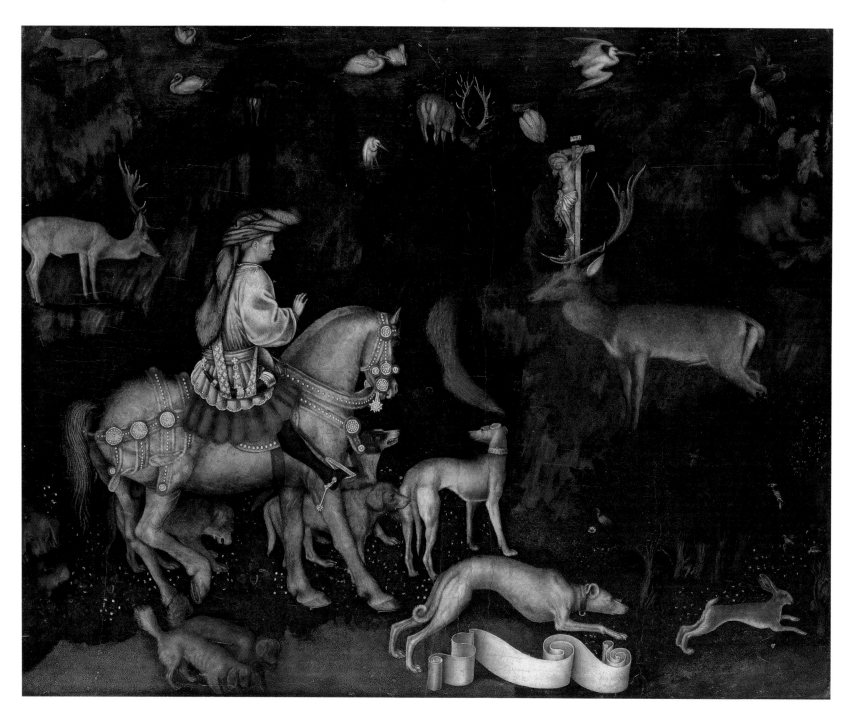

Paolo Uccello (c. 1397–1475)
The Hunt in the Forest

c. 1465–70
Tempera and oil on panel
73 × 177 cm (28¾ × 69⅝ in.)
Oxford, Ashmolean Museum

Hunting was, and remains, an important part of aristocratic life. We do not know for whom this painting was made, but there is little doubt that it would have been for a palace either in Florence, Uccello's home town, or Urbino, where he lived towards the end of his life. Although the gold in the leaves has mostly vanished, the panel is still a gorgeous object, which would originally have adorned a chest or panelling in the *camera*, a room that doubled as reception room and bedchamber.

Despite its mixture of natural details and strong perspective – even the fallen tree trunks carry the eye to the vanishing point – this is a profoundly artificial image. The red trappings and costumes create a strong sense of pattern, while as a depiction of hunting practice it has little connection with reality. Hunting takes place in daylight; this image is set at night. Huntsmen use a variety of hounds, whereas Uccello depicts the same breed (although in different colours). Above all, Uccello's characters and their horses show a picturesque range of poses but not much organization: this is a hunt that would not catch much.

Of course, that did not matter. In Renaissance courts the hunt – the pursuit of a noble animal – could symbolize the quest for love or even Christian salvation, while the physical skill involved offered a peacetime equivalent to the disciplines of war. Uccello's *Hunt* is a visual expression of this culture, and is only strengthened by its refinement and artifice.

Giulio Romano (?1499–1546) and workshop
A Horse from the Gonzaga Stable (detail of the Sala dei Cavalli)

1528
Fresco
Mantua, Palazzo del Te

When Federico Gonzaga summoned Giulio Romano to Mantua in 1524, he commissioned him to design and decorate a new palace, next to his stud farms on the outskirts of the city. Giulio, one of Raphael's most gifted pupils, responded with a building in a quirky Classical style, decorated with mythological frescoes and a whole room of magnificent painted horses. The chestnut depicted here, with the Gonzaga brand on its cheek, is a portrait of one of Federico's favourite animals. It stands above an actual marble cornice, and is depicted so illusionistically that we seem to look beyond it, towards a view of the distant walled city.

Giambologna (Giovanni Bologna, Jean Boulogne) (1529–1608)
Turkey

1567
Bronze
62 × 50 cm (24⅜ × 19⅝ in.)
Florence, Museo Nazionale del Bargello

The Franco-Flemish sculptor Giambologna produced this monstrous bird as part of a menagerie of bronze animals commissioned for the grotto of the Medici villa of Castello, outside Florence. Together with an owl, peacock and eagle, it demonstrates not only Giambologna's observation of nature but also his technical skill and wit. In the wax model Giambologna expressively re-created the different textures of the turkey's plumage, flesh and scales, which were then skilfully transferred to the cast. The choice of bronze, a material used for prestigious and luxury commissions, is appropriate for such a pompous, anthropomorphic figure – a fitting adornment to a Renaissance court.

Piero di Cosimo
(1461/62–?1521)
The Forest Fire

c. 1505
Oil on panel
71 × 202 cm (28 × 79½ in.)
Oxford, Ashmolean Museum

Piero di Cosimo was an eccentric. According to the sixteenth-century art historian Giorgio Vasari, he lived on a diet of hard-boiled eggs and loved natural things so much that he never cut his vines or pruned his trees. Something of this peculiarity can be detected in this painting, in which native animals (from pigeon and woodcock to hare, deer and bears) escape a forest fire in the company of a lion and lioness, a multicoloured tropical bird (in the top right) and hybrid monsters (including a pig with a human head).

The panel may originally have been set into the wall or the furniture of a Florentine palace, and so must reflect the tastes of a highly educated patron. At this time there was a particular vogue for the Roman poet Lucretius, whose *De rerum natura* ('On the Nature of Things') described man's early development, including his discovery of fire from natural conflagrations. Piero's picture is not a literal representation of any single text but, like Lucretius, refers back to the ancient past, in this case the point at which man began to domesticate animals: as the flames drive the oxen into the open, a man follows with a yoke, while further off a couple are accompanied by a dog. However, it is still the wild beasts, so vividly imagined that they are almost audible, that dominate the scene, for a while at least.

Sandro Botticelli
(1444/45–1510)
Pallas and the Centaur

c. 1482
Tempera on linen
207 × 148 cm (81½ × 58¼ in.)
Florence, Galleria degli Uffizi

The hybrid creature here is a centaur, whose equestrian haunches betray his bestial character. The female pulling the monster's hair is likely to be Pallas, or Minerva, the Classical goddess of wisdom, although an attempt has been made to identify her with Camilla, a princess described in Virgil's *Aeneid* as one of Minerva's devotees. Certainly, an inventory of 1499 refers to a painting of Camilla outside the wedding chamber of Lorenzo di Pierfrancesco de' Medici, although it cannot be proved that this refers to our picture.

Whatever the heroine's precise identity, this work is undoubtedly a Medici commission, since the family's emblem – the interlocking ring – adorns her fashionable dress. The painting's overriding theme of reason and chastity overcoming animal passion links it to Botticelli's other mythologies, *Primavera* (page 131) and *The Birth of Venus* (page 54). Yet, in comparison with these celebrated images, this picture has a playful quality, indicated by the centaur's submissive gesture and diminutive body, more like a pet pony than an untamed stallion.

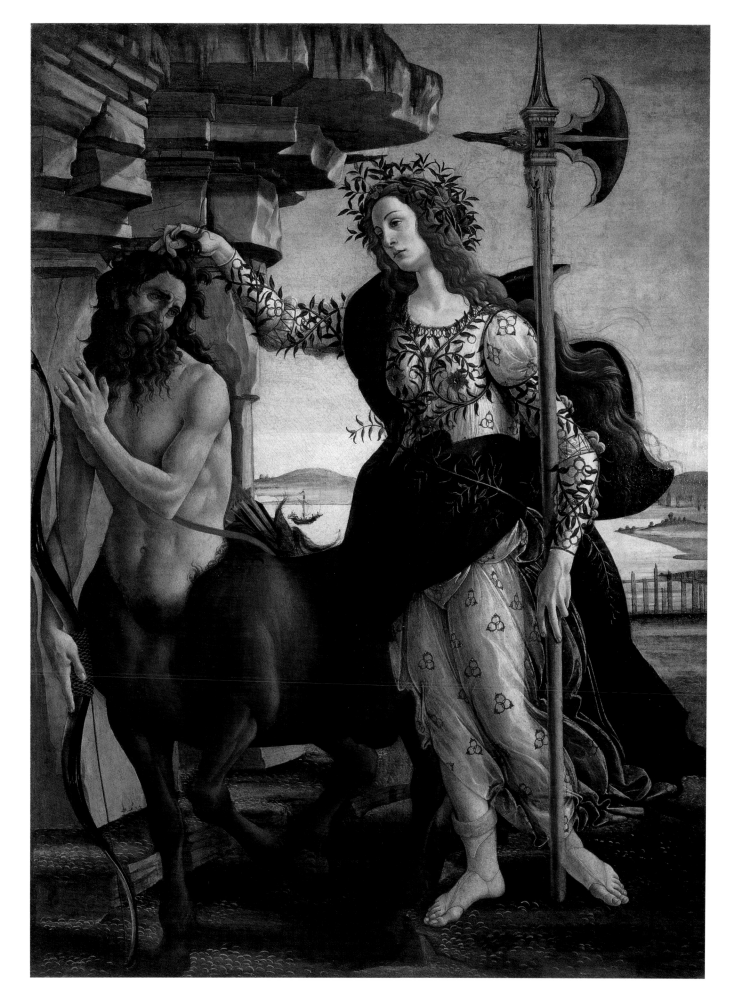

OPPOSITE

Joachim Beuckelaer

(c. 1534–c. 1574)

The Fish Market

c. 1570
Oil on canvas
133.4 × 206.4 cm (52½ × 81¼ in.)
UK, Hull, Ferens Art Gallery

The Antwerp artist Joachim Beuckelaer presents a stupendous assortment of fish with impressive accuracy. Their arrangement and setting seem at least a little less artificial than in Arcimboldo's painting (right), and yet both works symbolize the element of water. In Beuckelaer's other pictures, kitchen hearths (page 155) and market stalls laden with poultry, fruit and vegetables represent fire, air and earth, with all the bulk and texture of the produce convincingly portrayed. Here the transparent glazes of oil paint are fully exploited to represent the slippery sheen of the fish. The animal is presented as an object of consumption, in a society that was growing ever richer.

Giuseppe Arcimboldo

(?1527–1593)

Water

1566
Oil on panel
66.5 × 50.5 cm (26⅛ × 19⅞ in.)
Vienna, Kunsthistorisches Museum

A crab forms a crustacean breastplate; a turtle, octopus and large shell create the shoulder piece; pearls adorn the neck and ear; and a piece of coral and some spiny fish suggest a crown. Out of the myriad creatures of the sea, arranged with no concern for their respective sizes, Giuseppe Arcimboldo has fashioned an image of a ruler, possibly his patron, Emperor Maximilian II. At the same time, the painting is part of a series representing the Four Elements: naturally, this picture depicts *Aqua* ('Water'), inscribed on the reverse.

These layers of meaning reflect the contemporary passion for allegory, in which human figures or animals would carry complex symbolic meanings. Arcimboldo's fantastic imagery also perfectly suited a court filled with collections of stuffed animals and natural wonders, where artists, philosophers, alchemists and astrologers mixed freely. To this pre-scientific culture of curiosity, Arcimboldo contributed a pictorial alchemy all his own.

Albrecht Dürer (1471–1528)
Hare

1502
Watercolour and gouache, heightened
with opaque white, on paper
25 × 22.5 cm (9⅞ × 8⅞ in.)
Vienna, Graphische Sammlung Albertina

Direct observation from nature is one of the
supposed characteristics of Renaissance art,
even though often the painted animals and
plants were based on drawings in workshops.
Here, however, the watercolour is so vivid
that it can have been made only from life.
The sense of alertness, conveyed by the tense
body and the angles of the ears, is that of a
frightened, living creature. Above all, the
depiction of the raised hairs, whiskers and
soft, striped fur demonstrates Dürer's
remarkable skill with his medium.

Albrecht Dürer (1471–1528)
Rhinoceros

1515
Woodcut
23.5 × 29.6 cm (9¼ × 11⅝ in.)
London, The British Museum

Dürer's drawing of a rhinoceros made the
creature look even more outlandishly
prehistoric than in reality. This is because
the artist never actually saw it: instead, he
elaborated on a sketch made by a German
merchant when the animal arrived in Lisbon
on a boat from the East Indies.

 The rhino was supposed to be sent to
the pope, but never made it, dying in a
shipwreck on the way. Prints of Dürer's
drawing, on the other hand, were exported
all over Europe.

John White (*fl.* 1585–1593)
Purple-Clawed (or Land)
Hermit Crabs

c. 1585
Watercolour over black lead,
touched with white, on paper
18.8 × 15.5 cm (7⅛ × 6⅛ in.)
London, The British Museum

When John White travelled in 1585 to
Sir Walter Raleigh's settlement in 'Virginia'
(now part of North Carolina), he was
employed to 'drawe to life all strange birdes
beastes fishes plantes hearbes Trees and
fruictes and bring home of each sorte as
nere as you may. Also drawe the figures
and shapes of men and women in their
apparell …'.[2] He returned with a large
number of accomplished watercolours,
recording both the local people and animals.
Some of these were intended to show the
friendliness and productivity of the colony,
to which White himself travelled five times
in six years. Others have no obvious practical
or commercial function.

 As White has shown, hermit crabs
occupy the shells of snails and other molluscs:
Caracol means 'snail' in Spanish. They are
inedible and have no economic use. These
studies are, therefore, specimen drawings in
the formal style typical of Renaissance books
on natural philosophy. They demonstrate the
increasing interest in zoology, especially at
a time when exploration was exposing
Europeans to new lands and species.

MAN,
THE
MEASURE
OF
ALL
THINGS

Leonardo's drawing of a male nude (opposite) represents an ideal man who, with his limbs extended, fits perfectly into the forms of a circle and square. The image is based on a passage in a treatise by the Roman architect Vitruvius, who also attempted to show how the proportions of Classical buildings were directly inspired by the human figure.

In contrast to Vitruvius' geometric approach, in the mid-fifteenth century Leon Battista Alberti developed a canon of human proportions based on average measurements from 'many bodies, considered to be the most beautiful by those who know'.[1] Alberti also wrote a classic architectural work, *De re aedificatoria* ('On Building'), which was inspired by Vitruvius' text without being uncritical of it. Like Vitruvius, Alberti associated the structure of a column with the ratios of different parts of the body, but did not go as far as his fellow architect Francesco di Giorgio Martini, who superimposed male figures on to his designs for buildings and even whole cities. It was Alberti, however, who revived the Greek philosopher Protagoras' dictum 'Man, the measure of all things', and it is undeniable that some of his buildings have a human sense of scale and proportion (see page 240).

Alberti was also responsible in 1435 for codifying the technique of perspective apparently invented by Filippo Brunelleschi more than a decade earlier. According to Alberti's treatise *De pictura* ('On Painting'), the central vanishing point should be on the eye-level of the tallest figure standing on the base of the panel or relief. By this means the pictorial space is in harmony with its inhabitants, although successful variations were made on this, as can be seen in Piero della Francesca's *Flagellation of Christ* (page 242).

Looking at such a painting, it is easy to see how northern European artists came to envy the mathematical secrets of their Italian counterparts. Characteristically, Albrecht Dürer, frustrated by his unhelpful Venetian acquaintances, decided to beat them by mastering Vitruvian proportions: the result was *Adam and Eve* (page 245), an engraving that consciously challenged the pre-eminence of Italian art.

However, as both Dürer and Leonardo realized, mastery of the human body could not be learned solely from an ancient textbook. Leonardo da Vinci was, as we have seen, acquainted with Vitruvius' ideas, but, of all the artists of the Renaissance, he placed the most emphasis on physical observation. By measuring real people (page 246), he gained a proportional structure with which he could represent not just beautiful youths but also an unsurpassed range of different human types. For him, the harmony of a figure depended more on the relationship between its different parts than on its conformity to an abstract set of ratios: he argued that 'a man can be well proportioned if he is thick and short, or tall and thin, or medium',[2] provided his limbs are commensurate with one another.

Leonardo's amazing curiosity about the human body, in all its manifestations, was displayed most spectacularly in his anatomical drawings. There was nothing unique about his interest in dissection: many other artists, such as Michelangelo or Pollaiuolo, examined corpses, but they rarely got beyond the bones or sinews, as Leonardo did, to the organs or even to an unborn child (page 248). This was usually the territory of professional anatomists, who were of course unable to represent their findings with Leonardo's artistic skill.

Yet it is not really what Leonardo observed or the way in which he drew it that was most significant. His achievement can be seen most clearly in such works as the unfinished *St Jerome* (page 249). No longer the dignified scholar, this Jerome is a gaunt old man, twisting his sinewy neck in anguished penitence. Anatomy has been transformed into a new expressive language. Meanwhile, Jerome crouches on the ground like the lion that he befriended. In such works, man is perhaps no longer the measure of all things, but he is scrutinized with an intensity rarely seen before.

Leonardo da Vinci (1452–1519)
Human figure in a circle
('Vitruvian man')

c. 1485–90
Pen and ink on paper
34.3 × 24.5 cm (13½ × 9⅝ in.)
Venice, Gallerie dell'Accademia

This figure, with his arms and legs outstretched, inhabits the shapes around him with such confidence that it is as if they were made for him. The frontal pose is, of course, not a natural one, as is emphasized by the contrast between the feet resting on the base of the square, one foreshortened, the other in perfect profile. As this is principally an analysis of proportion, the muscles are only lightly defined, the most realistic parts being the face and genitals, and the emphasis is on the mathematical division of the body.

The drawing is inspired by a text by the Roman architect Vitruvius, a translation of which has been written on to the sheet. It seems to have influenced illustrations in later editions of Vitruvius' treatise – for example, Fra Giocondo's of 1511 – and it remains a classic image, even though Leonardo's approach to the human body was generally more empirical than this study would suggest.

Leon Battista Alberti (1404–1472)
The Little Chapel of the Holy Sepulchre

c. 1464–67
Florence, San Pancrazio, Rucellai Chapel

Leon Battista Alberti had recently designed a new palace for the banker Giovanni Rucellai when his patron gave him a commission for a funerary chapel in the neighbouring church of San Pancrazio. The Rucellai Chapel is an impressive barrel-vaulted room, housing a shrine modelled on descriptions of the ancient Holy Sepulchre in Jerusalem. This tiny building has many refined features, including the elegantly carved inscription in the frieze. Above all, its walls are richly adorned with marbles in different colours, showing the influence of a local building, the Romanesque baptistery in Florence. The regular pattern that they form expresses Alberti's preoccupation with geometry: the squares are basic units, or modules, which determine the proportions of the whole structure. This clear, rational design is combined with such Classical architectural forms as the graceful pilasters, which, Alberti believed, ultimately derived from the ratios of the body. Together with its small size, these qualities give the shrine its human scale and intimacy.

OPPOSITE

Lorenzo Ghiberti (1378–1455)
The Story of Jacob and Esau, from the 'Gates of Paradise'

1425–52
Gilded bronze
79 × 79 cm (31 ⅛ × 31 ⅛ in.)
Florence, Museo dell'Opera del Duomo

In contrast to the small reliefs, with Gothic frames, that Ghiberti had made for an earlier set of baptistery doors, the 'Gates of Paradise' were decorated with large rectangular panels, which provided more space for complicated narratives. Here Isaac is being tricked into giving his blessing not to his older son, Esau, but to the younger Jacob: the figures still have the graceful, elongated forms and looping drapery of Gothic sculpture; even the proportions of the Classical architecture seem a little stretched. Yet Ghiberti has skilfully applied the rules of perspective, as described by Alberti, to relief sculpture. In this system, orthogonals (lines that are actually parallel) appear to converge towards a vanishing point, which, Alberti writes, should be on the eye-level of a character standing on the base line. In fact, here it is nearer the centre of the relief, corresponding with the head of Isaac. Yet the effect is the same, to make the space truly human. Meanwhile, the women at the edges overlap with the frame, emphasizing the image's continuity with the reality outside.

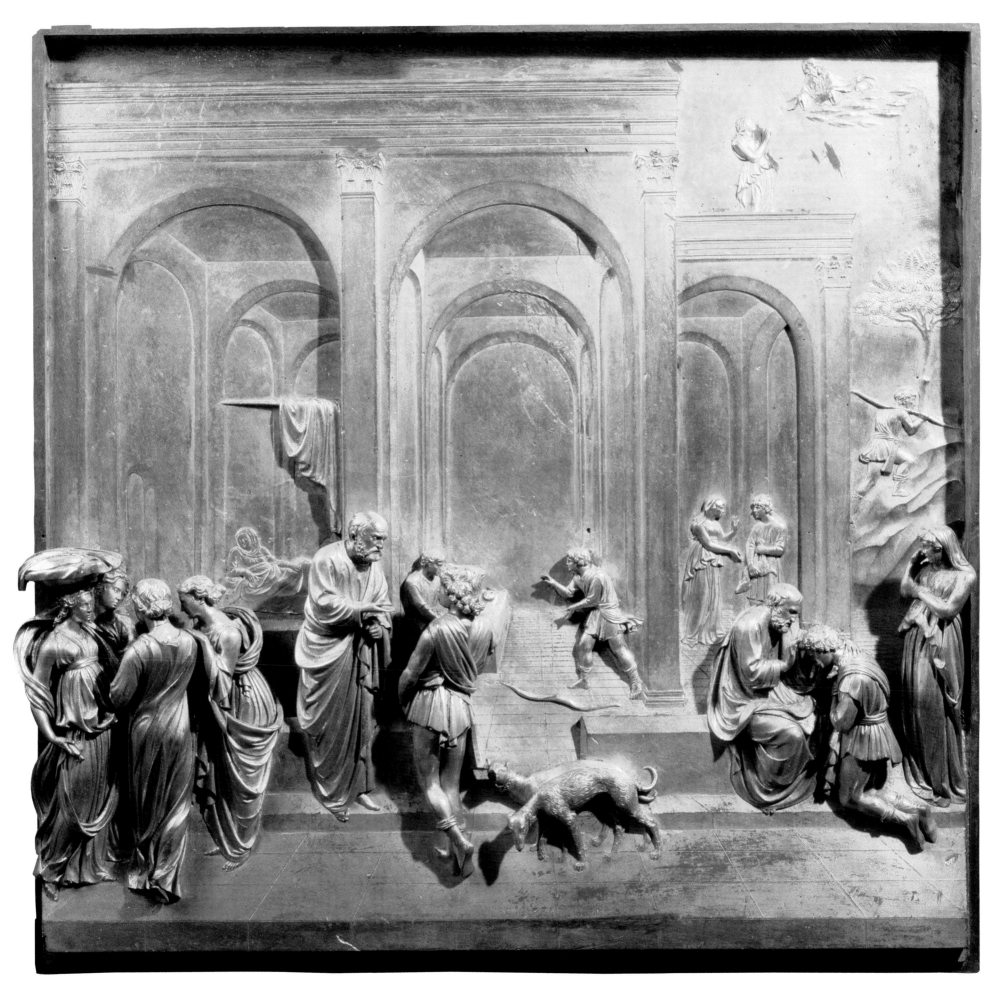

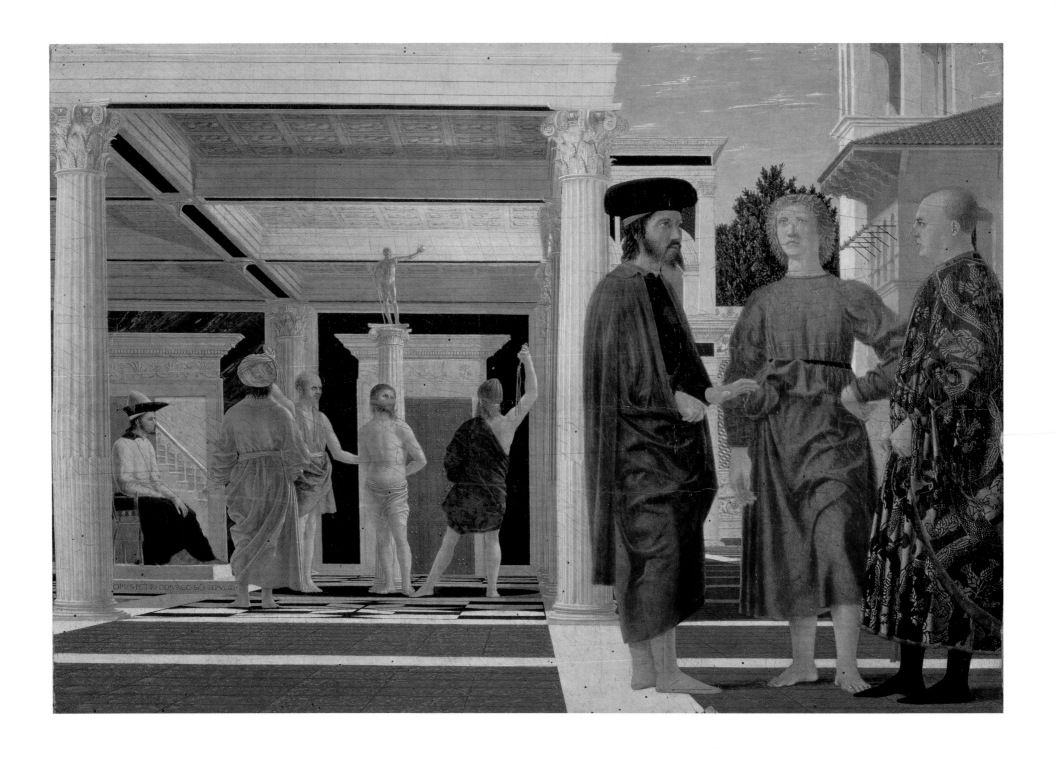

OPPOSITE

Piero della Francesca
(c. 1415–1492)
The Flagellation of Christ

c. 1460
Tempera on panel
59 × 81.5 cm (23 ¼ × 32 ⅛ in.)
Urbino, Galleria Nazionale delle Marche

As Christ is whipped at the column, his suffering is watched by the enthroned Pontius Pilate, whose palace is modelled on the portico designed by Alberti at San Pancrazio. This familiar scene from Christ's Passion is made extraordinary by the picture's composition, in which the Flagellation is pushed away into a distant corner, while three mysterious figures dominate the foreground. They have been identified, often unconvincingly, in a bewildering number of ways – from a gentile, a soldier and Joseph of Arimathea to relatives of Federico da Montefeltro, Duke of Urbino, who has been suggested as the painting's patron. Other interpretations have linked the picture with the Council of Mantua in 1459, which attempted to organize a crusade against the Turks: the Flagellation might have been seen as prefiguring the suffering of the Church at the hands of Ottoman invaders, and the man in the Greek hat on the left may be discussing this with his two companions.

In truth, the precise subject remains unknown. However, the spatial structure has the geometric clarity that is characteristic of Piero: for example, the paving of the room in which Christ is being tormented forms a pattern centred on the porphyry disc at the base of the column. Although the perspective is clearly influenced by Alberti's treatise *De pictura*, Piero uses a vanishing point that is lower than that which Alberti had suggested. The effect is to emphasize the scale of the three men at the front. Yet, despite their obvious importance, the key figure in this painting remains the smallest one of all, Christ himself, whose proportions define those of the whole space. In this painting, it is Christ who is the measure of the mystical scene around him.

Albrecht Dürer (1471–1528)
Nemesis

1501–02
Engraving
32.9 × 22.4 cm (13 × 8⅞ in.)
UK, Leeds Art Gallery

'From now on I shall concentrate on engraving. Had I done so all the time I should today be richer by a thousand guilders.'[3] Dürer's pithy statement is probably not far from the truth. His prints were extremely successful, as they combined the artist's technical skill with a capacity for inventing unique and memorable designs.

Nemesis was the Classical goddess of retribution. She floats above the valley, holding both a goblet and a bridle – symbols of favour and disfavour – since she has taken on the attributes of Fortune, who can smile as well as scowl. She is by no means idealized; her features were undoubtedly copied from an actual model. Yet her anatomy also reflects the ratios defined by Vitruvius in the first century BC: for example, the length of the face is one-tenth and the whole head one-eighth of the figure's height. In this way, Dürer began the systematic experiments with human proportion that were to continue for the rest of his life.

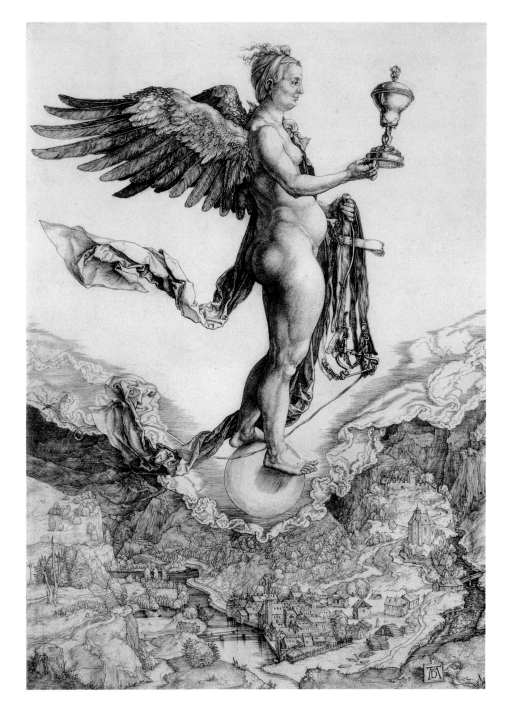

OPPOSITE

Antonio Pollaiuolo
(*c.* 1432–1498)
Battle of the Ten Nudes

1465
Engraving
38.4 × 58.9 cm (15⅛ × 23¼ in.)
New York, The Metropolitan Museum
of Art

Signed in Latin on the tablet hanging from
a tree, this is the largest Florentine print of
the fifteenth century. It depicts ten nude men,
stabbing, kicking, slashing and shooting
arrows at one another, in front of an
incongruous background of corn, olive trees
and vines. Not only are the nudes beautifully
proportioned, but their musculature is
defined in such detail that it is probably
based on studies of flayed corpses. However,
although their poses are meant to appear
dynamic, most of the figures look frozen
and artificial. The two men in the centre,
for example, mirror each other so exactly
that they are clearly based on a single design.
Pollaiuolo has diligently studied the structure
of muscles and bones but has somehow failed
to animate them.

Albrecht Dürer (1471–1528)
Adam and Eve

1504
Engraving
25.2 × 19.4 cm (9⅞ × 7⅝ in.)
London, The British Museum

Here, in contrast to *Nemesis* (page 243), the
figures are no longer shown in stiff profile
but in a dynamic *contrapposto*. In Adam's case
this was inspired by the recently discovered
Apollo Belvedere in the Vatican. The
asymmetrical pose, with one leg bent forward,
allows the artist to show more of the body's
contours. Although Adam's thigh has been
slightly lengthened in order to make him taller
than Eve, in general Dürer has remained
faithful to Vitruvian proportions.

In this print Dürer has at last met the
challenge offered by Pollaiuolo's engraving
(opposite). He acknowledges his Italian
predecessor in the design of the forest and,
in particular, the sign displaying his name
(and the date of the work) in Latin. Yet,
unlike Pollaiuolo, Dürer has created a highly
effective narrative, visualizing an Eden,
shared with a parrot and some less exotic
beasts, at the precise moment that it is lost.

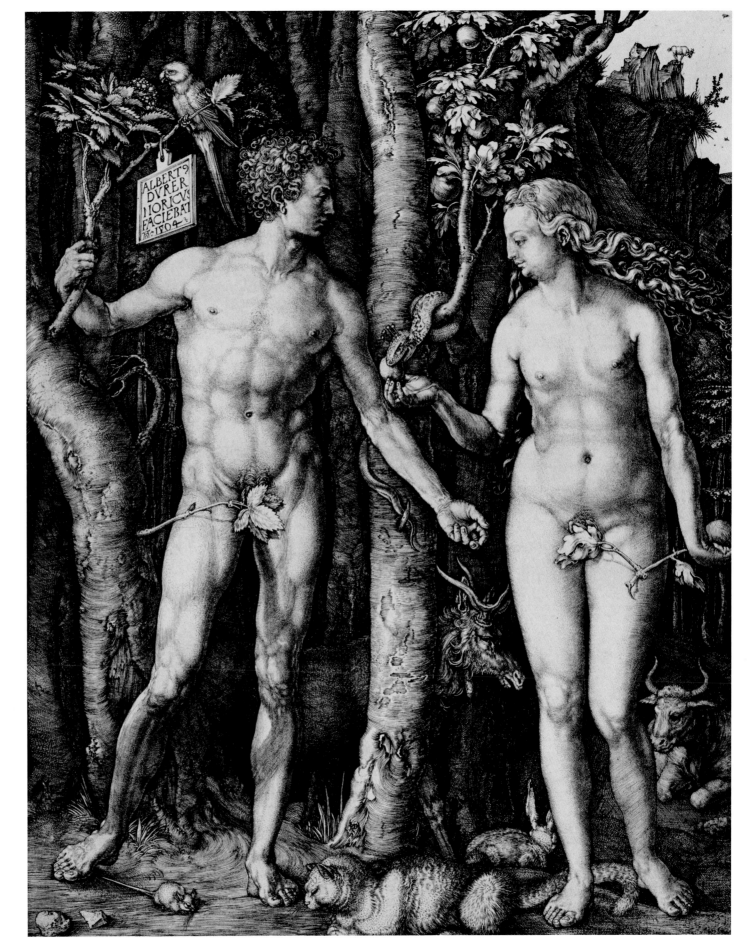

Leonardo da Vinci (1452–1519)

Profile of a man squared for
proportion, and studies of horsemen

Head *c.* 1490; horsemen probably 1503–04
Pen and ink, red and black chalk, charcoal
and pencil on paper
28 × 22.4 cm (11 × 8⅞ in.)
Venice, Gallerie dell'Accademia

Unike the 'Vitruvian man' (page 239), the
main character in this drawing looks like a
real individual, whose proportions have been
carefully measured. Through such careful
studies, Leonardo is able to compose a wide
array of human forms: as well as creating the
middle-aged man, of average beauty, he has
given an idealized profile to the horseman
on the right, while another, more excited
figure gallops across the bottom of the page.
Both riders may be related to Leonardo's
uncompleted mural (subsequently destroyed)
of the Battle of Anghiari, for the Palazzo
della Signoria in Florence.

Two heads in profile

c. 1500
Red chalk on paper
21 × 15 cm (8¼ × 5⅞ in.)
Florence, Galleria degli Uffizi

Leonardo's ability to represent different
human types is demonstrated by these two
profiles. The youth has been identified with
Salai, a beautiful but good-for-nothing youth
who joined Leonardo's service as a boy,
causing mayhem with his dishonesty and
greed. Yet there is obviously an ideal quality
in his Classical features and magnificent
locks, which resemble the tight, regular curls
that ancient Roman sculptors carved with a
hand-drill from marble blocks. In contrast,
the old man, with his prominent nose and
chin, represents another extreme. For the
mean, we have to look elsewhere (left).

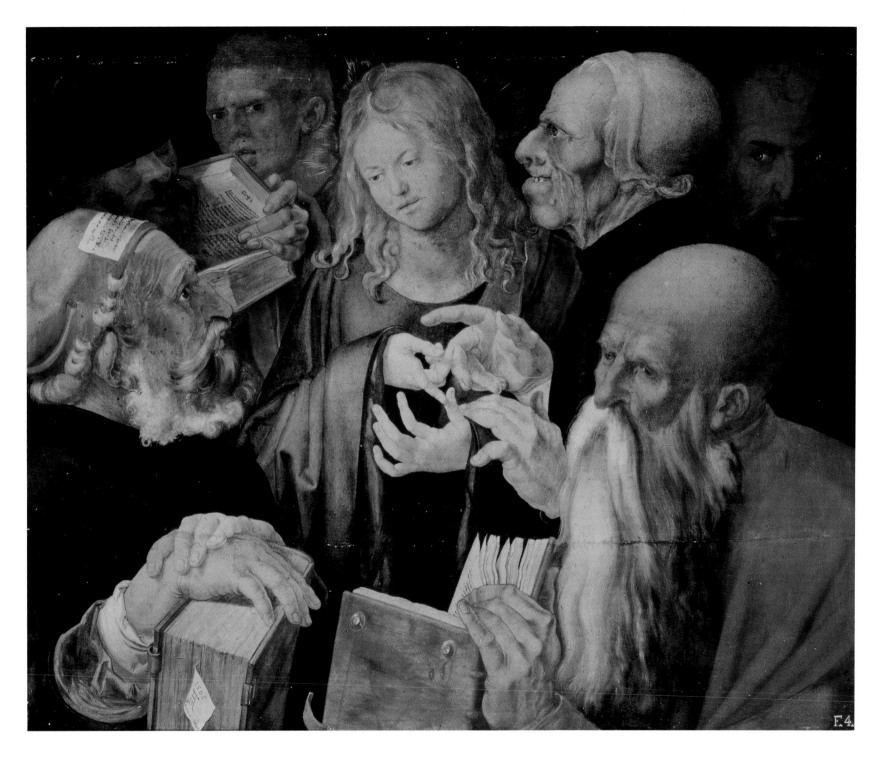

Albrecht Dürer (1471–1528)
Christ among the Doctors

1506
Oil on panel
64.3 × 80.3 cm (25 ⅜ × 31 ⅝ in.)
Madrid, Museo Thyssen-Bornemisza

This panel, made during Dürer's second stay in Venice, juxtaposes the youthful Christ with the religious scholars in the Temple, who range from the venerable to the grotesque and downright sinister. The composition reflects paintings by such northern Italians as Mantegna (see page 198), which also eliminate the setting in order to concentrate on a dense cluster of figures. Moreover, there is also a link with Leonardo's studies (opposite), which show a similar interest in systematically exploring human form and character. As well as contrasting features and expressions, Dürer presents a variety of poses, from brightly lit profiles to the frontal view of the man looming out of the shadows on the right. Meanwhile, in the centre, Christ's fingers are almost submerged in a knot of gesticulating hands.

Leonardo da Vinci (1452–1519)

Anatomical study of the neck and shoulders

1513 or later

27.4 × 20.4 cm (10¼ × 8 in.)

Facsimile copy in the Bibliothèque des Arts Décoratifs, Paris, after the original drawing (pen and ink on blue paper) in Windsor, Royal Library

Although Leonardo's interest in dissection was not unique, he pursued it far more persistently than any other artist. Giorgio Vasari tells us that Leonardo collaborated with Marcantonio della Torre, an anatomist at the University of Pavia, making meticulous drawings of bodies that he had flayed himself. Twenty years later, in 1517, when he was living in France, Leonardo was described as having compiled an anatomical treatise, 'with the demonstration in draft not only of the members, but also of the muscles, nerves, veins, joints, intestines, and of whatever can be reasoned about in the bodies both of men and women, in a way that has never yet been done by any other person'.[4]

This work unfortunately never progressed beyond its draft, and only bits of that survive. Yet, it is clear from this late drawing that Leonardo's studies were extremely thorough. In this case, he has analysed the tendons as well as the bones of the neck, so as to indicate how the head can be nodded and turned.

The human foetus in the womb

c. 1510

30.4 × 22 cm (12 × 8⅝ in.)

Facsimile copy in the Bibliothèque des Arts Décoratifs, Paris, after the original drawing (pen and ink with red chalk, on paper) in Windsor, Royal Library

The official who visited Leonardo at Cloux, in France, in 1517 wrote that the artist had 'already dissected more than thirty bodies, both men and women of all ages'.[5] It is noticeable, of course, that his proportional drawings concentrate on the male form, and yet, in his anatomies, he was particularly interested in the female reproductive organs, although it was not until later that Gabriele Fallopio discovered the oviducts, subsequently known as the Fallopian tubes.

Here the unborn child seems related to Leonardo's studies of the mythological twins hatched from eggs laid by their mother Leda (after she was seduced by Jupiter in the guise of a swan). It seems likely, however, that this drawing was principally made out of curiosity. It is certainly the earliest surviving image of this subject made by any artist.

Leonardo da Vinci (1452–1519)
St Jerome

c. 1480–82
Oil and tempera on panel
103 × 74 cm (40½ × 29⅛ in.)
Rome, The Vatican, Pinacoteca Vaticana

St Jerome translated the Bible into Latin in the late fourth century, and also spent time as a penitent in the desert in Syria. It is in this manifestation that Leonardo has represented him, accompanied by the lion that he befriended. Jerome's contorted pose is emphasized by the twisted sinews of his neck, the depiction of which reflects Leonardo's close observation of human anatomy and, above all, his understanding of the way in which the body moves.

The picture was unfinished when Leonardo moved to Milan around 1482. As we can see, he has blocked out the forms in brown paint, unlike earlier artists, who drew the outlines very precisely in black. Certain forms, such as the lion, are still very sketchy. Unsurprisingly, Leonardo concentrated on defining St Jerome before he abandoned the work. One can only imagine the effects, particularly in the landscape, that he would have created if he had added the colours and transparent glazes in the upper layers.

TERTIA
MUSCULO-
RVM TA-
BVLA.

After Andreas Vesalius (1514–1564)
Anatomical Study, illustration from *De humani corporis fabrica* (Basel, 1543)

Vesalius' career exemplifies the internationalism of intellectual life in this period. Born in Flanders, he was educated in Paris and taught surgery in Padua. His dissections were public institutions, and in his classic text *De humani corporis fabrica* ('On the Fabric of the Human Body') he managed to produce the anatomical treatise that had eluded Leonardo. As this illustration shows, his images of flayed corpses were a treasury of information about the human body.

Yet Vesalius is in some respects a medieval figure, deferring to the authority of the Classical doctor Galen, sometimes in preference to natural observation. Like Leonardo, he made mistakes about the relative positions of the kidneys, showing an over-reliance both on Galen and on the results of animal dissection. Above all, he did not believe in the circulation of the blood. As he admitted, 'not long ago, I would not have dared to diverge a hair's breadth from Galen's opinion'.[6] By 1555, when he wrote those words, he felt able to give himself a little latitude, but 'I still distrust myself.' The weight of ancient learning was not so easy to shed.

Ligier Richier (c. 1500–1567)
Monument containing the heart of René de Châlons, Prince of Orange

After 1544
Stone
Height 174 cm (68½ in.)
France, Bar-le-Duc, Church of St-Etienne

Ligier Richier was a sculptor who achieved considerable renown in his native Lorraine, in eastern France. Towards the end of his life, he and his son signed a petition to the Duke of Lorraine, in order to be able to practise the Protestant faith. It must have been unsuccessful, since soon afterwards Richier went to Geneva, where he died.

In this extraordinary work, a cadaver, carved in stone, clasps the Prince of Orange's heart, with a cartouche neatly wrapped around his right arm. The imagery of the decomposing body occurs in medieval tombs; yet here it has been invested with the anatomical knowledge gained during the sixteenth century. In fact, the figure looks in certain areas like an *écorché*, a statue of a flayed body, made for educational purposes. As well as the bones, the sinews are represented with great accuracy, to emphasize the twisted pose of this disturbingly animated corpse.

Postscript:
NINETEENTH-CENTURY PERSPECTIVES

As readers of E.M. Forster's *A Room with a View* (1908) will know, by the early twentieth century the 'tactile values' analysed by the American art historian Bernard Berenson had led to a popular interest in both Giotto and the masters of the early Renaissance. Sandro Botticelli, neglected for centuries, had already been rediscovered, amid renewed interest in the Italian Quattrocento (fifteenth century).

It was not always so. In the early nineteenth century few artists or historians showed much interest in anything earlier than the High Renaissance, and, even when painters referred to that period in their work, their sentimental narrative style had little connection with its style or indeed with historical accuracy (see page 257). Ingres, in particular, indiscriminately raided the Renaissance for touching stories and striking anatomies: the *Grande Odalisque* (page 256) is an especially bizarre figure, an elongated Mannerist form set in an Oriental harem.

It was among a small group of German painters living in Rome that an alternative view of the Renaissance first developed. The 'Nazarenes' admired the sacred art of the Quattrocento, and were particularly committed to reviving the technique of fresco, which they valued for its lucidity and technical skill. Above all, Friedrich Overbeck (page 258) inspired a generation of younger British artists, such as William Dyce (page 259) and, ultimately, the Pre-Raphaelites, although the latter were in fact more eclectic than their name suggests.

A great cultural past can of course be a challenge as well as a legacy. Edouard Manet, the friend of the French Impressionists, famously refused to exhibit with them, preferring the more conventional Salon. Unfortunately, this august institution did not always approve of him. Manet's *Déjeuner sur l'herbe* (page 260) was rejected by the Salon jury of 1863, when he was forced to exhibit it in an alternative show organized by the emperor Napoleon III. Together with his contemporary work *Olympia* (page 263), the painting consciously borrowed from celebrated Renaissance images, subverting them while also revealing the artist's unquestionable admiration for his predecessors. To a twenty-first-century viewer these canvases may seem relatively tame, but in their time they brought the heritage of the Renaissance into a shocking contemporary setting.

Jean-Auguste-Dominique Ingres
(1780–1867)
*Francis I Receives the Last Breath
of Leonardo da Vinci*
1818
Oil on canvas
40 × 50.5 cm (15¾ × 19⅞ in.)
Paris, Musées de la Ville de Paris,
Musée du Petit Palais

In his *Lives of the Most Excellent Painters, Sculptors and Architects* (1568), Giorgio Vasari described how the aged Leonardo, then living in the French château of Amboise, repented of his lack of religious faith and received the sacrament from his bed. He confessed to the king, Francis I, that 'he had offended God and mankind by not working at his art as he should have done. Then he was seized by a paroxysm, the forerunner of death, and, to show him favour and to soothe his pain, the king held his head. Conscious of the great honour being done to him, the inspired Leonardo breathed his last in the arms of the king …'[1]

Vasari's account of Leonardo's demise clearly fired the imagination of Ingres: the story firmly places 'Léonard' within the culture of the French Renaissance, and also appeals to nineteenth-century sentiment and the preoccupation with having a 'good' death. Ingres has modelled Francis's features on sixteenth-century portraits (page 176), while Leonardo has the noble demeanour that he himself recorded in a chalk drawing. The French painter presents us with a vision of an age of heroes, although its anecdotal style is far removed from the monumental Classicism of the High Renaissance.

Jean-Auguste-Dominique Ingres
(1780–1867)
Grande Odalisque

1814
Oil on canvas
91 × 162 cm (35 ⅞ × 63 ¾ in.)
Paris, Musée du Louvre

Neo-classical artists, such as Ingres, drew heavily on ancient art. Ingres was himself living in Rome at the time that he painted the *Grande Odalisque*, the shallow, horizontal composition of which resembles that of a Roman relief. However, the painting is still more obviously inspired by the late Renaissance style that we now call Mannerism. Like many Mannerists, Ingres has elongated and twisted his subject's body, in particular her sinuous back. Appropriately enough for a Frenchman in Italy, Ingres seems to have been particularly inspired by the Italian artists, such as Rosso Fiorentino and Francesco Primaticcio, who worked at Fontainebleau in France during the sixteenth century.

Yet the *Grande Odalisque* is no dull imitation, not least because its Renaissance style is combined with a fashionable fascination with the Near East. This woman resides in a harem, an association guaranteed to quicken the pulse of the nineteenth-century male viewer.

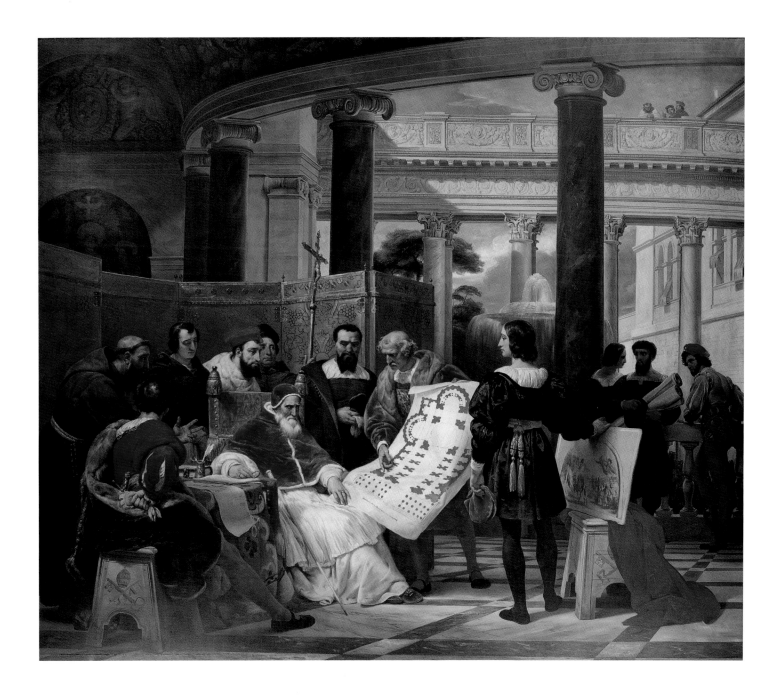

Horace Vernet (1789–1863)
*Pope Julius II Ordering Bramante,
Michelangelo and Raphael to
Construct the Vatican and St Peter's*

1827
Oil on canvas
Paris, Musée du Louvre

This ceiling decoration is a characteristic flight of fancy from one of the most successful artists of the nineteenth century. The construction of St Peter's, to replace the dilapidated fourth-century basilica, took more than a century: designs for a symmetrical 'Greek cross' alternated with a more conventional Latin cross (with a long nave), and the artists concerned worked fitfully on the project, usually until death necessitated a replacement.

Certainly the grand committee that Vernet depicts would not have taken place. However, by bringing together cultural heroes into a single image, without too much concern for history, Vernet has followed a Renaissance tradition, creating a School of Rome for the modern age.

Friedrich Overbeck (1789–1869)
Joseph Being Sold by His Brothers

1817
Fresco (detached)
243 × 304 cm (95⅝ × 119⅝ in.)
Berlin, Staatliche Museen zu Berlin,
Alte Nationalgalerie

Together with his fellow Nazarenes, Friedrich Overbeck was commissioned by Jacob Salomon Bartholdy, the Prussian consul general in Rome, to decorate a small upper room in his residence at the Palazzo Zuccari. Although the space was actually used for social events, a religious theme – the story of Joseph – was chosen. Overbeck himself had converted to Catholicism and was particularly interested in leading a revival of sacred painting. His fresco shows Joseph being led away by the Ishmaelites to whom he has been sold by his brothers. The brothers stain a cloak with a kid's blood in order to deceive their father into thinking that his favourite son has been devoured by a wild animal.

In order to prepare the plaster walls for their frescoes, the Nazarenes employed an old workman who was said to have done the same for the German painter Anton Raphael Mengs decades earlier. Stylistically, they drew on their favourite artists from the fifteenth and early sixteenth centuries. Overbeck was inspired above all by the decorative style of Pinturicchio, who on occasion had also depicted Eastern figures (page 195), although in reality Overbeck's painting could never be confused with an actual Renaissance mural. However, with its crisp outlines and light tones, clear definition of space and, above all, commitment to an almost forgotten technique, the fresco is a genuine attempt to capture the spirit of the early Renaissance.

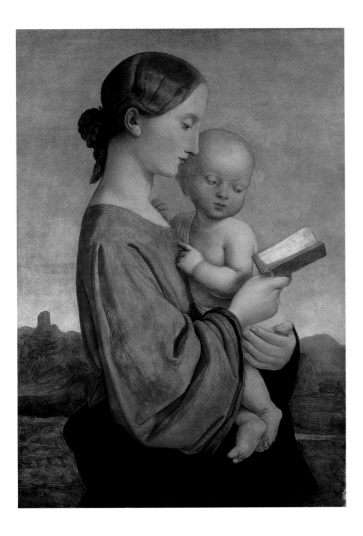

William Dyce (1806–1864)
Madonna and Child

c. 1838
Oil on plaster
78.7 × 60.3 cm (31 × 23 ¾ in.)
UK, Nottingham Castle Museum
and Art Gallery

As a young man, the Scottish painter William Dyce visited the German Nazarene Friedrich Overbeck at his studio in Rome. Like Overbeck, Dyce developed an enthusiasm for early Renaissance art and in particular the technique of fresco. Before producing a series of murals for the Palace of Westminster in the 1840s, he painted this much smaller work on plaster, although its use of oil distinguishes it from a true fresco.

As well as capturing the bright colours and crispness of fifteenth-century Italian art, the picture has a simple profile format recalling the portraiture of the period, as if it depicts an actual individual. This fresh, direct approach made Dyce popular with both Roman Catholics and High Anglicans. He was even asked to make another version of this painting for Albert, the Prince Consort. Dyce was himself a member of the Ecclesiological Society, which promoted church decoration as a necessary accompaniment to Christian ritual, and his sincere piety shines through all his religious works.

Ford Madox Brown
(1821–1893)
John Wycliffe Reading His Translation of the Bible

1847–48
Oil on canvas
120 × 153 cm (47 ¼ × 60 ¼ in.)
UK, Bradford, Cartwright Hall Art Gallery

Despite its medieval English subject, this canvas, by a painter associated with the Pre-Raphaelites, is in fact inspired by Continental Renaissance art. In 1845, on his way to Italy, Brown was profoundly impressed by the work of Holbein in Basel, and, on reaching Rome, he also came under the influence of the German Nazarene Friedrich Overbeck, himself an admirer of early Renaissance painting. Together these experiences led Brown to produce clear, bright pictures that combine realistic detail with formal, symmetrical compositions. As in many fifteenth-century altarpieces, 'Gothic' qualities can be seen in the pointed frame, the gilding around the saints in the corners and the architecture behind Wycliffe's figure. Above all, however, Brown has paid tribute to the refined naturalism of the early Renaissance, still at that time regarded as 'primitive' in comparison to the heroic style of Raphael and Michelangelo.

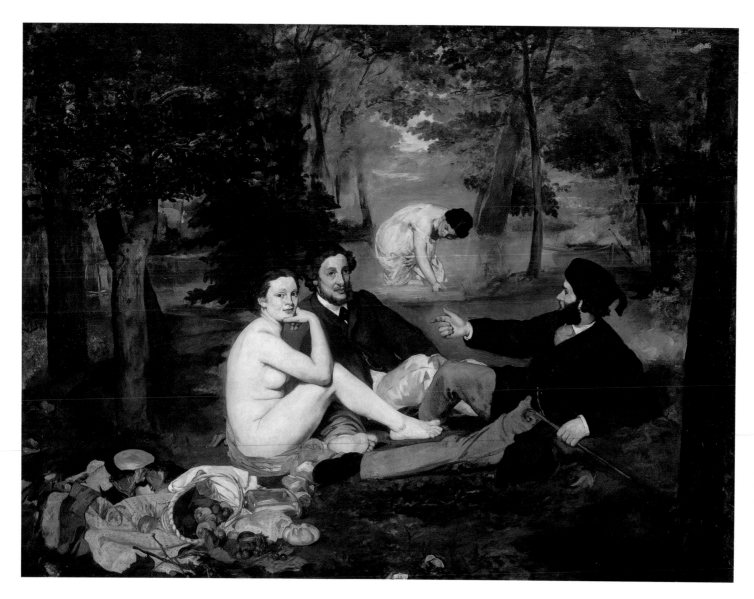

Edouard Manet (1832–1883)
Le Déjeuner sur l'herbe (Luncheon on the Grass)

1863
Oil on canvas
208 × 264.5 cm (81⅞ × 104⅛ in.)
Paris, Musée d'Orsay

A seated, naked woman meets our gaze with
startling directness, amid the debris of a rather
messy picnic. This notorious painting, rejected
from the official Salon of 1863, was exhibited
in the alternative Salon des Refusés, organized
at the behest of the emperor Napoleon III.
In parody of *Le Concert champêtre* (opposite),
the two musician-poets have been turned into
contemporary bohemians, while Manet's nude
is adapted from a male figure on the right of
Marcantonio Raimondi's *Judgement of Paris*
(below). Despite this classic prototype, her
anatomy is not at all idealized, and she even
shows us the sole of her foot.

This would by itself be disturbing enough
for a viewer brought up on the pastoral imagery
of *Le Concert champêtre*, but the painting also
has a sketchy, unfinished appearance, with
abrupt contrasts of tone, unlike Titian's subtle
chiaroscuro. In this way, the picture breaks the
tradition to which it refers.

Marcantonio Raimondi
(c. 1470/82–1527/34)
The Judgement of Paris
(after a design by Raphael)

c. 1517–20
Engraving
29.2 × 43.3 cm (11½ × 17 in.)
Paris, Bibliothèque Nationale de France

Marcantonio Raimondi was the most
successful Italian printmaker of the sixteenth
century. Trained in Bologna, he worked in
Venice and Rome, where he forged a highly
effective partnership with Raphael. In
The Judgement of Paris the Trojan prince,
on the left, is visited on Mount Ida by three
goddesses. He judges their beauty and awards
the prize of a golden apple to Venus, who is
being playfully buffeted by her son, Cupid.
Mercury, the messenger god who organized
the meeting, looks back over his shoulder,
while other divinities watch from the sky.

Not all of Raimondi's reproductions
were authorized: in 1506, for example, Dürer
bitterly complained that his woodcuts of
The Life of the Virgin had been copied by
Raimondi without permission. It is perhaps
fitting, therefore, that centuries later
Raimondi's work should in turn have been
raided for inspiration by the great French
painter Edouard Manet (above).

Titian (Tiziano Vecellio)
(*c.* ?1485/90–1576)
Le Concert champêtre
(*The Pastoral Concert*)

c. 1509
Oil on canvas
105 × 137 cm (41⅜ × 53⅞ in.)
Paris, Musée du Louvre

Le Concert champêtre is one of the most problematic paintings of the Renaissance. It was once attributed to Giorgione, whose style is reflected in the idyllic landscape and general air of dreaminess and abstraction. It is now believed to have been completed, or perhaps wholly executed, by Titian, who was Giorgione's pupil in Venice at the beginning of the sixteenth century.

The finely dressed young men are musicians, perhaps poets. They gaze at each other, seemingly oblivious to the nymph-like women and pastoral setting. The lyrical mood is complemented by the hazy atmosphere, in which everything is seen in an enigmatic blur; painting has been turned into poetry, and *vice versa*.

Titian (Tiziano Vecellio)
(c. ?1485/90–1576)
The Venus of Urbino

1538
Oil on canvas
119 × 165 cm (46⅞ × 65 in.)
Florence, Galleria degli Uffizi

This picture's evocative title is a late invention: in the sixteenth century it was simply referred to as a 'nude woman'. Commissioned by Guidobaldo della Rovere, Duke of Urbino, the painting represents a courtesan in a palatial setting, accompanied by servants and a sleeping dog. The principal subject is emphasized by the woman's left hand, which is also carefully aligned with the edge of the panel. Her warm flesh is set off by the satin sheets; and, in case the senses need yet more stimulation, the hot-red tones of the couch reappear in the room behind. This is, after all, a place of pleasure.

Yet, although the nudity has no mythological justification, Titian's accomplishment makes our enjoyment respectable. Perhaps the most remarkable passage is the miraculous description of the hair flowing over the bare shoulder of 'Venus'. Of such beauty, we are all allowed to be connoisseurs.

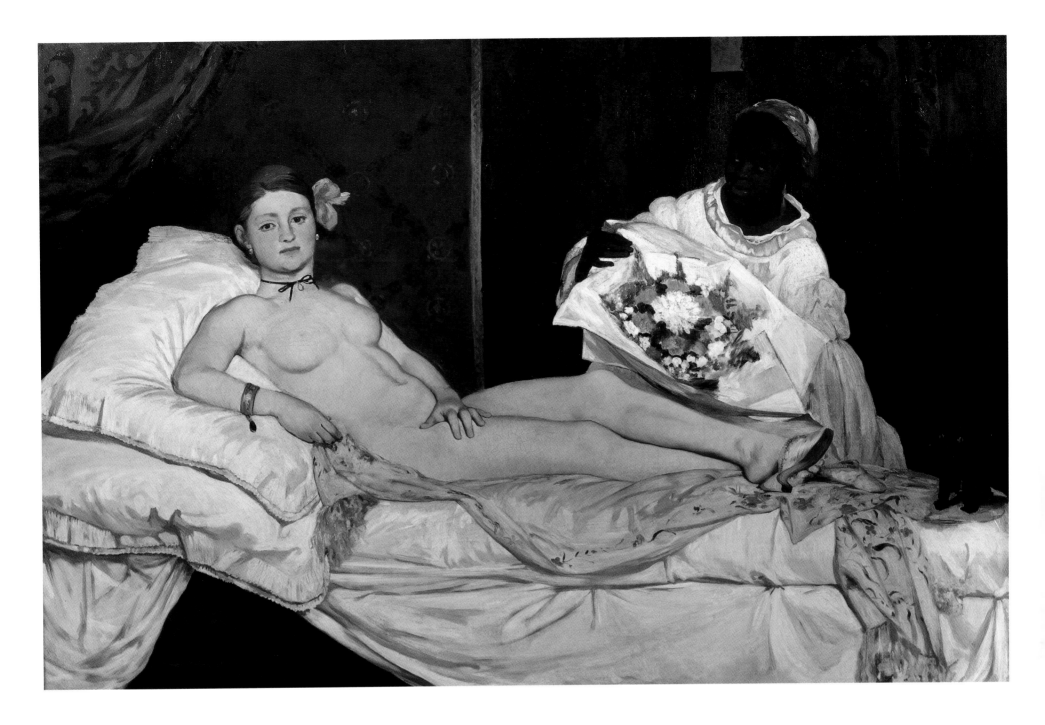

Edouard Manet (1832–1883)
Olympia

1863
Oil on canvas
130.5 × 190 cm (51 ⅛ × 74 ¼ in.)
Paris, Musée d'Orsay

When *Olympia* was exhibited at the Salon, it received reviews that were shockingly bad. As a parody of the reclining nude, especially Titian's *Venus of Urbino* (opposite), Manet's canvas was even more offensive than his *Déjeuner sur l'herbe* (page 260). Instead of the Venetian's graceful courtesan, Olympia is a contemporary prostitute, imperfect, even a little roughly painted. The decorous servants in an elegant chamber are replaced by a maid emerging from a waiting-room with a client's gift of flowers. Even the little dog has metamorphosed into a rather terrifying cat. Above all, Olympia's gaze and the position of her hand are outrageously direct.

The critics went wild. Olympia was 'a sort of female gorilla'; 'her body has the livid tint of a cadaver displayed in the morgue; her outlines are drawn in charcoal and her greenish, bloodshot eyes appear to be provoking the public'; and – the final insult – she was 'protected all the while by a hideous Negress'.[2]

Even as late as the 1860s the Renaissance was more than just a distant heritage. Inevitably, the marvellous blend of naturalism and idealization achieved by Titian and his contemporaries set standards that were hard to ignore. Manet's response was not to evade this legacy but to confront it. In the academic culture of nineteenth-century France, *Olympia* and *Le Déjeuner sur l'herbe* amounted to a ferocious fusillade.

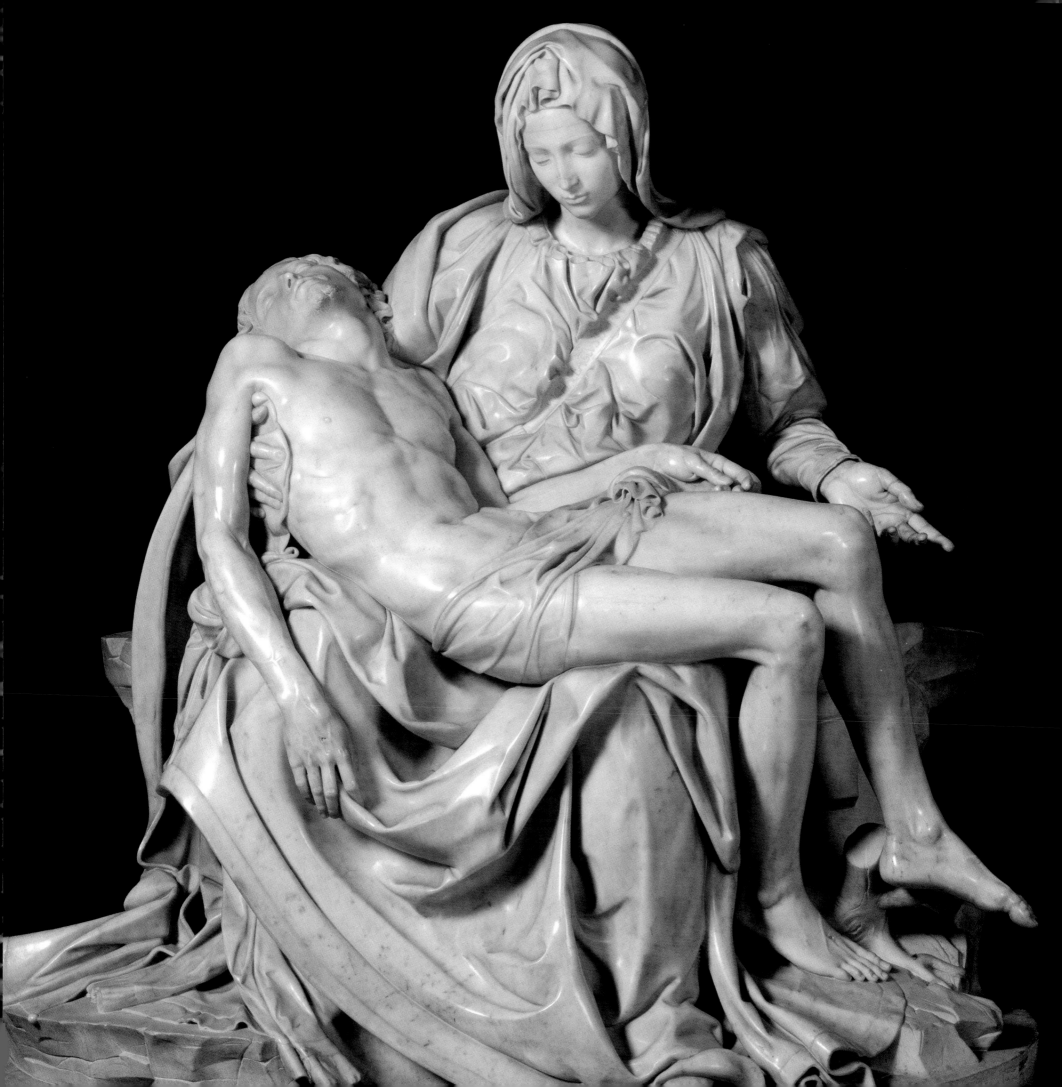

NOTES

INTRODUCTION

1 F. Colonna, *Hypnerotomachia Poliphili: The Strife of Love in a Dream*, trans.
 J. Godwin, London (Thames & Hudson) 1999, p. 59.

2 *Ibid.*, p. 234.

3 *Ibid.*, p. 236.

4 *Ibid.*, pp. 464–65.

5 V. da Bisticci, *Vite di uomini illustri*, ed. P. d'Ancona and E. Aeschlimann,
 Milan 1951, pp. 442–43; quoted in E.H. Gombrich, *The Heritage of Apelles*,
 Oxford (Phaidon) 1976, p. 94.

6 L. Alberti, *De pictura* (dedication to Filippo Brunelleschi), trans.
 C. Grayson, in *On Painting and On Sculpture*, London (Phaidon) 1972, p. 33.

7 Quoted in J. Hale, *The Civilization of Europe in the Renaissance*, London
 (HarperCollins) 1993, p. 586; and M. Baxandall, *Painting and Experience
 in Fifteenth-Century Italy*, 2nd edn, Oxford (Oxford University Press) 1988,
 p. 113.

8 G. Vasari, *The Lives of the Artists*, selection trans. G. Bull, Harmondsworth
 (Penguin) 1971, p. 266.

9 *Ibid.*, p. 266.

10 *Ibid.*, p. 225.

11 Quoted in E. Panofsky, *Albrecht Dürer*, 3rd edn, Princeton, NJ (Princeton
 University Press) 1948, p. 9.

12 *Ibid.*, p. 171.

THE ANCIENT WORLD

1 L. Alberti, *De pictura, Bk III*, trans. C. Grayson, in *On Painting and
 On Sculpture*, London (Phaidon) 1972, p. 97.

2 G. Vasari, *The Lives of the Artists*, selection trans. G. Bull, Harmondsworth
 (Penguin) 1971, p. 225.

3 *Ibid.*, p. 101.

4 Quoted in F. Haskell and N. Penny, *Taste and the Antique: The Lure of
 Classical Sculpture, 1500–1900*, New Haven, Conn., and London (Yale
 University Press) 1981, p. 252.

5 Quoted in *Andrea Mantegna*, exhib. cat., ed. J. Martineau, London, Royal
 Academy of Arts, January–April 1992; New York, The Metropolitan
 Museum of Art, May–July 1992, p. 421.

SACRED THEMES

1 G. Vasari, *The Lives of the Artists*, selection trans. G. Bull, Harmondsworth
 (Penguin) 1971, p. 225.

2 *Ibid.*, p. 179.

3 J. Ruskin, *The Stones of Venice*, London 1853, III, p. 379.

4 Quoted in E. Panofsky, *Albrecht Dürer*, 3rd edn, Princeton, NJ (Princeton
 University Press) 1948, p. 44.

5 Translated from E.G. Holt, *Literary Sources of Art History*, Princeton, NJ
 (Princeton University Press) 1947, pp. 245–48; quoted in J.T. Paoletti and
 G.M. Radke, *Art in Renaissance Italy*, London (Laurence King) 1997, p. 416.

LOVE

1 Quoted in *Titian*, exhib. cat., ed. D. Jaffé, London, The National Gallery, February–May 2003; Madrid, Museo Nacional del Prado, June–September 2003, p. 132.
2 Ovid, *Metamorphoses*, trans. M.M. Innes, London (Penguin) 1955, p. 73.
3 *Ibid.*

WAR

1 B. Sastrow, *Social Germany in Luther's Time: Being the Memoirs of Bartholomew Sastrow*, trans. A.D. Vandam, London (Constable) 1902, p. 194; quoted in J. Hale, *The Civilization of Europe in the Renaissance*, London (HarperCollins) 1993, p. 127.
2 Leonardo da Vinci, *The Notebooks of Leonardo da Vinci*, trans. E. MacCurdy, London (Jonathan Cape) 1938, II, pp. 552–53.
3 *Ibid.*, p. 553.

HOME

1 Quoted in P.F. Brown, *Venetian Narrative Painting in the Age of Carpaccio*, New Haven, Conn., and London (Yale University Press) 1988, p. 161.

THE CITY

1 Quoted in *The Genius of Venice, 1500–1600*, exhib. cat., ed. J. Martineau and C. Hope, London, Royal Academy of Arts, November 1983–March 1984, p. 392.

PRINCES AND COURTIERS

1 G. Vasari, *The Lives of the Artists*, selection trans. G. Bull, Harmondsworth (Penguin) 1971, p. 306.
2 Quoted in *Titian: Prince of Painters*, exhib. cat., Venice, Palazzo Ducale, June–October 1990; Washington, D.C., National Gallery of Art, October 1990–January 1991, p. 410.
3 G. Vasari, *The Lives of the Artists*, trans. J.C. Bondanella and P. Bondanella, Oxford (Oxford University Press) 1991, p. 343.
4 Quoted in L. Campbell, *Renaissance Portraits: European Portrait Painting in the 14th, 15th, and 16th Centuries*, New Haven, Conn., and London (Yale University Press) 1990, p. 220.

THE LURE OF THE EAST

1 G. Vasari, *The Lives of the Artists*, trans. J.C. Bondanella and P. Bondanella, Oxford (Oxford University Press) 1991, p. 250.
2 *Bellini and the East*, exhib. cat. by C. Campbell and A. Chong, Boston, Isabella Stewart Gardner Museum, December 2005–March 2006; London, The National Gallery, April–June 2006, p. 122.

LANDSCAPE

1 E.H. Gombrich, *The Heritage of Apelles*, Oxford (Phaidon) 1976, pp. 33–34.
2 Quoted in P. Humfrey, *Painting in Renaissance Venice*, New Haven, Conn., and London (Yale University Press) 1995, p. 118.
3 G. Vasari, *The Lives of the Artists*, selection trans. G. Bull, Harmondsworth (Penguin) 1971, p. 275.

BIRDS AND BEASTS

1 Quoted in F. Hartt and D.G. Wilkins, *History of Italian Renaissance Art: Painting, Sculpture, Architecture*, New York (Abrams) 2003, p. 495.
2 Quoted in *A New World: England's First View of America*, exhib. cat. by K. Sloan *et al.*, London, The British Museum, March–June 2007, p. 42.

MAN, THE MEASURE OF ALL THINGS

1 L. Alberti, *De statua*, trans. C. Grayson, in *On Painting and On Sculpture*, London (Phaidon) 1972, p. 135.
2 Quoted in A. Blunt, *Artistic Theory in Italy, 1450–1600*, Oxford (Clarendon Press) 1956, p. 32.
3 Quoted in E. Panofsky, *Albrecht Dürer*, 3rd edn, Princeton, NJ (Princeton University Press) 1948, p. 44.
4 Account by Antonio de Beatis, secretary to the Cardinal of Aragon, quoted in A.E. Popham, *The Drawings of Leonardo da Vinci*, revised and with a new introductory essay by M. Kemp, London (Pimlico) 1994, p. 59.
5 *Ibid.*, p. 59.
6 A. Vesalius, *De humani corporis fabrica*, Basel, revised edition 1555; quoted in J. Hale, *The Civilization of Europe in the Renaissance*, London (HarperCollins) 1993, p. 549.

POSTSCRIPT: NINETEENTH-CENTURY PERSPECTIVES

1 G. Vasari, *The Lives of the Artists*, selection trans. G. Bull, Harmondsworth (Penguin) 1971, p. 270.
2 Quoted in S.F. Eisenman *et al.*, *Nineteenth Century Art: A Critical History*, London (Thames & Hudson) 1994, p. 242.

TIMELINE

1395–c. 1405
Claus Sluter's *Well of Moses*, Chartreuse de Champmol, Dijon

1401–03
The competition for the first set of baptistery doors in Florence is won
by Lorenzo Ghiberti

1404
Birth of Leon Battista Alberti

1410s–1420s
Donatello's figures for the exterior of the Orsanmichele, Florence

c. 1411–c. 1416
The Limbourg brothers produce *Les Très Riches Heures* for the Duke of Berry

1415
Henry V of England defeats the French at Agincourt

1417
The Great Schism of Western Christianity comes to an end

1423
Gentile da Fabriano's *Adoration of the Magi* (Florence, Galleria degli Uffizi)

c. 1424–28
Masolino and Masaccio's frescoes for the Brancacci Chapel, Santa Maria del Carmine,
Florence; Masaccio's Pisa polyptych (dispersed, in various collections); and the *Trinity*
fresco, Santa Maria Novella, Florence

1425–52
Ghiberti's 'Gates of Paradise', the second set of doors for Florence's baptistery

1427
Gentile da Fabriano dies in Rome

1432
Jan van Eyck completes the Ghent altarpiece, St Bavo's Cathedral

1434
Cosimo de' Medici becomes *de facto* ruler of Florence

c. 1435
Rogier van der Weyden's *Descent from the Cross* (Madrid, Museo Nacional del Prado)

1435
Alberti produces the treatise *De pictura* ('On Painting'); it is translated a year later
into Italian

1436
Filippo Brunelleschi completes the dome of Florence Cathedral

1437
Filippo Lippi's Barbadori altarpiece (Paris, Musée du Louvre)

1438–39
Council of Ferrara and Florence discusses union of Western and Eastern churches

1438–45
Fra Angelico's altarpiece and frescoes at the monastery of San Marco, Florence

c. 1440
Follower of Robert Campin, *The Virgin and Child before a Firescreen* (London, The National Gallery)

1444
Konrad Witz's *Miraculous Draught of Fishes* (Geneva, Musée d'Art et d'Histoire)

c. 1445
Domenico Veneziano's St Lucy altarpiece (Florence, Galleria degli Uffizi)

1447–53
Donatello, in Padua, creates the 'Gattamelata' monument

1452
Alberti writes *De re aedificatoria* ('On Building')

1453
Constantinople falls to the Ottoman Turks; the French defeat the English at Castillon, ending the Hundred Years' War

1455
Johann Gutenberg publishes his printed edition of the Bible

Late 1450s
Donatello's *Judith and Holofernes* (now Florence, Palazzo Vecchio) is made for the fountain of the Palazzo Medici, Florence

c. 1460
Benozzo Gozzoli paints the *Adoration of the Magi* frescoes for the chapel in the Palazzo Medici, Florence

1465–70
Andrea Mantegna works on the Camera Picta, Palazzo Ducale, Mantua

1475
Birth of Michelangelo

c. 1477–78
Hugo van der Goes's Portinari triptych (Florence, Galleria degli Uffizi)

1478
The Pazzi Conspiracy attempts to assassinate Giuliano and Lorenzo de' Medici during High Mass in Florence Cathedral; Giuliano is killed and Lorenzo wounded

1479
Gentile Bellini arrives in Constantinople to work as a court painter for Sultan Mehmed II, returning to Venice in 1481

c. 1479–92
Andrea del Verrocchio's monument to Bartolomeo Colleoni, Venice

1480s
Piero della Francesca's *On the Perspective of Painting* is published and dedicated to Federico da Montefeltro, Duke of Urbino

c. 1480
Giovanni Bellini's San Giobbe altarpiece (Venice, Gallerie dell'Accademia)

1481–83
Frescoes in the Sistine Chapel are painted by Botticelli, Ghirlandaio, Perugino and other artists

c. 1482
Sandro Botticelli's *Primavera* (Florence, Galleria degli Uffizi)

c. 1482–99
Leonardo da Vinci is active in Milan, where he paints *The Last Supper* in the refectory of Santa Maria delle Grazie

1483–86
Domenico Ghirlandaio's frescoes of the life of St Francis, Sassetti Chapel, Santa Trinita, Florence

1486–90
Ghirlandaio works on the Tornabuoni Chapel, Santa Maria Novella, Florence

1490
Aldus Manutius opens an important printing press in Venice. In 1499 he publishes Francesco Colonna's *Hypnerotomachia Poliphili*

1492
Christopher Columbus arrives in America

1494
Albrecht Dürer makes his first visit to Venice
The Medici family is expelled from Florence, where a republic is declared

1496–97
Mantegna's paintings for Isabella d'Este's *studiolo* in the Palazzo Ducale, Mantua

1497
The Dominican prior Girolamo Savonarola presides over a 'bonfire of the vanities' in Florence

1498
Savonarola is burned at the stake

1498–99
Michelangelo's *Pietà*, St Peter's Basilica, Rome

1499
Louis XII of France invades Italy and conquers Milan

1500–05
Hieronymus Bosch's *Garden of Earthly Delights* (Madrid, Museo Nacional del Prado)

1501–04
Michelangelo produces the statue of *David* (Florence, Galleria dell'Accademia)

1503–06
Leonardo, in Florence, paints the *Mona Lisa* (Paris, Musée du Louvre)

1508
Raphael moves from Florence to Rome

c. 1509
Giorgione's *Tempest* (Venice, Gallerie dell'Accademia)

1512
Michelangelo completes the Sistine Chapel ceiling
The Medici family returns to Florence

1514
Albrecht Dürer's *Melencolia I* (London, The British Museum)

1516
Matthias Grünewald completes the Isenheim altarpiece (Colmar, Musée d'Unterlinden)

1517
Martin Luther protests against indulgences in his Ninety-Five Theses

c. 1518–20
Albrecht Altdorfer's *Landscape with a Footbridge* (London, The National Gallery)

1519
Leonardo dies in France
Charles V becomes Holy Roman Emperor

1520

Raphael dies in Rome

The meeting between Francis I of France and Henry VIII of England takes place on the Field of the Cloth of Gold

1523

Titian completes *Bacchus and Ariadne* (London, The National Gallery) for Alfonso d'Este's Camerino d'Alabastro in Ferrara

1525

Francis I of France is captured by the Imperial army at the Battle of Pavia

The Peasants' Revolt reaches its peak in Germany

1526

Hans Holbein the Younger makes his first trip to England

Francis I is released from imprisonment in Madrid

1527

Rome is sacked by the Imperial troops of Charles V

The Medici family is expelled from Florence, where a republic is declared

c. 1528

Lucas Cranach the Elder, *The Judgement of Paris* (New York, The Metropolitan Museum of Art)

1530

The Medici family returns to Florence

1534

Michelangelo returns to Rome for the last time

The Act of Supremacy is passed, in which Henry VIII is established as the Head of the Church of England

1536–41

Michelangelo paints *The Last Judgement* on the altar wall of the Sistine Chapel

1545

The Council of Trent meets for the first time

1547

At the Battle of Mühlberg the Imperial troops defeat the Lutheran Schmalkaldic League

1548

Titian meets the future king of Spain, Philip II, who will become his most important patron

1550

Giorgio Vasari publishes the first edition of his *Lives of the Artists*

1553

Maarten van Heemskerck, *Self-Portrait with the Colosseum* (Cambridge, Fitzwilliam Museum)

1556

The Holy Roman Emperor Charles V abdicates, dividing his realms between his son, Philip II of Spain, and his brother, Ferdinand I, who becomes emperor

1563

The final decrees of the Council of Trent are issued

1564

Michelangelo dies in Rome

1565

Pieter Bruegel the Elder paints the 'Panels of the Months' cycle (Vienna, Kunsthistorisches Museum)

1566

Revolt and iconoclasm break out in The Netherlands

1569

Cosimo I de' Medici is made Grand Duke of Tuscany by Pope Pius V

1571

Venetian and Spanish forces defeat the Ottoman fleet at Lepanto

1572

French Protestants (Huguenots) are massacred on St Bartholomew's Day (24 August)

1573

Paolo Veronese is summoned before the Inquisition in Venice

1582

Pope Gregory XIII reforms the calendar

1588

The Spanish Armada is defeated by the English

1598

Michelangelo Merisi da Caravaggio begins work on the paintings for the Contarelli Chapel, San Luigi dei Francesi, Rome

FURTHER READING

PRIMARY SOURCES

L. Alberti, *De pictura* and *De statua*, trans. C. Grayson as *On Painting and On Sculpture*, London (Phaidon) 1972

B. Castiglione, *Il libro del cortegiano*, trans. C.S. Singleton as *The Book of the Courtier*, ed. D. Javitch, New York and London (Norton) 2002

B. Cellini, *Autobiography*, trans. G. Bull, London (Penguin) 1998

F. Colonna, *Hypnerotomachia Poliphili: The Strife of Love in a Dream*, trans. J. Godwin, London (Thames & Hudson) 1999

G. Vasari, *The Lives of the Artists*, selection trans. G. Bull, Harmondsworth (Penguin) 1971 [most widely read translation]; also trans. J.C. Bondanella and P. Bondanella, Oxford (Oxford University Press) 1991 [most recent translation, with slightly wider selection]

EXHIBITION CATALOGUES

The Age of Van Eyck: The Mediterranean World and Early Netherlandish Painting, 1430–1530, exhib. cat. by T.-H. Borchert, Bruges, Groeningemuseum, 2002

Albrecht Dürer and His Legacy: The Graphic Work of a Renaissance Artist, exhib. cat. by G. Bartrum *et al.*, London, The British Museum, December 2002–March 2003

Bellini and the East, exhib. cat. by C. Campbell and A. Chong, Boston, Isabella Stewart Gardner Museum, December 2005–March 2006; London, The National Gallery, April–June 2006

Fra Angelico, exhib. cat. by L.B. Kanter and P. Palladino, New York, The Metropolitan Museum of Art, October 2005–January 2006

The Genius of Venice, 1500–1600, exhib. cat., ed. J. Martineau and C. Hope, London, Royal Academy of Arts, November 1983–March 1984

Splendours of the Gonzaga, exhib. cat., ed. D. Chambers and J. Martineau, London, Victoria and Albert Museum, November 1981–January 1982

Titian, exhib. cat., ed. D. Jaffé, London, The National Gallery, February–May 2003; Madrid, Museo Nacional del Prado, June–September 2003

ARTICLES

K. Bomford, 'Friendship and Immortality: Holbein's *Ambassadors* Revisited', *Renaissance Studies*, XVIII, issue 4, December 2004, pp. 544–81

L. Campbell, 'The Art Market in the Southern Netherlands in the Fifteenth Century', *Burlington Magazine*, CXVIII, 1976, pp. 188–98

E.H. Gombrich, 'Hypnerotomachiana', *Journal of the Warburg and Courtauld Institutes*, XIV, 1951, pp. 119–25; revised version published in E.H. Gombrich, *Symbolic Images*, Oxford (Phaidon) 1985, pp. 102–108

A. Lucas and J. Plesters, 'Titian's *Bacchus and Ariadne*', *National Gallery Technical Bulletin*, II, 1978, pp. 25–47

T. Nichols, 'Secular Charity, Sacred Poverty: Picturing the Poor in Renaissance Venice', *Art History*, XXX, issue 2, April 2007, pp. 139–69

R. San Juan, 'The Court Ladies' Dilemma: Isabella d'Este and Art Collecting in the Renaissance', *Oxford Art Journal*, XIV, 1991, pp. 67–78

J. Shearman, 'Donatello, the Spectator, and the Shared Moment', in *The Enduring Instant: Time and the Spectator in the Visual Arts* [a collection of papers from a section of the XXXth International Congress for the History of Art], ed. A. Roesler-Friedenthal and J. Nathan, Berlin (Gebr. Mann) 2003, pp. 53–69

C.M. Sperling, 'Donatello's Bronze *David* and the Demands of Medici Politics', *Burlington Magazine*, CXXXIV, 1992, pp. 218–24

M. Teasdale Smith, 'Conrad Witz's *Miraculous Draught of Fishes* and the Council of Basel', *Art Bulletin*, LII, 1970, pp. 150–56

GENERAL

L. Campbell, *Renaissance Portraits: European Portrait Painting in the 14th, 15th, and 16th Centuries*, New Haven, Conn., and London (Yale University Press) 1990

E.H. Gombrich, *The Heritage of Apelles*, Oxford (Phaidon) 1976

J. Hale, *The Civilization of Europe in the Renaissance*, London (HarperCollins) 1993

E. Panofsky, *Renaissance and Renascences in Western Art*, London (Paladin) 1970

J. White, *The Birth and Rebirth of Pictorial Space*, 3rd edn, London (Faber & Faber) 1987

ITALY

C. Acidini Luchinat (ed.), *The Chapel of the Magi: Benozzo Gozzoli's Frescoes in the Palazzo Medici-Riccardi, Florence*, London (Thames & Hudson) 1994

F. Ames-Lewis, *Drawing in Early Renaissance Italy*, New Haven, Conn., and London (Yale University Press) 1981

C. Avery, *Florentine Renaissance Sculpture*, London (John Murray) 1970

M. Baxandall, *Giotto and the Orators: Humanist Observers of Painting in Italy and the Discovery of Pictorial Composition, 1350–1450*, Oxford (Clarendon Press) 1971

————, *Painting and Experience in Fifteenth-Century Italy*, 2nd edn, Oxford (Oxford University Press) 1988

J.H. Beck, *Italian Renaissance Painting*, 2nd edn, Cologne (Könemann) 1999

A. Blunt, *Artistic Theory in Italy, 1450–1600*, Oxford (Clarendon Press) 1956

E. Borsook, *The Mural Painters of Tuscany: From Cimabue to Andrea del Sarto*, 2nd edn, Oxford (Clarendon Press) 1980

P.F. Brown, *Venetian Narrative Painting in the Age of Carpaccio*, New Haven, Conn., and London (Yale University Press) 1988

J. Burckhardt, *The Civilization of the Renaissance in Italy*, London (Phaidon) 1995

K. Christiansen, *Andrea Mantegna: Padua and Mantua*, New York (G. Braziller) 1994

K. Clark, *Leonardo da Vinci*, rev. edn, Harmondsworth (Penguin) 1989

A. Cole, *Art of the Italian Renaissance Courts: Virtue and Magnificence*, London (Weidenfeld & Nicolson) 1995

P. De Vecchi *et al.*, *The Sistine Chapel: A Glorious Restoration*, New York (Harry N. Abrams) 1994

S.J. Freedberg, *Painting in Italy, 1500–1600*, Harmondsworth (Penguin) 1975

C. Ginzburg, *The Enigma of Piero: Piero della Francesca*, trans. M. Ryle and K. Soper, London and New York (Verso) 2000

R. Goffen, *Renaissance Rivals: Michelangelo, Leonardo, Raphael, Titian*, New Haven, Conn., and London (Yale University Press) 2002

F. Hartt and D.G. Wilkins, *History of Italian Renaissance Art: Painting, Sculpture, Architecture*, New York (Abrams) 2003

H. Hibbard, *Michelangelo*, Harmondsworth (Penguin) 1985

H.P. Horne, *Botticelli: Painter of Florence*, Princeton, NJ (Princeton University Press) 1980

P. Humfrey, *Painting in Renaissance Venice*, New Haven, Conn., and London (Yale University Press) 1995

———— and M. Kemp (eds), *The Altarpiece in the Renaissance*, Cambridge (Cambridge University Press) 1990

P. Joannides, *Masaccio and Masolino: A Complete Catalogue*, London (Phaidon) 1993

M. Kemp, *Leonardo da Vinci: The Marvellous Works of Nature and Man*, Oxford (Oxford University Press) 2006

R. Krautheimer, with T. Krautheimer-Hess, *Lorenzo Ghiberti*, Princeton, NJ (Princeton University Press) 1970

R.W. Lightbown, *Donatello and Michelozzo: An Artistic Partnership and Its Patrons in the Early Renaissance*, London (Harvey Miller) 1980

————, *Sandro Botticelli: Life and Work*, London (Thames & Hudson) 1989

J.T. Paoletti and G.M. Radke, *Art in Renaissance Italy*, London (Laurence King) 1997

A. Paolucci, *Paolo Uccello, Domenico Veneziano, Andrea del Castagno*, Florence (Scala) 1991

J. Pope-Hennessy, *Italian Renaissance Sculpture*, London (Phaidon) 2000

P. Pray Bober and R. Rubinstein, with S. Woodford, *Renaissance Artists and Antique Sculpture: A Handbook of Sources*, London (Harvey Miller) 1986

P.L. Rubin, *Giorgio Vasari: Art and History*, New Haven, Conn., and London (Yale University Press) 1995

————, *Images and Identity in Fifteenth-Century Florence*, New Haven, Conn., and London (Yale University Press) 2007

J. Ruda, *Fra Filippo Lippi: Life and Work*, London (Phaidon) 1993

J. Shearman, *Mannerism*, Harmondsworth (Penguin) 1967

————, *Only Connect: Art and the Spectator in the Italian Renaissance*, Princeton, NJ (Princeton University Press) 1992

M. Wackernagel, *The World of the Florentine Renaissance Artist*, trans. A. Luchs, Princeton, NJ (Princeton University Press) 1981

E. Welch, *Art and Society in Italy, 1350–1500*, Oxford and New York (Oxford University Press) 1997

J. Wilde, *Venetian Art from Bellini to Titian*, Oxford (Clarendon Press) 1974

H. Wölfflin, *Classic Art: An Introduction to the Italian Renaissance*, trans. P. and L. Murray, London (Phaidon) 1994

THE NORTH

O. Benesch, *The Art of the Renaissance in Northern Europe*, London (Phaidon) 1965

L. Campbell, *The Fifteenth Century Netherlandish Schools*, London (The National Gallery) 1998

————, *Van der Weyden*, London (Oresko Books) 1979

C.C. Christensen, *Art and the Reformation in Germany*, Athens, Oh. (Ohio State University Press) 1979

E. Dhanens, *Hubert and Jan van Eyck*, New York (Tabard Press) 1980

M.J. Friedländer, *Early Netherlandish Painting*, trans. H. Norden, 14 vols., Leyden (A.W. Sijthoff) and Brussels (La Connaissance) 1967–76

W.S. Gibson, *Bruegel*, London (Thames & Hudson) 1977

C. Harbison, *The Art of the Northern Renaissance*, London (Weidenfeld & Nicolson) 1995

J.L. Koerner, *The Moment of Self-Portraiture in German Renaissance Art*, Chicago (University of Chicago Press) 1993

————, *The Reformation of the Image*, London (Reaktion) 2003

M. Meiss, *French Painting in the Time of Jean de Berry*, London (Phaidon) 1967–74

E. Panofsky, *Albrecht Dürer*, Princeton, NJ (Princeton University Press) 1943; 2nd edn, 1945; 3rd edn, 1948; published as *The Life and Art of Albrecht Dürer*, with introduction by J.C. Smith, 2005

————, *Early Netherlandish Painting*, Cambridge, Mass. (Harvard University Press) 1953

MUSEUMS AND OTHER SITES WITH IMPORTANT RENAISSANCE WORKS

AUSTRALIA

Melbourne, National Gallery of Victoria (www.ngv.vic.gov.au)

AUSTRIA

Innsbruck, Hofkirche (www.hofkirche.at)

Vienna, Graphische Sammlung Albertina (www.albertina.at)

Vienna, Kunsthistorisches Museum (www.khm.at)

BELGIUM

Antwerp, Koninklijk Museum voor Schone Kunsten (www.kmska.be)

Bruges, Groeningemuseum
(www.brugge.be/internet/en/musea/Groeningemuseum-
Arentshuis/Groeningemuseum/index.htm)

Bruges, Memling in Sint-Jan-Hospitaalmuseum
(www.brugge.be/internet/en/musea/Hospitaalmuseum/
Historische_hospitalen_1/index.htm)

Brussels, Musées Royaux des Beaux-Arts de Belgique: Musée d'Art Ancien
(www.fine-arts-museum.be)

Ghent, St Bavo's Cathedral (www4.gent.be/gent/english/monument/
sint-baafskathedraal/stbaafskathedraal.htm)

BRAZIL

São Paulo, Museu de Arte de São Paulo (www.masp.uol.com.br)

CANADA

Ottawa, National Gallery of Canada (www.gallery.ca)

CZECH REPUBLIC

Kroměříž, Archiepiscopal Castle (www.azz.cz)

Prague, Národní Galerie (www.ngprague.cz)

DENMARK

Copenhagen, Statens Museum for Kunst (www.smk.dk)

FRANCE

Bar-le-Duc, St-Etienne (www.barleduc.fr)

Beaune, Hôtel-Dieu (www.hospices-de-beaune.com/gb/musee)

Blois, Château Royal, Musée des Beaux-Arts (www.musees.regioncentre.fr)

Chantilly, Musée Condé (www.chateaudechantilly.com)

Colmar, Musée d'Unterlinden (www.musee-unterlinden.com)

Dijon, Chartreuse de Champmol (now the Centre Hospitalier Spécialisé),
 Le Puits de Moïse (www.dijon-tourism.com/uk/culture_monuments.htm)

Dijon, Musée des Beaux-Arts (www.musees-bourgogne.org)

Fontainebleau, Château (www.uk.fontainebleau-tourisme.com)

Lille, Palais des Beaux Arts (www.pba-lille.fr)

Paris, Musée Jacquemart-André (www.musee-jacquemart-andre.com)

Paris, Musée du Louvre (www.louvre.fr)

Villeneuve-lès-Avignon, Musée Municipal Pierre de Luxembourg
 (www.villeneuvelesavignon.fr/tourisme/gb/index.asp)

GERMANY

Berlin, Staatliche Museen zu Berlin, Gemäldegalerie (www.smb.museum)

Dresden, Gemäldegalerie Alte Meister (www.skd-dresden.de)

Frankfurt am Main, Städel Museum (www.staedelmuseum.de)

Karlsruhe, Staatliche Kunsthalle (www.kunsthalle-karlsruhe.de)

Munich, Alte Pinakothek (www.pinakothek.de)

Nuremberg, Germanisches Nationalmuseum (www.gnm.de)

Regensburg, Historisches Museum (www.regensburg.de)

Stuttgart, Staatsgalerie (www.staatsgalerie.de)

Wittenberg, Stadtkirche St. Marien (www.wittenberg.de)

HUNGARY

Budapest, Szépművészeti Múzeum (www.szepmuveszeti.hu)

IRELAND

Dublin, National Gallery of Ireland (www.nationalgallery.ie)

ITALY

Arezzo, Casa Vasari (www.comune.arezzo.it)

Arezzo, San Francesco (www.comune.arezzo.it)

Bergamo, Accademia Carrara (www.accademiacarrara.bergamo.it)

Bologna, Pinacoteca Nazionale (www.pinacotecabologna.it)

Ferrara, Pinacoteca Nazionale (www.pinacotecaferrara.it)

Florence, Badia Fiorentina (no website available)

Florence, Cathedral (Duomo) (Santa Maria del Fiore)
 (www.duomofirenze.it)

Florence, Galleria dell'Accademia (www.polomuseale.firenze.it/accademia)

Florence, Galleria degli Uffizi (www.polomuseale.firenze.it/uffizi)

Florence, Museo Nazionale del Bargello (www.polomuseale.firenze.it/bargello)

Florence, Museo dell'Opera del Duomo (www.operaduomo.firenze.it)

Florence, Museo di San Marco (www.polomuseale.firenze.it/musei/sanmarco)

Florence, Orsanmichele (www.polomuseale.firenze.it/musei/orsanmichele)

Florence, Palazzo Medici Riccardi (www.palazzo-medici.it)

Florence, Palazzo Pitti (Galleria Palatina) (www. polomuseale.firenze.it/
 musei/palazzopitti)

Florence, Palazzo Vecchio (www.comune.firenze.it/servizi_pubblici/
 arte/musei)

Florence, San Lorenzo, including the Old Sacristy and the Cappelle Medicee
 (www. polomuseale.firenze.it/musei/cappellemedicee)

Florence, San Pancrazio, Cappella Rucellai (incorporated with the Museo
 Marino Marini: www.museomarinomarini.it)

Florence, Sant'Apollonia (www.polomuseale.firenze.it/musei/apollonia)

Florence, Santa Croce (www.santacroce.firenze.it)

Florence, Santa Felicita (no website available)

Florence, Santa Maria del Carmine, Cappella Brancacci
 (www.comune.firenze.it/servizi_pubblici/arte/musei)

Florence, Santa Maria Novella
 (www.comune.firenze.it/servizi_pubblici/arte/musei)

Florence, Santa Trinita, Cappella Sassetti (no website available)

Florence, Santissima Annunziata (no website available)

Mantua, Palazzo Ducale (www.mantovaducale.beniculturali.it)

Mantua, Palazzo del Te (www.centropalazzote.it)

Milan, Biblioteca e Pinacoteca Ambrosiana (www.ambrosiana.it)

Milan, Pinacoteca di Brera (www.brera.beniculturali.it)

Milan, Santa Maria delle Grazie (Leonardo da Vinci's *Last Supper*:
www.cenacolovinciano.it)

Modena, Galleria e Museo Estense (www.museimodenesi.it)

Naples, Museo Nazionale di Capodimonte
(http://capodimonte.spmn.remuna.org)

Orvieto, Cathedral (Duomo) (www.opsm.it)

Padua, Basilica del Santo and Piazza del Santo (www.basilicadelsanto.org)

Padua, Cappella degli Scrovegni (www.cappelladegliscrovegni.it)

Parma, Cathedral (Duomo) (www.cattedrale.parma.it)

Parma, Galleria Nazionale (www.artipr.arti.beniculturali.it/htm/
Galleria.htm)

Parma, San Giovanni Evangelista (www.turismo.comune.parma.it)

Perugia, Collegio del Cambio (www.perugiaonline.it/
perugia_collegiodelcambio.html)

Perugia, Galleria Nazionale dell'Umbria (www.gallerianazionaleumbria.it)

Pesaro, Musei Civici (www.museicivicipesaro.it)

Prato, Cathedral (Duomo) and Museo dell'Opera del Duomo
(www.cultura.prato.it/musei/opera)

Recanati, Museo Civico Villa Colloredo Mels (www.lorenzo-lotto.it)

Rome, Galleria Borghese (www.galleriaborghese.it)

Rome, Galleria Nazionale d'Arte Antica (Palazzo Barberini)
(www.museidiroma.com/barberini.htm)

Rome, Musei Capitolini (Museo Capitolino and Palazzo dei Conservatori)
(www.museicapitolini.org)

Rome, The Vatican: San Pietro in Vaticano and the Musei Vaticani
(including the Sistine Chapel and Raphael's Stanze) (www.vatican.va)

Rome, Villa Farnesina (occupied by the Accademia Nazionale dei Lincei:
www.lincei.it)

Sansepolcro, Museo Civico (www.paginesi.it/arezzo/sansepolcro/storia.htm)

Siena, Cathedral (Duomo) (Libreria Piccolomini)
(www.operaduomo.siena.it/luoghi.htm)

Siena, Pinacoteca Nazionale (www.musei.it/toscana/siena/
pinacoteca-nazionale.asp)

Urbino, Palazzo Ducale–Galleria Nazionale delle Marche
(www.comune.urbino.ps.it)

Venice, Ca' d'Oro (Galleria Franchetti)
(www.venice-museum.com/franchetti1.html)

Venice, Frari (Santa Maria Gloriosa dei Frari) (no website available)

Venice, Gallerie dell'Accademia (www.gallerieaccademia.org)

Venice, Museo Correr (www.museiciviciveneziani.it)

Venice, Palazzo Ducale (www.museiciviciveneziani.it)

Venice, St Mark's Basilica (www.basilicasanmarco.it)

Venice, San Zaccaria (no website available)

Venice, Santi Giovanni e Paolo (and Campo Santi Giovanni e Paolo)
(no website available)

Venice, Scuola Grande di San Rocco (www.scuolagrandesanrocco.it)

Venice, Scuola di San Giorgio degli Schiavoni (no website available)

Verona, San Zeno Maggiore (www.comune.verona.it/turismo/Passeggiando/
ItinerarioC/sanzeno.htm)

Viterbo, Museo Civico (www.comune.viterbo.it)

Volterra, Pinacoteca e Museo Civico (www.comune.volterra.pi.it/english)

JAPAN
Tokyo, Kokuritsu Seiyo Bijutsukan (The National Museum of Western Art)
(www. www.nmwa.go.jp/en)

THE NETHERLANDS
Amsterdam, Rijksmuseum (www.rijksmuseum.nl)

Leiden, Stedelijk Museum De Lakenhal (www.lakenhal.nl)

Rotterdam, Boijmans Van Beuningen Museum (www.boijmans.nl)

POLAND
Cracow, Muzeum Książąt Czartoryskich (The Princes Czartoryski Museum)
(www.muzeum.krakow.pl)

Gdańsk, Muzeum Narodowe (www.muzeum.narodowe.gda.pl)

Poznań, Muzeum Narodowe (www.mnp.art.pl)

PORTUGAL
Lisbon, Museu Nacional de Arte Antiga (www.mnarteantiga-ipmuseus.pt)

RUSSIA

St Petersburg, The State Hermitage Museum (www.hermitagemuseum.org)

SPAIN

El Escorial, near Madrid, Monasterio, Real Sitio de San Lorenzo
 (www.patrimonionacional.es/escorial/escorial.htm)

Granada, Capilla Real (www.capillarealgranada.com)

Madrid, Museo Nacional del Prado (www.museodelprado.es)

Madrid, Museo Thyssen-Bornemisza (www.museothyssen.org)

SWITZERLAND

Basel, Kunstmuseum (www.kunstmuseumbasel.ch)

Geneva, Musée d'Art et d'Histoire (www.ville-ge.ch/mah)

UNITED KINGDOM

Bristol, City Museum and Art Gallery (www.bristol.gov.uk/museums)

Cambridge, Fitzwilliam Museum (www.fitzmuseum.cam.ac.uk)

East Molesey, Surrey, Hampton Court Palace (www.hrp.org.uk/
 HamptonCourtPalace)

Edinburgh, National Gallery of Scotland (www.nationalgalleries.org)

Glasgow, Kelvingrove Art Gallery and Museum
 (www.glasgowmuseums.com)

Hull, Ferens Art Gallery (www.hullcc.gov.uk)

Liverpool, Walker Art Gallery (www.liverpoolmuseums.org.uk/walker)

London, The British Museum, Department of Prints and Drawings
 (www.britishmuseum.org)

London, The National Gallery (www.nationalgallery.org.uk)

London, Victoria and Albert Museum (www.vam.ac.uk)

Oxford, Ashmolean Museum (www.ashmolean.org)

Oxford, Christ Church Picture Gallery (www.chch.ox.ac.uk)

Windsor, Windsor Castle, Royal Library (www.royalcollection.org.uk)

UNITED STATES OF AMERICA

Baltimore, Walters Art Museum (www.thewalters.org)

Boston, Isabella Stewart Gardner Museum (www.gardnermuseum.org)

Boston, Museum of Fine Arts (www.mfa.org)

Chicago, Art Institute of Chicago (www.artic.edu)

Cleveland, Oh., Cleveland Museum of Art (www.clevelandart.org)

Detroit Institute of Arts (www.dia.org)

Hartford, Conn., Wadsworth Atheneum (www.wadsworthatheneum.org)

Los Angeles, J. Paul Getty Museum (www.getty.edu/museum)

New Haven, Conn., Yale University Art Gallery
 (www.artgallery.yale.edu)

New York, The Frick Collection (www.frick.org)

New York, The Metropolitan Museum of Art (including The Cloisters)
 (www.metmuseum.org)

New York, Morgan Library and Museum (www.morganlibrary.org)

St Louis, St Louis Art Museum (www.stlouis.art.museum)

Washington, D.C., National Gallery of Art (www.nga.gov)

PICTURE CREDITS

INDEX

For Zoe and Emilia

I am indebted to Nicola Bailey, Claire Chandler, Michelle Draycott, Julian Honer and Nick Wheldon at Merrell for their perfectionism and professionalism in the creation of this book. I am grateful to my wife, Zoe, for the invaluable advice and support that she gave me while I was writing the text; and I would like to thank my parents, who first took me to Italy, for so many years of help and encouragement.

First published 2008 by Merrell Publishers Limited

81 Southwark Street
London SE1 0HX

merrellpublishers.com

British Library Cataloguing-in-Publication Data:
Masters, Christopher
Renaissance
1. Art, Renaissance
I. Title
709'.024

ISBN-13: 978-1-85894-448-7
ISBN-10: 1-85894-448-1

Produced by Merrell Publishers Limited
Designed by Dennis Bailey
Copy-edited by Elisabeth Ingles
Proof-read by Daniel Kirkpatrick
Indexed by Diana LeCore

Printed and bound in China

JACKET FRONT
Detail of Sandro Botticelli, *Primavera*, c. 1482 (Galleria degli Uffizi, Florence, Italy/ The Bridgeman Art Library; see page 131)

JACKET BACK, CLOCKWISE FROM TOP LEFT:
Detail of Jan van Eyck, *Portrait of Giovanni (?) Arnolfini and His Wife (The Arnolfini Portrait)*, 1434 (The National Gallery, London, UK/ The Bridgeman Art Library; see page 147); Detail of Agnolo Bronzino, *An Allegory with Venus and Cupid*, probably 1540–50 (The National Gallery, London, UK/The Bridgeman Art Library; see page 133); Detail of Fra Angelico, *The Annunciation*, c. 1440 (Museo di San Marco, Florence, Italy/The Bridgeman Art Library; see page 94); Detail of Paolo Uccello, *The Battle of San Romano*, probably c. 1438–40 (The National Gallery, London, UK/The Bridgeman Art Library; see page 138)

PAGE 2
Detail of Pieter Bruegel the Elder, *The Tower of Babel*, 1563 (Kunsthistorisches Museum, Vienna, Austria/The Bridgeman Art Library; see page 74)

PAGE 265
Detail of Michelangelo Buonarroti, *Pietà*, 1498–99 (Araldo de Luca/Corbis; see page 30)